BY THE SAME AUTHOR

John Ruskin: The Argument of the Eye,
Thames & Hudson, Princeton University Press, 1976

Under Siege, Literary Life in London 1939-45,
Weidenfeld & Nicolson, OUP New York, 1977

Ruskin and Venice,
Thames & Hudson, 1978

Art and Society: Ruskin in Sheffield, 1876,
Brentham Press, 1979

Irreverence, Scurrility, Profanity, Vilification and Licentious Abuse:
Monty Python, The Case Against,
Methuen, 1981

(ed.) New Approaches to Ruskin: 13 Essays,
Routledge, 1981

In Anger: Culture in the Cold War, 1945-60,
Weidenfeld & Nicolson, OUP New York, 1981

Footlights! A Hundred Years of Cambridge Comedy,
Methuen, 1986

(ed.) The Ruskin Art Collection at Oxford: The Rudimentary Series,
Lion & Unicorn Press, Royal College of Art, 1984

Too Much: Art and Society in the Sixties, 1960-75,
Methuen, 1986

The Heritage Industry: Britain in a Climate of Decline,
Methuen, 1987

Future Tense: A New Art for the Nineties,
Methuen, 1990

Culture and Consensus: England Art and Politics since 1940,
Methuen, 1995

Ruskin and Oxford: The Art of Education,
Oxford University Press, 1996

Ruskin's Venice,
Pilkington Press, 2000

(ed.) *Ruskin's Artists: Studies in the Victorian Visual Economy*,
Ashgate, 2000

Ruskin, Turner and the Pre-Raphaelites
(with Ian Warrell and Stephen Wildman), Tate Gallery
Publications, 2000

*An Address Delivered in St Andrew's Church, Coniston, on the Centenary of
the Death of John Ruskin*,
privately printed by the Cygnet Press for the Ruskin Association, 2003

*Experience and Experiment: The UK Branch of the Calouste
Gulbenkian Foundation*,
(with John Holden), Calouste Gulbenkian Foundation, 2006

(ed.) *There is No Wealth but Life: Ruskin in the 21st Century*,
Ruskin Foundation, 2006

Not a sideshow: Leadership and Cultural Value,
Demos, 2006

John Ruskin,
(VIP 10), Oxford University Press, 2007

Of Ruskin's Gardens,
Guild of St George Lecture 2009

Ruskin on Venice: 'The Paradise of Cities',
Yale University Press, 2010

John Byrne: Art and Life,
Lund Humphries, 2011

The Cultural Leadership Handbook: How to run a creative organization,
(with John Holden), Gower, 2011

Chris Orr: The Making of Things,
(with Chris Orr), Royal Academy Publications, 2013

Cultural Capital: The Rise and Fall of Creative Britain,
Verso, 2014

(ed.) John Ruskin, *Giotto and his Works in Padua*,
David Zwirner Books, 2018

RUSKIN AND HIS CONTEMPORARIES

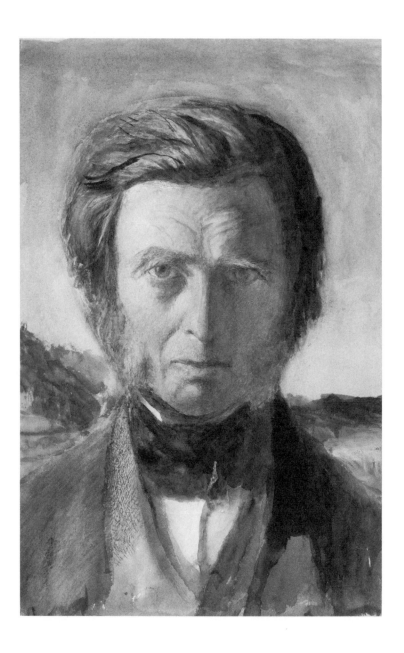

Ruskin and
his Contemporaries

ROBERT HEWISON

PALLAS ATHENE

In celebration of the Ruskin Seminar at Lancaster University

CONTENTS

PREFACE

❧

I neither wish to please, nor displease you;
but to provoke you to think. (27.99)

After the celebrations in 1919 that marked the centenary of his birth on 8th February, 1819, Ruskin's reputation went into a steep decline. The 14-18 war had created a no-man's-land between the apparent certainties of the Victorian era and the pessimistic modernism that emerged from that appalling conflict. People wanted a new start, and the factors that had bolstered what was remembered as Victorian complacency – imperial power, industrial strength, religious conformity, social deference, patriarchy – were being questioned, and in any case were visibly in decline. Besides, there was a natural tendency for a new generation to want to challenge, or simply forget, the ideas and values that had shaped the beliefs of their forebears.

Despite the fact that he had spent most of his life disputing the ruling ideas of his society – its utilitarianism, its philistinism, its materialism and its abuse of the natural world – Ruskin became just one more eminent Victorian to be consigned to the attic. His art collection was dispersed, his house sold, his exquisite drawings could be had for almost nothing, and second-hand book dealers begged people to take away the bulky volumes of the Library Edition of his Collected Works – all thirty-nine of them. There were a few fans, a few collectors. The utopian society he had founded, the Guild of St George, hung on as an

eccentric relic, and it turned out that when it came to designing a new social order after yet another world war, some of Ruskin's ideas had percolated into the minds of its designers.

But it wasn't until the 1960s that Ruskin began to be taken seriously again. The post-war generation was free of the Oedipal instincts of their fathers, and viewed the Victorians as unthreatening grandparents. Part of this revival was biographical. Ruskin had led an extraordinary life, and the mystery and scandal of his unconsummated marriage could now be explored with relish. But as the whole of Victorian life came into perspective, Ruskin's ideas began to be released from their mouldy bindings. His output, like his language, was daunting, but here was someone who drew as well as he wrote, who became as passionate about economics as he was about art, who changed people's taste in architecture and design, and who took science as seriously as he did painting and sculpture. The 1960s were interested in breaking down the hierarchies and barriers between disciplines: here was an inter-disciplinarian before the term even existed. Ruskin became contemporary.

It wasn't long before Ruskin's writings became of more than academic interest. It turned out that this prophet and preacher still had something to say. Though cast in an increasingly unfamiliar Biblical form of speech, Ruskin's insistence on the value of art, that the health of a society depended on the vitality of its culture, and that co-operation was better than competition, struck a chord that resonated beyond the conservative context in which his ideas had been formed. Somehow, Ruskin managed to be a reactionary and a revolutionary at the same time. He wanted to conserve the environment, but knew it would take a revolution in economics to achieve that. Ruskin's environmentalism, and his criticism of neoliberal economic theory, are as

valid now as when he first brought them together in that simple idea: 'There is no wealth but life'.

☗ ☗ ☗

This helps to explain why, when it came to marking the centenary of Ruskin's death on 20th January 1900, Ruskin's reputation stood as high as it had a hundred years before. When that measure of social, cultural and political significance, the *Oxford Dictionary of National Biography*, commissioned a new article on Ruskin to replace the original of 1901, it was given exactly the same length as the first one. Thanks to the revival of the Guild of St George, the restoration of Ruskin's Lake District house, Brantwood, the creation of the Ruskin Foundation, and the opening of the Ruskin Library at Lancaster University, there is an institutional framework to ensure the preservation of Ruskin's manuscripts, books and artefacts, and the transmission of his ideas. Ruskin's bicentenary in 2019 will be celebrated internationally with as much vigour as the centenary of his death in 2000. It is to be hoped that his ideas will not then suffer the eclipse they did after 1919. This book is a contribution to ensuring that they do not.

INTRODUCTION

❧

Half way through his literary career, Ruskin stopped writing books. His rate of literary production actually increased, but after 1860 his published writings would take the form of collections of articles, lectures, pamphlets, letters to newspapers and other public interventions. From 1871 onwards his monthly newsletter, *Fors Clavigera*, became a stream of consciousness that anticipates Ezra Pound's *Cantos*. Once he had started to publish on his own behalf with the help of his former pupil, George Allen, part-publication became increasingly the norm: his late guidebooks to Florence and Venice, for instance, and his botanical and geological studies. These parts eventually would be bound between hard covers, but reading them in that form – and still more in the majestic binding of Cook and Wedderburn's Library Edition – distances you from the humble informality of the original simple cardboard covers.

Now that I am more than half way through my own literary career, I have decided to follow Ruskin's example. *Ruskin and his Contemporaries* is a compilation. It is constructed from disparate sources, some published, some unpublished, and some entirely new. Some are articles in collections that I or colleagues have edited, and I am grateful to my fellow editors for their commissions. Many chapters began life as papers given to the Ruskin Seminar at Lancaster University, a wonderful place to try out ideas. These are joined by lectures commissioned and delivered

elsewhere, including from my time in 2000 as Slade Professor of Fine Art at Oxford.

△ △ △

I can see why Ruskin came to prefer the short form, especially the lecture. As his message became more urgent he sought an immediacy of communication, a direct dialogue with his audience. By all reports, he became a charismatic lecturer, improvising as he spoke, and enhancing his delivery with visual aids such as the huge lecture-diagrams he prepared; by painting over the glass of a Turner watercolour to demonstrate the effects of industrial pollution; or placing a hand-plough on the demonstration table in order to talk about engraving. The lecture became his mode of address. As he wrote in the introduction to one of his part-publications, *Love's Meinie*, in 1881: 'I still write habitually in a manner suited for oral delivery, and imagine myself speaking to my pupils, if ever I am happily thinking in myself' (25.14).

There is a great deal to be said for the lecture as literary form. The 'academic hour' – which is supposed to last fifty minutes – imposes the concentration of length, the need to construct the arc of an argument, and the demand for clarity from an audience that has no text in front of them, and so cannot turn back to see what might have been meant. It is also necessary to keep your audience awake, with provocations to retain their attention and jokes that open their faces – and therefore their minds – to new ideas. Modern technology supplies increasingly sophisticated visual aids, but it is still the words that count. The lecture encourages a sprightlier form of discourse than in a journal article, or a solemn chapter in a book.

Nonetheless, *Ruskin and his Contemporaries* is a book, constructed like a book. All the material has been revised, to smooth out otherwise unavoidable repetitions, to refer forwards and backwards, and to incorporate entirely new material. The organisation is chronological, beginning with an overview that was originally written as the introduction to my first book, *John Ruskin: The Argument of the Eye* (1976), but not used. That book's title suggested the essence of my approach to Ruskin as someone with a unique ability to link word and image, so that each carries the other. The chapter is also biographical, and the chronological approach that follows allows us to observe the formation of Ruskin's mind under the influence of his mother's Evangelicalism and his father's æsthetic tastes and Ultra-Tory politics. His father's wealth created the circumstances in which he was able to develop two relationships that influenced his whole life: with the art and personality of J. M. W. Turner, and the place that is Venice.

Not counting his parents, nine of the seventeen chapters are shaped by Ruskin's relationship with an individual. Holman Hunt is visited twice, though at very different points in his and Ruskin's lives. Three relationships are adversarial – with Victor Hugo, Henry Cole, and Charles Darwin. The chapter on Darwin was especially written, because it is impossible to write about Ruskin and science without coming to terms with Darwin. The fact that Ruskin was unable to do so, I believe, is one of the reasons for his despair, and ultimate insanity.

His relationships with Holman Hunt, Octavia Hill and Oscar Wilde were shaped by Ruskin's critical patronage. In the case of Octavia Hill, as of Kate Greenaway, who is not discussed here, there was also an element of unrequited love on their parts. Ruskin's own frustrated passion for Rose La Touche runs as a

thread throughout the book. I hope that Oscar Wilde's complete exclusion from the Library Edition has been compensated for here.

Ruskin, in his own impossibly idiosyncratic way, also had relationships with contemporary institutions. Indeed, he founded some. This calls for a discussion of ideas as well as personalities: his belief in the value of drawing, which links the London Working Men's College to the Ruskin School of Drawing in Oxford, and his utter abhorrence of utilitarianism and economic liberalism, in opposition to which he set up the Guild of St George. It is a tribute to the tenacity of Ruskin's ideas that both the Guild of St George and the Ruskin School of Art survive into the 21st century, and are flourishing.

Discussion of Ruskin's ideas calls for what might be called a more 'theoretical' approach, and in the last two chapters I discuss, first of all, the Paradise myth that became the ruling idea of *Ruskin and Venice: 'The Paradise of Cities'* (2010). In my conclusion, I bring Ruskin into the 21st century, by showing the influence of his ideas on work that I have done and arguments that I have made in opposition to the ruling economic and institutional orthodoxies of our own age. Ruskin is still our contemporary.

�109 �109 �109

Fifty years of writing about Ruskin means that I have accumulated many personal debts. I hope that I will be forgiven for not listing them all here, and refer you to the acknowledgments in *Ruskin on Venice: 'The Paradise of Cities'* (2010), which describes the progress of my Ruskin studies. I would, however, like to thank Alan Davis for his scrupulous reading of and stimulating

response to drafts of this book, the designer of the jacket, Geoffrey Winston, and my publisher Alexander Fyjis-Walker for adding me to his roll of Ruskin writers. Lastly, I thank my wife, Erica, for seeing the point of it all.

College House Cottage, 2018

A NOTE ON THE REFERENCES

ᇰᄋ

Quotations from Ruskin's published works are taken from *The Works of John Ruskin*, Library Edition, (1903-12) ed. E. T. Cook and Alexander Wedderburn, 39 vols, London, George Allen, and New York, Longmans Green. They are cited by volume and page number in the text. Thus vol. 16, p. 31, appears as: (16.31). Quotations from *The Diaries of John Ruskin* (1956-9), ed. Joan Evans and J. H. Whitehouse, 3 vols, Clarendon Press are cited in the text as D followed by volume and page number, thus (D2.401) means *Diaries* vol. 2, p. 401.

In like manner:

1845L: *Ruskin in Italy: Letters to his Parents, 1845* (1972), ed. H. J. Shapiro, Oxford, Clarendon Press

1858L: *John Ruskin: Letters from the Continent, 1858* (1982), ed. J. H. Hayman, Toronto, Toronto University Press

JRTC: *The Correspondence of Thomas Carlyle and John Ruskin* (1982), ed. George Allen Cate, Stanford, Stanford University Press

LN: *The Correspondence of John Ruskin and Charles Eliot Norton* (1987), ed. J. L. Bradley and Ian Ousby, Cambridge, Cambridge University Press

RFL: *The Ruskin Family Letters: The Correspondence of John James Ruskin, his Wife, and their son John* (1973), ed. Van Akin Burd, 2 vols, Ithaca, Cornell university Press

RLV: *Ruskin's Letters from Venice, 1851-1852* (1955), ed. J. L. Bradley, New Haven, Yale University Press

WL: *The Winnington Letters of John Ruskin* (1969), ed. Van Atkin Burd, Cambridge Mass., Harvard University Press

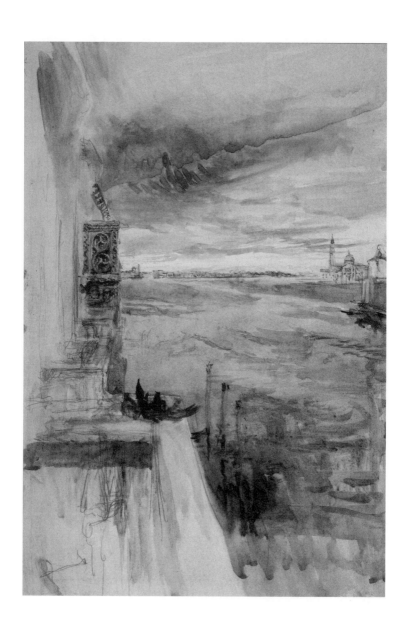

CHAPTER I

JOHN RUSKIN AND
THE ARGUMENT OF THE EYE

❧

On 4 March, 1877, Ruskin was in Venice. He had arrived the previous September, on a year's leave from his post as the first Slade Professor of Fine Art at Oxford University, a position he had taken up in 1870. This was his longest visit since the completion of his masterpiece, *The Stones of Venice*, in 1853. He had hoped to recapture the delight he felt when he first saw Venice in the 1830s, but he knew that the 19th century had caught up with city, and that so much had changed. He wrote to a friend:

> Alas, every place on the Continent is now full of acute pain
> to me, from too much association with past pleasure, giving
> bitterness to the existing destruction. I do not know how I
> should have felt in returning to the places which my Father
> and Mother and I were so happy in, had they remained in
> unchanged beauty – but I think the feeling would have been
> one of thrilling and exalting pensiveness, as of some glorious
> summer evening in purple light. But to find all the places we
> had loved turned into railroad stations or dust-heaps – there
> are no words for the withering and disgusting pain. (37.204-5)

He had private, as well as public, reasons for believing that a paradise had been lost.

Ruskin began his stay at the Grand Hotel, where his room looked out towards the basin of San Marco (Fig. 2) and across to

Opposite: Fig. 2: John Ruskin, San Giorgio Maggiore, The Basin of St Marks and a Balcony of the Casa Contarini Fasan, 1876

Fig. 3: John Ruskin, The Zattere, with the Chiesa dei Gesuati, *1877*

the Salute church on the other side of the Grand Canal; in February, however, he moved to cheaper lodgings above a trattoria on the Zattere, the long quay facing the wide sweep of water that lies between the main body of Venice and the semi-industrial island of the Giudecca. The site of lodgings is now occupied by the Calcina Hotel, which proudly, but misleadingly, bears a plaque commemorating his stay in a building that had not yet been built in 1877.

On 4 March he was up early, and the moon was still visible in a soft sky. Inside the room that he used as his study were a mass of books and papers, sheets of proofs for correction, letters to and from his many correspondents, rapid sketches scribbled during his trips by gondola, and the careful watercolour studies that he was making of Carpaccio's painting of *The Dream of St Ursula*, which he was studying in the Accademia Gallery. There were plaster casts of sculptures on the Ducal Palace, histories

and guide books to Venice, the 13th edition of John Murray's *Handbook for the Traveller in Venice*. There was a copy, in Greek, of Plato's *Laws*, from which he tried to translate a passage each morning. To distract him from more serious work, there was a copy of Casanova's memoirs. Sea horses swam in a glass bowl, beside it lay a cockleshell picked up during a rowing expedition to the Venetian island of St Helena. There was an Italian missal, his mother's Bible, and a 14th century illuminated version besides.

Ruskin enjoyed the view from his study, but a lime kiln opposite blew smoke in white drifts across the water. Large steamers would pass within thirty yards of his window on their way to the port, and the scream of their whistles and the rattle of their steam cranes were a strain on his nerves. As usual, he had set aside the first few days of the month in order to write the next number of *Fors Clavigera*, his monthly letters addressed 'to the workmen and labourers of Great Britain' (27.vii). These printed pamphlets – the equivalent to publishing a personal blog – were the most direct form of communication with the public that he had, other than when he gave lectures.

The number for April was intended to contain important news about his plans for social reform. As is described in Chapter XI, before coming to Venice he had been to Sheffield to talk to a group of working-men who wanted to set up a communal farming experiment. As a result, he had bought a small farm near Abbeydale, just outside Sheffield, and agreed to let them have the land rent free. Now, Ruskin wanted to give his Sheffield workers some advice on coming into their property. In spite of the noise from the steamer *Pachino*, he was at work as the moon set.

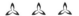

There is a particular reason for describing the circumstances of 4th March 1877 in such detail. The minutiæ of this particular morning do not just set the scene, the nature of the man this book is about meant that things that might seem insignifcant to others were full of meaning to him. What the weather was like, what objects were immediately to hand, could be very important for Ruskin's mood and his choice of subject. It is always useful to know what books a writer was reading, but in Ruskin's case they were just one inspiration. The cockleshell and the snailshell appear elsewhere in *Fors Clavigera*. That morning, when he looked up from his table because of the noise from the steamer *Pachino*, he was surprised to see that the cross of St George was painted on her bows. St George was the patron saint of his utopian society, The Guild of St George, and the steam cranes, and Plato, and St George all made their way into his work that day.

Ruskin, about to be 58, was at a turning point in his life. During this winter in Venice he experienced a crisis when he very nearly lost his reason. He survived – but the experience prompted him to write a fragment of autobiography, one that allows us into his mind, where we can explore his intellectual formation, and see how certain images helped to shape his ideas.

Ruskin wanted to advise the Sheffield workers who were about to take over the farm at Abbeydale on how to run their affairs, and this advice was set in the wider context of his plans for social reform. As Plato had prescribed laws for an ideal society, so Ruskin would prescribe his. He had been trying to get these ideas on the Guild of St George down on paper for the past three mornings. When he saw the cross of St George on the bows of the steamer, this seemed to confirm that this should be the topic for the next number of *Fors Clavigera*.

To explain the Guild's beliefs, he felt he should first explain

his own. That in turn involved saying something about the course of his life. So, turning to the blank sheet of paper that every writer has to face, he began to write a memoir, one that turns into an accidental self portrait. He set out to analyse the course of his spiritual life. But he did so in unusual terms. He began by saying:

> All my first books, to the end of *The Stones of Venice*, were written in the simple belief I had been taught as a child; and especially the second volume of *Modern Painters* was an outcry of enthusiastic praise of religious painting, in which you will find me placing Fra Angelico (see the closing paragraph of the book) above all other painters. (29.87)

Ruskin wanted to explain the progress of his spiritual life through his ideas on art. His justification was that the teaching of art is the teaching of all things. As Chapter X will show, this was an article of faith, of religious faith, throughout his life. The conviction that art was an expression of the love and the will of God had been established long before he knew very much about Fra Angelico, or indeed about Italian art.

The source of his faith was Nature, which he understood in terms that were at the same time romantic, religious, and, as Chapter IX demonstrates in more detail, scientific. His study of Turner, discussed in Chapter III, had taught him that the natural world, as he read in Wordsworth, was the source of 'a sense sublime / of something far more deeply interfused', that gave him access to the work of God.[1] The principles of Natural Theology taught him that the earth was the creation of God, and the surface of the earth bore the traces of the handwriting of God. Because it was the creation of God, Nature should be studied in terms of geology and botany, in order to increase

the knowledge of the work of God. Chapter XIV describes the terrible impact the theories of Darwin were to have on his faith in the 1870s.

The 'simple belief I had been taught as a child' pushed Ruskin towards a visual understanding of the world. From a young age he made collections of minerals, trying at the same time to express his passion for the external world in poems modelled on Wordsworth and Byron, and through his own drawings. The contemporary artist – the 'modern painter' – who brought all these ideas together for Ruskin was Joseph William Mallord Turner, and in 1836, when he was just fifteen years old, Ruskin was provoked into expressing his enthusiasm for the work of the man who was becoming what would turn out to be his flawed hero, as Chapter III shows. That year, Turner had a painting in the summer exhibition at the Royal Academy, which he called *Juliet and Her Nurse* (Plate 1). Shakespeare's characters do appear as small figures in the foreground, but the scene has been transposed from Verona to Venice, presenting a night view looking down on the Piazza San Marco with the cathedral, the campanile and the Ducal Palace illuminated by moonlight and the flare of fireworks.

The painting gave violent offence to the neo-classical taste of the art critic of the conservative *Blackwood's Magazine*. Young Ruskin wrote an article in Turner's defence, protesting that the painting was not the mess of absurd colours and false perceptions that the critic of *Blackwood's* claimed it to be, but that it was a true representation of the scene, both accurate and sublime. Turner, to whom Ruskin's father had sent the article, was not keen on publication, and so it was put aside, and did not appear until after Ruskin's death. But he had begun to find his direction in life.

The way ahead was not at first clear. As shown in the next chapter, he began, like many young people, by following the tastes of his parents, who collected pictures of pleasant and picturesque landscapes, constructed on formulæ that derived from the landscape painters of the 18th century. His parents encouraged his precocious talent for drawing by hiring teachers who trained him in the picturesque conventions of the day. But as Ruskin learned more about Turner, and got to know him personally through buying his work, he began to appreciate Turner's genius, and set out to argue for the profundity and modernity of his vision in the first volume of *Modern Painters*, published in 1843. It was well received, but this was only the beginning of a project that would not be completed until the appearance of the fifth volume in 1860.

In truth, when he started, Ruskin had a limited knowledge of art, and art history. It was only after he had already published his first volume that he decided that he should make a serious study trip to France and Italy. He had already travelled on the continent with his parents several times before, but in 1845, he travelled without them for the very first time. As he describes in his fragment of autobiography, the effect of that journey was life-changing.

In Florence he was forced to acknowledge that there were artists who painted in a very different way to Turner. In spite of his Protestant prejudices, he accepted the religious spirit of Angelico and the other artists who, literally, were pre-Raphael, for he saw that their religious vision was as valid as the romantic imagery of Turner. He wrote in a letter home to his father that in the list of great religious painters he must put Angelico: 'in a class by himself, he is not an *artist*, properly so called, but an inspired saint' (1845L.144). In 1852 he wrote to his father: 'Till

1845 I had never seen an Angelico – did not know what a Giotto was like – in about four months I explored a whole half world of painting in Florence' (RLV.180). That is why the second volume of *Modern Painters* became 'an outcry of enthusiastic praise of religious painting' (Pl. 2).

But Fra Angelico was not the only discovery that Ruskin made in 1845 – years later, he would write that he regretted that he had ever gone on from Florence to Venice. First of all, the decay of many of the buildings shocked him, and the restorations that were under way made him furious. In order to record as much as possible of what he saw, he began to buy examples of a new, and revolutionary, way of seeing and recording the world: the daguerreotype. This was the start of one of the most important collections of the 19th century.[2] And because, possibly because of the daguerreotype, he was beginnning to see architecture differently, he began to change the way he drew (Pl. 3). In Venice he had met up with his latest drawing master, James Duffield Harding. Ruskin commented to his father: 'there is one essential difference between us. His sketches are always pretty because he balances their parts togther & considers them as pictures – mine are always ugly, for I consider my sketch only as a written note of certain *facts*' (1845L.189).

There was yet another discovery to be made in Venice. The religious content of works by Angelico was enough to justify Ruskin's pleasure in looking at them, but in Venice he was seduced by the sensual powers of Titian and Tintoretto. His Protestant conscience was troubled. Recalling his feelings in 1877, he wrote:

> I discovered the gigantic power of Tintoret, and found
> that there was quite a different spirit in that from the spirit
> of Angelico; and, analysing Venetian work carefully, I

found, – and told fearlessly, in spite of my love for the masters, – that there was 'no religion whatever in any work of Titian's, and that Tintoret only occasionallly forgot himself into religion'. (29.87)

The power of Tintoretto was indeed gigantic. One day, having idled by the canals and sketched the market boats, Ruskin and Harding wandered into the halls of the Scuola di San Rocco. They were overwhelmed by what they saw (Pl. 4). Ruskin wrote home to his father:

> I have had such a draught of pictures today enough to drown me. I never was so utterly crushed to the earth before any human intellect as I was today, before Tintoret. Just be so good as to take my list of painters, & put him in the school of Art at the top, top, top of everything, with a great big black line underneath him to stop him off from everybody – and put him in the school of Intellect, next after Michael Angelo. He took it so entirely out of me today that I could do nothing at last but lie on a bench & laugh. (1845L.211-2)

The vigour of Ruskin's study of the central figures expresses the impact the painting had (Pl. 5).

The sensuous nature of the experience of seeing Tintoretto was a reminder to Ruskin of his own humanity. The repressed only child of elderly, middle-class, Evangelical Protestant parents, he felt a delight in the faculty of sight that helped to compensate for other pleasures that were unknown to him. The consequence of the experience in the Scuola di San Rocco was not simply a major revision of *Modern Painters*. Ruskin felt that there was a connection between the art of Tintoretto and the city of Venice that seemed to be crumbling all around him. A link was made in his mind between Art, Man and his Society.

Tintoret swept me away at once into the 'mare maggiore' [*the wider sea*] of the schools of painting which crowned the power and perished in the fall of Venice; so forcing me into the study of the history of Venice herself; and through that into what else I have traced or told of the laws of national strength and virtue. (35.372)

The decision to study Venetian cultural history led to *The Stones of Venice*, published in three volumes between 1851 and 1853. He argued that there was a direct connnection between the condition of art and the health of the nation that produced it, and applied it to the whole historical and architectural fabric of the city. These humane interests pulled against the spiritual, for he found that although the religious painters depicted a spiritual vision that as a religious man he could respect, their art did not seem so great to him, and did not give so much pleasure to him, as those of more worldly men. In 1858 these conflicts came to a crisis point in Turin, and once more the crisis was in front of a picture, Veronese's *Solomon and the Queen of Sheba* (Pl. 6).

He gave two accounts of the change that overtook him in 1858, one written on that morning in Venice in 1877, another later, in his unfinished autobiography, *Præterita*. These accounts differ, although the result is the same: Ruskin sloughs off the Evangelical Protestant faith of his childhood. In the first version, he leaves his work in the art gallery in Turin, and goes to hear a Protestant service in an Evangelical chapel:

A little squeaking idiot was preaching to an audience of seventeen old women and three louts, that they were the only children of God in Turin; and that all the people in Turin outside the chapel; and all the people in the world out of sight of Monte Viso, would be damned. I came out of the

chapel, in sum of twenty years of thought, a conclusively *un*-converted man. (29.89)

In the later version, in his autobiography, the moment of decision is not so sudden. After the service he goes back to the gallery, and it is here, in front of Veronese's picture, that the essential change takes place:

> *Solomon and the Queen of Sheba* glowed in full afternoon light. The gallery windows being open, there came in with the warm air, floating swells and falls of military music, from the courtyard before the palace, which seemed to me more devotional, in their perfect art, tune and discipline, than anything I remembered of evangelical hymns. And as the perfect colour and sound gradually asserted their power on me, they seemed finally to fasten me in the old article of Jewish faith, that things done delightfully and rightfully were always done by the help and in the Spirit of God. (35.495-6)

This second version shows more clearly what happened to Ruskin. He had been suffering religious doubts for years, but it took a picture, the argument of the eye, to decide him finally. It was in fact a synæsthetic moment, for not only was there the sensual beauty of Veronese, but also music, so that 'perfect colour and sound' combined to ease him of the problem that had troubled him for so long. The change was not the result of a carefully argued debate between two sets of religious principles, it was a choice of images, between the modern ugliness of the Protestant chapel, and the jewels and colours of Veronese. Angelico, Tintoretto, and now Veronese, mark the milestones in his life.

One effect of the moment in the gallery in Turin, however, was that Ruskin moved away from the study of paintings for a

while. His religion, as he explains in his account of 1877, was now 'the religion of Humanity' (29.90). And that meant engaging in human problems. As discussed in Chapter VIII, and more extensively in Chapter XVII, the 1860s are the years of social criticism, when he found that, however popular he may have been as an art critic, his attack on the economic philosophy of his day was considered ridiculous. Contact with art was not lost, however, for his argument was still that the quality of art was an index of the health of a nation. But he now believed that the necessary medicine of reform – in his case a return to pre-industrial social values – should be applied directly to society, if art was to thrive.

Freed of the blinkers of religious dogma, Ruskin was able to take a wider view of art, and he began to create for himself a system that could apply to all art of all times. Art made sense of the world through images and symbols – if you knew how to look. He discovered fresh artists to admire, Carpaccio in Venice, and Botticelli in Florence. In 1874 the sight of Botticelli's *Madonna Enthroned* and *Madonna Crowned* in Florence left him 'more crushed than ever by art, since I lay down on the floor of the Scuola di San Rocco before the Crucifixion' (D3.807). The search led him back to the religious painters, and once again a turning point was reached in front of a picture. Ruskin travelled on from Florence in 1874 to Assisi, where he began to study a fresco in the lower Church, then attributed to Giotto, *The Marriage of Poverty and St Francis* (Pl. 7). In spite of the experience at Turin, Ruskin was still nagged by the apparent conflict between the ability to paint well – that is to say, to render the truth of appearance – and the ability to convey religious truth. At Assisi the problem was solved as he copied from the fresco. As he wrote in 1877:

While making this drawing, I discovered the fallacy under which I had been tormented for sixteen years, – the fallacy that Religious artists were weaker than Irreligious. I found that all Giotto's 'weaknesses' (so called) were merely absence of material science. He did not know, and could not, in his day, so much of perspective as Titian, – so much of the laws of light and shade, or so much of technical composition. But I found he was in the make of him, and contents, a very much stronger and greater man than Titian; that the things I had fancied easy in his work, because they were so unpretending and simple, were nevertheless entirely inimitable; that the Religion in him, instead of weakening, had solemnized and developed every faculty of his heart and hand; and finally that his work, in all the innocence of it, was yet a human achievement and possession, quite above everything that Titian had ever done! (29.91).

This reconciliation with religious painting helped to reconcile Ruskin with religion itself. Veronese had prised him out of the narrow Protestantism of his youth, but he found that living without any hope of an afterlife was as difficult as living in fear of eternal Hell. The return to belief was not a step back, rather, it was an expansion, as he saw first that Protestantism, and then agnosticism, were too narrow to permit a full comprehension of the world. He was, as he told his readers, becoming 'catholic' – neither Roman Catholic nor Evangelical Protestant – but catholic in the true sense of the word (29.92).

The problem for Ruskin's audience was that his expanded vision seemed to be becoming more and more obscure – even mystical. (Privately, in a sense it was, for as discussed in Chapter XV, since the 1860s he had been taking an interest in spiritualism.) In his public writing, because he wanted to bring all things

to unity, he would jump from subject to subject in a confusing manner, and, although discussing quite simple things, he would give them a deep significance. The fresco at Asissi had simple visual appeal, but iconographically it is very complicated, and in the same way Ruskin used a personal symbolism that others found hard to understand.

This mystical strain became even more apparent during his stay in Venice in 1876 and 1877. Since September he had been making a study of Carpaccio's *The Dream of St Ursula* (Pl. 8), part of a large cycle of paintings of the life the saint made in the 1490s that hung in the Accademia Gallery. He had had the painting taken down from the walls and placed in a private room so he could study it more closely. He found the work extremely demanding, and as he strugggled with his copy, the painting took on an intense personal meaning.

Two years before this winter in Venice, Rose La Touche (Pl. 9), to whom he had proposed marriage in 1866 when she was eighteen and he forty-seven, had died, possibly of *anorexia nervosa*. In 1858 he had been asked by her mother to give the then ten-year-old girl drawing lessons. The La Touches were a wealthy Anglo-Irish family; while Rose's mother had literary and artistic ambitions, her father had strong Evangelical convictions. She was a strange, sick girl, much persuaded by her father's religious beliefs, and prone to periods of mental disturbance. At first the La Touches, lionising Ruskin, encouraged the friendship, but as this turned to love Rose's instability grew worse, while Ruskin's gradual loss of faith became less and less acceptable. She once asked him how it could be possible to love him, if he proved to be a pagan. When he proposed to her in 1866 she did not say no, but asked him to wait three years. During these years they were unable to meet, and the La Touches turned against him.

Rose's condition did not improve, and her parents sought legal opinion about Ruskin's marital status, which concluded that if he were to marry and have children, the annulment of his marriage to Effie – now Mrs Millais – would become invalid. When contacted by the La Touches, his former wife, still scalded by the humiliation of the annulment of their marriage, added her private spite. In 1869 the third anniversary of his wedding proposal passed without an answer, but their relationship was not broken off altogether, falling instead into an agonizing pattern of brief ecstatic moments together followed by long periods of mutual misunderstanding, and interference from Rose's parents.

The scandal of his unconsummated marriage, annulled in 1854, Ruskin's public loss of faith, and Rose's religious mania, made their situation hopeless. This was the private grief that Ruskin felt alongside his despair at the condition of Europe. As is described in greater detail in Chapter V, he began to associate Carpaccio's painting of the sleeping saint with his dead love. He believed that Rose La Touche was trying to communicate with him through the picture of St Ursula, and under the emotional stress he came near to insanity. In 1878 he was to break down completely for the first time.

Although he had hinted at the experience caused by Carpaccio's picture in earlier issues of *Fors Clavigera* written in Venice, Ruskin did not mention it again in his April letter. He had already revealed a great deal of himself through Tintoretto, Veronese and Giotto. Carpaccio might have revealed too much. Instead, he abruptly cut short his account with a challenge from the Sheffield workers he was supposed to be addressing:

'But what is all this about Titian and Angelico to you, are

you thinking? 'We belong to cotton mills – iron mills; – what is Titian to us?' (29.91)

Belatedly, he tried to return to his original purpose, but now there is no time to explain the creed of the Guild of St George. All he can offer is the promise that, if his Sheffield men persevere, the significance of Angelico and Titian for iron workers will eventually become clear.

⚜ ⚜ ⚜

Neither the creed of St George, nor his autobiography, was ever finished. Like so many of his drawings, this sketch of his life was left incomplete. But it can still suggest a great deal. It is clear that he did not have the sort of mind that went straight forward on a single line of argument. He worked less by a process of analysis, in which ideas are separated from each other and broken down, than by synthesis, gradually drawing ideas together into a whole. It is the method of the painter as opposed to that of the scientist, and the crucial changes in his life that took place in front of paintings show that the faculty of sight was all important to him. His whole method depended on visual observation, and visual experiences were the turning points of his life.

Ruskin wrote in *Modern Painters*:

> The greatest thing a human soul ever does in this world is to *see* something, and tell what it *saw* in a plain way. Hundreds of people can talk for one who can think, but thousands can think for one who can see. To see clearly is poetry, prophecy, and religion, – all in one. (5.333)

Ruskin devoted his life to saying what he saw – though not always in a plain way. Poetry, prophecy and religion were never far away. The following chapters, linked by Ruskin's argument of the eye, explore the multiform ways in which he saw his world.

Based on an unused introduction to John Ruskin: The Argument of the Eye, *Thames & Hudson, 1976. A version was published in* John Ruskin and the Victorian Eye, *catalogue to an exhibition at the Phoenix Art Museum, 1993.*

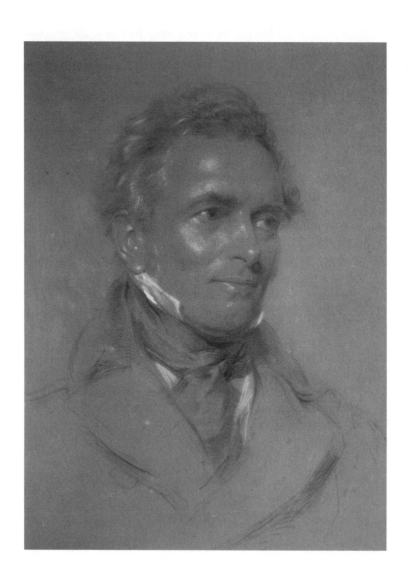

CHAPTER II

'ALL MY EYE AND BETTY MARTIN': RUSKIN AND HIS FATHER

☙

One of the stranger comments that Ruskin makes in the opening pages of his autobiography, *Præterita*, is on his relationship with his parents. Having evoked an intense, intimate, claustrophobic, early childhood, during which his mother conducted his education through daily reading of the Bible, Ruskin celebrates the security of his home life and the discipline that it taught him, especially in developing his powers of observation. But this Eden has its shadows. After counting his blessings, he lists his 'calamities':

> First, that I had nothing to love.
>
> My parents were – in a sort – visible powers of nature to me, no more loved than the sun and the moon: only I would have been annoyed and puzzled if either of them had gone out.[1] (35.44)

Præterita is a notoriously unreliable memoir. He began it in 1885, as an extension to *Fors Clavigera*, and it is as susceptible to the contingencies of mood, time and place as are all his other writings. Ruskin was not as isolated, friendless or without toys as his account makes out. He did love his parents, and they loved him. To compare them to the sun and moon suggests, not that they were emotionally absent, but that they were omnipresent. As male and female powers of nature they so dominated his

Opposite: Fig. 4: George Richmond, Portrait of John James Ruskin, *1848*

life that their love left no space for anything else, not even, he goes on to claim, for the love of God. The effect of this, he writes, was that 'when affection did come' – the implication is that this was his love for Rose La Touche, though it be could his adolescent crush, Adèle Domecq – 'it came with violence utterly rampant and unmanageable, at least by me, who never before had anything to manage' (35.45).

There is no doubt that Ruskin's parents lived through their only son, which was both the making, and unmaking of him. Margaret Cock (the family modified her surname to Cox) and John James Ruskin were cousins. They met when Margaret moved from Croydon to Edinburgh to join the Ruskin household as companion to John James's mother. His father, John Thomas Ruskin, was a grocer whose business failed in 1808; he subsequently fell into depression, and committed suicide in 1817. Financial disaster struck the family, and to avoid the shame of bankruptcy, John James, who by then was working as chief clerk to a wine importer in London, undertook to pay off his father's debts. He and Margaret got engaged in 1809, but it was not until 1818 that they were able to marry. Margaret was thirty-eight when their son, John, was born in 1819. She dedicated her only child to God.

John James also poured his ambitions into his son. Ruskin joked in *Praterita* that his mother wanted him to be Archbishop of Canterbury, while his father wanted him to be Poet Laureate. John James had used his knowledge of the wine trade to establish his own sherry-importing firm, Ruskin, Telford and Domecq, and had begun making serious money, enough for his son not to have to go into the wine trade, or ever to have to work at all. But while the family disaster had made John James a driven man, it frustrated him in other ways. Rather

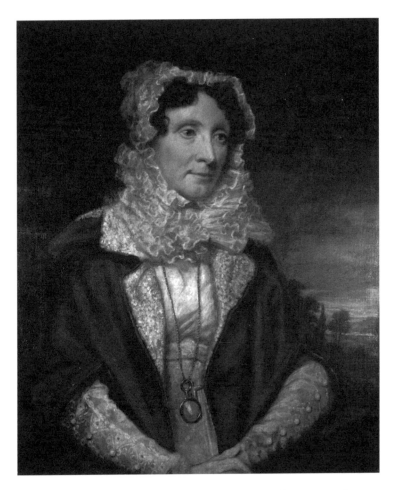

Fig. 5: James Northcote, Portrait of Margaret Ruskin, *1825*

than a London City clerk, he might have become an Edinburgh lawyer. As a young man he enjoyed amateur theatricals, had drawing lessons from a professional painter and was a lover of contemporary literature, notably Sir Walter Scott and, more controversially, Byron. He encouraged his son John to draw,

and paid for private lessons. He also encouraged him to write by paying him a farthing a line. He placed the teenager's poems and scientific articles in magazines, and went on to pay for the publication of his first books.

Margaret's Evangelical insistence on Bible study – and learning passages by heart – had a profound influence on her son, but the subject here is his father's shaping of his taste, and how the art collection that they formed together mediated their close, but conflicted, relationship.

ᘓ ᘓ ᘓ

Before Ruskin was a critic, he was a connoisseur. If we are to consider how a critic can change public taste, then it is helpful to know how that critic's predilections were formed in the first place. This is all the more so when the critic's mature views are a reaction against the conventional ideas with which the writer began. In the case of Ruskin, we can trace the formation of his taste both through his own drawings, and through the substantial collection that he and his father built up while the family enjoyed John James's growing financial success.

As members of an important new group of collectors, father and son represented not just a new taste, but a new social class – what Ruskin himself called the '*bourgeoisie*' (14.373). This newly enfranchised class, as Dianne Sachko Macleod shows in *Art and the Victorian Middle Class*, began to exercise its purchasing power in such a way as to shift collectors' interest away from the acquisition of Old Masters to contemporary art.[2] Buying from living artists established personal links that played a decisive part in shaping Ruskin's choice of artists to support as he became a critic.

The most famous of the artists in the family collection was J. M. W. Turner, the subject of the next chapter. E. T. Cook and Alexander Wedderburn, editors of Ruskin's complete works – known as the Library Edition – list 276 items – over 300 pieces in all – as works by Turner that passed through Ruskin's hands (13.597). But Turner was only one among some fifty artists represented by around 250 works which at one time or another formed part of the collection. The list of works and artists could be greatly extended if it included those purchases made for the Ruskin School of Drawing at Oxford, the Guild of St George, and other beneficiaries of Ruskin's philanthropy. In September 1863, shortly before John James Ruskin's death in March the following year, John James valued the collection at £10,000, but added in a characteristic note at the bottom of his accounts: 'Pictures as lately selling are worth £25,000'.[3]

The prudent accounting practices of Ruskin's merchant father allow us to follow the creation of the collection in detail. The primary sources are John James Ruskin's account books, now in the Ruskin Library at Lancaster University. One account book contains lists assessing John James's personal wealth each year from 31 December 1827 to 1 September 1863, the year before his death. A sum for pictures, valued at £500, appears as a separate category for the first time in December 1837. There are two further account books, one running from 1826 to 1845, the second completing the series at the end of 1863. These formal annual accounts include two headings giving evidence of dealings with artists, 'Sundries' where purchases – often tantalisingly briefly described – would be noted, and 'Charities and Gifts', where an occasional gift or loan is recorded. Between the entries summarising 1848 and 1849 is a list of pictures, with prices paid and an insurance valuation. Another helpful list is contained in the

manuscript of John James's unpublished diary for 1845-64. This is an inventory drawn up in 1852, listing title, the date of acquisition, artist and current valuation, and stating in which room at their house at 163 Denmark Hill the work was hung. Other works can be identified from a letter from John James Ruskin to his son in Italy in September 1845 (1845L.246-7).

⚜ ⚜ ⚜

Writing in retrospect, Ruskin dated the start of the collection to 1832, the year of the Great Reform Act that marked the arrival of the middle-class voter as a political, as well as a commercial and cultural power in the land. It was also the year that John James finished paying off his own late father's debts, so, presumably, buying pictures was now a permissible pleasure. By then the family had moved from Bloomsbury, in central London, to the cleaner air of Herne Hill, Camberwell, across the Thames in what was then still leafy suburban South London. According to Ruskin, the collection formally began with the purchase of a work by Anthony Van Dyke Copley Fielding, who was later to give Ruskin drawing lessons. *Scene between Inveroran and King's House, Argyleshire* was bought on 1 May 1832 at the annual exhibition of the Old Water Colour Society for 45 guineas and marked down by the Society as going to 'Mrs [*possibly an error for Mr, though Mrs Ruskin did share her husband's interest*] Ruskin, Herne Hill, Dulwich, Frame & glass £12.0.0.'[4]

In 1883 Ruskin recalled how:

> The pleasure which that single drawing gave on the morning of its installation in our home was greater than to the purchaser accustomed to these times of limitless demand and supply would be credible, or even conceivable; – and our back

parlour for that day was as full of surprise and gratulation as
ever Cimabue's joyful Borgo. (33.380)

John James's insurance list of 1848 records the picture as £54
(acquisition) and £35 (insurance).[5] According to his inventory
of 1852 it later hung in the drawing room of their second South
London house on nearby Denmark Hill, where the family had
moved in 1842, when it was valued at £52 10s.[6] In 1869, five years
after his father's death, Ruskin put it up for sale at Christie's,
marked at 440 guineas, but it was bought in and then hung
above the fireplace in the Ruskin Drawing School in Oxford,
whence it was removed in 1883.[7]

It would be wrong, however, to imagine that 28 Herne Hill
was entirely bare of pictures before 1832. In 1878 Ruskin men-
tions that a drawing by Prout, *An English Cottage*: 'bought,
I believe by my grandfather, hung in the corner of our little
dining parlour at Herne Hill as early as I can remember, and
had a most fateful power over my childish mind' (14.385) – an
acknowledgment of the influence of the collection on his cul-
tural formation.[8]

Possibly the most significant of the drawings already in the
Ruskin household were those by John James himself, who as a
boy had taken lessons from the landscapist Alexander Naysmith.
A study by John James after Naysmith, *Conway Castle*, hung in
his father's dressing room, and Ruskin records that he would tell
him a story about it when he had finished shaving (35.38).[9] There
were also family portraits, including four by James Northcote
R. A. (Fig. 5). Later there came portraits by George Richmond
(Fig. 4), who became an important source of knowledge about
professional practice for Ruskin. The 1852 inventory also lists
an oil portrait by Richmond's brother Tom, of Ruskin's wife
Effie, valued at £25, and the portrait of her by George Frederick

Watts (£42) that is now at Wightwick Manor, the National Trust property near Wolverhampton. The collection is testimony to Ruskin's early friendship with Watts, for he also acquired an oil sketch, *Michael the Archangel contending with Satan for the Body of Moses* in 1849 or 1850 – sadly, its whereabouts are currently unknown. The most famous family portrait of all would be Millais's portrait of Ruskin, begun at Glenfinlas in Scotland in 1853, for which John James paid £350. By the time it was finished in 1854, Ruskin's marriage to Effie was over, and hers to Millais about to begin.

<p style="text-align:center">ঌ ঌ ঌ</p>

John James was an enthusiastic collector. He wrote to his wife in 1839: 'I do rejoice in the power of buying a living artists picture' (RFL.607). Writing of his acquisition of George Cattermole's *Drinking* for 20 guineas in March 1842, he told his son: 'Never buy a picture *at any price not of the very first quality by whatever* artist but as for subject, it is all my eye and Betty Martin' (RFL.725). (In other words, nonsense.) Here is John James writing to his wife about his acquisitions at the Old Water Colour Society on 26 April 1839:

> 5 O Clock. Just left Exhibition. I really must give over going for I lay out as much as if I had not been elsewhere. I was captivated with a *Tayler* at 25 G[uinea]s *The Knights* – two warriors immense pawing Horse quite sparkling two fine page Boys walking – most strong powerful like oil – Castle & dark sky – a long upright rather.
>
> The other same price is only a Holland but so thoroughly Portuguese. Ruins of a monastery at Albocaca – taken there – large & fine figures. I was first caught by *Cattermoles*

splendid picture. Thinking it was 50 Gs went and found it 100 Gs – before I could recover from my astonishment, Moon the Engraver bought it. It is the *Wanderers refreshed*. After losing Cattermole I thought it Brickdusty & not dashing enough nor distinct but it is a beauty. One good I get by the two Exhibitions [*meaning the New Water Colour Society and the Old*] I will have no middling pictures.

Not a single Lewis. Our picture very valuable.

20 Prouts & only 2 sold. Cattermole Harding Cox De Wint Barrett favourites. I like only Harding Tayler & Cattermole. (RFL.604)

With the exception of De Wint, works by all the artists mentioned in this letter, who represented the cream of the contemporary English watercolour school, entered the collection.

With his aptitude for business, picture collecting was an ideal hobby for John James, and gave him a social life; he became part of a circle of connoisseurs, whose collections helped to develop his son's critical eye. There was Benjamin Godfrey Windus, an important Turner collector and, like the Ruskins, a future patron of the Pre-Raphaelites, who gave Ruskin *carte-blanche* to visit his collection; Elhanan Bicknell, ranked in 1861 as one of the top four collectors of contemporary art; and Samuel Rogers, whose Turner-illustrated edition of his poems *Italy* (1830) had a powerful effect when Ruskin was given it as a boy. Charles Stokes was a rival Turner collector, and there was also competition with H. A. J. Munro of Novar, who beat Ruskin to the acquisition of Turner's watercolour *Splügen*. Ruskin also knew the collection of Francis Hawkesworth Fawkes, son of Turner's patron Walter Fawkes.

All but the obscurest picturesque landscape artists collected by his father are mentioned in the early editions of volume

one of *Modern Painters*. But as his critical confidence grew, the limitations to what Ruskin was later to call 'this – perhaps slightly fenny – atmosphere of English common sense' (14.390) began to pall, and compliments were changed to criticism in the succeeding editions. He produced a judicious, reconciliatory balance of praise and blame when he wrote in 1878:

> I cannot but recollect with feelings of considerable refresh-
> ment, in these days of the deep, the lofty, and the mysteri-
> ous, what a simple company of connoisseurs we were, who
> crowded into happy meeting, on the first Mondays in Mays
> of long ago, in the bright, large room of the Old Water-Col-
> our Society; and discussed, with holiday gaiety, the unim-
> posing merits of the favourites, from whose pencils we knew
> precisely what to expect, and by whom we were never either
> disappointed or surprised. (14.389–90)

This ironically expressed disenchantment with the conven-tions of the picturesque came about through Ruskin's engage-ment with Turner, but his hand as well as his eye was trained in the conventions of the picturesque. Between June 1834 and January 1836 he had lessons from Copley Fielding, President of the Old Water Colour Society, at a guinea a time. Before that Ruskin had been taught by a local jobbing drawing master, Charles Runciman. One of the strongest influences in shaping Ruskin's early style, although he did not formally take lessons from him, was Prout. Thanks to the liberality of the Ruskin dining table, the patronage relationship with artists was social as well as economic. Prout, a South London neighbour, became a close family friend. As it happens, he died in 1852 after dining at Denmark Hill. Ruskin's early architectural drawings imitate Prout's dots and dashes to suggest the pleasing, crumbly texture

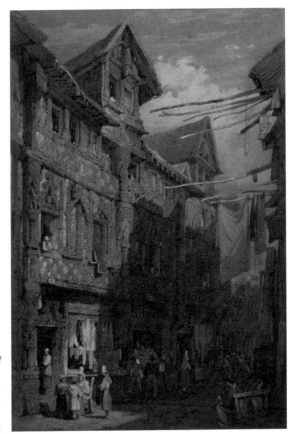

Fig. 6: Samuel Prout, Old Street, Lisieux, Normandy, 1834

of old buildings (see Fig. 6). He also learned from other artists in the family collection, notably David Roberts. His most important drawing master came after Copley Fielding, James Duffield Harding, who was his companion on that momentus day in 1845 when they entered the Scuola di San Rocco and saw Tintoretto's *Crucifixion* for the first time (Pl. 4).

When lessons with Harding began in 1842 Ruskin's tutor was no longer a member of the Old Water Colour Society, for

Harding hoped – in vain – to be elected to the Royal Academy. He was of a younger generation than Copley Fielding, and had learned from the example of Turner. As part of his teaching method he got his pupils to study Turner's engravings for his *Liber Studiorum*, a work upon which Ruskin was to lay special emphasis. Their time together in Venice, however, caused Ruskin to reconsider his appreciation of Harding, as told in Chapter I. This was a little embarrassing, for he was revising the first volume of *Modern Painters*, and preparing volume two. He wrote to his father: 'I am in a curious position with him – being actually writing criticism on his work for publication, while I dare not say the same things openly to his face' (3.200n). Pupil had become critic.

ᨆ ᨆ ᨆ

Ruskin responded enthusiastically to the fresh impetus given to the English watercolour in the 1840s, when the eighteenth-century style of washes and pen outline gave way to more complex processes using watercolour mixed with white, known as body colour, that gave a dense texture closer to oil paint. These technical developments, involving a combination of painting wet-in-to-wet, and using both layered and stippled colour, provided a means of achieving a more accurate representation of the subtle gradations found in nature (15.149). By 1845 he was ready to throw off the conventions of the picturesque and the Old Water Colour Society, and would shortly abandon his attempts to paint like Turner – though his pastiches were a very practical form of criticism, a visual analysis of the transformative operations of Turner's imagination.

He continued, however, to have important contacts with

two members of the Old Water Colour Society after 1845: John Frederick Lewis, and William Hunt, so-called 'birds nest Hunt', the crippled watercolourist of minutely accurate small-scale still-lives. The first Hunt entered the family collection in 1833 for £10. More than thirty were to follow, many commissioned by Ruskin between 1856 and 1861 as part of an abortive scheme to create teaching examples for the Government Art Schools (see p. 199). Ruskin took lessons from Hunt in 1854 and 1861, which probably took the form of observing Hunt at work. He appears to have taken similar 'lessons' from Dante Gabriel Rossetti (36.230). Hunt's use of minute touches of local colour to create an overall optical mix made its way into Ruskin's handbook, *The Elements of Drawing*, published in 1857.

Hunt is among the artists praised in Ruskin's pamphlet of 1851, *Pre-Raphælitism*, an act of association which is less eccentric than it sounds when we learn that in 1854 the Pre-Raphælite Rossetti had drawings by William Hunt pinned to his studio wall. The other artist famously associated by Ruskin with Pre-Raphælitism in the pamphlet was John Frederick Lewis, for whom Ruskin played a triple role as collector, active patron and critic. John James bought his first Lewis at the O. W. C. S. in 1837, *A Fiesta Scene in the South of Spain – Peasants etc. of Granada dancing the Bolero*, for the princely sum of £115. The subject obviously appealed to a successful sherry importer, and it became 'the pride of Herne Hill' (13.593). There was no opportunity for socializing with the painter, however, for in 1837 Lewis left England for the Levant, taking up residence in Cairo as an English Orientalist, where he stayed until 1851. During this time, perhaps under the influence of Eastern light, he significantly sharpened the focus of his finished works. Because of his failure to exhibit in London, his membership of the O. W. C. S. was in danger of

lapsing, but in 1850 his large, minutely detailed watercolour *The Hhareem* caused a sensation, and was duly praised in Ruskin's *Pre-Raphælitism*, though Ruskin was always to stress Lewis's independence from the original Pre-Raphælite Brotherhood.

On Lewis's return to England, a social relationship with the Ruskins began, and it was Lewis, in Edinburgh for an exhibition at the Royal Scottish Academy, who was responsible for Ruskin's invitation to give his first public lectures in Edinburgh in 1853. Lewis, a master of watercolour techniques as they developed in the 1840s, was elected President of the O. W. C. S. in 1855, but there was friction among the members. Lewis was also feeling dissatisfaction with the financial rewards of working in watercolour, which sold for less than oil, while, as in the case of James Duffield Harding, membership of the O. W. C. S. meant he could not be considered for the Royal Academy. Ruskin appears to have encouraged Lewis in his decision to switch to oil. While praising him publicly in his annual critical survey of the Royal Academy's summer exhibition, *Academy Notes*, Ruskin wrote to him privately in 1856: 'Are you sure of your material – if one of those bits of hair stroke fade – where are you? *Why* don't you paint in oil only now?', signing the letter 'yours reverently'.[10] Tantalisingly, there is an entry in John James's account book for 27 November 1857: '2 Oil pictures Lewis £315', but these have not been identified.[11]

At the beginning of 1858 Lewis took the plunge and resigned from the O. W. C. S. – and then fell seriously ill. The Ruskins were in a position to give material help. At the Royal Academy exhibition in May 1858 Lewis showed five works, of which John James bought two in watercolour, *Lilies and Roses, Constantinople* and *An inmate of the Hhareem, Cairo* – without telling his son. He did not wish to influence Ruskin's review of the show in that

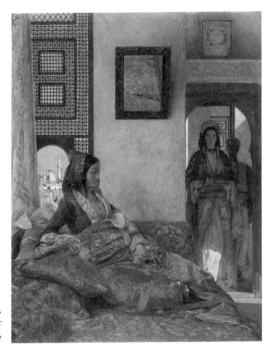

Fig. 7: John Frederick Lewis, An Inmate of the Hhareem, *1858*

year's *Academy Notes* (14.159n, 14.180n), which was just as well, for Ruskin praised both. The whereabouts of these two works is uncertain, but the watercolour in the Victoria and Albert Museum known as *Life in the Hhareem*, dated 1858, is almost certainly the Ruskins' *An Inmate of the Hhareem* (Fig. 7). Their support did not end there. An exchange of letters while Ruskin was in Italy during the climactic period of his 'un-conversion' in 1858, suggests that Lewis had appealed for help. John James wrote to Ruskin: 'To Lewis letter I could only answer by sending £100 – sorry one is to find a man of genius driven so near the Breakers with night soon coming on' (1858L.82n4). The money appears to have been payment or part-payment for a commission that Ruskin refers to as 'Fawn & Fountain' (1858L.186).

It is characteristic of Ruskin that after all this personal support, he should write in his *Academy Notes* for 1859 of Lewis's oil, *Waiting for the Ferry, Upper Egypt*: 'very nice … but waiting for a ferry-boat is dull work; and are we never to get out of Egypt any more?' (14.218–19). He explained in a private letter to Lewis: 'it became my duty to speak lest the public should think I supposed you were doing yourself justice – which I don't'.[12] Reverence has been replaced by bluntness.

<p style="text-align:center">⚛ ⚛ ⚛</p>

The mutual pleasure father and son took in their connoisseurship is described by Ruskin in his recollection in *Præterita* of their first Turner acquisition – which, it is worth noting, did not take place until 1839, when the collection was already well established.

> My father at last gave me, not for a beginning of Turner collection, but for specimen of Turner's work, which was all – as it was supposed – I should ever need or aspire to possess, the *Richmond Bridge, Surrey*. The triumphant talk between us over it, when we brought it home, consisted, as I remember, greatly in commendation of the quantity of Turnerian subject and character which this single specimen united: – 'it had trees, architecture, water, a lovely sky, and a clustered bouquet of brilliant figures'. (35.254)

Ruskin is hinting that this formulaic content was becoming a cliché. But when they began, not just to buy, but to commission watercolours from Turner in 1842, just as Ruskin was embarking on the writing of the first volume of *Modern Painters*, the insight this afforded into Turner's working methods helped to shape Ruskin's ideas about how the creative imagination actually

worked. But patronage of Turner also began to affect the relationship between father and son.

Ruskin's increasing appetite for Turners led to friction, while their Turnerian tastes began to diverge after their first, conventional and conservative, purchase. Turner's watercolour *Gosport* followed *Richmond* for 60 guineas in 1839 and *Winchelsea* for £57 15s, as a going-up-to-Oxford present in 1840. At Oxford Ruskin received a generous allowance of £200 a year, so he was able to begin to buy on his own account. The first Turner he coveted was *Harlech*. In *Præterita* Ruskin writes that he and his father ran into Turner's agent Thomas Griffith at the Old Water Colour Society, who offered him the *Harlech*; John impulsively accepted, without asking the price. John James was horrified. Griffith's price was 70 guineas: 'it was thirty above the *Winchelsea*, twenty-four above *Gosport*, and my father was of course sure that Mr Griffith had put twenty pounds on at the instant' (35.258).

This is more evidence of the unreliability of *Præterita* as a factual record. The figures given in the 1852 inventory price *Harlech* at 60 guineas, the same price as *Gosport*, while *Winchelsea* cost £57 15s. Yet there is a truth to the story, which lies in his father's suspicion of Griffith, against whom he had been warned by his fellow collector Windus. Because Griffith controlled his access to Turner, Ruskin saw the dealer differently. He wrote in 1878:

> I loved – yes, loved – Mr Griffith; and the happy hours he got for me! (I was introduced to Turner on Mr Griffith's garden lawn.) He was the only person whom Turner minded at that time: but my father could not bear him. So there were times, and times. (13.478)

John James's view of Griffith can be seen in the correspondence

between father and son in April 1842, which describes John James's attempts to arrange a part exchange that finally led to the acquisition of Turner's *Richmond, Yorkshire* at the price of parting with a Prout, a David Cox and a Harry Wilson, which is a reminder that the Ruskins sold as well as bought. John James conceded: 'Whatever they say of Griffith, the only really valuable pictures we have are his & the few bought regularly at W. C. old Exh' (RFL.725). When John James bought Turner's magnificent oil, *Slavers throwing overboard the dead and dying: Typhoon coming on*, to celebrate the publication of *Modern Painters* volume one in 1843, he bought it through Griffith. He paid £241 10s – that is, 250 guineas, minus the exchange value of a Cattermole.

Griffith's role in the relationship between father and son should be seen as an occasion for conflict, but not its cause. This tension was exacerbated in 1842, when Griffith sought commissions for new works on Turner's behalf, a moment that changed the Ruskins' status from mere collectors to active patrons. This event was crucial to Ruskin's intellectual development; but he remembered it as a source of bitterness between himself and his father. Basing their choice on sample sketches: 'my father let me chose at first one [*commission*], then was coaxed and tricked into letting me have two' (35.309). Also on offer were four finished watercolours, of which the *Splügen* was one, which, because John James was away on business, went to Munro of Novar. Ruskin recalled:

> I ought to have secured it instantly, and begged my father's pardon, tenderly. He would have been angry, and surprised, and grieved; but loved me none the less, found in the end I was right, and been entirely pleased. I should have been very uncomfortable and penitent for a while, but loved my father all the more for having hurt him, and, in the good of

the thing itself, finally satisfied and triumphant. As it was, the *Splügen* was a thorn in both our sides, all our lives. My father was always trying to get it; Mr Munro, aided by dealers, always raising the price on him, till it got up from 80 to 400 guineas. Then we gave it up, – with unspeakable wear and tear of best feelings on both sides. (35.310)

This was written at some distance in time, but Ruskin's difficult dealings with his father are well illustrated in an agitated letter to George Richmond, probably written in 1843, about a portfolio of drawings by William Blake he had been offered, through Richmond, by the dealer William Hogarth, and for which he had apparently paid £100:

I have got nervous about showing them to my father when he comes home, in the mass. He has been *very* good to me – lately – with respect to some efforts which I desired to make under the idea that Turner would not long be able to work – and these efforts he has made under my frequent assurances that I never would be so captivated by any other man. Now I am under great fear that when he hears of my present purchase, it will make him lose confidence in me and cause him discomfort which I wish I could avoid. (36.32)

Ruskin evidently persuaded Hogarth to take this remarkable purchase back, though at least one Blake drawing remained in his collection until the 1880s. Ruskin could not contain his 'sick longing for Turner' (13.xlvii), a phrase quoted by his father in a reproving letter of 1847. John James continues:

I freely confess I have been restrained from my very constitutional prudence and fear, and in case I may fall into the same mistake, I wish to hide no motive from you. I have, you know, my dearest John, two things to do – to indulge

you, and to leave you and mama comfortably provided for; but if you have any longings like 1842 I should be glad to know them, while I honour you for the delicacy of before suppressing the expression of them. (13.xlvii)

The relationship became especially strained in 1851 on Turner's death. Ruskin was away in Venice, so had to persuade John James to act as his agent in getting into Turner's studio, and bombarded him with anxious letters about what and what not to get hold of. He wrote from Venice in February 1852:

It is a pity that I cannot frankly express my feelings on this subject without giving you cause to dread the effects of enthusiasm; but it is just because I am enthusiastic that I am – *if* I am – powerful in any way. If you have any faith in my genius, you ought to have it in my judgement also. You may say (probably all prudent fathers *would* say), 'If he wants to buy all these just now, what will he want to buy as he grows older?' – 'He began with one – and thought himself rich with two – now he has got thirty, and wants thirty more: in ten years he will want three hundred.' I feel the force of this reasoning as much as you do, and I know this to be the natural course of human desire – if no bridle be set upon it: nor am I so foolish as ever to expect in this world to have all my desires gratified or even to be able to say there is nothing that I wish for. That, I believe, *ought* only to be said by a man when he is near death. But I can very firmly and honestly assure you that I *am much* more satisfied with my collection now than when it was smaller, and that if I now express more exorbitant desires, it is not because I want more, but because you are more indulgent to me. (36.134–5)

Ruskin was 33 when he wrote this, and as he says, already an

influential critic. Yet here is the psychological crux in Ruskin's life: the desire for parental love and approval that is always potentially withheld, the fear of paternal disapproval that never goes away. As Ruskin summed it up to his confidante Lady Trevelyan in 1862: 'If he loved me less, and believed in me more, we should get on; but his whole life is bound up in me, and yet he thinks me a fool' (36.414). The last years of John James's life were marred by a quarrel between father and son about political economy, and the son's perceived self-indulgence, a quarrel that can be seen being worked out in their reasons for collecting art. It left Ruskin with feelings of guilt that could never be assuaged. Not long before John James died, Ruskin accused his father of spoiling him and frustrating him at the same time:

> You fed me effeminately and luxuriously to that extent that
> I actually now *could* not travel in rough countries without
> taking a cook with me! – but you thwarted me in all the
> earnest fire of passion and life. About Turner you indeed
> never knew how much you thwarted me. (WL.459)

Yet John James *did* indulge his son's passion for Turner, and relations were not always as bad as *Præterita* suggests. When the pair called on the artist George Price Boyce in his studio in 1854 Boyce noted in his diary: 'A most delightful feeling seemed to exist between [Ruskin] and his father'.[13] Even when relations were at their most strained in 1863 John James could tell Georgiana Burne-Jones: 'I keep nothing from John'.[14]

John James died in March the following year. In death there can be reconciliation, and in the colophon to the 'Epilogue' to Ruskin's *Notes on Turner*, written just after his first breakdown, when the contradictions in his life had become unbearable, we find: 'Brantwood, 10th May 1878. Being my father's

birthday, – who – though as aforesaid, he sometimes would not give me this, or that, – yet gave me not only all these drawings, but Brantwood - and all else' (13.485).

'Brantwood' was his house in the Lake District, where Ruskin was writing; 'These drawings' were the father and son's collection. The death of John James Ruskin in 1864 in itself affected Ruskin's relations with artists. Not only did it place a fortune in his hands, it removed the father's loving but restraining hand. As Ruskin himself grew older, and more patriarchal – even before his father's death he was calling himself in his letters to Burne-Jones: 'Papa' (36.438) – alongside his friendships with major figures such as Burne-Jones, Rossetti, Frederick Leighton and G. F. Watts, new artists appear who are treated less as friends, and more as employees, becoming members of the extensive company of copyists recruited for Ruskin's many record-making schemes. The fact that they were copyists, not colleagues, is an indication of the shift in Ruskin's relation to the Victorian visual economy as a whole. Taught by his father to be a collector, and making his reputation as a critic, he became in the 1850s and 1860s an active patron of living artists. With the shift in Victorian taste that had occurred by the 1870s, emblematically illustrated by Ruskin's humiliating defeat by Whistler in a libel case in 1878, Ruskin, while keeping up with developments, was to move from personal patronage to the wider field of education. He was able to buy Old Masters[15] as well as contemporary art, and his collector's love of acquisition and his charitable generosity were now indulged by the endowment both of the Ruskin School of Drawing and the Guild of St George, beginning the dispersal of the Ruskin family art collection by the creation of more public, and even richer collections.

An earlier version of this chapter appeared as 'Father and Son: the Ruskin family art collection', the introduction to Ruskin's Artists: Studies in the Victorian Visual Economy, *ed. Robert Hewison, Ashgate, 2000.*

CHAPTER III

'I THINK HE MUST HAVE READ MY BOOK':
RUSKIN AND TURNER

❧

On 15th May 1843 Ruskin noted in his diary: 'Called on Turner today, who was particularly gracious. I think he must have read my book, and have been pleased with it, by his tone' (D1.247). The book in question was the first edition of the first volume of *Modern Painters*, or, to give it its full title, *Modern Painters: Their Superiority in the Art of Landscape Painting to all The Ancient Masters proved by examples of the True, the Beautiful and the Intellectual, From the Works of Modern Artists, especially from those of J. M. W. Turner, Esquire, R. A. By a Graduate of Oxford* (3.xxxi). It had been published in the first week of May, and, given that title-page, it is not surprising that the twenty-four-year-old author – whose first book this was – should hope and assume that the sixty-eight-year-old artist that he was to call his 'earthly Master' (13.xxii) would be gratified by his efforts.

Sadly, this was to be one of the several disappointments that Ruskin experienced in his life-long engagement with the greatest English painter of the nineteenth century. It was not until just over eighteen months later, when the book had already gone into a second edition, that Ruskin was able to write in his diary of himself and his father out at a dinner with Turner and of:

> Turner's thanking me for my book for the first time. We
> drove home together, reached his house about one in the

Opposite: Fig. 8: William Parrott, Turner on Varnishing Day, *c. 1840*

morning. Boylike, he said he would give sixpence to find the Harley St gates shut, but on our reaching his door, vowed he'd be damned if we shouldn't come in and have some sherry. We were compelled to come in, and so drank healths again, as the clock struck one, by the light of a single tallow candle in the under room – the wine, by the by, first rate. (D1.318)

This genial picture, of the almost certainly drunk Turner, a probably awed young Ruskin and his more robust sherry-merchant father, drinking by a miserly single candle in the room beneath the mysterious treasure-trove of Turner's decrepit private gallery that he had built for himself in Queen Anne Street, might be a scene from one of the plays that were the artist's recreation. Turner's generosity with his wine, but parsimony with his illumination, suggests something of the intoxicating, but also baffling, effect he had on his admirer. Turner was the first artist Ruskin wrote about, and also the last, in that as late as 1881 he published a revised edition of his *Catalogue of the Drawings and Sketches* acquired by the nation through the Turner Bequest, and – though he is not named – Turner is the abiding spirit in the concluding 'Epilogue' to the final volume of *Modern Painters*, composed at Chamonix in 1888. In a sense, this was only the latest revision of that first book that Ruskin had so eagerly assumed Turner's favourable opinion of in 1843, and which he had been writing and re-writing ever since.

These revisions mean that the Turner Ruskin presents in the first edition of the first volume of *Modern Painters* is very different to the Turner of the closing pages of the fifth and last volume, published seventeen years later. Ruskin's attempts to account for the pattern of rise, apogee and fall that he traced in Turner's works can be followed in the increasingly complex

system of periodisation that he imposed during his successive accounts of Turner's career. This begins with the revised and expanded edition of the first volume of *Modern Painters* that he published in 1846 – the edition in which that volume is usually read. Turner's earliest, picturesque phase before 1800 is ignored; a rough division is made between the period up to 1820 when colour is unimportant and Turner's neo-classical tastes produce what he calls 'nonsense pictures', such as *The Decline of the Carthaginian Empire* (3.241). This is followed by the period after 1820 when Turner is released from, in Ruskin's phrase, 'the brown demon' (13.124) of conventional academic painting into colour: 'but his powers do not attain their highest results till towards the year 1840, about which period they did so suddenly, and with a vigour and concentration which rendered his pictures at that time almost incomparable with those which had preceded them' (3.250n). For reasons that will become clear, this last comment only appears in the editions of 1846 and 1848.

The periodisation that Ruskin imposed thirty years later in the catalogue he wrote to accompany an exhibition of his own collection of works by Turner at the Fine Art Society in 1878 is much more complex. There are now five distinct periods, beginning in 1800 and changing decade by decade until the fifth and last period of 1840 to 1845. Though Turner did not die until 1851, Ruskin's rejection of his post-1845 productions is so firm as effectively to ignore them. In his 1878 catalogue Ruskin subdivided these five periods into nine divisions, but after the sixth edition of the catalogue, these become ten. (The bibliographical complexity of Ruskin's publications sometimes threatens to turn Ruskin scholarship into the equivalent of train spotting.)

These successive changes are more than mere elaboration. They represent an increasingly darker and more tragic vision

of the painter. Take for instance Ruskin's response to Turner's *The Fighting 'Téméraire', tugged to her Last Berth to be broken up, 1838,* exhibited at the Royal Academy in 1839 (Pl. 10). After two passing references in the first edition of 1843, in 1846 the work is presented as an example of how Turner broke with the academic tradition of historical landscape in order to achieve a more truthful vision of his own:

> For the conventional colour he substituted a pure straight-forward rendering of fact, as far as was in his power; and that not of such fact as had been before even suggested, but of all that is *most* brilliant, beautiful, and inimitable; he went to the cataract for its iris, to the conflagration for its flames, asked of the sea its intensest azure, of the sky its clearest gold. (3.246)

Ten years later, in his unofficial catalogue to the exhibition at Marlborough House organised by the National Gallery of works acquired following Turner's death through the Turner Bequest, published in 1857, Ruskin links the *Téméraire* to an earlier work by Turner, his *Ulysses Deriding Polyphemus – Homer's Odyssey* of 1829:

> The one picture, it will be observed, is of sunrise [*Ulysses*]; the other of sunset [*Téméraire*].
>
> The one of a ship entering upon its voyage; and the other of a ship closing its course for ever.
>
> The one, in all the circumstances of its subject, uncon-sciously illustrative of his own life in its triumph.
>
> The other, in all the circumstances of its subject, uncon-sciously illustrative of his own life in its decline.
>
> I do not suppose that Turner, deep as his bye-thoughts often were, had any under meaning in either of these pictures;

but, as accurately as the first sets forth his escape to the wild brightness of Nature, to reign amidst all her happy spirits, so does the last set forth his returning to die by the shore of the Thames: the cold mists gathering over his strength and all men crying out against him, and dragging the old 'fighting *Téméraire*' out of their way, with dim, fuliginous contumely. (13.168-9)

There are two things to note about this passage, written in 1856 and published in January 1857. Ruskin is now pushing back the date of Turner's apogee from 1840-45, to the period 1829-39. In his Turner study, *The Harbours of England*, published in May 1856, he had said the *Téméraire* was 'the last thoroughly perfect picture he ever painted' (13.41).[1] Secondly, he is treating Turner's works not as 'pure straight forward rendering of fact' (3.246) but as emblems of his state of mind, and as allegories of his career.

At least in that last passage Ruskin admits that the 'under meaning' that he perceives may be an in-reading on his part. But what are we to make of his choice of works by Turner with which to bring the great arc of *Modern Painters* to a close in 1860? Not, however, that the fifth volume of *Modern Painters* really is a close. Ruskin admitted in his final chapter: 'it being time that it should end, but not of 'concluding' it; for it has led me into fields of infinite enquiry' (7.441). This sense of 'infinite enquiry' causes the physical text of the closing pages of *Modern Painters* to split and fragment as great surges of footnotes on Turner and on colour threaten to overwhelm the main argument, like the typhoon in *Slavers*, as a tidal wave of Biblical, mythological, literary, economic and political allusion sweeps conventional critical discourse before it.

The pictures upon which Ruskin chose to build his magnificent, but in the sublime sense, appalling, climacteric are from

an even earlier period in Turner's career. *Apollo and Python* was exhibited at the Royal Academy in 1811 (Pl. 11). Ruskin does not mention it in his published writings until 1857, when, although calling it 'one of the noblest pictures in the world' (13.122) he criticises the figure of Apollo and does not make the deep symbolic reading of 1860. There, the contest between the young god and the serpent is 'the strife of purity with pollution; of life with forgetfulness; of love, with the grave' (7.420). This life and death struggle is also the battle between light and darkness, and Turner's pessimism is such that even in the serpent's death, a fresh worm of evil arches from its mortal wound.

This image is preceded by an even more extraordinary choice, *The Goddess of Discord Sowing the Apple of Contention in the Garden of the Hesperides* of 1806 (Pl. 12). In 1857 Ruskin presents it as coming from Turner's 'student' period, objecting to its lack of colour, criticising its geology – excepting the fossil-accuracy of the dragon guarding the garden – and stating: 'nearly all the faults of the picture are owing to Poussin; and all its virtues to the Alps' (13.114). By 1860, however, this work carries an unwieldy freight of symbolic meaning. The dragon, while simultaneously a reversed image of a mountain glacier, has become symbolic of 'the evil spirit of wealth' (7.403). The apples, which in mythology are those that lead to the judgement of Paris, and ultimately the tragedy of Troy, are emblems of economic competition, of wealth that has fallen from a rotten tree. The smoke and vapours in the mountains symbolise what Ruskin was later to call 'The Storm-Cloud of the Nineteenth Century'. Poussin is forgotten as this becomes:

> Our English painter's first great religious picture; and exponent of our English faith. A sad-coloured work, not executed in Angelico's white and gold; nor in Perugino's crimson and

azure; but in a sulphurous hue, as relating to a paradise of smoke. That power, it appears, on the hill-top, is our British Madonna: whom, reverently, the English devotional painter must paint, thus enthroned, with nimbus about the gracious head. Our Madonna, – or our Jupiter on Olympus, – or, perhaps, more accurately still, our unknown god, sea-born, with the cliffs, not of Cyrene, but of England, for his altar; and no chance of any Mars' Hill proclamation concerning him, 'whom therefore ye ignorantly worship.'

This is no irony. The fact is verily so. The greatest man of our England, in the first half of the nineteenth century, in the strength and hope of his youth, perceives this to be the thing he has to tell us of utmost moment, connected with the spiritual world. (7.407-8)

What has happened to the Turner of 'fact' of *Modern Painters* volume one? What has happened to 'truth to Nature'? What, indeed, has happened to Turner?

♣ ♣ ♣

There are a number of straightforward explanations for this dramatic shift of emphasis. One is that in 1843 the young Ruskin did not know what he was talking about. He almost admitted as much in a letter written to his father from Venice in February 1852, after he had got over the initial shock of Turner's death on 19th December 1851:

When I wrote the first volume of Modern Painters I only understood about *one third* of my subject: and one third, especially of the merits of Turner. I divided my admiration with Stanfield – Harding and Fielding. I knew *nothing* of

the great Venetian colourists – nothing of the old religious
painters – admired only, in my heart, Rubens, Rembrandt,
and Turner's gaudiest effects: my admiration being rendered
however right as far as it went – by my intense love of nature.
(RLV.179)

In 1843 Turner was still very much alive, and Ruskin would
not be in a position to survey his works in their entirety until
1857 and 1858. One would also hope that a work that took five
volumes and seventeen years to complete shows some change
and maturation.

This is especially true of Ruskin's theory of the imagination.
His initial defence of Turner on the grounds of his 'truth to
Nature' was polemically constructed to oppose Turner's critics
who accused him of the wildest fancies, untrue to the civilised
'Nature' of late eighteenth century taste. Further, Ruskin's
Evangelical reading of the natural world as the word of God, his
'intense love of nature', meant that 'truth to Nature' as Ruskin
understood it, was truth to God. Thus the non-practicing Turner
could be recruited as a 'religious' painter. It should also be noted
that at this stage Ruskin was much more interested in Turner's
landscape watercolours and engravings, which he knew well
(see Fig. 11), rather than what he was later to call his Academy
'caprices' (13.148).

It took time for Ruskin's theory of the imagination to mature,
but it is there in embryo in his brief chapter in the first volume
of *Modern Painters*, 'Of Ideas of Truth', which, importantly,
remained unchanged from the first edition to the last. Here,
visual fact supports moral truth:

> There is a moral as well as material truth, – a truth of impres-
> sion as well as form, – of thought as well as of matter, and

the truth of impression and thought is a thousand times the more important of the two. (3.104)

Ruskin then goes further:

Truth may be stated by any signs or symbols which have a definite signification in the minds of those to whom they are addressed, although such signs be themselves no image nor likeness of anything. Whatever can excite in the mind the conception of certain facts, can give ideas of truth, though it be in no degree the imitation or resemblance of those facts. (3.104)

The concept of 'realism' is demolished. Fact is not the same as imitation, and the way lies open for Ruskin to elaborate his theory of symbolism in succeeding volumes as his knowledge and thought deepen. Turner's addition of a blood red sky to the finished version of his sample study of *Goldau*, a watercolour commissioned by Ruskin in 1843, to indicate that the foreground rocks come from an avalanche that has buried a village and its inhabitants, is a case in point.

There is also, in the first edition, a harbinger of Ruskin's literally Apocalyptic vision of Turner. In a moment of ecstatic enthusiasm, he writes of the artist:

Glorious in conception – unfathomable in knowledge – solitary in power – with the elements waiting upon his will, and the night and the morning obedient to his call, sent as a prophet of God to reveal to men the mysteries of His universe, standing, like the great angel of the Apocalypse, clothed with a cloud, and with a rainbow upon his head, and the sun and the stars given into his hand. (3.254)

This passage was mocked, and accused of blasphemy, in a

review in *Blackwood's Magazine*, and it disappears after the second edition of 1844. But it may have a curious echo in Turner's painting of 1846, *The Angel standing in the Sun*, which he exhibited, supported in the Royal Academy catalogue, by a quotation from the Book of Revelation. The contemporary critic in *The Times*, for one, saw a connection between the subject and Ruskin's writing, but it has also been suggested that Turner was having a private joke at Ruskin's expense. Turner's attitude to Ruskin's interpretations is a subject that will be returned to, but significantly, Ruskin did not like the painting, and dismissed it in 1857 as painted 'in the period of decline' and 'indicative of mental disease' (13.167).

Ruskin went through a whole series of life-changing moments between 1843 and 1860. He only began properly to appreciate the significance of Turner's engravings in the *Liber Studiorum* in the winter of 1843, and did not obtain a complete run until he commissioned a reprint from Turner in July 1845, so that all his references to that work do not appear until, in effect, he restarts *Modern Painters* with the publication of the second volume in 1846, together with a heavily revised edition of the first.[2] 1845 was the year of his first independent tour of Italy. This not only revealed to him the 'wider sea' of European art and architecture, but gave him vital insight into the transformative powers of Turner's imagination when he visited the Pass of Faido in the Alps to examine the actual site of the watercolour that he had commissioned early in 1843, but which could not have been delivered until after the first volume of *Modern Painters* was published.

His opinion – and knowledge – of Turner's early works was changed by his visit to Farnley Hall near Leeds, in 1851, to see the collection formed by Turner's early patron, the late Walter Fawkes. This visit was the occasion of that oddly titled pamphlet,

Pre-Raphælitism. Lastly, there was the period of intense study from January 1857 to May 1858 when the great range of Turner's canvasses were on display together at Marlborough House, while Ruskin was labouring day after day in the basement of the National Gallery, sorting through and cataloguing what in his judgement were the best of the nineteen thousand or more drawings and sketches that were also part of the Turner Bequest.

These experiences – especially the last – produced profound changes in Ruskin's intellectual outlook. One reason for the acceptance of a neo-classical work like *The Garden of the Hesperides* was the complete change in his attitude to Greek mythology, as Dinah Birch has admirably shown in her study, *Ruskin's Myths*.[3] Another was his increasing disenchantment with the system of political economy – 'the evil spirit of wealth' (7.403) – that supported the visual economy with which he was so deeply engaged. We also have to consider the change in Ruskin's religious position during the 1850s, which climaxes in his 'un-conversion' in 1858, when he set aside the bonds of his Evangelical beliefs. This event follows the completion of his work in the National Gallery, and precedes the completion of *Modern Painters* volume five.

᠅ ᠅ ᠅

The question here is how did Ruskin come to see Turner in the tragic terms that he did? Even in 1860, he confessed himself in difficulty with his subject. In the final chapter of *Modern Painters*, he says he is satisfied that he has shown Turner 'is the greatest landscape painter who ever lived' (7.423), yet later writes: 'Full of far deeper love for what I remember of Turner himself, as I become better capable of understanding it, I find

myself more and more helpless to explain his errors and his sins'
(7.441). This suggestion of moral, as well as artistic failure, is
a view that Ruskin had formed by the time of Turner's death.
The letter to his father of February 1852 quoted earlier states
baldly that Turner's mind 'failed in 1845' (RLV.180). In 1857,
while working on the Turner bequest, he was approached by a
journalist, Walter Thornbury, who was about to write the first
biography of Turner, published in 1862. Ruskin told him:

> Fix at the beginning the following main characteristics of
> Turner in your mind, as the keys to the secret of all he said
> and did –
>
> [*Ruskin then draws a line down the page and on the left puts*]
>
> Uprightness
> Generosity
> Tenderness of heart (extreme)
> Sensuality
>
> [*and on the right puts*]
>
> Obstinacy (extreme)
> Irritability
> Infidelity
>
> [*he then adds the comment*]
>
> And be sure that he knew his own power, and felt himself
> utterly alone in the world from its not being understood.
> Don't try to mask the dark side.[4] (13.554)

This reference to a 'dark side' is echoed in the conclusion to
Modern Painters in 1860, where Ruskin interprets the frontis-
piece to the *Liber Studiorum – Tyre at Sunset, with the Rape of
Europa* – as an emblem of cultural decay: 'I need not trace the
dark clue farther, the reader may follow it through all his work

and life, this thread of Atropos' (7.436-7) – Atropos being the Fate who cuts the thread of life. The prophet of God of *Modern Painters* volume one has become an angel of Death in *Modern Painters* volume five.

To understand this characterisation of Turner, and this emphasis on fate and death, it is necessary to look more closely at Ruskin's personal relations with the artist. Unfortunately, this means entering a dark side all of its own, for the evidence and records of their personal encounters are woefully thin – a few diary entries, a few notes to the Ruskin family from Turner, a few engagements noted in John James Ruskin's diaries, a few undated anecdotes and recollections.

Surprisingly – or possibly significantly – Ruskin's own account is misleading. Famously, according to Ruskin in *Præterita*, his first encounter with Turner's work was the gift of a copy of the 1830, illustrated edition of Samuel Rogers's *Italy*, for his thirteenth birthday in 1832. Such a gift was made, but a close reading of the references to Rogers's *Italy* in *Præterita* reveals a vagueness about when he really first saw the book. In an earlier account, written in 1878, Ruskin states that a completely different work, the vignette *Vesuvius Angry* engraved in the annual, *Friendships Offering*, for 1830: 'was the first piece of Turner I ever saw' (13.428).

Such confusions at least do not contradict the important point that Turner's engraved work, in vignette form, first sparked Ruskin's interest. He appears to have visited the Royal Academy summer exhibition for the first time in 1833, and so would have seen works such as *Mouth of the Seine, Quille–Boeuf* exhibited that year. In *Præterita*, however, the key year is 1836, when the attack in *Blackwood's Magazine* on *Juliet and Her Nurse* (Pl. 1), on *Rome, from Mount Aventine* and on *Mercury and Argus* raised

the seventeen-year-old Ruskin 'to the height of "black anger" in which I have remained pretty nearly ever since' (35.217). John James Ruskin took the precaution of first sending his son's reply to *Blackwood's* to Turner – though it appears that Turner had no personal connection with the Ruskins at this time. Turner politely, but in terms of his future relations with Ruskin, importantly, asked the author, whom he only knew by the signature 'J. R.' not to proceed, which is why it did not appear in print until after Ruskin's death.

Given the supposed early passion of Ruskin for Turner, it is surprising that the Ruskins did not acquire an actual work by him, the watercolour *Richmond Bridge*, until three years later, in 1839. In the light of Ruskin's contempt for Claude in *Modern Painters* and his dislike of what he called Turner's 'Twickenham Classicism' (12.373) – Twickenham, where Turner had built a small house, is very close to Richmond – the choice seems a conservative one, though it more likely reflects the taste of the father than the son. The creation of the Ruskin family art collection eventually led to a meeting with Turner himself. According to *Præterita*, the first actual meeting with Turner was on 22 June 1840, at a dinner at the Norwood house of Turner's agent Thomas Griffith. Ruskin reproduces his diary entry for that day:

> 'Introduced to-day to the man who beyond all doubt is the greatest of the age; greatest in every faculty of the imagination, in every branch of scenic knowledge; at once *the* painter and poet of the day, J. M. W. Turner. Everybody had described him to me as coarse, boorish, unintellectual, vulgar. This I knew to be impossible. I found in him a somewhat eccentric, keen-mannered, matter-of-fact, English-minded – gentleman: good-natured evidently, bad-tempered evidently,

hating humbug of all sorts, shrewd, perhaps a little selfish, highly intellectual, the powers of the mind not brought out with any delight in their manifestation, or intention of display, but flashing out occasionally in a word or a look.'

[*Ruskin then comments*]

Pretty close, that, and full, to be seen at a first glimpse, and set down the same evening. (35.305)

But this apparently well-documented encounter turns out to be an invention. Ruskin *did* dine with Griffith on 22 June 1840, and Turner *was* present, but this is Ruskin's actual diary entry:

Yesterday [*he is writing on 23 June*] at Griffith's at dinner: J. M. W. Turner, Jones [*George Jones R. A.*], Dr Fitton of the Geological [*the President of the Geological Society*], Augustus Liddell [*cousin of the future Dean of Christ Church*]. All worked well together, Jones laughing at Cambridge and some others of the Royal Dukes, for passing over one of his largest pictures, because there was a Chalon [*the portrait painter who had painted a miniature of Ruskin in 1836*] on each side of it. They know no more of painting than so many infants. Turner talking with great rapture of Aosta and Courmayeur. (D1.82-3)

And that is all he has to say. The manuscript of the diary shows no sign of tampering or missing entries. From it we can only guess at the relationship. *Was* this the first time they met? Ruskin's editors cite the possibility that they might have met first at a bookseller's in Oxford (35.305n). If it was, did they actually speak? Is the fact that there is no record of a direct conversation not significant? We are truly in the dark, and all we can say is that when it came to writing his autobiography, Ruskin was not afraid, to put it politely, to improve a story, just, as Alan Davis has shown, that he was willing to 'improve' Turner's own

drawings when making etchings from them in *Modern Painters* volume five.[5]

It is not until a year later, after Ruskin's long recuperative tour abroad in 1840 and 1841 following a nervous breakdown at Oxford, that we have a record of another meeting, again at Griffith's dinner table. Ruskin's diary entry for 5 July 1841 suggests no great personal intimacy: 'Turner there is no mistaking for a moment – his keen eye and dry sentences can be the signs only of high intellect' (D1.209). By November however Ruskin is on calling terms with Turner, and at the beginning of 1842 the Ruskins are among those invited by Griffith to commission watercolours from the range of Swiss subjects that Turner has produced in sample form. It can be assumed that in May 1842 he saw Turner's latest works in the Royal Academy, including *Snowstorm – Steam-Boat off a Harbour's Mouth making Signals in Shallow Water and going by the Lead*, before once more going abroad with his parents. At Geneva in June he read English reviews of these works and the project that he had probably had in mind since 1841 became a definite decision: to write a defence of Turner – and to publish it this time.

To Ruskin's delight, while he was hard at work on what was to become *Modern Painters*, Turner attended Ruskin's dinner for his twenty-fourth birthday on 8 February 1843. It was: 'the happiest birthday evening (save one) [*a reference to the object of his first passion, Adèle Domecq*] I ever spent in my life. Turner happy and kind' (D1.242).

These friendly social relations continued through 1844, but according to that possibly tainted source, *Præterita*, in the winter of 1844-45 Turner became anxious to dissuade Ruskin from going abroad, where he planned to visit Turnerian sites as well as study the Old Masters. The explanation offered by Ruskin

was that Turner felt anxious about him, presumably on behalf of his parents, because of the disturbed political situation in Switzerland. According to Ruskin he said 'there'll be such a fidge about you, when you're gone' (35.342). But Ruskin's account ends oddly: 'I made no answer, but grasped his hand closely, and went. I believe he made up his mind that I was heartless and selfish; anyhow he took no more pains with me' (35.341).

That last phrase, 'he took no more pains with me' suggests a shift in the relationship, not just a letting go. The continental journey of 1845 was life-changing for Ruskin, but 1845 was also the year from which Ruskin dates the beginning of Turner's decline. He put it most brutally in 1878, when he wrote that in 1845 Turner's mind failed: 'suddenly with snap of some vital chord' (13.409) – though shortly after he wrote this passage, it was Ruskin's mind that snapped for the first time.

The seventy-year-old Turner's health did indeed begin to fail in 1845, but Ruskin is saying much more than that. In 1845 Ruskin missed the Academy exhibition because he was abroad, and those works shown by Turner that he did later see he did not like, dismissing one – a view of Venice – as 'a second-rate work, and the two others [*both of whaling*] altogether unworthy of him' (3.250-1). These comments come from the revised edition of volume one of *Modern Painters*, published in 1846, in which Ruskin deplores Turner's cavalier use of unstable materials, so that they quickly cracked and faded, and criticises the condition of Turner's gallery in Queen Anne Street. He writes: 'The fact of his using means so imperfect, together with that of his utter neglect of the pictures in his own gallery, are a phenomenon in human mind which appears to me utterly inexplicable; and both are without excuse' (3.249n).

We do not know Turner's response to this, though a remark

by Turner in a letter to the Reverend W. H. Fawkes of 27 December 1847 referring to Ruskin as the 'Under Graduate of Oxford'[6] may not have been entirely kindly meant. Indeed, at some time between 1846 and 1848, Ruskin and Turner fell out. We do not know when this was, or what it was about, except that in some way Turner impugned Ruskin's honour. The evidence for the dispute comes from a diary entry of 1854 and a letter to Thomas Carlyle written in June 1867 when they too were at loggerheads. Ruskin wrote to Carlyle:

> I always suffer this kind of thing from those I have most cared for, and then I *cannot* forgive, just because I know I was the last person on earth they ought to have treated so. *Turner* did something of the same kind to me. I never forgave him, to his death. (JRTC.136)

The diary entry of 1854, recording a conversation with Griffith, shows that Ruskin at some time had sent a letter to Turner 'closing our intercourse' and that Turner 'could not make up his mind about answering or putting the thing to rights' (D2.489).

As to when this was, we can only speculate. In his edition of Turner's correspondence John Gage suggests that it may have been in 1846.[7] It is tempting to read a brief note from Turner to Ruskin in November 1848, usually interpreted as an encouraging comment on Ruskin's failing marriage: 'My dear Ruskin!!! Do let *us* be happy. Yours most truly and sincerely, JMW Turner',[8] may be an apology of some kind. Whenever it was, the dispute was not long enough to interrupt the annual flow of birthday invitations to the Ruskin's dinner table, nor did it prevent Ruskin being made an executor of Turner's will in a codicil of 2 August 1848.

Frustrating as the lack of hard evidence is, this dispute does cast a shadow over the later years of the Ruskin-Turner

relationship. He writes little about Turner in the second volume of *Modern Painters*, and it could be more than just his interest in the Gothic Revival that delayed the work's continuation until 1856. It seems that Ruskin did not learn about Turner's domestic arrangements, living with his widowed former Margate landlady Mrs Sophia Booth as 'Admiral Booth' in Chelsea, until after the artist's death, but one of his reasons for not writing Turner's biography, as had been proposed to him, was that: 'There might be much that would be painful to tell and dishonest to conceal' (RLV.120). Ruskin's view of Turner as having somehow failed after 1845 was already well established. What is increasingly emphasised in the following years is Ruskin's view of the artist as lonely and traduced, hardened and embittered by his critical reception.

The pain that is evident in Ruskin's later writing about Turner may have an additional source. That is Turner's refusal to respond to his would-be interpreter's enthusiasm. The previous chapter showed what emotional baggage Turner's drawings carried in terms of Ruskin's relations with his father. It may even be that he saw Turner as an alternative father figure. Turner's reluctance to engage in any discussion of his work, even when he sat below his own *Slavers* hanging in the family dining room, was a source of endless frustration. Turner clearly believed – like many artists – that his work should speak for itself and that criticism was useless. This resistance to interpretation is present from the very first refusal to sanction the publication of Ruskin's letter to *Blackwood's Magazine* in 1836, and Ruskin regularly alludes to his refusal to discuss his pictures. Turner at times seems to have teased and tantalised Ruskin:

> He tried hard one day for a quarter of an hour to make me guess what he was doing in the picture of Napoleon [*War.*

The Exile and the Rock Limpet of 1842], before it had been exhibited, giving me hint after hint in a rough way: but I could not guess, and he would not tell me. (7.435n)

This refusal of interpretation is not only a painful form of rejection: it is also an invitation to supply the meaning that is being withheld – hence Turner's possibly apocryphal grumble: 'He sees *more* in my pictures than I ever painted!'[9] To which, in effect, Ruskin replied: 'his work was the true image of his own mind' (7.422).

�097 �097 �097

A darkness, then, was already descending by the time when, after the resolution of the disputed terms of Turner's will, in January 1857 Ruskin gained permission to catalogue and conserve the mass of watercolours and sketches that had been deposited in the basement of the National Gallery in Trafalgar Square. In 1852 he had decided to resign as an executor, when the complexities of Turner's will had become apparent, but it appears that he nonetheless had some access to Turner's Gallery after his death (13.41, RLV 138). In 1857 he undertook a Herculean labour, sorting, cleaning, mounting, annotating some 3000 leaves, and cataloguing:

Dust of thirty years accumulation, black, dense, and sooty, lay in the rents of the crushed and crumpled edges of these flattened bundles, looking like a jagged black frame, and producing altogether unexpected effects in brilliant portions of skies, whence an accidental or experimental finger mark of the first bundle-unfolder had swept it away. (7.4)

Ruskin – this is the preface to *Modern Painters* volume five, framing the whole work – adds:

> The manual labour would not have hurt me; but the excitement involved in seeing unfolded the whole career of Turner's mind during his life, joined with much sorrow at the state in which nearly all his most precious work had been left, and with great anxiety, and heavy sense of responsibility besides, were very trying. (7.5)

The work was indeed arduous, and with the whole of Turner's working life spread out before him, Ruskin did not appreciate everything that he saw. Many of the slight sketches and colour beginnings that have become prized by contemporary taste, he dismissed. He selected 1,900 works as suitable for exhibition, and made up 303 parcels of the rest. Of these, Ruskin labelled no fewer than 108 as 'entire rubbish', making critical comments about individual drawings such as 'thoroughly bad ... slovenly and substanceless'.[10] Ruskin had used such terms as 'disgraceful' and 'useless' (13.151) of some of the exhibited oil paintings at Marlborough House and written of 'definite failure of hand and eye' (13.158), but his private comments on the drawings, and the dismissal of so many of them, suggest that the review of so much of Turner's work had led to disillusionment.

To complicate matters further, during this process of critical triage, he discovered a parcel set aside by Turner's executors containing a quantity of sexually explicit drawings. Some were merely nude studies; others were crudely pornographic. In a letter to the Keeper of the National Gallery, Ralph Wornum, Ruskin described them as 'grossly obscene'.[11] This letter confirms Ruskin's opinion of them, but it was not written until 1862, and it adds another level of complication. In it he says

that in December 1858, in Ruskin's presence and with his assent, Wornum burnt the offending works: 'I am satisfied you had no course than to burn them, both for the sake of Turner's reputation (they having been assuredly drawn under a certain condition of insanity) and for your own peace'.[12] The odd thing, however, is that at least some of the works survived the flames, and in the archives at Tate Britain is a label referring to them in Ruskin's hand: 'They are kept as evidence of the failure of mind only'.[13]

The mystery of these drawings has been thoroughly explored by the great Turner scholar Ian Warrell in his book, *Turner's Secret Sketches*. Ruskin's letter to Wornum is genuine; the existence of Turner's pornographic drawings and Ruskin's alleged destruction of them was gossiped about while he was still alive, but Warrell has seriously questioned whether the burning took place. It may be that Ruskin was giving Wornum cover for an event which in the end did not happen.[14] Whatever his motives for writing a letter four years after the supposed event, Ruskin's censorship in any case was not complete, because such drawings continue to exist. We therefore can see what Ruskin saw, and speculate what effect this had on him.

Some scholars, including Warrell, believe the discovery of these drawings was the source of a major crisis that helps to explain the despairing view of Turner in *Modern Painters* volume five. Warrell writes: 'The revelation that the artist he admired so much was a mortal, sexual being clearly appalled him'.[15] It is certainly true that the year 1858 marked an important turning-point in Ruskin's life: in January he met the then ten-year-old Rose La Touche for the first time; in July, after finishing his work at the National Gallery he experienced his 'un-conversion' in Turin. The Ruskin scholar Alan Davis, on the other hand,

argues that the emphasis on the impact of these drawings is a projection of twenty-first century sexual anxieties. Ruskin may have been upset by the hundred or so erotic scribblings, but, as his dismissal of so many of the rest of Turner's work shows, he had lost faith in Turner's work as a whole: 'The real shock to Ruskin was not that Turner drew a few sexy pictures. It was that he drew *thousands* of sketches that Ruskin considered to be idly conceived, badly observed, and executed in a slovenly manner'.[16] It was this, Davis suggests, that led Ruskin to 'improve' three of Turner's drawings in the etched copies he made for *Modern Painters* volume five, and accounts for the depressed view of Turner in that final volume.

Francis O'Gorman supports Davis's argument, and develops the point:

> Ruskin had endeavoured in *Modern Painters* to make Turner a Christian painter, explaining how his interpretation of the natural world was, whether Turner knew it or not, an astonishing revelation of the generosity of God and his moral teaching in the forms of the earth. Teaching of God through nature, Turner could never be made hopeless. And yet, by the end, hopeless he was. All that Turner had seemingly understood of divine blessing, of a world made for human beings by God, had failed him. Death had become the conqueror in a world of life.

O'Gorman comments: 'a few drawings of sexual subjects were nothing to this'.[17] Nonetheless, these images must form part of the 'dark clue' of Ruskin's later view of Turner, even if we are dealing with Atropos (death) rather than Eros. In June 1858, at a time when Ruskin was experiencing the religious crisis that was to lead not only to his rejection of Evangelicalism but

his acceptance of his own physical nature, he wrote to his father that having examined Turner's sketches:

> There is evidence of a gradual moral decline in the painter's mind from the beginning of life to its end – at first patient, tender, self-controlling, exquisitely perceptive, hopeful and calm, he becomes gradually stern, wilful, more and more impetuous, then gradually more sensual, capricious – sometimes in mode of work, even indolent and slovenly – the powers of art and knowledge of nature increasing all the while, but not now employed with the same calm or great purpose – his kindness of heart never deserting him, but encumbered with sensuality, suspicion, pride, vain regrets, hopelessness, languor, and all kinds of darkness and oppression of heart. (1858L.52)

᛭ ᛭ ᛭

It is in this mood that Ruskin embarked on the long-awaited conclusion to *Modern Painters*, and I have to answer my earlier rhetorical question, what has happened to Turner? Yes, he was a difficult, secretive and sensual man, though full of human sympathy. Yes, he paints the follies of mankind in the face of the implacable forces of Nature. Yes, he is aware of the transitoriness of beauty and is the author of poems he called *The Fallacies of Hope*. Yes, he was attacked and misunderstood by the critics – though he nonetheless made his fortune. Yes, his work and his health declined after 1845, but not as far as insanity.

But what we see in the closing pages of *Modern Painters* is the extent to which Ruskin has so identified himself with his hero that the work is now a true image, not of Turner's, but of Ruskin's mind. As Dinah Birch has observed, Ruskin's: 'reading

of Turner is autobiographical in its deepest motives'.[18] When he writes in *Modern Painters* volume five that all of Turner's 'failure and error, deep and strange, came of his faithlessness' (7.444), in 1858 Ruskin had, temporarily, lost his own faith. The despair is Ruskin's as, in the basement of the National Gallery, he is forced to review not only the splendour of his hero's artistic career and the decay of its substance, but his personal relationship with the man, a tragedy where another father figure appears to thwart him. He is dismayed, and pours his despair into the climax of *Modern Painters* in a culminating sense of identification between critic and artist, a process that has moved from naive admiration and imitation of his drawing style, to personal knowledge, to patronage, celebration, interpretation, editing, possibly censorship – and then a final laying out of the dead master's works. In his last chapter Ruskin writes:

> Only another Turner could apprehend Turner. Such praise as he received was poor and superficial: he regarded it far less than censure. My own admiration of him was wild in enthusiasm, but it gave him no ray of pleasure; he could not make me at that time understand his main meanings; he loved me, but cared nothing for what I said, and was always trying to hinder me from writing, because it gave pain to his fellow-artists. (7.453)

This too is a 'dark clue' to the conclusion to *Modern Painters*.

Revised from an unpublished Slade Lecture given at Oxford in 2000.

CHAPTER IV

'A VIOLENT TORY OF THE OLD SCHOOL': RUSKIN AND POLITICS

❦

Readers of Ruskin have to contain his contradictions. Always a dialectical thinker, he believed that the truth stood on two legs (5.169). He was never satisfied that he had handled a subject properly until he had 'contradicted myself at least three times' (16.187). This is especially so with his politics. He never voted, despised politicians, and dismissed Parliament as 'not worth a rat's squeak' (17.326-7). Yet throughout his life he was passionately interested in politics – and his politics were contradictory. As Francis O'Gorman writes in his introduction to *The Cambridge Companion to John Ruskin*: 'One of the most striking contrasts in this collection is that between Nicholas Shrimpton's account of Ruskin's High Tory politics … and Stuart Eagles' analysis of the inspiration Ruskin's work gave to the Labour movement'.[1] While Shrimpton asserts: 'What Ruskin was not was an ancestor of the British Labour Party';[2] Eagles quotes Labour's first post-war Prime Minister, Clement Atlee, saying that it was through Ruskin's *Unto This Last* 'that I entered the socialist fold'.[3]

Ruskin delighted in contradictions, using them as a provocative rhetorical device. In January 1871 he started writing the monthly numbers of *Fors Clavigera*, which he saw as an answer to his moral obligation to intervene in political affairs. But this was not politics as others might see it, and he was soon having fun with conventional political discourse:

Opposite: Fig. 9: George Richmond, The Author of Modern Painters, *photogravure, 1843*

Consider, for instance, the ridiculousness of the division of parties into 'Liberal' and 'Conservative'. There is no opposition whatever between these two kinds of men. There is opposition between Liberal and Illiberals; that is to say, between people who desire liberty, and who dislike it. I am a violent Illiberal; but it does not follow I am a Conservative. (27.14)

As will be elaborated in Chapter XI, in the July 1871 number he described himself as: 'a Communist of the old school – reddest also of the red' (27.116). In the October number he was: 'a violent Tory' – again – 'of the old school' (27.167). But Ruskin's truth stands on two legs: he was both Communist and Tory, only neither in the sense of the *communards* in Paris that he was thinking about in 1871, nor of the economically liberal Conservatives of the Tory party in London. Shrimpton and Eagles are both right. Ruskin *was* a High Tory, *and* a powerful influence on the British Labour Party. This chapter, however, which takes the story up to 1853, is more about where Ruskin's politics came from, than where they led to, although the starting-point helps to explain the destination.

🔸 🔸 🔸

Unsurprisingly, he began with views learned from his father. Ruskin said as much when he wrote in *Fors Clavigera*: 'I am, and my father was before me, a violent Tory of the old school (Walter Scott's school, and Homer's)' (27.167). When he decided to develop the reminiscences that appeared in *Fors Clavigera* into a full-scale autobiography, he lifted this passage to form, with slight variations, the opening lines of *Præterita* (35.13), giving it a prominence that raises it above rhetorical paradox.

Ruskin's reference to Scott and Homer was more than literary; they were authors his father had encouraged him to read, with political lessons in mind. In both *Fors Clavigera* and *Præterita* he gave the same gloss. Scott and Homer had taught him: 'a most sincere love of kings, and dislike of everybody who attempted to disobey them' (35.14). His father put his own views less elegantly in a letter to his son commenting on Napoleon III's *coup d'état* in 1851:

> Pretty work in Paris – a Kingdom to be scrambled for or played for or battled for – I have a taste for Despotism & see no way in which a Country torn into fragments – can again be again united but under an Iron Despotism – but civil War is feared – I am so partial to Despotism that I am tired of Radicals Socialists & mobs & equality & fraternity.[4]

Ruskin's authoritarianism – his 'Illiberalism' – was not just an inheritance from his father, however. His reading of Plato, as well as Scott and Homer, encouraged a suspicion of democracy, but he also had access to a contemporary political tradition, with a coherent set of values, and a distinctive representation in Ruskin's contemptible House of Commons. He shared his politics with a vigorous Parliamentary grouping with a specific ideology. Like his father, he was an Ultra-Tory, and the Ultra-Tory ideal of a constitutional government within a hierarchical social order profoundly shaped his understanding of society and history.[5]

When Sir Robert Peel broke the unity of the Tory party on the wheel of the repeal of the Corn Laws in 1846, this was the second, not the first, great betrayal of Tory principles. The first had been the introduction of Catholic Emancipation in 1829, which allowed Roman Catholics to sit in Parliament. Ultra-Tories could never reconcile themselves to this, for it destroyed the absolute unity of

Church and State: 'as if', as Ruskin put it in 1851, 'the State were not, in all Christendom, necessarily also the Church' (9.423).

Support for the Anglican Church as the established religion of the State, where the monarch headed both, was central to the Ultra-Tory view of society as a balance of forces: the power of the House of Commons limiting and limited by the aristocracy; aristocracy and the enfranchised classes in turn limiting the power of the Crown. This had been the position since the Glorious Revolution of 1688 had seen off the Roman Catholic James II and installed the Protestant William III.

The Anglican Church, unlike that of the Catholics, whose extra-territorial allegiance to the Pope was seen as a permanent threat to national unity, set the seal on this social contract. It was logical that those who governed should be members of the national church, and only those. There was no obligation to be an Anglican, one could be Catholic or Nonconformist if one chose, but to do so was to accept exclusion from institutions such as the universities of Oxford and Cambridge, and the Houses of Parliament. If one wished to participate in the government of the British state, then it was necessary to be a member of the only church that upheld it. This was certainly John James' view: 'So entirely is Protestantism interwoven with the whole frame of our constitution and laws, that I take my stand on this, against all agitators in existence, that the Roman religion is totally incompatible with the British constitution' (9.423-4).

Within the Anglican Church, however, two forms of Protestantism were in a state of cold war. On the one side were the High Anglicans, who regarded Henry VIII's break with Rome as less of an interruption of the Apostolic Succession than their opponents, the Evangelicals, who based their authority on the

word of the Bible. The High Church took a more æsthetic view, and had a taste for reviving the robes and rituals of the pre-Henrician church. This was one of the first signs that the practitioner was on the way to 'going over to Rome'. Such had been the case among a number of Oxford and Cambridge college Fellows in the 1830s and 40s, whose tastes included a preference for Gothic architecture. At this time, it was obligatory to be in Holy Orders to hold a Fellowship, just as being an undergraduate required being a confirmed Anglican. Ruskin had been baptised a Scottish Presbyterian, but was confirmed as a member of the Church of England shortly before going up to Christ Church, Oxford, in 1837.

As it happened, the leader of the High Church party in Oxford, Dr Pusey, was a Canon of Christ Church, giving his name to the – in Ruskin's usage – pejorative term 'Puseyism'. Pusey remained an Anglican, but his colleague at Oriel College, Henry Newman, initiator of the controversial *Tracts for the Times* in 1833, went over to Rome in 1845. The 'Oxford Movement' was at its height when Ruskin went to Oxford, and it is possible that the reason why his mother also took up residence during term time was to preserve him from Tractarian temptation and keep him in the Evangelical way of faith.

The Evangelical party, however, was not monolithic. As Boyd Hilton explains:

> The term 'evangelical' covers a range of theological positions, but still more problematic is the fact that it is seriously frayed at the edges. By 1850 about one-third of Anglican clergymen, including many of the brightest and the best, may have been designated 'Evangelical' with a capital letter, and so would the majority of Nonconformists.[6]

Evangelical opinions ranged from an extreme, authoritarian wing that believed in the over-powering, all-reaching nature of God's governance, and sought to reproduce it on earth, and a more moderate group who put most of the ills of the world down to original sin, and therefore emphasised self-help and non-interference. Their belief that individuals were responsible for their own fate made these sympathetic to the principle of *laissez-faire*, which Ruskin would fiercely attack in his later economic writings.

Adolescent Ruskin was brought into personal contact with leading Evangelical divines associated with the Ultra-Tory party. Between 1833 and 1835 he attended the school run by the Reverend Thomas Dale; before going up to Oxford he heard Dale's lectures as the first Professor of English Literature at the newly founded King's College, London. The Ruskin family were regulars at the Camden Chapel in Camberwell, where the Reverend Henry Melvill held forth. A contemporary guide-book to the preachers of London, *The Metropolitan Pulpit*, illustrates the extent to which the Evangelical was also the political:

> Mr Melvill is not only a violent politician, but occasionally carries his politics into the pulpit. I have heard him deliver sermons in which there were passages of so ultra-political a character, that had a stranger been conducted blindfolded into the place in which he was preaching, and it had been a time when Parliament was sitting, he would have been in danger of mistaking the sermon of the reverend gentleman for a speech of the Earl of Winchester in the Lords, or of Sir Robert Inglis in the Commons.[7]

Winchester was leader of the Ultra-Tories in the Lords, Sir Robert Inglis in the House of Commons.

Dale and Melvill dined at the Ruskins' home, as did the Reverend George Croly, an Ultra-Tory Ulsterman whose daughter Helen-Louisa-Mary became Ruskin's goddaughter. Croly – who introduced Ruskin to Sir Robert Inglis – was also a poet, novelist, and Evangelical polemicist, and a contributor to *Blackwood's Magazine*, regularly read in the Ruskin household, in spite of its art critic's hostility to Turner. *Blackwood's* was one of the intellectual resources of the Ultra-Tories. Their ideal of a balance or harmony of forces in the constitution extended to the social and economic fields. These rested on the national virtue of sound agriculture, encouraging a belief in protectionism, represented by the Corn Laws, as a guarantee of the landed interest. The economic liberalism practiced by more modern Conservatives was anathema because it encouraged divisive competition and weakened the state. Here, however, Ruskin and his father deviated from orthodoxy. While inclining to authoritarianism, John James, as a sherry importer, believed in free trade.

Ultra-Tory economic theory is encapsulated in a series of articles on 'Political Economy' by the journalist who served effectively as political editor at *Blackwood's*, David Robinson.[8] He argued that England needed a managed economy designed to maintain the highest national income available for distribution among the classes, as opposed to an unmanaged one in which the national income was reduced by competition from foreigners and between the classes. Robinson attacked Ricardo, the disciple of Adam Smith, and criticised the degeneracy of the aristocracy. He recommended education and high living standards as an antidote to social distress, and advocated a policy of reclaiming wasteland and the encouragement of cottage gardens. Although there is no evidence Ruskin had read these specific articles, such ideas were to resurface when Ruskin started to lay

out his plans for his utopian society, the Guild of St George, in *Fors Clavigera*. In *Fors* there is another echo. Robinson signed his articles: 'One of the Old School'.

Being a member of the old school meant a rejection of the very idea of political economy as a mode of thought. Robinson's nostalgic agrarianism was romantic and anti-utilitarian, a position that Ruskin was familiar with from his reading of Wordsworth, Coleridge, Southey and, slightly later, Carlyle, who called political economy 'the dismal science' because of the classical economists' pessimism about over-population and the prospect of a stationary state. The Ultra-Tory land-and-labour-based ideal was plainly in contrast to the liberal capitalism that Ruskin was to attack in *Unto This Last* in 1860. His own father was a capitalist, but a merchant, not an industrialist. In the Ultra-Tory polity each man would know his place in the hierarchy, and economic and social competition would be at a minimum. The privileged would acknowledge their duties to those below them; the lower orders would be content with the security that a harmonious social order gave. In her study of Ruskin and social reform Gill Cockram has written: 'Organic unity made manifest in great works of art, whether it be Turner's paintings or Gothic cathedrals, provided the original metaphor for Ruskin's social criticism'.[9] But organic unity was more than a metaphor, it was an Ultra-Tory ideal. Justice – seen more in terms of judgement than equity – would be guaranteed by the moral values of a common religion. It was a distinctly patriarchal view of the world.

⚛ ⚛ ⚛

In 1848 hierarchies were challenged right across Europe. Although the Chartists presented no real threat in Britain,

politics seriously inconvenienced Ruskin when he wanted to travel on the continent. Having married in April, he had intended to take his bride, Effie, on a honeymoon to Venice, but the Venetians' revolt against their Austrian masters prevented that. Instead he had to wait for the revolutionary troubles in France to subside sufficiently to be able to visit Normandy. They encountered a column of captured Rouen insurgents near Caen, and on a visit to Paris, like 21st century travellers, they had their bags searched for gunpowder.

Political events may have been a nuisance, but they were also a stimulus. Ruskin's route to his later direct intervention in political economy ran through architecture. His interest, stimulated by his observations in Venice in 1845 and 1846, diverted him from the continuation of *Modern Painters* into the composition of *The Seven Lamps of Architecture*, published in 1849. Studying the Gothic churches of Normandy he had observed the depredations of 'the Restorer, or Revolutionist' (8.3n), a coupling that eloquently links æsthetics and politics.

The Seven Lamps of Architecture demonstrates both Ruskin's hostility to Roman Catholicism and his Ultra-Toryism. He cites the writings of his family friend the Reverend George Croly in a virulent attack on the 'lying and adulterous Power' of the Roman Catholic Church, which is 'the darkest plague that ever held commission to hurt the Earth' (8.268). In later life Ruskin felt embarrassed by such passages of 'rabidly and utterly false Protestantism' (8.15), and cut them from a revised edition in 1880. But in 1849 he was in full flight.[10] His 'lamps' are Biblical, the seven-branched menorah of Exodus and Revelation, expressions of faith and moral principle – 'Sacrifice', 'Truth', etc – that carry both religious and æsthetic value. Ruskin's Evangelical conviction of the fallen state of man – in biblical and architectural

terms, his ruin – combines with his Ultra-Toryism to name his seventh lamp 'Obedience'.

Beginning with an attack on 'that treacherous phantom which men call Liberty' (8.248), Ruskin argues that the discipline of obedience must be applied to what he had earlier called 'the distinctively political art of Architecture' (8.20). Architecture can only be great when it is governed, like Church and State, by national principles, expressed by a national style. This call for 'Obedience, Unity, Fellowship and Order' (8.255) – Ultra-Tory virtues all – leads to a reflection on the 'horror, distress and tumult' (8.261) that had afflicted Europe in 1848, and which he had witnessed. All parties are condemned, but their individual failings have a common cause: 'the recklessness of the demagogue, the immorality of the middle class, and the effeminacy and treachery of the noble, are traceable in all these nations to the commonest and most fruitful cause of calamity in households – idleness' (8.261).

By this Ruskin does not simply mean sinful sloth or unavoidable unemployment, but the absence among all classes of engagement with a fulfilling occupation. Had the energy devoted to building the railways gone instead into building cathedrals, how much better would things be. The argument that he develops, that it is not work in itself that is important, but what that work produces, anticipates the contrast in *Unto This Last* between wealth and 'illth' (17.89) and, more immediately, the question of the quality of labour in 'The Nature of Gothic' in *The Stones of Venice*.

☙ ☙ ☙

An advertisement in *The Seven Lamps of Architecture* shows that

Ruskin was already committed to *The Stones of Venice* by the time *The Seven Lamps* appeared in May 1849. In the following October he and Effie set off for the first of two long stays in Venice. The Austrians were back in control, but in England two political crises gave a polemical focus to Ruskin's Venetian research. The first was an outbreak of overt hostilities in the Anglican cold war between Evangelicals and High Churchmen: the Gorham case. In 1848 the High Church Bishop of Exeter had refused to appoint the Evangelical George Gorham to a new living, on the grounds that his Evangelical views on baptism were unsound. Gorham went to law, with the case finally being decided in his favour by the Privy Council in March 1850. Ruskin read about the case on his way back to London from Venice, and felt compelled to write his own 4,500 word 'Essay on Baptism', favouring the Evangelical view. This was not published in his lifetime, but it shows the extent to which Ruskin felt threatened by the apparent weakness of the quarrelling Church of England in the face of the threat of the burgeoning power of Rome.

The internal dispute caused by the Gorham case had hardly been concluded – though not settled – when at the end of September 1850 Rome went on the offensive, with what became known as the Papal Aggression. The first move was innocuous enough: the Catholic Church in England needed to reorganise to cope with its increased numbers, largely caused by Irish immigration. But it was decided to create a system of bishoprics, whose titles would correspond to the dioceses of the Church of England, with Cardinal Wiseman as Archbishop of Westminster at the head of a restored Catholic hierarchy. This provoked Protestant outrage and rioting, and the Whig administration led by Lord John Russell felt obliged to bring in an Ecclesiastical

Titles Bill to stop Roman Catholic use of Church of England titles. This was more than a question of branding; to Protestants the move had felt like a takeover aimed at reuniting England with Rome.

The Bill came to Parliament in February 1851, and satisfied neither Roman Catholic nor Radical members, nor the Tories who had supported Catholic Emancipation. Disraelian Tories and Radicals each took advantage of Russell's weakness to bring in other measures, and the government fell. After a week without a government, Russell returned to power with a reshaped cabinet and the Ecclesiastical Titles Bill was eventually passed, though it became a dead letter. The crisis had a direct effect on Ruskin however. In his introductory chapter to *The Stones of Venice* – published on 3rd March, the day Russell returned to power – his remarks about the religious cynicism 'of our present English legislature' (9.27) and the way its members had 'sacrificed their principles' (9.29) when challenged by Rome referred unmistakably to the Papal Aggression.

Three days later, on 6th March, he published his most explicitly political work yet, a pamphlet entitled *Notes on the Construction of Sheepfolds* (12.509-58). The sheepfolds were a metaphor for the quarrelling doctrinal groups in England and Scotland. He warned: 'If the Church of England does not forthwith unite with herself the entire Evangelical body, both of England and Scotland, and take her stand with them against the Papacy, her hour has struck' 12.557). He had intended to publish these *Notes* as one of a number of appendices to the first volume of *The Stones of Venice*, but his more cautious father dissuaded him. This did, however, give him the opportunity to add a last-minute footnote on the state of affairs that had left the United Kingdom: 'for a week without any government, because her chief men cannot

agree upon the position which a Popish cardinal is to have leave to occupy in London' (12.530n). John James may have felt that his son was being too political, but when it came to anti-Popery, he allowed him to reprint some anti-Catholic and Ultra-Tory opinions of his own, as part of an appendix that *was* included, on the subject of 'The Papal Power in Venice' (9.419-24).

This appendix shows how important the Ultra-Tory insistence on the unity of Church and State was to Ruskin's understanding of Venetian history. He could not pretend that the Gothic glories of Venice were other than the product of a Roman Catholic culture, but he was able to give a Protestant reading to the Republic's 'magnificent and successful struggle' against the political power of Rome (9.27). In his view, until the end of the 14th century Venice enjoyed political and clerical unity, symbolised by the fact that the Doge's chapel, the basilica of St Mark's, was physically and symbolically central to the life of the Republic, whereas the city's modest cathedral was in the remote *sestiere* of Castello.[11] A historical note supplied by Ruskin's friend, the resident Venetian expert Rawdon Brown, points out that, although appointed by the Pope, Venetian cardinals served their Republic's interests. So long as the Venetian clergy and its government co-operated, the Republic flourished; but when the clergy were specifically excluded from the political arena in the early 15th century, decline set in (9.423).

In his contribution to this same appendix, John James conversely condemns Catholic Emancipation in 1829 because, by allowing Roman Catholics *into* the political arena of Parliament, it also broke the unity of State and Church. For Ruskin, when private piety in Venice became separated from public policy – in other words, the separation between faith and politics, Church and State – the rot set in. The fall of Venice was not due to her

Catholicism, but to the corruption of that faith – emblematised by the corruption of late Gothic art and architecture – and the pagan influence of the Renaissance. *The Stones of Venice* opens with a sonorous warning that, with the maritime empire of Tyre having disappeared, and that of Venice now but a ruin, the British Empire 'may be led through prouder eminence to less pitied destruction' (9.17). The events of 1850 and 1851, Ruskin's contemporary references imply, were the consequence of that fatal decision in 1829 to compromise the organic unity of the Protestant state:

> What excuse are we to offer for the state, which, with Lords Spiritual of her own faith already in her senate, permits the polity of Rome to be represented by lay members? To have sacrificed religion to mistaken policy, or purchased security with ignominy, would have been no new thing in the world's history; but to be at once impious and impolitic, and seek for danger through dishonour, was reserved for the English parliament of 1829. (9.423)

ᚧ ᚧ ᚧ

The first volume of *The Stones of Venice* appeared, as we have seen, in March 1851, the final two volumes not until July and October 1853 – Ruskin and Effie having spent another long period in Venice between 1851 and 1852. But Ruskin did not lose touch with English affairs while abroad and, possibly emboldened by his political interventions so far, he decided in March 1852 that the news from England had become 'really too ridiculous' and that he must say something about current political events (RLV.212). He had already had some effect on public

opinion by writing to *The Times* in defence of the Pre-Raphaelite Brotherhood (12.319-27), and he now proposed to write three more letters to the paper, on the current dispute about taxation and the Corn Laws, elections, and education. As was his practice with drafts of the continuation of *The Stones of Venice*, he sent them to his father for approval.

John James did not approve. Referring to himself as John Bunyan's 'Mr Fearing' he was anxious that his son should not be exposed to ridicule or controversy, reminding him that he had earlier been worried by the publication of *Notes on the Construction of Sheepfolds*. Flippant remarks about Disraeli and advocacy of a weighted voting system favouring the propertied and educated classes showed his son straying too far into a field where he had neither experience nor expertise. John James told him to read all of the political works of the Tory thinker Edmund Burke. Worse, Ruskin also appeared to be straying from the Ultra-Tory path. John James was embarrassed on both his own and his son's part:

> I am prodigious afraid in my character of Mr Fearing that were my name to appear to your Lucubrations on Election – embracing in their extraordinary small space – something of Radicalism – of Socialism – of Republicanism & Whiggism – Furnivall – Kingsley – & Carlyle squeezed like Lemons – my Business & means of buying *Libers* might be curtailed for even in this Land of Free Opinion we are not all free to hold strong opinions without becoming Martyrs.[12]

Ruskin protested that his politics had not changed, but accepted his father's censorship. Fortunately, his third letter, on Education, went down better. He might, controversially, advocate the study of politics by schoolboys and even peasants,

but its lessons, as defined by Ruskin, were orthodox Ultra-Tory:

> The impossibility of equality among men; the good which arises from their inequality; the compensating circumstances in different states and fortunes; the honourableness of every man who is worthily filling his appointed place in society, however humble; the proper relations of poor and rich, governor and governed; the nature of wealth, and mode of its circulation; the difference between productive and unproductive labour. (11.260)

John James liked this letter so much that it was given the reverse treatment to *Notes on the Construction of Sheepfolds*, and was added as an appendix to the third volume of *The Stones of Venice*.

Thus father and son got over this dispute, but John James's anxiety about his son's interest in politics, and the direction they might be taking, were a warning of difficulties to come. John James believed in his son's books, but told him: 'your politics are slum Buildings liable to be knocked down' (12.lxxxiv). When Ruskin set out properly to explore 'the nature of wealth, and mode of its circulation' in *Unto This Last*, reconciliation would not be so easy.

<p style="text-align:center">⚜ ⚜ ⚜</p>

As to 'the difference between productive and unproductive labour' that theme, adumbrated in the closing chapter of *The Seven Lamps of Architecture*, had been explored in the second volume of *The Stones of Venice*, in the book's pivotal chapter 'The Nature of Gothic'. It is pivotal because it is at the centre of the three volumes, and pivotal because – for his progressive

admirers – this is the chapter in which Ruskin's politics take a radical turn. Here, he protests against industrialism and laments 'the great cry that rises from all our manufacturing cities, louder than their furnace blast' (10.196), yet, however seminal this chapter proved to be, it was still consistent with an Ultra-Tory view of the world, and passed John James's censorship.

Although it sits at the centre of Ruskin's history of Venice, 'The Nature of Gothic' is determinedly a-historical. He is not concerned with identifying a particular style of Gothic and relating it to a particular period, but is trying to establish '*Gothicness*' (10.181), a moral and æsthetic essence summed up by certain characteristics. Not every Gothic building will necessarily display all of these in formal terms, but all true Gothic buildings will none the less convey their spirit. The 'Gothic' is both a visual style, and a way of being. It is Ruskin's version of the 'Medieval', a word that in the 19th century exists simultaneously on two temporal planes: the historical Medieval of the Middle Ages, and the revived Medievalism of contemporary critics of Victorian society. For Ruskin, the most important exponents of this critical Medievalism were Pugin in *Contrasts* (1836 and 1841), whom he did not acknowledge, and the acknowledged Carlyle in *Past and Present* (1843), both of whom drew severe conclusions about the difference between the Middle Ages and the present day. Nicholas Shrimpton has demonstrated how *The Stones of Venice* is a 'late flowering of this distinctive tradition of polemical literature'.[13]

The six characteristics that Ruskin identifies are simultaneously æsthetic categories and psychological attributes, what he calls 'mental elements' (10.184). Each æsthetic category: Savageness, Changefulness, Naturalism, Grotesqueness, Rigidity and Redundance has its correspondent human characteristic: Rudeness (meaning rough vitality rather than discourtesy), Love

of Change, Love of Nature, Disturbed Imagination, Obstinacy and Generosity. The 'Nature' of the chapter's title means both essence, and the ruling spirit of the values he identifies. The organicism, the energy, the variety, the abundance of Gothic architecture express the vitality of what Ruskin was to call in *Unto This Last* simply 'LIFE' (17.105). Yet, after the hungry 1840s and the year of revolutions in 1848, Ruskin saw that man was alienated from Nature. It was a double alienation: man had crowded into cities, where he tried to compensate for his separation from the natural world through the evolution of Gothic architecture. And now, thanks to the Renaissance, man was alienated from the Gothic. The forces of Classicism and Industrialism had combined to turn men into slaves.

Ruskin develops a question he had first asked in *The Seven Lamps of Architecture* – 'was it done with enjoyment?' (8.218) – into a critique of the Nature of Labour. As an Ultra-Tory, he imagined pre-lapsarian Venetian society as a benign hierarchy of statesmen, soldiers, traders, fishermen, artists and craftsmen bound together by common rights and duties, where each man knew and kept his place, but enjoyed the freedom and security that it gave him. Industrialism had destroyed that freedom. Ruskin knew nothing of Marx, but both were addressing the same social and economic conditions at the same period, and both concluded that man's alienation was the consequence of having the value of his labour stolen from him. Any man has some capacity, however small, to create, and in that capacity lies his humanity. But the capitalist division of labour – and Ruskin's challenge is directly to the liberal economists' hero, Adam Smith, using the example of pin making that Smith used in *The Wealth of Nations*[14] – meant: 'it is not, truly, the labour that is divided; but the men' (10.196). Atomised, men become mere

parts of an industrial machine. Thus it should be no surprise that the 'great cry' from our cities should be: 'we manufacture everything there except men' (10.196).

The rules of Classical, 'Pagan' architecture demanded regularity, a symmetry, a consistency of repetition that left no room for individual, 'Protestant', self-expression. It was Roman slavery all over again. The process of industrialisation of labour made it possible to demand perfect finish, and achieve an untruth to materials that created the modern domestic interior, whose: 'perfectnesses are signs of a slavery in our England a thousand times more bitter and more degrading than that of the scourged African, or helot Greek' (10.193). Marx argued that industrialism robbed workers of the economic value of their labour; Ruskin argued that by denying them any opportunity for self-expression, however small, industrialism robbed them of the moral and æsthetic value of their work. This value, the wealth of life, would be recovered in the Ultra-Tory utopia where the 'honourableness of every man ... is worthily filling his appointed place in society' (11.160).

꙰ ꙰ ꙰

The radical potential of this conservative message was immediately picked up when, the following year, 'The Nature of Gothic' was reprinted as a form of manifesto by the Christian Socialist founders of The London Working-Men's College (see Chapter VIII). Its message was also noted by an Oxford undergraduate, William Morris, who, having made his own journey from *The Stones of Venice* to revolutionary socialism, decided to honour Ruskin's chapter by reprinting it as a high art, modern Gothic, vellum bound creation in 1892.

THE NATURE OF GOTHIC.

E are now about to enter upon the examination of that school of Venetian architecture which forms an intermediate step between the Byzantine and Gothic forms; but which I find may be conveniently considered in its connexion with the latter style. ❡ In order that we may discern the tendency of each step of this change, it will be wise in the outset to endeavour to form some general idea of its final result. We know already what the Byzantine architecture is from which the transition was made, but we ought to know something of the Gothic architecture into which it led. ❡ I shall endeavour therefore to give the reader in this chapter an idea, at once broad and definite, of the true nature of Gothic architecture, properly so called; not of that of Venice only, but of universal Gothic: for it will be one of the most interesting parts of our subsequent inquiry, to find out how far Venetian architecture reached the universal

Fig. 10: The Nature of Gothic, *first page of the Kelmscott Press edition printed by William Morris (using his own 'Golden' typeface) in 1891*

In his introduction Morris writes that 'The Nature of Gothic': 'seemed to point out a new road on which the world should travel'.[15] Ruskin did not travel as far as Morris on that road, but in 1853 he was beginning to free himself from the bonds of Evangelicalism, and to think about political economy in ways that would offend the orthodoxies of the 1860s and give a language and argument to the labour movement of the 1880s and after. In 1856 he told a friend that he had 'been bred a Tory', but had 'gradually developed myself into an Indescribable thing – certainly *not* a Tory' (36.239). Yet he continued to deny the possibility of equality, and never abandoned his authoritarianism.

Such were his contradictions, and more were to follow. For all that Ruskin's politics turned out to be revolutionary, he remained a Tory of the old school.

The theme of this new chapter was first explored in 'Notes on the construction of The Stones of Venice', Studies in Ruskin: Essays in Honor of Van Akin Burd, *ed. Robert Rhodes and Del Ivan Janik, Ohio University Press, 1982.*

VENICE.

THERE is a glorious City in the Sea.
The Sea is in the broad, the narrow streets,
Ebbing and flowing; and the salt sea-weed
Clings to the marble of her palaces.
No track of men, no footsteps to and fro,
Lead to her gates. The path lies o'er the Sea,
Invisible; and from the land we went,
As to a floating City—steering in,

CHAPTER V

'PARADISE OF CITIES': RUSKIN AND VENICE

cn

Writing in 1877 to his new found Venetian ally Count Alvise Zorzi (Fig. 12), Ruskin described himself as: 'a foster-child of Venice. She has taught me all that I have rightly learned of the arts which are my joy' (24.405). Ruskin felt deep affinities with several sites and cities – Chamonix, Amiens, Rouen, Geneva –, but there is no questioning the overwhelming importance of Venice in his personal and his intellectual life. He visited Venice at least once in every decade of his working career; he wrote his most concentrated and important work there. He was at his happiest there as a young man; in middle-age a stay in Venice provoked a near breakdown. Venice shaped him, and in return he has helped to shape our perception of the city. As he wrote twice in his life, at the age of 22 and the age of 67, it was his 'Paradise of cities' (D1.183; 35.296).

☙ ☙ ☙

He first saw the city in 1835. The increasingly prosperous Ruskin family had first visited Italy in 1833, travelling down the Rhine and through Switzerland as far as Milan and Turin, but they turned away from Venice because of the summer's heat. Tourism had picked up since the end of the Napoleonic war, but travel by coach was a challenging experience. To reach Venice, the

Opposite: Fig. 11: J. M. W. Turner, Illustration to Rogers' 'Italy', *1830*

Fig. 12: Anon., Count Alvise Zorzi

party, Ruskin, his father, mother, his orphaned cousin Mary Richardson, plus servants, had to travel by water, a romantic moment that Ruskin made use of in an unfinished story, 'Velasquez the Novice', where they are accompanied on their voyage by a chorus of flower-girls who sing a song in praise of 'the queen of the sea' to which they are heading (1.541).

The queen of the sea, a title that Venice had laid claim to for centuries, had seen better days. In 1797 Napoleon forced the dissolution of the Venetian Republic, closed its monasteries and looted its churches. Occupation by the French was followed by that of the Austrians; after the Congress of Vienna Venice and the Veneto became a province of the Austro-Hungarian Empire. Although the Austrians did what they could to revive commerce, the population fell and the city decayed.

The gloomy boarded up palaces, collapsing buildings and mysterious narrow canals were perfectly suited, however, to the sensibility of a romantically inclined adolescent such as Ruskin. His mind had long been prepared for the city. At the age of 13 he had been given a copy of Samuel Rogers's poems, *Italy*, illustrated by Turner, which evoked Venice's most characteristic and appealing feature:

There is a glorious City in the Sea,
The Sea is in the broad, the narrow streets,
Ebbing and flowing; and the salt-seaweed
Clings to the marble of her palaces.[1]

Then there was Byron, familiar name in the Ruskin household, a not uncritical friend of the Venetians, who took up residence there in 1817, adding the scandal of his reputation to that of a city notorious for its illicit pleasures. Byron's warning to Britain about the fate of maritime empires may have planted an idea in Ruskin's mind:

… thy lot
Is shameful to the nations, – most of all,
Albion! To thee: the Ocean queen should not
Abandon Ocean's children; in the fall
Of Venice think of thine, despite thy watery wall.[2]

Ruskin responded to *Childe Harold's Pilgrimage* with Gothick travel verse of his own:

I've tried St Mark's by midnight moon and in Rialto
 walked about
A place of terror and of gloom which is very much talked
 about,
The gondolier has rowed me by the house where Byron
 took delight
The palace too of Foscari is very nearly opposite.[3]

The Ruskins' stay at the Hotel Danieli in 1835 was not long, from 6th to 17th October, but John had time to make a careful study of the south side of St Mark's, with the Porta della Carta and part of the Ducal Palace, which he later worked up into a stiff, engraving-like drawing (Fig. 13). The visit proved useful the

Fig. 13: John Ruskin, The South Side of St Mark's, *1835*

following year, when Turner showed his *Juliet and Her Nurse* (Pl. 1) at the Royal Academy. Part of Ruskin's defence of the picture against the criticisms of *Blackwood's Magazine* was based on his own observation. Far from being a composite view, it was 'accurate in every particular, even to the number of the divisions in the Gothic of the Doge's palace' (3.637). This was something of an exaggerated claim, and he was later to revise his opinion of Turner's topographical accuracy, recognising the romanticism that coloured his early ideas: 'My Venice, like Turner's, had been chiefly created for us by Byron' (35.295).

Romance was still in the air when Ruskin next visited Venice, in May 1841. He had left Oxford without sitting his final exams, having strained himself with over-work, his heart broken when Adèle Domecq, a daughter of his father's business partner, married another. His parents took him on a long, recuperative continental tour in the winter and spring of 1840 and 1841, and he recovered sufficiently to return to Oxford to take a degree. In Venice, however, he had not yet forgotten Adèle. He wrote in his diary on his arrival on 6th May:

Thank God I am here! It is the Paradise of cities and there
is a moon enough to make half the sanities of earth lunatic,
striking its pure flashes of light against the grey water before
the window; and I am happier than I have been these five
years – so happy – happier than in all probability I shall be
again in my life, I feel fresh and young when my foot is on
these pavements, and the outlines of St Mark's thrill me as
if they had been traced by A[dèle']s hand. (D.1.183)

He had honed his skills as a draughtsman, but although he
was producing sophisticated architectural studies in the manner
of Samuel Prout or David Roberts, there is a hint of a more crit-
ical attitude developing, especially if his drawing was not going
well. Venice: 'is quite beyond everybody but Turner' (1.447). He
was also becoming distrustful of Byron's romantic image of the
city: 'it now looks as though there had been a slight proportion
of what one would call gammon about it' (1.453). This is a fore-
taste of what he would argue in *The Stones of Venice*:

The Venice of modern fiction and drama is a thing of yes-
terday, a mere efflorescence of decay, a stage dream which
the first day of daylight must dissipate into dust. No pris-
oner, whose name is worth remembering, or whose sorrow
deserved sympathy, ever crossed that 'Bridge of Sighs' which
is the centre of the Byronic ideal of Venice. (10.8)

This view sharpened on his next visit in 1845, when, as we saw
in Chapter I, he was travelling without his parents for the first
time. Not only was he forced to question the way artists such as
his drawing instructor James Duffield Harding pictured Venice,
he was challenged by his encounter with the art of Tintoretto
and other Venetian masters (Pl. 4). He was also confronted by
modernity. A railway bridge had been built across the lagoon

connecting the city directly with the mainland. The romantic gondola ride had been replaced by the rattle of iron and the hiss of steam. As he wrote to his father, worse was to come:

> It began to get a little better as we got up to the Rialto, but, it being just solemn twilight, as we turned under the arch, behold, all up to the Foscari palace – *gas lamps*! On each side, in grand iron new posts of the last Birmingham fashion, and sure enough, they have them all up the narrow canals, and there is a grand one, with more flourishes than usual, just under the bridge of sighs.
>
> Imagine the new style of serenades – by gas light. Add to this, that they are repairing the front of St Mark's, and appear to be destroying its mosaics. (1845L.198-9)

The 'stage dream' of Venice was disappearing before his eyes:

> Of all the fearful changes I ever saw wrought in a given time, that on Venice since I was last here beats. It amounts to destruction – all that can be done of picture now is in the way of restoration. (1845L.189)

Ruskin's use of the word 'restoration' is ambiguous. It was restoration that was changing everything for the worse. What he meant by 'of picture' was the urgent need to record as much as possible before it was gone:

> You cannot imagine what an unhappy day I spent yesterday before the Casa d'Oro, vainly attempting to draw it while the workmen were hammering it down before my face. It would have put me to my hardest possible shifts at any rate, for it is intolerably difficult, and the intricacy of it as a study of colour is inconceivable ... but fancy trying to work while one sees the cursed plasterers hauling up beams and dashing in the

old walls and shattering their mouldings, and pulling barges
across your gondola bows and driving you here and there, up
and down and across, and all the while with the sense that *now*
one's art is not enough to be of the slightest service, but that
in ten year's more one might have done such glorious things.
Venice has never been painted as she should, never. (1845L.209)

Unable to record more than a fraction of what he wanted,
Ruskin was delighted to discover a new visual aid: the daguerre-
otype: 'Daguerreotypes taken by this vivid sunlight are glorious
things. It is very nearly the same thing as carrying off the palace
itself – every chip of stone and stain is there – and of course there
is no mistake about *proportions*' (1845L.220). On this trip Ruskin
bought ready-made views of the city, but by the time of *The Stones of
Venice* he had his own equipment, operated by his servant (Fig. 14).

Ruskin got into trouble with his father for extending his stay to

Fig. 14: The 'Frenchman', Daguerreotype of the Ca' d'Oro under Restoration, 1845

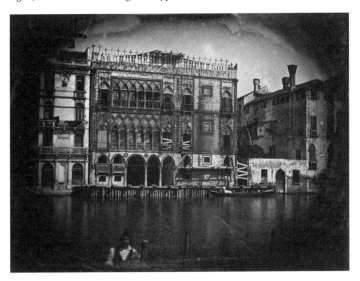

over a month, 10th September – 14th October, and the following year he was back for two weeks in May. 'The rate at which Venice is going', he wrote, 'is about that of a lump of sugar in hot tea' (36.63). His drawings, though still pleasing, became more direct and investigative, and his diary began to fill with architectural notes. He decided to postpone the completion of *Modern Painters*, and began the architectural enquiries that led to *The Seven Lamps of Architecture* in 1849, and then the great study of Venice herself.

⚜ ⚜ ⚜

When Ruskin and Effie, accompanied by Effie's friend Charlotte Ker, arrived at the Hotel Danieli in the first part of November, 1849, Venice was in an even more ruinous state than before. In March 1848 the Venetians had successfully expelled their Austrian occupiers, but then endured a siege of eighteen months. Bombardment, starvation and cholera broke the Venetian resistance, when the Ruskins arrived just two months after the siege had ended, the Austrians were grimly re-asserting their authority, with exile for the leaders and fines for the rest who had remained in the city. Gun batteries menaced the citizens; soldiers were knifed at night. Ruskin and Effie had to negotiate the delicate politics of post-siege Venice, where a ball, as Effie acknowledged, was 'a political measure'.[4] Effie, who spoke German, enjoyed the social life created by the Austrian army, and though he was irked by the Austrian presence, Ruskin did not have a high opinion of Italians, privately calling them 'a nation of malignant idiots' (1845L.194).

His original intention had been to take Effie on to the South of France for her health, but once they arrived in Venice, he found work taking over:

To my consternation, I found that the Venetian antiquaries were not agreed within a century as to the date of the building of the façade of the Ducal Palace, and that nothing was known of any other civil edifice of the early city, except that at some time or other it had been fitted up for somebody's reception, and been thereupon fresh painted. Every date in question was determinable only by internal evidence; and it became necessary for me to examine not only every one of the older palaces, stone by stone, but every fragment throughout the city which afforded any clue to the formation of its styles. (9.3-4)

This he set out to do, measuring, drawing and taking daguerreotypes, creating an invaluable archive of studies and notebooks that enabled him to establish a historical typology of

Fig. 15: John Ruskin, Worksheet 17: Notes on the Ca' d'Oro, 19 November 1849

Fig. 16: John Ruskin, Notebook M: Notes on the Ca' d'Oro, *November 1849*

the development of Venetian Gothic (Figs 15, 16). With the help of the resident British antiquarian, Rawdon Brown, he consulted the written archives in the Ducal Palace, but he also closely examined: 'one document more, to which the Venetian antiquaries never thought of referring, – the masonry of the palace itself' (9.53). We can see Ruskin at work in this letter home:

> Mr Brown recommended me one man as the only one who knew *anything* of those connected with the library of the Ducal Palace. I asked him, among other matters, whether the windows, which have now no tracery in them, ever had any. Never, he said – there was not the slightest trace of it. These windows require ladders to get up to them and are difficult in the opening – so it struck me as quite possible that nobody might have taken the trouble to look. Yesterday I went for this special purpose – got the library steps and opened all the windows, one after another, round the palace. I found the bases of

the shafts of the old tracery – the holes for the bolts which had
fastened it – the marks of its exact diameter on the wall – and
finally, in a window at the back, of which I believe not one of
the people who have written on the place know so much as the
existence, one of its spiral shafts left – capital and all. (9.xxx)

The first fruit of this intensive research, which continued
until they set off for home on 6th March, 1850, was volume one
of *The Stones of Venice* which, apart from its polemical intro-
ductory chapters, was an attempt to lay down a set of universal
principles by which all architecture, not just Venetian, could be
judged. Another visit was necessary before the actual history of
Venice could be begun. So, following the publication of volume
one in March 1851, on 1st September the Ruskins were back in
Venice for another winter.

This time they were on their own apart from a maid and a
man-servant, and instead of staying in a hotel, they took a suite
of rooms on the *piano nobile* of a palazzo on the Grand Canal,
belonging to a Baroness Wetzlar – it is now the Gritti Palace
Hotel (Fig. 17). Sadly, their Austrian friend Lieutenant Paulizza,

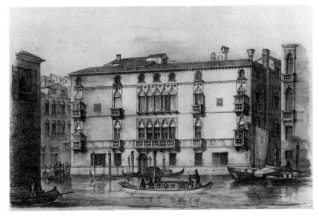

Fig. 17:
Anon.,
The Casa
Wetzlar,
Now the
Gritti Pal-
ace Hotel

who on their first visit acted as a *cavaliere servente* to Effie and was useful to Ruskin in gaining him access to military locations, had died as a result of wounds received during the siege. Becoming residents improved their social status, and they entered the highest society. Ruskin accompanied Effie to military balls in Venice and Verona. Two officers fought a duel over which should dance with her. The only real whiff of scandal, however, came at the end of their stay in June 1852, when they moved briefly into a hotel, and Effie's jewels were stolen. Suspicion fell on an Englishman attached to the Austrian army, and this time Ruskin was challenged to a duel – which he wisely declined.

With his wife entertained, Ruskin was able to enjoy his work. Their routine together suited them both and, though he began to suffer religious doubts at this time, this was probably one of the happiest periods of his life. From his letters to his parents, it seemed as if it was:

> I rise at half past six: am dressed by seven – take a little bit of bread, and read till nine – then we have breakfast punctually: very orderly served – a little marmalade with a silver leafage spoon on a coloured tile at one corner of the table – butter very fresh – in ice – fresh grapes and figs – which I never touch; on one side – peaches on the other – also for ornament chiefly – (I never take them) – a little hot dish, which the cook is bound to furnish every morning – a roast beccafico – or other little tiny kickshaw – before Effie white bread and coffee: Then I read Pope or play myself till 10 – when we have prayers: and Effie reads to me and I draw till eleven: then I write till one when we have lunch: then I go out, and sketch or take notes till three – then row for an hour and a half – come and dress for dinner at 5, play myself till seven – sometimes out on the water again in an idle way:

tea at seven – write or draw till nine – and get ready for bed.
(RLV.22)

He was now writing the second part of *The Stones of Venice*,
and sending it back in instalments to his anxious father in
London. John James was paying for this lavish trip, picking up
the bills for daguerreotypes, Old Master paintings, and plaster
casts of sculptural details of St Mark's and the Ducal Palace.
He was also subsidising the publication of Ruskin's books. The
first two volumes of *Modern Painters* had been gratifyingly well
received, but John's latest works were not meeting the same
response. John James begins to sound like a modern literary
agent:

> You can only be an author of the *present* day by studying
> public taste – and for the *future* by writing what is durable –
> publishers know – Smith says the public expected a more pic-
> torial illustrated Book – full pictures – not fragments – then
> as to Books no *technical* works are popular or sell – Modern
> Painters is the *selling* book.[5]

Ruskin was forced to abandon the expensive project of issu-
ing large-scale illustrations to *The Stones of Venice* in a separate
part-publication, *Examples of the Architecture of Venice*. Many of
the technical details he had so thoroughly researched had to be
cut out of his text. But over one thing he was firm. There was an
important connection between *The Stones of Venice* and his still
unfinished *Modern Painters*. In art, the Renaissance led to the
school of classical landscape to which Turner was so superior;
in history, it led to the fall of Venice.

He argued that once the unity of the Venetian church and
state had been broken at the beginning of the 15th century, the
luxury and Paganism of the Renaissance was able to flourish

through the decadence of Gothic art and architecture. The Venetians turned to the architecture of Andrea Palladio and the paintings of Titian and Veronese when the Gothic flower had been corrupted by an excessive focus on its own perfection. At first the painters of the Renaissance, such as Tintoretto, had had a healthy effect, but eventually the Renaissance sank into the luxurious enjoyment of worldly pleasure. This was only one small sign of a general change in Europe which led to the curative, but inartistic, Reformation in England, and the revival of artistic but irreligious classicism in Italy.

The Stones of Venice is therefore an argument in favour of Gothic architecture at the moment of its purity, and because he traced the history of the Venetian state from its first buildings on the island of Torcello, Ruskin wrote about the Byzantine architecture that had preceded the Gothic. In doing so he was not only helping to change public taste in favour of Gothic architecture, he was also effecting a shift of taste within the Gothic Revival as a whole, by drawing attention to the earlier Byzantine buildings, until then generally dismissed as immature and crude.

But, as we saw in Chapter IV, he was also going beyond the limits of art criticism, by linking art to the society that produced it and trying to say something about society itself, and modern society at that, in 'The Nature of Gothic'. As the opening sentence of volume one of *The Stones* made clear, the fall of Venice, like the fall of Tyre, was a warning to modern Britain.

△ △ △

The completion of *The Stones of Venice* with the publication of the second and third volumes in July and October 1853 was

a significant achievement. It was the only large-scale work in which Ruskin carried out what at the beginning he said he would do, even if editorial pressure from his father made him thrust much of his research material – what he called the 'dryer or bonier parts, in which the strength of the book consists' (RLV.119) – into a series of unwieldy appendixes. Seventeen years would pass before he returned to Venice. In 1854 Effie left him for the Pre-Raphaelite that Ruskin had championed, John Everett Millais, and successfully sued for an annulment of her marriage on the grounds of Ruskin's inability to consummate it. Ruskin got on with *Modern Painters*.

Venice was not forgotten. In 1859 he wrote to his new American friend, Charles Eliot Norton, explaining that he had been through so much 'hard, dry, mechanical toil' in Venice, 'that I quite lost, before I left it, the charm of the place. Analysis is an abominable business' (9.xxvii). But, at the end of a long and amusing letter about the pains of research in Venice, he assured Norton: 'I have got all the right feeling back now, however; and hope to write a word or two about Venice yet, when I have got the mouldings well out of my head – and the mud' (9.xxix). Venice has a special place in the closing chapters of the fifth and final volume of *Modern Painters*, where the Venice that the young Giorgione saw at the close of the 15th century becomes an emblem of beauty – and good government:

> A city of marble, did I say? Nay, rather a golden city, paved with emerald. For truly every pinnacle and turret glanced or glowed, overlaid with gold, or bossed with jasper. Beneath, the unsullied sea drew in deep breathing, to and fro, its eddies of green wave. Deep-hearted, majestic, terrible as the sea, – the men of Venice moved in sway of power and war; pure as her pillars of alabaster, stood her mothers

and maidens; from foot to brow, all noble, walked her knights; the low bronzed gleaming of sea-rusted armour shot angrily under their blood-red mantle-folds. Fearless, faithful, patient, impenetrable, implacable, – every word a fate – sate her senate. In hope and honour, lulled by flowing of wave around their isles of sacred sand, each with his name written and the cross graved at his side, lay her dead. A wonderful piece of world. Rather, itself a world. It lay along the face of the waters, no larger, as its captains saw it from their masts at evening, than a bar of sunset that could not pass away; but for its power, it must have seemed to them as if they were sailing in the expanse of heaven, and this a great planet, whose orient edge widened through the ether. A world from which all ignoble care and petty thoughts were banished, with all the common and poor elements of life. (7.374-5)

During the 1860s Ruskin turned to social writings that might help to make that vision real. He considered re-visiting Venice in 1863, and in 1864 made enquiries about the possibility of establishing 'a little bachelor's den' somewhere on the Grand Canal (36.440). He would have visited in 1866 but for the death of one his companions on the journey out, and the fighting in Italy that, in spite of ending in an Austrian victory, led to Austria's cession of Venice and the Veneto to the new United Italy.

When, in 1869, Ruskin finally did return to Venice he feared that the memories of the happy times he had spent there as a younger man would depress him. That year Verona was his main object of study, and he made only flying visits to Venice – by train. He was relieved to find: 'this Venice of mine is far less injured than I feared, and much of it, just as it was, and I have more pleasure in it than I expected'.[6] Part of the pleasure came

from his 'discovery' of the work of Vittore Carpaccio, whose cycle of paintings of the life of St Ursula in the Accademia Gallery would acquire profound personal significance (Pl. 8). In 1870 he decided to make a proper visit.

Ruskin's father had died in 1864, leaving him a large fortune, so he was able to travel in style. In 1869 there had been official recognition of his work when he was elected as the first Slade Professor of Fine Art at Oxford, so it was as 'the Professor' that he was now travelling. With him were three ladies: his cousin and companion to his mother, Joan Agnew, Joan's friend Constance Hilliard and Constance's mother Mrs J. C. Hilliard. In addition to a maid and valet, Ruskin had brought his head gardener, David Downs, in order to show him the horticulture of Italy. They stayed at the Hotel Danieli from 20th May to 20th June. There was serious work to be done, as Ruskin wanted to study Carpaccio and Tintoretto in preparation for his Oxford lectures. In the Scuola di San Rocco he had a scaffold built so that he could copy from Tintoretto's *Presentation in the Temple*. None the less he and the ladies were happy to behave like tourists, viewing the city by moonlight and, in Ruskin's case, drawing some of its more familiar sights.

What Ruskin was not happy about in these later visits were all the other tourists who, partly inspired by his writing, now flocked to the city:

> I can't write this morning, because of the accursed whistling of the dirty steam-engine of the omnibus for Lido, waiting at the quay of the Ducal Palace for the dirty population of Venice, which is now neither fish nor flesh, neither noble nor fisherman; – cannot afford to be rowed, nor has strength nor sense enough to row itself; but smokes and spits up and down the piazzetta all day, and gets itself dragged by a screaming

kettle to Lido next morning, to sea-bathe itself into capacity
for more tobacco. (27.328)

This public anger was matched by a private sadness; he wrote
to his mother:

> I go out and have my cup of coffee in the sunshine, and
> then sit in my boat, as I used to do with Harding, and
> draw, not as I used to do with delight, for I know too well
> now what drawing should be, but with a pleasant sense that
> other people will have real pleasure in what I am doing. But
> I don't think I ever heard of any one who so mourned over
> his departed youth. (20.li)

One reason for this sadness made itself felt very strongly
when Ruskin was next in Venice, in June and July 1872. The
Professor's party was even bigger, for Joan Agnew now had a

Fig. 18: Anon., The Ruskin Party in Venice, *1872*

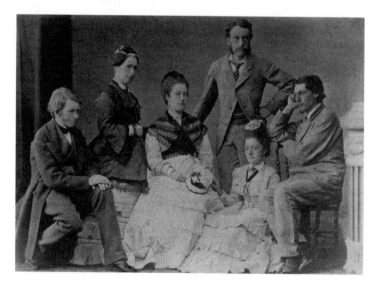

husband, the minor landscape painter and son of Keats's doctor, Arthur Severn, and besides the Hilliards Ruskin had brought an artist assistant, Albert Goodwin (Fig. 18). Venice was meant to be the triumphal climax of a four-month continental tour, but the visit was spoiled by quarrels in the party.

The cause of the tension was Ruskin's love for Rose La Touche (Pl. 9). In 1872, just as Ruskin was settling down to work in Venice, news came from two of Ruskin's go-betweens with Rose, Mr and Mrs George Macdonald, that Rose was in London and wanted to see him. A telegram calling him home reached him in the Scuola di San Giorgio degli Schiavoni, where he was studying Carpaccio's cycle of paintings of the life of St George. Ruskin hesitated, and tried to persuade the Macdonalds to bring Rose to meet him in Switzerland, saying he could not leave his friends in the lurch. There was a dispute with Joan and Arthur Severn, who left Venice ahead of him; then Ruskin dropped his work in Venice and dashed back to London, where there was another short, happy interlude with Rose, before another set of misunderstandings.

Rose La Touche died, insane, in May 1875, but Ruskin's obsession with her went beyond the grave. He had already dabbled in spiritualism, and in December 1875 he was convinced by a medium that Rose was trying to get in touch with him. This experience helped him to regain his belief in an after-life, but it did not bring Rose back. In 1876, exhausted and frustrated by his work at Oxford, he took leave of absence in order to spend the whole winter in Venice.

△ △ △

The reason for this journey was that Ruskin was planning to

revise *The Stones of Venice*. But he also had Carpaccio's painting, *The Dream of St Ursula* taken down from the walls of the Accademia Gallery and placed in a private room, where he began a series of studies (Pl. 8). As he worked intensely on these in the weeks running up to Christmas and the first anniversary of his 'teachings' from the dead Rose, he became convinced that she was trying to get in touch with him again, through the medium of St Ursula. Carpaccio's St Ursula, like Ruskin's Rose, had died a virgin, having told her betrothed, an English prince and pagan, to wait three years before their marriage. Ruskin wrote to his cousin Joan: 'There she lies, so real, that when the room's quite quiet – I am afraid of waking her! How little one believes things, really! Suppose there is a real St Ursula, di ma, – taking care of somebody else, asleep, for me?'[7]

Already in a highly nervous state, a series of chance events encouraged him to believe that what he was praying for, that Rose would send him a sign, was happening. In Carpaccio's painting two plants stand on the windowsill of St Ursula's sleeping chamber, on the right a dianthus, on the left vervain. First a specimen of vervain, and then a pot of dianthus was sent to Ruskin, quite independently, by friends. On Christmas Eve a letter came from Joan containing one from Rose's mother, which convinced him that he must forgive Mrs La Touche for her treatment of him.

On Christmas Day a gift of shells that Ruskin associated with Mr La Touche convinced him that he too must be forgiven. He felt impelled to pray in St Mark's and when visiting the house of his gondolier, the daughter of the house with her baby made him think of the Virgin and child. On leaving he went to the Scuola degli Schiavoni where he found another image of a sprig of vervain, this time in Carpaccio's *The Baptism of the*

Sultan (depicting another conversion of an unbeliever). His next destination was the Armenian monastery on the island of San Lazzaro, and he went in search of a gondolier, only to be confronted by 'a horrid monster with inflamed eyes, as red as coals'.[8] Fleeing this image of the Devil he engaged a different gondolier and they started to row towards San Lazzaro, but by now the evening fog had come down and they got lost, nearly mistaking the madhouse on the island of San Servolo for the Armenians'. Later that night he got lost for a second time in the fog on the water. Ruskin continued in a confused state, convinced he was receiving messages from Rose, until New Year's Day and then, on 3rd January, he told Joan: 'It ended nobly, yesterday at eleven in the morning – and since then, my ordinary life has begun again. Rosie has said nothing whatever today; and little Bear [Ursula] contented herself with looking more beautiful and in more perfect rest, than ever yet, but was silent, like Rose'.[9]

There is no doubt that Ruskin came very close to a complete mental breakdown, but the experience left him exalted. He told Joan that he was going to begin his new version of *The Stones of Venice*. This turned out to be a two volume 'Travellers' Edition'. He also found time to write a personal guide to his favourite paintings in the Accademia Gallery, and a loose collection of essays that he gradually assembled into an idiosyncratic guide-book, *St Mark's Rest*. He also made a remarkable contribution to the preservation of one of Venice's most important buildings.

<p style="text-align:center">⚬ ⚬ ⚬</p>

Like most ancient structures that were in daily use, St Mark's had been in a constant state of repair throughout its existence. This had often led to embellishment, but in the 19th century an

insensitive series of repairs began. St Mark's is a brick structure cased in sheets of marble, and from the 1840s onwards post-medieval ideas of harmony and symmetry began to be imposed on the variegated colours of the exterior. First the north side was largely refaced in grey Italian marble, and in places stucco. Inside the main body of the church, parts of the old *tesseræ* were lifted to level the floor, and then replaced with modern copies. After the Austrians left in 1866 the renovations continued, and this time there were substantial alterations to the south of the building, where the portico of the west façade was threatening to split away from the building. More grey marble was used, columns were moved, and acid used to clean them, which destroyed their protective patina. By 1876 new grey marble was creeping along the southern side of the façade, for the intention was to 'straighten' the whole of the west front (Pl. 20).

While many Venetians saw this as no more than necessary 'restoration', there was criticism among Venetian artists, some of whom Ruskin knew because he employed them to make copies of works he valued. Thus in December 1876 he was introduced to the thirty-year-old Count Alvise Zorzi, descended from a patrician Venetian family, who studied painting at the Accademia, and knew Ruskin's writing. Zorzi had written a book-length protest against the restoration of St Mark's, but lacked the money to publish it. Ruskin not only provided the money, but also a polemical introduction to the book describing what was being done as a 'catastrophe' (24.407). The bright red paperback, printed in Venice, *Osservationi interno ai ristauri interni ed esterni della Basilica di San Marco*, appeared on St Mark's Day, 25th April 1877, just under a month before Ruskin left to return to England.

It is a great pity that Zorzi's text has not yet been translated

into English, for, influenced by Ruskin, it anticipates many of the principles that now apply to architectural restoration. But it did the trick in Venice. Work was halted, enquiries were held, and in 1880 the decision was taken to return St Mark's as far as possible to its previous appearance. By this time Ruskin and Zorzi's local protest has been swept up in the international outcry launched by William Morris and his Society for the Protection of Ancient Buildings. This made much more noise than Ruskin's had done, but Morris was embarrassed to discover that the planned works had already been halted. Although on the committee of the SPAB, Ruskin took no personal part in the Morris protest, but he did issue a circular in 1879, appealing for funds to help commission artists to make copies of the mosaics in St Mark's that he feared were threatened with restoration. Many of these copies ended up in the collection of the Guild of St George.

One reason why Ruskin was not directly involved in the SPAB protest was that in January 1878 his mind had given way completely for the first time. There had been a partial repeat of the 'teachings' of 1876 at Christmas 1877, but shortly afterwards, at Brantwood, his home in the Lake District, he lost his reason for almost three months – only to make a remarkable recovery. He told his friend Norton in July 1878: 'I went crazy about St Ursula and the other saints – chiefly young-lady saints' (LN.412). One consequence of this illness was that he was unable to appear at the libel case mounted against him by the artist James McNeil Whistler in November 1878. He lost the case, and used it as a reason for resigning his Professorship at Oxford. Further attacks were to follow.

⚜ ⚜ ⚜

Ruskin saw Venice for the last time in October 1888. He had quarrelled with his cousin, Joan Severn, who, after his mother died in 1871 at the age of ninety, became increasingly his carer. He had fallen in love with a Rose-substitute, the young art student Kathleen Olander. Possibly to get him out of the way, Joan encouraged him to make another continental journey, escorted by a servant and a twenty-old architectural student, Detmar Blow. Over the next five months Ruskin became increasingly confused and unhappy, especially after Kathleen Olander ended their communications. By the time he reached Venice he was obviously ill and would have to leave. He wrote to the Venetian copyist Angelo Allessandri: 'I am in more pain at going away than I can tell you, but there have been symptoms of illness threatening me now for some time which I cannot conquer – but by getting away from the elements of imagination which haunt me here' (37.609). His final diary entries on the journey tell their own sad story:

> September 28th. Friday Among the kindest people in the world –
>
> September 30th. Sunday – but I don't know what is going to become of me.
>
> October 10th. VENICE. And still less here. (D3.1150)

Ruskin returned to Brantwood, and after another attack in 1889 he remained there, gradually falling silent, until his death in January 1900.

<p align="center">⚜ ⚜ ⚜</p>

Almost single-handed, Ruskin changed the perception of Venice. In the 1830s it was seen through the prism of *la leggenda nera*,

the dark myth of an oppressive and secretive government with its own Inquisition, whose intricate plots ran through the maze of dark canals, and lurked between the arches of mysterious palaces. Her claim to be queen of the sea was countered by her reputation as courtesan of the world. The myth was an old one, but it was reinforced by the Napoleonic historian Pierre Daru, whose *Histoire de la République de Venise* (1819) set out to justify Napoleon's destruction of the city's ancient oligarchic constitution.[10] Byron added to the myth with his Venetian poems and plays. Ruskin read Daru, and loved Byron, but gradually saw through these mystifications of splendour and decay, instead transforming Venice into 'the Paradise of cities'. Similarly, the city's Gothic palaces were no longer savage fantasies but expressions of civic virtue, and St Mark's no longer a barbarous heap of looted architectural salvage but a gleaming jewel.

Beyond the unique qualities of 'a glorious city in the sea', where each individual building seemed to contain a work of art, to be a work of art, and to take part in a greater work of art, Ruskin discovered in Venice a special synthesis of all the forces that he believed were at work in art, religion and society. He could see this interaction in every possible mode: the city was set between land and sea and could not exist as it did if it were completely part of either. Its geographical location was poised between the cold north and the warm south, and the tides of Venice had their parallel in the ebb and flow of eastern and western influence. That ebb and flow caused a confluence of architectural styles. Venice was: 'the field of contest between the three pre-eminent architectures of the world: each architecture expressing a condition of religion; each an erroneous condition, yet necessary to the correction of the others, and corrected by them' (9.38).

In whatever mode, the synthesis evolved within a concentrated space, a few water-isolated square miles. That the *Stones of Venice* is the most entire of Ruskin's major works is a result of the physical unity of his subject; and, because from 1849 to 1853 he spent the longest period of concentration on a single topic in his life, unity of place coincided with unity of study.

His father, for one, complained that this study concentrated too much on details, that his drawings represented only fragments. Yet it was in the details, the carving of a cusp, the turning of a crocket, the finesse of a finial, that Ruskin found the truth he could not find in the chronicles. In *The Stones of Venice* he began to develop a critical method and literary form in which the part stood for the whole. J. B. Bullen has called this Ruskin's synecdochic method of cultural history. Ruskin, Bullen writes:

> Locates the European-wide conflict of interests at the point of maximum stress – Venice – and he does so in such a way that Venice becomes the 'arena' of the contending forces. Venice, Ruskin claims in a mood of interpretative extravagance, is 'the source of the Renaissance' (9.47), and it is 'the centre of the Renaissance system' (11.82). But that is not all. Ruskin further refines his 'history' away from that of the political historian. Inevitably the history of politics is propelled forward by time and events; Ruskin deals instead with the much slower time of the development of artistic style. Not only are the contending forces located in a single place, Venice; they are focused, as in a burning glass, within a single art – architecture.[11]

As an example, consider Ruskin's description of the Ducal Palace as 'the central building of the world' (9.38). In his minute examinations of the capitals of the Ducal Palace the capital

stood for the building, the building for Venice – and Venice for history. But this synecdoche is also synthesis, for what Ruskin wrote was: 'The Ducal palace of Venice contains the three elements in exactly equal proportions – the Roman, the Lombard, and Arab. It is the central building of the world' (9.38).

Venice became a stage for the interaction of forces that played out an archetypal drama: the tragedy of rise, and triumph and decline and fall:

> Nations first manifest themselves as a pure and beautiful animal race, with intense energy and imagination. They live lives of hardship by choice, and by grand instinct of manly discipline: they become fierce and irresistible soldiers; the nation is always its own army, and their king or chief head of government, is always their first soldier ... Then, after their great military period, comes the domestic period; in which, without betraying the discipline of war, they add to their great soldiership the delights and possessions of a delicate and tender home-life: and then, for all nations, is the time of their perfect art, which is the fruit, the evidence, the reward of their national ideal of character, developed by the finished care of the occupations of peace ... But always, hitherto, after the great period, has followed the days of luxury, and pursuit of the arts for pleasure only. And all has so ended. (19.391-2)

Ruskin saw this archetype at work in all great civilizations, but, as explored in Chapter XVI, in Venice there stood behind it another, even more enduring myth, that of Paradise, and man's fall.

This allegory was supported by Ruskin's training as an Evangelical, which taught him to read both words and the world as 'types' that were both symbolic and real. Events are historically

true, but also signs of what has happened and things to come. Venice had fallen, but the possibility of redemption existed if it would recognise its fallen nature. St Mark's is 'a type of the Redeemed Church of God' (10.140).

There were other Paradises in Ruskin's life: Chamonix, Geneva and, in the closing pages of *Præterita*, he returns to the childhood garden of Herne Hill. This modulates into the garden he had constructed at the family's second home, on Denmark Hill, where Rose had once been. Rose La Touche's presence in this personal Eden suggests another level of interpretation, the psychosexual. There are moving parallels between their relationship and the story of St Ursula and her pagan prince. There is a tradition of reading Ruskin's works exclusively in terms of his tortured emotional life, but while the resonances are powerful, the approach becomes limiting, reducing great literature to mere autobiography.

Venice's double identity as virgin and whore might lend itself to such a reading, but that does not mean that the city is a nightmare version of Effie. Venice's own myth, elaborated over centuries of civic patronage is more powerful than any Ruskinian in-reading. On the other hand, we cannot pretend that Ruskin's version of Venice is objective history. It is a re-imagining of the city that, through his writing, becomes a redemption, and through his architectural research, a rediscovery.

☙ ☙ ☙

The rise and fall of Venice was a true story from which lessons were to be directly drawn, but it was also a figure with a much wider significance: 'these two histories of the religion and policy of Venice are only intense abstracts of the same course of

thought and events in every nation in Europe' (24.258). Venice was part of the continuity of Europe, reaching back to the civilization of Tyre, the ancient city which the Venetian navy had helped to destroy in the 12th century, and on whose dominions Venetian power and culture were partly built. It also reached forward to the great naval power of Ruskin's own day, England.

Ruskin's ideas of what lessons could be drawn from the fall of Venice were modified in the course of his life. At first confined to the dogmatic Evangelical Protestantism of his parents, he saw resistance to the political power of Roman Catholicism as a principal virtue of Venice. After he had lost his faith in the 1860s, and then re-established it on a broader plane, he recognized the 'degree in which all my early work on Venetian history was paralyzed by this petulance of sectarian egotism', and added, with the wisdom of age: 'there are few of the errors against which I have to warn my readers, into which I have not myself at some time fallen' (24.260). Sectarian or not, Ruskin never changed his view that there should be consistency between private morality and public virtue, and that the moment that individual self-discipline was surrendered to luxury – especially in art – then national strength was attacked by a fatal weakness.

Study of the conditions under which art lost its moral strength led Ruskin to consider the conditions under which it was created, and to argue that here, too, there must be a consistency of attitude between one man and another, from the humblest worker to the highest artist, and his patron. Each must have his place and recognition of his status as a man. (He was at one with his age in according moral superiority, but a lesser social status, to women.) The parallel with England was clear, for the Industrial Revolution had reduced the mass of men to the status of a machine.

Ruskin gradually laid greater and greater emphasis on this aspect of *The Stones of Venice*. The government of Venice became his ideal: an elected monarchy governing a benevolent and courageous aristocracy, who would in turn supervise the activities of a harmonious community of soldiers, merchants, farmers, fisherman and craftsmen, all of whom found their collective expression in the artistic glories of the state. Power and consent would flow back and forth from the highest to the lowest, in an organic relation as natural as Venice's with the sea.

The backward-looking nature of Ruskin's criticism of contemporary society does not make it any the less biting. And as the conditions of the 19th century appeared to worsen, and Ruskin's personal disappointments multiplied, the dialogue between past and present became increasingly bitter. So Carpaccio's painting in the Accademia of the arrival of the English ambassadors to arrange the marriage of St Ursula dissolves into a black picture of the present day:

> The orderliness and freshness of a Venetian campo in the great times; garden and city you see mingled inseparably, the wild strawberry growing at the steps of the king's court of justice, and their marble sharp and bright out of the turf. Clean everything, and pure; – no cigars in anybody's poisoned mouth – no voiding of perpetual excrement of saliva on the precious marble or living flowers. (24.176-7)

In the end, as the tourists reading Ruskin's guide to the Accademia were forced to recognize, Venice was herself subject to the ruinous pressure of the society to which she was supposed to be the proud contrast. Venice lived in Ruskin's imagination, while the city lived off the trope of death in Venice.

There had been something melancholy yet noble about the

decaying Venice of Ruskin's boyhood – Byron's Venice, when the city seemed to be in a natural process of decline that would allow the buildings slowly to slip into the water, and the land to return to the state of the marshy islands where the founders of Venice had first taken refuge. The Venice of Ruskin's old age was one of iron bridges and steam whistles, the buildings destroyed by the act of propping them up. When he traced the process of collapse in society, not just in Venice, but in England, France and anywhere where wealth and pleasure supplanted faith and nobility, Ruskin placed the final stage at 'the reign of St Petroleum instead of St Peter' (24.262).

As the monstrous cruise ships blot out the Ducal Palace and the Salute, what words would Ruskin find today?

Based on the introduction to the catalogue of Ruskin and Venice, *an exhibition at the J. B. Speed Art Museum, Louisville, Kentucky in 1978, and published by Thames and Hudson.*

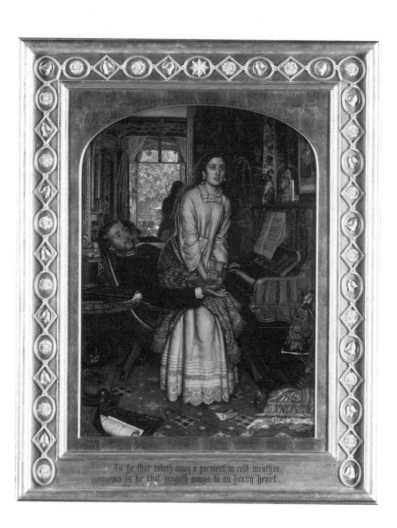

As he that taketh away a garment in cold weather,
so is he that singeth songs to an heavy heart.

CHAPTER VI

THE AWAKENING CONSCIENCE: RUSKIN AND HOLMAN HUNT

୧ଚ

And now, reader, look round this English room of yours, about which you have been proud so often, because the work of it was so good and strong, and the ornaments of it so finished. Examine again all those accurate mouldings, and perfect polishings, and unerring adjustments of the seasoned wood and tempered steel. Many a time you have exulted over them, and thought how great England was, because her slightest work was done so thoroughly. Alas! if read rightly, these perfectnesses are signs of a slavery in our England a thousand times more bitter and more degrading than that of the scourged African, or helot Greek. (10.193)

The second volume of *The Stones of Venice*, from which this passage is taken, was published on 28th July 1853. The following month Ruskin's greatest admirer among the Pre-Raphaelite Brotherhood, William Holman Hunt, began work on a painting of an actual English room, whose appearance, and whose subject, *The Awakening Conscience* (Pl. 13, Fig. 19), strike a powerful resonance with Ruskin's imagined one.

The painting depicts the back parlour of Woodbine Villa, 7 Alpha Place, in North West London. Discussions of the work customarily describe Alpha Place as being in St John's Wood, one of the new districts being developed to accommodate

Opposite: Fig. 19: William Holman Hunt, The Awakening Conscience, *1853*

London's burgeoning *bourgeosie*. In fact, it is just across the border with the rather less salubrious working-class district of Kilburn, where Woodbine Villa's owner may have found it easier to ply her trade. The house belonged to a Mrs Ford, who rented it out as a *maison de convenance* – Hunt himself described it as a 'Courtesan's house'.[1] Alpha Place is still there, but Woodbine Villa was demolished in post-war slum clearance.

Hunt had rented the room for moral, rather than immoral, purposes. He wished to portray the moment when 'the still small voice'[2] of conscience is heard by a young woman, even as she rises, *en déshabille*, from the lap of her lover, whose gloved left hand may conceal a wedding ring, while her exposed one bears none. The moment of revelation is symbolised by the single star at the head of the frame Hunt designed in 1854 for the completed picture, supported by bells and marigolds, emblems of warning and sorrow. A slightly shortened version of Proverbs 25:20: 'As he that taketh away a garment in cold weather, so is he that singeth songs to an heavy heart', emphasises the man's chilling cruelty. Lest there be any doubt about the seriousness of Hunt's intentions, recall that this was painted as a companion piece to *The Light of the World* (Pl. 14) begun in 1851, where the figure of Christ knocks at the stubbornly closed door of the human heart. Although this work is allegorically timeless, and its companion is aggressively contemporary, they were intended to be seen as a pair: 'each being in a different way a representation of the Spirit of Righteousness to a sinner'.[3] Both were shown at the Royal Academy summer exhibition in 1854, supported by further Biblical citations in the catalogue, although Hunt's intended link was weakened because they were not hung in the same room.

Neither painting was well received. *The Light of the World*,

discussed at greater length in Chapter XV, was criticised for making a spiritual ideal so literally real; *The Awakening Conscience* appears to have been too challenging in its subject matter for mid-Victorian public decorum. Critics read it as sensational rather than spiritual; *The Illustrated London News* made a dismissive joke, saying the work had become known as 'the loose lodging'.[4] This aspect of the conception had been a concern to Hunt's friends. The painter and nonsense-poet Edward Lear had warned him that the idea might be misunderstood when he saw Hunt's initial design in January 1853 – as indeed it was. It was only after his mentor, the established painter Augustus Egg, had encouraged Hunt, and persuaded the patron Thomas Fairburn to say he would take the picture, that work began. There was also discussion about the title. Hunt's first thought was simply *A*, or *The 'still small voice'*, and it was another patron, Thomas Combe, who suggested the final title, although when shown in Birmingham in 1856 it became *The Awakened Conscience*, and Hunt uses that title in his memoirs.

'A' is almost certainly a reference to Hunt's model, Annie Miller, a working-class girl whom he had picked up in a pub at the age of 15, and whose education he was trying to improve, in the eventually frustrated hope of being able to marry her. Their relationship was one of propriety, however, for Hunt was still a virgin in 1853. The book lying on the table has been identified as *The Origin and Progress of the Art of Writing*, presumably a reference to Miller's studies. It has been suggested that the man may be Augustus Egg, but it is also possible that professional models were used.[5]

Because the 27-year-old Hunt had left England for the Holy Land in January 1854, he was in no position to defend the two works for himself against their critical reception when they went on show at the Royal Academy at the end of April. Ruskin, however, decided to repeat an exercise he had first carried out in May 1851. Then, his two letters to *The Times* in defence of the Young British Artists of his day, the Pre-Raphaelite Brotherhood, helped to transform their position. In 1851 the Royal Academy had shown works by Holman Hunt, John Everett Millais and Charles Collins. Ruskin – with reservations – defended them all. In 1854 only Collins and Hunt were showing, and once again Ruskin wrote two letters to *The Times*, the first concentrating on *The Light of the World*, the second on *The Awakening Conscience*.

Ruskin's second letter, published on 25th May 1854, expresses astonishment at the incomprehension with which *The Awakening Conscience* had been greeted: 'People gaze at it in a blank wonder, and leave it hopelessly; so that, though it is almost an insult to the painter to explain his thoughts in this instance, I cannot persuade myself to leave it thus misunderstood' (12.333). His explanation sounds remarkable echoes of the passage from *The Stones of Venice*:

> There is not a single object in all that room – common, modern, vulgar (in the vulgar sense, as it may be), but it becomes tragical, if rightly read. That furniture so carefully painted, even to the last vein of the rosewood – is there nothing to be learnt from that terrible lustre of it, from its fatal newness; nothing that has the old thoughts of home upon it, or that is ever to become a part of home? Those embossed books, vain and useless – they also new – marked with no happy wearing of beloved leaves; the torn and dying bird upon the floor; the gilded tapestry, with the fowls of

the air feeding on the ripened corn; the picture above the
fireplace, with its single drooping figure – the woman taken
in adultery; nay, the very hem of the girl's dress, at which the
painter has laboured so closely, has story in it, as we think
how soon its pure whiteness may be soiled with dust and
rain, her outcast feet failing in the street; and the fair garden
flowers, seen in the reflected sunshine of the mirror, – these
also have their language. (12.334-5)

It is hard to ignore the sexual politics of this picture, and
Ruskin did not wish us to do so. He is not well known for
addressing sexual matters, but here he is explicit. You could put
a price on every object in this English room – including the girl.
It was this that had produced popular disapproval: 'a very dark
and repulsive side of modern life' declared the *Athenæum*.[6] But
Ruskin also suggested that the contemporary public did not
appreciate the painting because the pictorial conventions of the
day meant that: 'to many persons the careful rendering of the
inferior details in this picture cannot but be at first offensive, as
calling their attention away from the principal subject' (12.334). In
other words, the overall detail of the painting, so firmly emphasis-
ing 'the fatal newness' of the furnishings, was in itself an offence
to eyes accustomed, ever since the Royal Academy lectures of Sir
Joshua Reynolds, to having their viewing done for them.

Ruskin, however, makes the 'trivial objects' in the room the
basis of his defence. Because he was writing from memory – he
was on his way to Switzerland – he misread some of the details,
but his use of expressions such as 'rightly read', 'story' and
'language' shows that, as we saw in relation to architecture in
the previous chapter, he responded to the painting as a text – a
moral text supported by two Biblical quotations in the Academy
catalogue and one inscribed on the frame. As an Evangelical

accustomed to reading both the Bible and God's creation, the natural world, in terms of symbolic types, Ruskin responded to the symbolism that underlies the apparent realism of Hunt's picture, which, Ruskin wrote, meets 'full in the front the moral evil of the age in which it is painted' (12.335) – meaning prostitution. The suggestive reference to slavery in the passage from *The Stones of Venice* quoted earlier was part of his argument that modern manufacturing processes enslaved the worker. Here, he is explicitly alluding to the white slave trade. While the pairing with *The Light of the World* suggests redemption, Ruskin asks for our pity as – in his reading – the woman foresees her imminent fall.

Ruskin had private reasons for this reading, which will be revealed later, but whether right or wrong, Hunt was happy to reproduce Ruskin's interpretation in full in his memoirs. And we find there an important connection to another, much earlier, interior, and another moment of revelation – Tintoretto's *Annunciation* in the Scuola di San Rocco in Venice (Pl. 15). Hunt would not have seen this picture when he painted *The Awakening Conscience*, but he had read Ruskin's description of it in the second volume of *Modern Painters*. There, Ruskin writes that when the viewer examines its composition:

> He will find the whole symmetry of it depending on a narrow line of light, the edge of a carpenter's square, which connects these unused tools with an object at the top of the brick-work, a white stone, four square, the corner stone of the old edifice, the base of its supporting column. This, I think explains the typical *[That is to say, typological]* character of the whole. The ruined house is the Jewish dispensation; that obscurely arising in the dawning of the sky is the Christian; but the corner-stone of the old building remains, though

the builder's tools lie idle beside it, and the stone which the builders refused is become the Headstone of the Corner. (4.264-5)

Hunt knew this description, because in his memoirs he describes reading it to Millais in his studio, and it clearly had an influence on his practice.[7] *The Awakening Conscience* is an exercise in the symbolic realism that Ruskin discovers in Tintoretto, and Ruskin returned the compliment, by making a profound critical reading of Hunt's naturalistic iconography.

⚜ ⚜ ⚜

There is, however, one aspect of the picture that we are no longer able to see: the central motif of light breaking across the face of the young woman. Ruskin describes the 'lost' girl's face as:

Rent from its beauty into sudden horror; the lips half open, indistinct in their purple quivering; the teeth set hard; the eyes filled with the fearful light of futurity, and with tears of ancient days. (12.334)

If we do not *quite* see this in the picture, it is because in 1856 Thomas Fairbairn, who had paid 350 guineas for it, found her expression too painful to live with, and got Hunt to repaint the face. (The painting was also retouched by Hunt in 1857, 1864, 1879 and 1886.)

Ruskin drew attention to the literary and musical as well as visual resonances in Hunt's narrative. Richard Leppert has argued that since music stimulates the emotions, its presence serves as an erotic signifier – although he also points out that it would be difficult to play the piano in an easy chair.[8] Within the picture, music asserts the textuality of the supporting Biblical

citations in the Academy catalogue and on the frame. The music on the piano is Thomas Moore's 'Oft in the Stilly Night', the music on the floor is a nod to Hunt's friend Edward Lear, whose setting of Tennyson's 'Tears, Idle Tears' was published in October 1853. The emotions they seem intended to provoke are not sensuality, but sadness and regret.

Further instances of the moral symbolism in details that Ruskin does not highlight are the convolvulus in the vase on the piano, implying entanglement; the skein of embroidery caught by a ray of sunlight on the bottom right, implying the unravelling of the relationship; and the discarded glove, pointing to the woman's future. Note also the French clock on the mantelpiece, lent by Augustus Egg. The figures decorating the clock are Chastity binding Cupid, the opposite of what has happened in this room.

There is, however, one detail that Ruskin got wrong: the subject of the engraving above the piano. It was a revealing mistake that provoked a scandalised response in certain quarters. Ruskin describes it as 'the picture above the fireplace, with its

Fig. 20: Samuel Bellin,
after Frank Stone,
Cross Purposes, *1840*

single drooping figure – the woman taken in adultery' (12.334). It is not above the fireplace, but, more importantly, it is not the Biblical figure of the woman taken in adultery – the woman, significantly, that Christ forgives. It is very hard to see what it is, but in 1865, in a pamphlet on *The Light of the World*, Hunt revealed that it was Frank Stone's popular engraving, *Cross Purposes* (Fig. 20).[9] Stone was an Associate Royal Academician who doubled as an art critic, and who strongly opposed the Pre-Raphaelites, so this was a humorous touch on Hunt's part. In a small revenge, he places Stone's work within an interior whose vulgarity, as Ruskin suggests, is a form of moral criticism.

⚜ ⚜ ⚜

Ruskin's tragic view – that the adulterous woman is destined for a life on the streets – differs from 20th century readings by Kate Flint and Judith Bronkhurst. Flint thinks him too pessimistic,[10] while Bronkhurst writes that 'redemption is possible', drawing attention to the encounter between the cat and the bird that Ruskin believes 'is torn and dying on the floor' (12.335) at the bottom left of the picture. Bronkhurst reads this differently, explaining: 'The cat is a straightforward type of the seducer, but the bird it has been tormenting has escaped'.[11] Viewers will have to make up their own minds, but it does not look as though the bird will get very far.

There is one aspect of the composition that Ruskin mentions only in passing, but which helps to explain the power of this picture: 'the reflected sunshine of the mirror' (12.335). It is the mirror that gives us the key to a painting that its original viewers felt baffled and offended by. There are in fact three mirrors. A second is reflected in the first, above the lover's head, on the

left of the composition, which in turn reflects a third, above a mantelpiece. The importance of the mirrors is confirmed by their presence in Hunt's preliminary sketch.

This is the moment to recall Hunt's assertion in his memoirs that the Pre-Raphaelites were never 'realists': 'I think art would have ceased to have the slightest interest for any of us had the object been only to make a representation, elaborate or unelaborate, of a fact in nature'.[12] As with *The Light of the World*, Hunt was trying to create a modern symbolism that would replace the exhausted conventions of Renaissance iconography. Following Ruskin's principles in *Modern Painters,* the 'realism' of these minutely recreated 'facts in nature' was intended to give an imaginative and emotional access to the moral significance of the work.

What then, are these 'facts in nature' – especially in the mirror – intended to tell us? Firstly, we are given a particular access to this interior, because the mirror allows us to see what the woman can see. Caroline Arscott has put forward a Freudian reading, arguing that the mirror positions us as a viewer/voyeur in the place of the seducer at the piano, and so we are reduced to the condition of excited spectator, rather than – as was Ruskin – a moralising reader.[13] But the point about our entry into the picture is that it draws attention to the source of light on the woman's face. It is the light of Nature, coming in through the French windows, from an August-sun-lit exterior with the 'fair garden flowers' Ruskin that alludes to (12.335). We see them in reflection, and what she – and also we – can see causes her – and us – to reflect. In the Royal Academy catalogue one of the two Biblical quotations that gloss the work ends: 'Be ye strong; fear ye not; behold your God'.[14]

The idea of reflection can be taken further. Carol Jacobi,

discussing Hunt's painting technique, points out that the picture-surface creates a glassy, literally reflective, effect. She writes: 'The use of oil/varnish media and rigid supports produce a glass-like paint layer. These combine to promote a sense of the painting as window, or mirror, and the illusion of a rectangle of real vision circumscribed by the frame.'[15] The attention that Hunt paid to the frame, with its arched, mirror-like top, reinforces this effect.

Thus, although it was the 'inferior details', those 'trivial objects' whose visual emphasis so disturbed the critics, and whose symbolic significance so attracted Ruskin in this moralised interior, it is the whole, glossy quiddity of the object itself – a painting of a room to hang in a room – that makes it so effective. The painting enacts the process of symbolic realism that Ruskin had revealed to Hunt in *Modern Painters*. It is a physical type that stands for a moral idea: a mirror-like object that contains not one, but three mirrors, in a composition that embodies the mental process that is leading to a moment of self-understanding, and whose unresolved ambiguities are contained in the visual dynamic of image and mirror-image, – as it were, of positive and negative, recto and verso. By exploiting the possibilities of visual reflection, it asks us both to see, and to reflect upon, the woman's physical and mental self-awareness.

♕ ♕ ♕

That Ruskin should believe that this was the awakening conscience of an adulterous woman is, in the circumstances, understandable. His letter to *The Times* was published on 25th May 1854. Exactly one month before, on 25th April, Ruskin's wife Effie had left him, and he had been served with a citation

claiming that their marriage was void on the grounds of his impotence. Effie's ally, Lady Eastlake, wife of the President of the Royal Academy, spread the news at the private view of the Royal Academy on 28th April, and she was among those who were outraged when Ruskin published his first letter to *The Times*, on *The Light of the World*, on 5th May. It may be that Ruskin felt he should present a brave face to the world, and continue to express his critical opinions in public. To his enemies this was rank hypocrisy. The timing of his second letter seemed even more provocative to those in the know, for Effie was about to travel to London to undergo a medical examination to prove her virginity, and give evidence in her appeal to have her marriage annulled. Lady Eastlake's wrote to Effie that this second letter 'has condemned him in the eyes of the [*illegible*] world more than anything'.[16]

Shortly before Effie left Scotland for London, Millais left the capital in order to return to Glenfinlas to do more work on his still unfinished portrait of Ruskin. On 5th June he wrote to Effie's mother, Mrs Gray from a rain-soaked Glenfinlas: 'I have read the second letter in *The Times* upon Hunt's picture and can say *positively* that he has *mistaken* the story which he considers so easy to interpret. I think he has written it partly to gull the public into believing that he has the feelings of other folk'.[17] Of course Millais had to argue that Ruskin's reading was wrong. Technically, Effie had not been taken in adultery, but he had broken Ruskin's marriage, and would marry Effie, in the presence of Holman Hunt, in 1855.

Ruskin projected his own feelings onto the painting, but in one respect he was right. Those who broke the conventions of marriage risked social ostracism, and though Effie went on to have eight children, and her husband was made a baronet and

elected President of the Royal Academy, she would never be received at Court. She did not have to walk the streets, but the circumstances of her flight from Ruskin and her marriage to Millais would always be the subject of curiosity. As her new husband's career progressed, she would have cause to reflect on that.

Based on a paper given at a conference on 'The Gendered Interior in Nineteenth Century Art', Institute of Art History, University of Bern, November 2013.

CHAPTER VII

'THE MOST DISGUSTING BOOK EVER WRITTEN BY MAN': RUSKIN AND VICTOR HUGO

☙

On the 22nd May, 1855, John Ruskin wrote a cross letter to Frederick James Furnivall, one of his colleagues at the London Working Men's College, where, as will be explored further in Chapter VIII, Ruskin was teaching. He was becoming alarmed by the radical ideas espoused by his young disciple:

> I never was thoroughly ashamed of you and your radicalism till you sent me that ineffably villainous thing of Victor Hugo's. Did you ever read *The Hunchback of Notre Dame*? I believe it to be simply the most disgusting book ever written by man, and on the whole to have caused more brutality and evil than any other French writing with which I am acquainted.
>
> De Balzac is sensual, but he is an artist of the highest touch, and a philosopher even in his sensuality. Eugène Sue paints virtue as well as vice. Dumas is absurd and useless, but interesting. Béranger blasphemous, but witty. George Sand immoral, but elegant. But for pure, dull, virtueless, stupid, deadly poison, read Victor Hugo. (36.212)

The first thing to be said about this letter is that it shows Ruskin's remarkable familiarity with contemporary French literature. But his violent hostility towards France's greatest living

Opposite: Fig. 21: Benjamin Roubaud, Caricature of Victor Hugo, *1841*

poet is remarkable. This hostility was nonetheless a paradoxical proof of the profound influence that Hugo, and especially his novel, *Notre-Dame de Paris*, had on Ruskin. It is a case of what Harold Bloom has called 'the anxiety of influence',[1] but this chapter is intended to do more than demonstrate the links between Hugo's novel and Ruskin's thinking: it suggests that there is also a psychological link between the two men.

Ruskin hints in *Præterita* that he had been emotionally damaged by reading Hugo's novel. If such damage occurred, it would have been done during Ruskin's adolescence. Hugo's novel was published in 1831; two English translations of *Notre-Dame de Paris* appeared in 1833 – when Ruskin would have been fourteen. One, by William Hazlitt, the son of the art critic of the same name, used the title, *Notre-Dame. A Tale of the Ancient Regime*, which reflects the liberal interpretation of the novel's politics in Hazlitt's polemical introduction.[2] As Ruskin's letter to Furnivall reminds us, his sympathies lay elsewhere, and since he also uses the alternative title for the novel in England, *The Hunchback of Notre Dame*, it is more probable that he read it in the translation by Frederic Shoberl, which uses this title.[3] This version was widely read in England; three further translations appeared before 1849. But during the 1840s Hugo's reputation in England went into decline. According to Kenneth Hooker's study, *The Fortunes of Victor Hugo in England*: 'by 1852 a great part of the English reading public lost interest in Hugo'.[4]

The events in Paris in 1848 (the aftermath of which Ruskin saw at first hand), and Hugo's subsequent decision to go into exile in Jersey in 1852 in protest against the *coup d'état* that led to Napoleon's nephew adopting the title of Napoleon III, revived English interest. Hugo's polemic, *Napoléon-le-Petit*, published in London in both English and French in 1852 was widely read,

but, outside radical circles, there was little sympathy for Hugo's political views.

The revolutions that convulsed continental Europe in 1848 had had an important effect on Ruskin, both political and personal, as Chapter IV shows. The fact that, like his father, Ruskin welcomed the *coup d'état* that drove Hugo into exile is sufficient to demonstrate the political distance between Ruskin and Hugo in 1855, the year of Ruskin's letter to Furnivall. But before turning back to the years when Ruskin first read *Notre-Dame de Paris*, there remains the mystery of the identity of that 'ineffably villainous thing of Victor Hugo's' that Furnivall had sent him. Ruskin's letter does not identify it.[5]

In Ruskin studies, historical context is everything. Furnivall was a Christian Socialist, and it was he who had persuaded the Ultra-Tory Ruskin to teach at the London Working Men's College. It seems that the text in question is neither *Napoléon-le-Petit*, nor Hugo's poems *Les Châtiments*, published in 1853. But it could be one of the pamphlets produced by French political exiles in Jersey and smuggled into France – sometimes hidden in busts of Napoleon III – and a great source of irritation to the island authorities. The 'Imprimerie Universelle de Jersey' published half a dozen pamphlets and speeches by Hugo before his expulsion from Jersey – and subsequent move to Guernsey – in 1855. One such, titled *Victor Hugo á Napoléon Bonaparte*, published in April 1855, is an attack on the state visit by Napoleon III to Britain in that same month, a visit occasioned by the Anglo-French alliance in the Crimean War.

The pamphlet takes the form of an open letter to Napoleon III, which begins: 'What have you come here for? What do you want? Who have you come to insult? The people of England, or the outlawed of France.'[6] Linking himself with other

'democratic socialists'[7] Hugo winds up with a typically dramatic peroration:

> Sometimes, at night, unable to sleep, the sleep of the father-land being the insomnia of the exile, I look out towards the dark horizon of France, I see the eternal heavens, the face of eternal justice, and I ask the darkness about you. I ask the shades of God what they think of you, and I pity you, mon-sieur, in the presence of the awesome silence of the infinite.[8]

Hooker disputes Hugo's claim, made when he reprinted this text in the collection *Actes et Paroles*, that when Napoleon arrived in Dover he would have been able to read this open letter fly-posted on the walls – there is no record of this. But Hooker appears to have been unaware that the pamphlet was also trans-lated into English, as *The Visit of the Emperor of the French to England*, a copy of which can be found in the British Library. In the light of the context, and the timing, it is likely that this was the publication that had so offended Ruskin, who wrote in the same year that Napoleon III was 'a great Emperor' (5.415).

<p style="text-align:center">𐐧 𐐧 𐐧</p>

Notre-Dame de Paris, however, belongs to an earlier period in Hugo's political trajectory, when he was still nominally a Roman Catholic, and was in receipt of a royal pension from Charles X. The novel also belongs to an earlier phase of Romanticism. One thing that Hugo and Ruskin had in common was the legacy of Sir Walter Scott. In 1822 Hugo had written of Scott's *Quentin Durward*:

> After the picturesque, but prosaic, romance of Walter Scott,
> a different romance remains to be created, yet more beautiful

and more complete, in our view. This is the romance, at once both drama and epic, picturesque but poetic, real but ideal, true but great, which will enchase Walter Scott in Homer.[9]

It was Scott who had shown how the concept of History could be made manifest in the Sublime, where one can feel the physical presence of History in his characters and their environment. For Scott, the Sublime was made material in the Scottish landscape; for Hugo, it was the medieval architecture of Paris, and it is arguable that *Notre-Dame de Paris* became that 'different romance' that Hugo was thinking of in 1823. Certainly, when the novel was published in England, there was no shortage of critics to accuse Hugo of plagiarising Scott.

The links between *Notre-Dame de Paris* and Ruskin's architectural history *The Stones of Venice* were first pointed out in an article by J. B. Bullen on 'The tradition of Renaissance historiography'.[10] In this groundbreaking essay Bullen writes:

> One of the most dominant and extensively employed metaphors in *Notre-Dame* is that of the building as a book. As Hugo sees it, architectural form is a mode of writing or language; the whole medieval city of Paris is a 'chronicle in stone', made up of individual 'volumes' of which the principal is Notre-Dame itself. The church, he says, is a legible 'book': 'Each face, each stone of this venerable monument is a page not only of our country's history, but also of the history of science and architecture.' 'Indeed', he goes on, 'many a massive tome and often the universal history of mankind might be written from these successive weldings of different styles at different levels of a single monument.'[11]

Bullen demonstrates how this idea of architecture as book transfers itself to *The Stones of Venice*, above all in Ruskin's

interpretation of St Mark's: 'Never had city a more glorious Bible' (10.141). But it is not simply the idea of building as book that anticipates Ruskin, but the idea of architecture as cultural and collective history, written before the Gutenberg revolution so powerfully evoked in Hugo's chapter 'This Will Kill That'. The cathedral of Notre-Dame and the basilica of St Mark's are almost living personalities in the texts of Hugo and Ruskin.

There are other, closer parallels. Bullen points out that the date chosen by Hugo for the start of his story, the 6th of June 1482, plays a similar role that of 8th May 1418 (date of the death of Doge Carlo Zeno) in *The Stones of Venice*. The celebrated flight of a migratory bird over Europe in the second volume of the *Stones* (10.185-8) makes a pendant to the bird's-eye view of Paris in *Notre-Dame*. It is even possible that there is an echo of the notion of destiny, the ANANKH in Hugo, in the name that Ruskin was later to chose for *Fors Clavigera* – fate, or chance, that hits the nail on the head. Hugo discovered the Sublime in medieval architecture, but also the Grotesque. In the third volume of *The Stones of Venice* Ruskin begins to develop his own theory of the Grotesque. Note that the discussion of the Grotesque begins with the description of a monstrous stone head at the base of the campanile of the Church of Santa Maria Formosa, a face that recalls the twisted features of Quasimodo.

We should remind ourselves, however, that *Notre-Dame de Paris* is a novel, and *The Stones of Venice* a work of cultural polemic. In the twenty years since the publication of *Notre-Dame de Paris*, Ruskin had absorbed the ideas of the French art historian Alexis Rio, who, stimulated by Hugo in the 1830s, developed with Charles Forbes René de Montalembert a new religious æsthetic which inspired the Catholic and Gothic revival in France. Rio's book *The Poetry of Christian Art* was Ruskin's

constant companion during his 1845 tour of Northern Italy, a journey, as we have seen, that changed almost all his ideas, and launched his study of the Gothic. It was Rio who suggested to Ruskin a critical method that led him to his distinctive form of cultural history. Rio wrote:

> The revolutions undergone by the fine arts being the surest index of those taking place at the same time in people's imaginations, their study can lead to the most instructive results, and are thus susceptible to the highest interest, even from a philosophical point of view. The works of painters, like those of poets, when they are recognised, encouraged and extolled by their fellow citizens, are the faithful mirror in which are successively reflected the changes that occur in the national spirit.[12]

Rio specifically proposed that this method should be applied to the history of Venice:

> If, instead of staying with the external events which appear to be the surface of history, one wanted to take the trouble, or rather impose on oneself the duty, to penetrate further, and chose to research those archives that best reflect the national spirit, what precious and unexpected discoveries might emerge from this enquiry, and could give a completely different perspective, a completely different colour, to the annals of Christian people, and particularly those of the republic of Venice![13]

We cannot be certain that Ruskin had read Montalembert, except indirectly through the works of Pugin, as we shall see, but Rio, Montalembert and Ruskin all use the word 'Pagan' to describe the malevolent influence of the Renaissance and – to

return to Victor Hugo – it is possible that it was in *Notre-Dame de Paris* that Ruskin encountered the term, *Renaissance*, together with its negative inflection, for the first time.[14]

The parallels between Hugo and Ruskin in their treatment of architecture are clear. Victor Hugo, in *Notre-Dame de Paris*: 'architecture was the great script of the human race. ... Not only every religious symbol but also every human thought has its own page and its own monument in this immense book.'[15] Ruskin, in *The Seven Lamps of Architecture*: 'every form of noble architecture is in some sort the embodiment of the Polity, Life, History, and Religious Faith of nations' (8.248). It thus followed that these texts in stone should be protected, and both Hugo and Ruskin, through practical actions and rhetorical gestures did what they could to conserve them. In 1835 Hugo was appointed to the Comité des Monuments Inédits de la Littérature, de la Philosophie, des Sciences et des Arts, a French version of what in 20th-century England became English Heritage. Ruskin helped to inspire William Morris's Society for the Protection of Ancient Buildings. In their writings, both men denounced the Renaissance as a threat to the Gothic. Hugo, in *Notre-Dame de Paris*:

> The magnificent art produced by the Vandals has been killed by the academies. To the centuries and the revolutions, which at least laid waste with impartiality and grandeur, has been added the swarm of architects from the schools, licensed, sworn and attested, defacing with the choice and discernment of bad taste, and replacing Gothic tracery with Louis Quinze chicory to the greater glory of the Parthenon. This is the ass kicking the dying lion.[16]

Ruskin, in the first volume of *The Stones of Venice*: 'the Renaissance frosts came, and all perished' (9.278).

Architecture, however, had another enemy – modernity. The French use a term, popularised by the cultural historian Pierre Nora, for what we British in a more limited way call 'heritage': *lieux de mémoire*, meaning places and things that are framed as sites of memory. But long before the French discovered their *lieux de mémoire*, Ruskin had lit 'The Lamp of Memory' in *The Seven Lamps of Architecture*. It was in this chapter that Ruskin laid down the law about architectural restoration:

> Neither by the public, nor by those who have the care of public monuments, is the true meaning of the word *restoration* understood. It means the most total destruction which a building can suffer: a destruction out of which no remnants can be gathered: a destruction accompanied with false description of the thing destroyed. Do not let us deceive ourselves in this important matter; it is *impossible*, as impossible as to raise the dead, to restore anything that has ever been great or beautiful in architecture. (8.242)

Confronted by the growth of industrialisation in the 19th century, this was a difficult position to sustain. The reopening of the Crystal Palace – symbol of Victorian modernity – in June 1854, at Sydenham (too close to his home in Denmark Hill) prompted Ruskin to write a pamphlet that addressed the restoration question once more. He was prepared to acknowledge the mechanical ingenuity needed to build a screw-driven frigate, a tubular bridge or a hall of glass, but he was immediately reminded of the contemporary decay in Venice, and launched into an attack on what was going on in France.

'Under the firm and wise government of the third Napoleon' (12.421) France was enjoying renewed prosperity, but the consequence was that the cathedrals of Rheims, Amiens, Rouen,

Chartres and Paris were under repair. This was doubtless necessary, and skilfully and expensively carried out, but:

> They are, nevertheless, more fatal to the monuments they are intended to preserve, than fire, war, or revolution. For they are undertaken, in the plurality of instances, under an impression, which the efforts of all true antiquaries have as yet been unable to remove, that it is possible to reproduce the mutilated sculpture of past ages in its original beauty. (12.422)

The modern world wanted everything to look like the Champs Elysées, and indeed Paris had nothing to fear from the 'gorgeous prolongations' of the Rue de Rivoli; but: 'I speak of the changes wrought during my own lifetime on the cities of Venice, Florence, Geneva, Lucerne, and chief of all on Rouen' (12.427). The medieval texture of Rouen was being erased by modern hotels and offices.

Ruskin regularly complained about restorations in France – and that meant that he was complaining about the operations of Viollet-le-Duc. Viollet-le-Duc was the most prominent architect-restorer in France, and his principles were the complete opposite to Ruskin's. Far from opposing all but emergency work on buildings – and then not hiding the results – Viollet-le-Duc believed that buildings should be put back to how they looked at the defining moment of their architectural existence – even if in fact they had never actually looked as neat and complete as they did after he had finished with them. This Platonic ideal of the essence of a building, reconstructed after the depredations of the French Revolution, accounts for that extraordinarily scraped and empty feeling that so many French ancient monuments have, even today.

Ruskin owned a copy of Viollet-le-Duc's *Dictionnaire*

Raisonné de l'Architecture Francaise, which is now, replete with his marginalia, in the Ruskin Library, Lancaster. It is apparent that there were certain aspects of Viollet-le-Duc's work that Ruskin respected. In 1884 Ruskin praised Viollet-le-Duc's enthusiasm, sagacity and patriotism in his account of the Romanesque phase in his history of medieval architecture (33.465). In general, when Ruskin mentions Viollet-le-Duc directly, his remarks are judicious, except in the field of geology, where Ruskin rejected his ideas on the formation of Mont Blanc, published in 1876. In this context, Ruskin went so far as to make a joke in French: '"C'est magnifique; – mais ce n'est pas" – la géologie' (26.223).

Ruskin does appear to have criticised Viollet-le-Duc directly in 1861, when he was invited to address a meeting organised by the Gothic-loving Ecclesiological Society to protest against the restorations going on in France. The report of Ruskin's remarks does not mention Viollet-le-Duc by name, but he declared the position in France 'hopeless' (19.461). The whole ecclesiastical architecture of France 'was likely to be destroyed by one perpetual scrape' (19.462). This clearly alludes to Viollet-le-Duc's methods, and pre-dates by sixteen years William Morris's Society for the Protection of Ancient Buildings, which Morris referred to as 'anti-scrape'. Finally, and appropriately for the building at the heart of this discussion, in 1874 Ruskin cites Viollet-le-Duc's work directly when he mockingly describes a visit to Notre-Dame, where Viollet-le-Duc had almost completely renewed the towers and walls and the majority of the sculptures of the façade.

⁂

Had Victor Hugo not been in exile when Viollet-le-Duc was at the height of his powers, he too would have protested at his

Fig. 22: D. Rouage, Illustration to Victor Hugo's 'Notre Dame de Paris', *1836*

activities. As a young man he had declared 'war on the dem-
olitionists'. Which makes Ruskin's anti-Hugolian vehemence
all the more in need of explanation. His letter to Furnivall of
1855 was private and unpublished, but he scarcely concealed

his opinion. In 1880 he declared in *Fiction, Fair and Foul* that
Hugo was in effect a sadist, *Notre-Dame de Paris* being 'the
effectual head of the whole cretinous school' of prison literature
(34.277). That Ruskin had his political reasons is clear, but we
can now see that that there are deeper and more subtle reasons
for rejecting Hugo than a temporary admiration for Napoleon
III. After Napoleon was captured by the Prussians after the
Battle of Sedan in 1870, Ruskin wrote that he 'did not, indeed,
meet my old Tory notion of a King; and in my own business of
architecture he was doing, I saw, nothing but mischief; pulling
down lovely buildings, and putting up frightful ones carved all
over with L. N.'s' (27.171).

Ruskin stayed true to the political conservatism of Sir Walter
Scott, and Hugo left it behind. As Bullen has written: 'Broadly
speaking, Hugo's is a progressive lesson whereas Ruskin's is
one of decline and fall'.[17] Ruskin's Romanticism was pessimis-
tic. Following Carlyle, the contrast between past and present
became, as we saw in Chapter IV, a form of critical medieval-
ism. In the face of modern industrialisation, the teeming world
described by Hugo could never be brought back to life.

Even the Gothic Revival, which summoned up this lost
world, was riven by political issues. In England the choice of
architectural style was never simply æsthetic, but theologi-
cal, and in the 19th century a theological choice was a politi-
cal choice. The principal advocate and defender of the Gothic
Revival in England before Ruskin was also the advocate and
defender of the Catholic Revival, the convert Charles Augustus
Welby Pugin, who with his visual polemic in his book *Contrasts*
gave a practical demonstration of critical medievalism. First
published in 1836, the second edition of 1841 is substantially
enlarged by the republication of a long extract, in French, of

Montalembert's *Vandalisme en France*, which cites both Alexis Rio and Victor Hugo. As an Evangelical Protestant it was Ruskin's project to purify the Gothic Revival of its Catholic Revival overtones, and to make Protestant a new national architectural style. *The Seven Lamps of Architecture* and *The Stones of Venice* were largely to accomplish this conversion.

Such was Ruskin's Evangelical belief, that he showed bad faith when it came to acknowledging the influence of Pugin. He attacked Pugin indirectly in *The Seven Lamps*, where he wrote of the 'abuse and fallacy of Romanism' – lines he dropped in the 1880 edition as 'a vulgar attack on Roman Catholicism' (8.41n). He attacked him directly in *The Stones of Venice*, where he wrote of the 'blasphemy' and 'fatuity' of Pugin's 'Remarks on Articles in the *Rambler*' (9.437). The violence of this response reveals Ruskin's sensitivity to the charge that he might have been influenced by Pugin's ideas. In a letter to Furnivall of the 3rd April 1855 he declared:

> Whatever I owe, and it is at least two thirds of what I am, to other people, I certainly owe nothing to Pugin, – except two *facts*, one about Buttresses, and one about ironwork. I owe, I know not how much, to Carlyle, and after him to Wordsworth, Hooker, Herbert, Dante, Tennyson, and about another dozen people. But assuredly *Nothing* to Pugin.[18]

But the issue would not go away. In 1856, Ruskin felt driven to make this private assertion public, in an appendix to the third volume of *Modern Painters*, where he tried to defend himself against the charge of plagiarism – 'Plagiarism' being the appendix's somewhat disingenuous title:

> It is also often said that I borrow from Pugin. I glanced at Pugin's *Contrasts* once, in the Oxford architectural

reading-room, during an idle forenoon.[19] His 'Remarks on Articles in the *Rambler*' were brought under my notice by some of the reviews. I never read a word of any other of his works, not feeling, from the style of his architecture, the smallest interest in his opinion. (5.428-9)

Ruskin was lying. We know, for example, that he had read Pugin's *True Principles of Pointed or Christian Architecture*, because he made notes on it. It is this text that begins with the principles that were adopted by Ruskin:

> The two great rules for design are these: 1st, that there should be no features about a building which are not necessary for convenience, construction, or propriety; 2nd, that all ornament should consist of enrichment of the essential construction of the building.[20]

Without wishing to excuse Ruskin's dishonesty we can understand his motives. It is the closeness of the originating ideas, and the distance that separates their consequences, that provokes his anxiety about being influenced by Pugin – and, it appears from the vehemence of his letter to Furnivall, by Victor Hugo.

<p style="text-align:center">⚜ ⚜ ⚜</p>

There is, finally, another similarity between Hugo and Ruskin. They were both magnificent men of words, but they both also had a remarkable visual facility, as can be seen from their love of drawing. There is a visual voluptuousness in Ruskin's prose that seems to evade the self-censorship that suppressed his physical sensuality. In 1875 Ruskin wrote to a confidante: 'The worst of me is that the Desire of my *Eyes* is so much to me! Ever so much more than the desire of my mind' (37.153).

At the close of his life, writing *Præterita*, Ruskin looked back on the Romantic reading of his youth: 'I never got the slightest harm from Byron: what harm came to me was from the facts of life, and from books of a baser kind, including a wide range of the works of authors popularly considered extremely instructive – from Victor Hugo down to Doctor Watts' (35.143). The reference to Dr Isaac Watts appears to be ironic, for he was the author of an illustrated book of children's hymns, *Divine Songs*, and he may be intended as the innocent opposite to the harmful Hugo. For in this context, the phrase 'the facts of life', has overtones of sexual knowledge, and this, coupled with the name of Victor Hugo, causes one to read *Notre-Dame de Paris* with particular attention.

There, we do indeed find a passage that, for someone with Ruskin's visual sensibility, may have carried a particular erotic charge. This is the scene at the end of book seven, where the puritanical priest Frollo conceals himself in a sort of cupboard in order to observe the sexual dalliance of Captain Phoebus with the virginal Esmerelda, who is soon semi-nude:

> She threw her arms about the officer's neck, looked up at him beseechingly and, giving a lovely, tearful smile, rubbed her delicate breasts against his woollen doublet with its coarse braid. Her lovely half-naked body writhed on his knees. The captain, beside himself, pressed his burning lips to those beautiful African shoulders. The girl lay back, seeing only the ceiling, trembling and palpitating beneath that kiss.[21]

But at this moment Esmerelda realises they are being observed. Frollo bursts from his hiding place, stabs the captain, kisses the girl and hurls himself out of the window into the Seine – an ejaculation, if ever there was one.

Exciting stuff for an Evangelical fourteen-year-old, but this passage also reveals a sexual taste that Victor Hugo was to develop in the 1840s. Graham Robb, in his enthralling biography, describes Hugo's pleasure in visual stimulation. According to Hugo's coded diaries: 'he hired prostitutes who specialised in stripping, which was cheaper and safer than physical contact and in any case a favourite activity with Hugo'.[22]

So, knowing what we know of Hugo's voyeurism, and the desire of the eye that Ruskin confessed, it appears that the youthful Ruskin's reading of *Notre-Dame de Paris* disturbed in him in ways that his mother's teaching did not help him to understand. Here is an anxiety yet more profound than the anxiety of influence. Is this why Ruskin condemned this magnificent novel, so fundamental to his intellectual formation, as 'the most disgusting book ever written by man'?

This is an English version of '"The most disgusting book ever written by man": Ruskin, Victor Hugo, et l'inquiétude des influences', in Victor Hugo et le débat patrimonial, *Actes du colloque organisé par L'Institut National du Patrimoine, sous la direction de Roland Recht, Paris, Somogy Editions d'Art, 2003.*

CHAPTER VIII

'ONLY TO SEE': RUSKIN AND THE LONDON WORKING MEN'S COLLEGE

જ

The origins of the London Working Men's College lie in the movements for social reform that had been stirred, but not satisfied, by the Reform Act of 1832: they are to be found in Owenism, Chartism, Christian Socialism, and in the desire of earnest graduates of Oxford and Cambridge to extend the opportunities of a liberal education to working people. One part of this movement, which in turn was to lead to such reforming institutions as the University Extension schemes, Toynbee Hall, the Workers' Educational Association and the institution named in tribute to Ruskin, Ruskin College at Oxford, centred on the charismatic, but controversial, figure of the Reverend Fredrick Denison Maurice.

Born into a dissenting family in 1803, Maurice read law at Cambridge, and then went to Oxford where he took Holy Orders in the Anglican Church. In 1840 he became Professor of English and Modern History at the newly opened King's College, London, later becoming Professor of Divinity in 1846. Maurice's devout but liberal views drew around him a circle of serious men in their thirties who were interested in Christian Socialism, among them Charles Kingsley – author of *The Water Babies* – , Thomas Hughes – author of *Tom Brown's Schooldays* – , John Ludlow, Vansittart Neale, R. B. Litchfield, who became Charles Darwin's son-in-law, and Frederick James Furnivall,

Opposite: Fig. 23: William Jeffrey, Photograph of John Ruskin, 1856

whom we met in the previous chapter, and about whom there is more to tell shortly.

In 1848 Maurice set up a night school for workingmen in Little Ormond Yard in Bloomsbury, and in 1852 he and others began classes at the Hall of Association established by the Society for Promoting Workingmen's Associations, in Castle Street East, Shoreditch. In 1853 a People's College opened independently in Sheffield, but the sharpest stimulus to creating the Working Men's College was the decision by King's College in that same year to sack Maurice because of the controversial religious views expressed in his *Theological Essays*, published earlier that year – the controversy was over the meaning of 'eternity'.

In December 1853 Maurice was appointed Principal of the as yet unfounded Working Men's College, which formally opened on 30th October 1854 with an inaugural meeting at St Martin's Hall in Long Acre. At that meeting a small pamphlet was distributed, about the size of a postcard, titled *On the Nature of Gothic Architecture and herein of the True Function of the Workman in Art*. It was a reprint of the central chapter of the second volume of Ruskin's *The Stones of Venice*, first published three years before, in 1851.

Given both Ruskin's and his father's Ultra-Tory Evangelicalism, it may well be asked what he was doing mixed up with this bunch of free-thinkers, Christian Socialists and radicals, whose values were so opposed to his own. One answer is that Ruskin, like Dickens, and indeed like the Christian Socialists themselves, had seen the social and political upheavals of the hungry 1840s. In 'The Nature of Gothic' he warned against the greed born of industrialisation, its cultural effects and the social dangers it represented. These evils had to be answered by recovering the moral essence of Gothic architecture where, he

Fig. 24: Sixpenny pamphlet version of the 'Nature of Gothic' chapter of
The Stones of Venice, 1854

argued, social relations were such that the craftsmen who built and embellished the great cathedrals and other works of that period were free to express themselves through un-alienated labour. Ruskin's chapter articulated many ideas with which the founders of the Working Men's College could sympathise, as the addition of a subtitle to the pamphlet, *and herein of the True Function of the Workman in Art* testifies.

The immediate, personal reason for Ruskin permitting the republication and sale of 'The Nature of Gothic' was his connection with Frederick Furnivall. Furnivall (1825-1910) is a truly fascinating character, worthy of rescue from Victorian oblivion. Son of a rich Evangelical and Tory doctor, Furnivall became a vegetarian and teetotaller, an inveterate founder of scholarly societies – the Early English Text Society, Chaucer Society, New Shakespeare Society, Browning Society, Shelley Society – and so a shaper of the idea of English literature as an academic subject. He was also a passionate oarsman and founder of rowing clubs for men *and* women. Hence his memorialisation in the name of Furnivall Gardens, by the Thames at Hammersmith.

After University College London, and then Cambridge, Furnivall studied law in a radical chambers, where he became a Christian Socialist and so met Maurice. As a result of reading the first two volumes of *Modern Painters*, Ruskin, he said, 'became one of my gods',[1] but they did not meet until 1849, when the newly wed Ruskin and Effie were living temporarily at Park Street, Mayfair. It was in fact Effie who first met Furnivall at a *conversazione* in Chester Terrace, and then invited him to meet Ruskin. Effie described Furnivall as 'an amiable weak young man, a vegetarian, Christian Socialist and worshipper of men of genius',[2] but for Furnivall: 'there began a friendship which was for many years the chief joy of my life'.[3]

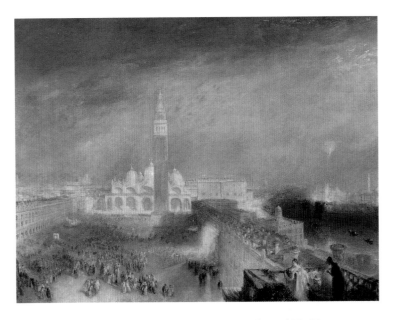

Plate 1: J. M. W. Turner, St Mark's Place, Venice – Juliet and Her Nurse, *1836*

Plate 2: John Ruskin,
Study of the Upper
Part of a Reliquary by
Fra Angelico, Then in
Santa Maria Novella,
Florence, *1845*

Plate 3: Anon., The Fondaco dei Turchi, Venice, Before Restoration

Plate 4: Jacopo Tintoretto, Crucifixion in the Scuola Grande di San Rocco, *1565*

Plate 5: John Ruskin, Study of Jacopo Tintoretto's 'Crucifixion in the Scuola Grande di San Rocco', *1845*

Plate 6: Paulo Veronese, Solomon and the Queen of Sheba, c. 1584

Plate 7: Master of the Veils (formerly attributed to Giotto), The Marriage of Poverty and St Francis, detail, c. 1330, lower church of St Francis, Assisi

Plate 8: John Ruskin, Drawing of Carpaccio's 'Dream of St Ursula' from the 'Legend of St Ursula', *November-December 1876*

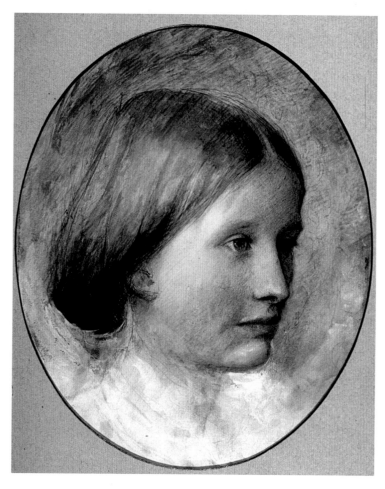

Plate 9: John Ruskin, Portrait of Rose La Touche, *1874*

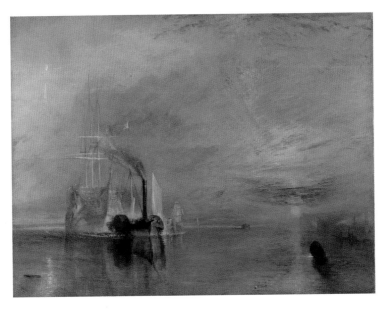

Plate 10: J. M. W. Turner, The Fighting 'Téméraire', Tugged to Her Last Berth to Be Broken Up, 1838, *1839*

Plate 11: J. M. W. Turner, Apollo and Python, *1811*

Plate 12: J. M. W. Turner, The Goddess of Discord Choosing the Apple of Contention in the Garden of the Hesperides, *1806*

Plate 13: William Holman Hunt, The Awakening Conscience, *1853*

Plate 14: William Holman Hunt,
The Light of the World, *1851-3*

Plate 15: Jacopo Tintoretto, The Annunciation, *1576-81*

Plate 16: William Holman Hunt, The Triumph of the Innocents *(second version), 1883-4*

Plate 17: William Holman Hunt, The Triumph of the Innocents *(second version),*
detail of 'airy globes', 1883-4

Plate 18: William Holman Hunt, The Scapegoat, *1854-5*

Plate 19: William Holman Hunt, The Shadow of Death, *1870-3*

Plate 20: John Bunney, The West Front of St Mark's, *1877-82*

Effie got her comeuppance when Furnivall was one of the few people to take Ruskin's side when she obtained an annulment of her marriage in 1854. But as we saw in Chapter VII, although Ruskin and Furnivall did see a great deal of each other during the 1850s, Ruskin was always chiding this early disciple for his radicalism, and resisting his attempts to get him further involved in the complicated institutional politics of the Working Men's College.

In 1851 Furnivall became the conduit for an exchange of letters between Ruskin and Maurice on the subject of Ruskin's Evangelical pamphlet, *Notes on the Construction of Sheepfolds*, and in spite of the correspondents' complete disagreement, when in 1854 Furnivall asked Ruskin for permission to reprint 'The Nature of Gothic' and suggested that he take charge of the new college's drawing classes, Ruskin agreed.

It is worth pointing out that the term 'college', when coupled with the phrase 'working men', was not as ideologically innocent as it may now sound. Not only did it distinguish this pioneering institution from previous Mechanics' Institutes, for Maurice it summoned up the social bonds of masculine fellowship. He wrote in 1855: 'Was it not a glorious thing then that the working people should lay hold of this name, that they should say, we are determined we will have Colleges ... because we want to connect all our education with our social life, with our fellowship as human beings'.[4] But it also has to be said that – as happens in academe – the collective leadership of the College were a disputatious lot, and it struggled in its early years through its lack of organisation. Things got especially difficult when Furnivall became an agnostic and anti-Sabbatarian, causing Maurice to attempt to resign. The positivist intellectual, and early biographer of Ruskin, Frederick Harrison, who came to

teach history at the beginning of 1860, during Ruskin's last full term, recorded that Ruskin:

> Says that Maurice reconciled Biblical difficulties by turning them the other side up, like railroad cushions. This is an exact account of Maurice's influence, as we who listened to his sermons and sat in conference with him used to feel. His moral earnestness and keen sympathies with right and wrong animating one of the most illogical and self-contradictory minds ever met, combined to disturb, not to guide the beliefs of inquiring youth. And, as Ruskin and many of us felt, the College had neither head, nor system, nor principles, but went on with kindly, social, loose, and highly respectable orthodox ideas in religion and in politics.[5]

Ruskin wrote in *Præterita* that he 'loved' Maurice, but found him 'puzzle-headed, and, though in a beautiful manner, *wrong-headed*' (35.486). Ruskin's moral authoritarianism lies behind his comment: 'Maurice, in all his addresses to us, dwelt mainly on the simple function of a college as a collection or collation of friendly persons, – not in the least as a place in which such and such things were to be taught, and others denied; such and such conduct vowed, and other such and such abjured' (35.488). It is for this reason, along with his ideological differences, that Ruskin always insisted on having nothing to do with the actual running or internal politics of the College, restricting himself to the business of his drawing-classes, first in Red Lion Square, and then at great Ormond Street, where the college moved in 1857 (Fig. 24).

So what was it that Ruskin actually did at the College, which in its first enrolment had 145 students? The College ran four terms a year, with a two-week break at Christmas, and a long vacation from August to October. Because of his regular continental

Fig. 25: Anon., The Art Room of the Working Men's College, Great Ormond Street

journeys Ruskin did not teach beyond Easter. The College made classes available across the liberal humanities, and there were at first three art teachers, Ruskin, Dante Gabriel Rossetti, whom Ruskin, seeking friendship within the Pre-Raphaelite circle, had recruited. The third was the portrait painter Lowes Dickinson (1819-1908) who exhibited regularly at the Royal Academy, and drew F. D. Maurice's portrait in 1873.

Dickinson was a Christian Socialist, and carried on teaching at the College until the 1870s. At first the trio taught together, a two-hour session on Thursday evenings, with 40 to 50 men in the class, which must have meant cramped conditions. From the 29 March 1855 the class divided, with Ruskin and Dickinson giving a class in elementary and landscape drawing, and Rossetti

more advanced figure drawing and painting. In 1856 Dickinson moved to Tuesdays. Over time a number of Pre-Raphaelite artists also contributed to the teaching: Madox Brown, Burne-Jones, Val Prinsep, Arthur Hughes, Thomas Woolner and Alexander Munro together with H. Stacy Marks and Cave Thomas, but Dickinson records that he ended up doing most of the teaching, while about a dozen former pupils became assistants.

With the exception of the summer term, Ruskin taught regularly from 1854 to 1858, when the pressure to complete *Modern Painters* caused him to withdraw, returning for one final full term in 1860. But he continued to visit the College and give addresses, the last recorded one being on 'Competition and Mechanical Art' on 18 November 1865. He appears formally to have withdrawn in 1868. In a letter to his former pupil, Ebenezer Cooke, when he was Slade Professor and creating the Oxford Drawing School, he explains:

> I retired from the College because I felt that under the conditions of London life, art never could be rightly studied. Whether this be so or not my position at Oxford demands of me that I should give what assistance I can to any school of importance willing to receive it and I shall regularly send my drawing instructions and examples.[6]

This suggests that he had not entirely lost faith in the College, although by this time disenchantment with many earlier projects had set in.

Ruskin's first drawing exercise consisted of making a pencil sketch of a simple plaster sphere – but his pupils were not allowed to use line, only shading. Later he sometimes also used racquet-balls as a subject, where the shape offered more opportunities. The point was that they were asked immediately to draw

from a three-dimensional object, whereas the system used by the government's schools of design – what became known as the South Kensington system, described in Chapter X – required months of laborious copying from printed decorative elements on the flat. Those who had had experience of this found Ruskin's methods a shock, and it is probable that Ruskin's observation of the effects of the South Kensington system increased his hostility to it.

After the ball came plaster casts of leaves, fruit and various natural objects such as twigs and leaves. The engraver Thomas Sulman, who joined in 1854, records:

> He taught each of us separately, studying the capacities of each student. … For one pupil he would put a cairngorm pebble or fluor-spar into a tumbler of water, and set him to trace their tangled veins of crimson and amethyst. For another he would bring lichen and fungi from Anerley Woods. Once, to fill us with despair of colour, he bought a case of West Indian birds unstuffed, as the collector had stored them, all rubies and emeralds. Sometimes it was a fifteenth-century Gothic missal, when he set us counting the order of the coloured leaves in each spray of the MS. At other times it was a splendid Albert Dürer woodcut. (5.xl)

Ruskin commissioned the watercolour artist William Hunt to paint examples of still life, and brought in plates from Turner's *Liber Studiorum*. A tree cut down in his garden at Denmark Hill in South London was fixed in the corner of the classroom. He supplied paper and drawing materials, and quantities of blocks of violet-carmine for wash drawing, which he believed to be 'pleasanter to the eye than black' (38.233). Rossetti, teaching the more advanced class that used watercolour, discovered these

in a cupboard one day, and threatened to confiscate them. He also presented the College library with most of the books he had used in his research for *The Stones of Venice*. Nor was his teaching confined to the classroom; he would invite pupils out to Denmark Hill and arrange weekend sketching parties.

Many of the techniques that Ruskin used at the College, including using a hole cut in a card as a view-finder to judge tone, are also to be found in his text-book, the *Elements of Drawing*, which he published during his busiest time at the College, in 1857 – though he did stress that there is a difference between learning from a manual and having a teacher beside you. Ruskin's impromptu lectures as he walked about the room, sometimes correcting or demonstrating on the edge of the pupil's drawing paper, seem to have left a strong impression. The engraver John Emslie, who joined in 1856 after studying at a government art school and who became an assistant art master, wrote that Ruskin's voice:

> Was a good loud one, and every word he uttered could be heard all over the class-room. His praise of any good effort was tremendous, and, I imagine, sometimes astonished the recipient of it. On the other hand, he would speak with great severity to any one who did not seem to be working up to his usual level.[7]

At the College, Ruskin discovered his powers as teacher and speaker, but his ambitions were strictly limited, both in terms of technique and intended outcomes. He declared in his lecture on manufacture and design at Bradford in 1859, reprinted in *The Two Paths*:

> My men continually come to me, in my drawing class in London, thinking I am to teach them what is instantly to

enable them to gain their bread. 'Please, sir, show us how to design.' 'Make designers of us.' ... Alas! I could as soon tell you how to make or manufacture an ear of wheat, as to make a good artist of any kind. (16.335)

The most succinct expression of his principles comes in a note written to Lowes Dickinson:

The teacher of landscape drawing [*Ruskin*] wishes it to be generally understood by all his pupils that the instruction given in his class is not intended either to fit them for becoming artists, or, in any direct manner, to advance their skills in the occupations they at present follow. They are taught drawing, primarily in order to direct their attention accurately to the beauty of God's work in the material universe; and secondarily, that they be enabled to record with some degree of truth, the forms and colours of objects, when such a record is likely to be useful. (16.471)

Unlike elsewhere in the College, the drawing class had no examinations, because, he told a College general meeting: 'any sort of competition in art work was invariably pernicious, leading men to strive for *effect* instead of truth' (16.469). There was a political message here, as he made clear in his last recorded address to the College on the 18th November 1865 on 'Competition and Mechanical Art'. Ruskin told the men: 'They could not enjoy their work so long as they were thinking whether they were doing it better than Jones or Robinson by their side. These remarks did not apply to drawing only, but to many things in trade ... it was the love of gain which set our rich men scrambling for money like so many pigs rooting up the ground' (19.466).

Ruskin's insistence that he was not giving vocational training was in line with the principles of the College, for Maurice had

declared: 'It was not to be an institution to which the uneducated might resort, to pick up knowledge which might be of pecuniary benefit to them'.[8] As Ruskin told the government's Commission on the future of the National Gallery in 1857: 'My efforts are directed not to making a carpenter an artist, but to making him happier as a carpenter' (13.553).

In fact, a few of the two or three hundred pupils who must have passed through Ruskin's class – a floating group of about forty – *were* artists, or became so, among them the 'American Pre-Raphaelite' Thomas Charles Farrer. A number of Royal Academy students joined the class for a few terms, as did Rossetti's brother William Michael – while others like Thomas Sulman, John Emslie and W. H. Hooper, were engravers. Hooper did the illustrations to Ruskin's *Elements of Perspective* in 1859. The most interesting case is that of James Smetham (1821-1889), another figure worthy of recovery, particularly in relation to Ruskin. A devout Methodist, Smetham was a professional painter who exhibited eighteen works at the Royal Academy between 1851 and 1869. He was strongly influenced by Ruskinian principles, having first encountered them in 1849, though he found he had to modify them in practice. He enrolled in the College in 1854, and so also became friendly with Rossetti, who appears to have been very kind to him, as indeed was Ruskin. Sadly, Smetham was a depressive, had a number of breakdowns and, rather like Ruskin, eventually relapsed into silence. Ruskin remained in touch with him until at least 1871.

The term 'working men' is a loose one, and it is clear that a good many at the College were already skilled craftsman or literate clerks, and the fact that a dozen in the art class rose to become drawing masters themselves points to their attainments. The photographer William Jeffrey was one (Fig. 23); John

Emslie, taught by Rossetti, another. From the College came that small group of assistants who were to be vital to Ruskin's future projects. The most important was undoubtedly the skilled joiner George Allen, who became an assistant master, married Ruskin's mother's maid Hannah, and was sent by Ruskin to train as an etcher and engraver under J. H. Le Keux and Thomas Lupton – he executed some 90 plates for Ruskin – before becoming Ruskin's publisher and as a result, ultimately saving him financially. Ruskin had less luck with a carpenter, George Butterworth, who appears to have got ideas above his station. Ruskin wrote that Butterworth's: 'pride, wilfulness, and certain angular narrowness of nature, kept him down, – together with the deadly influence of London itself, and of working men's clubs, as well as colleges' (35.488).

Two clerks became important helpers to Ruskin. William Ward, introduced to Ruskin's ideas by the future curator of the Museum of the Guild of St George, Henry Swan, joined in 1854 and by 1856 had risen to assistant master, and is referred to as such in *The Elements of Drawing*. Ward's speciality was making facsimiles of Turner watercolours, and Ward became an agent for the distribution of Ruskin-commissioned photographs. Their correspondence runs from 1855 to 1886. The other was a clerk at Ruskin's publishers, Smith Elder, John Bunney, who was to move to Florence and then Venice, supporting himself as a painter and doing copying work for Ruskin. His masterpiece is the record of the façade of St Mark's, commissioned by Ruskin in 1877 when it was threatened with restoration (Pl. 20).

Although not strictly an assistant, the final pupil who should be mentioned is Ebenezer Cooke, who, inspired by Ruskin's teaching carried on the fight against the South Kensington system, and became a pioneer in the campaign to recognise the

value of children's art that was taken up in the 20th century. When the South Kensington system began to lose its grip under the influence of the Arts and Crafts movement in the 1890s, Cooke was the principal author of the government Science and Art Department's *Alternative Syllabus of Instruction in Elementary Schools*, published in 1895.

$$\wedge \quad \wedge \quad \wedge$$

Ruskin may have kept himself distinct from the operations and many of the values of the Working Men's College, yet it is evident that there was a considerable interchange, and that the benefits were not one way. Ruskin credited Furnivall with introducing him to the delights of philology, for instance. *The Elements of Drawing* was an important result of these years, and it is possible that in the 1870s, when Ruskin began to address 'the workmen and labourers of Great Britain' in *Fors Clavigera* he had the sort of people who had been his pupils at the College in mind – even if in 1874 he complained that no one from the College had come to his aid in this enterprise (28.25). Ruskin remained a Tory, but, like Ruskin, the Christian Socialists attacked the economic orthodoxies of Ricardo, Malthus and McCulloch, and it is indeed possible, as Frederick Harrison has suggested, that the ideological climate in the College encouraged Ruskin to write his most important, and influential, social criticism in 1860, the articles that became *Unto This Last*.[9]

As we saw in Chapter IV, that Ruskin *did* influence the course of socialism, and so the cause of working men and women, is evinced by the second time that 'The Nature of Gothic' was reprinted, by William Morris in 1892. Ruskin said of his work at the Working Men's College: 'I have not been

trying to teach you to draw, only to *see*' (15.xx). His political analysis in the Nature of Gothic may be a conservative one, but it is clear why, when Morris came to republish it, he should say: 'it seemed to point out a new road on which the world should travel' (10.460).

Based on a lecture given to the Ruskin Society, later published in The Companion: The Journal of the Guild of St George, *vol. 1, no. 3, Autumn/Winter 2003.*

CHAPTER IX

'THE TEACHING OF ART IS THE TEACHING OF ALL THINGS': RUSKIN, SIGHT AND INSIGHT

ల

In the last chapter we saw how limited Ruskin's ambitions were for his class at the London Working Men's College. Yet Ruskin also asserted: 'The teaching of Art, as I understand it, is the teaching of all things' (29.86). It is a casual remark, thrown off in a parenthesis. It appears in Letter 76 of *Fors Clavigera*, his monthly 'letters to the workmen and labourers of Great Britain', the issue for March 1877, written in Venice. He was, in this case, literally addressing workmen and labourers, for as we will see in Chapter XI, he was giving advice to a group of workers in Sheffield who, influenced by the presence of the Museum of the Guild of St George up at Walkley, were about to set up a communitarian farming experiment on land bought by Ruskin for the Guild.

But what was it that Ruskin was trying to teach? At the profoundest level, it was not art at all. It was something that preceded art, indeed all forms of knowledge. As we saw him tell his class of clerks and artisans at the London Working Men's College: 'I am only trying to teach you to *see*' (15.xx). Sight came before everything. Speaking at the opening of the Cambridge School of Art in 1858, he explained that sight was:

> The most important thing to be taught in the whole range of teaching. To be taught to read – what is the use of that, if you know not whether what you read is false of true? To be

Opposite: Fig. 26: Anon., The Ruskin School of Drawing, in the Ashmolean Museum, Oxford

taught to write or to speak – but what is the use of speaking if you have nothing to say? To be taught to think – nay, what is the use of being able to think, if you have nothing to think of? But to be taught to see is to gain word and thought at once, and both true. (16.179-80)

Sight was the basis of all understanding, as he explained in his teaching manual for amateur draughtsmen, *The Elements of Drawing*: 'once we see keenly enough, there is very little difficulty in drawing what we see; but, even supposing that this difficulty be still great, I believe that the sight is a more important thing than the drawing; and I would rather teach drawing that my pupils may learn to love Nature, than teach the looking at Nature that they may learn to draw' (15.13).

Clear sight, accuracy of observation of both image *and* word, was a mental discipline that Ruskin taught consistently, and he believed that the best way both to instil that discipline and test the accuracy of a person's perception was through the practice of drawing – hence his decision to teach drawing at the Working Men's College, and then to endow the University of Oxford with a drawing school that continues as the Ruskin School of Art (Fig. 26). Ruskin believed, however, that accurate perception, refined by the practice of drawing, was more than an exercise for the eye, it was also a facility for the mind. Speaking, once again at the opening of an art school – this time St Martin's School of Art in London in 1857 – he was reported as telling the students:

Drawing enabled them to say what they could not otherwise say; and he said, secondly, that drawing enabled them to see what they could not otherwise see. By drawing they actually obtained a power of the eye and a power of the mind wholly different from that known to any other discipline. (16.440)

This remark is significant when we consider modern investigations of visual cognition, which do indeed show that the eye and the brain work dynamically together, and that vision is active engagement, not passive reception. Semir Zeki, Professor of Neurobiology at London University, argues in his book *Inner Vision: An Exploration of Art and the Brain* that one 'sees' with the brain, not the eye, and that what he calls 'the visual brain' is involved in a process of comparing and sorting that amounts to understanding.[1] Ruskin seems to have anticipated this idea when he wrote that sight was a great deal more than the passive reception of visual stimuli; it was: 'an absolutely spiritual phenomenon; accurately, and only to be so defined: and the "Let there be light," is as much, when you understand it, the ordering of intelligence, as the ordering of vision' (22.195).

For Ruskin, to achieve a clarity and nicety of vision, it was necessary to go back to the beginning and recover what he called in *The Elements of Drawing* 'the innocence of the eye':

> The whole technical power of painting depends on our recovery of what may be called the *innocence of the eye*; that is to say, of a sort of childish perception of these flat stains of colour, merely as such, without consciousness of what they signify, – as a blind man would see them suddenly gifted with sight. (15.27n)

But, as Professor Zeki's studies show us, the trouble is that people's eyes are not innocent. Part of the activity of visualisation is the sorting and comparison of remembered images so as to establish a constant version of the things that pass partially and fleetingly before us. A sector of the brain, for instance, is devoted to recognising and reading faces. What we have seen influences what we now see; what we have been taught to see,

shapes our vision. And as we see we also feel and think. Ruskin believed that the unconscious, or semi-conscious ideas that come as we look at things could interfere with the truth of our perception. Discussing Walter Scott's and William Wordsworth's claims to take an unconscious delight in the sight of nature, Ruskin comments that their supposedly spontaneous delight:

> So far from being without thought, is more than half made up of thought, but of thought in so curiously languid and neutralised a condition that they cannot trace it. … And observe, farther [*Ruskin was always asking us to observe*], that this comparative Dimness and Untraceableness of the thoughts which are the sources of our imagination, is not a *fault* in the thoughts, at such a time. It is, on the contrary, a necessary condition of their subordination to the pleasure of Sight. If the thoughts were more distinct we should not *see* so well; and beginning definitely to think, we must comparatively cease to see. (5.355-6)

Ruskin was not against thought, but first it was necessary to see clearly, and the danger is always that false associations will corrupt not only what we think, but what we see. In cultural terms, our eyes can be corrupted by conventions of one kind or another, most especially by the ways in which we are taught to see. That is why Ruskin stood out against not only the conventional tastes that rejected the fresh visions first of Turner and then of the Pre-Raphaelites, but all three of the principal means by which visual perception was formally shaped in the 19th century.[2]

First of all, he rejected the gentleman-amateur tradition of the picturesque, the late 18th and early 19th century watercolour landscape tradition in which he had himself been trained. His sloughing off of this tradition, both as a visual discipline and

a moral attitude, is a crucial part of his critical development during the early 1840s.

Secondly, he became the implacable enemy of the official, government-promoted method for training artists and designers, the so-called South Kensington system managed by the Department of Science and Art. This method, based on the laborious copying in shades of grey and sepia from printed examples supplied by the Department, seemed expressly designed to blind the student to the vividness of nature, while cramping his or her physical response. (Ruskin's battle with South Kensington is described in the following chapter.)

The South Kensington system, where the emphasis was on imparting skills in design, was Ruskin's principal enemy, but he was equally critical of the training of fine artists, as exemplified by what he called the 'base system' for teaching students at the Royal Academy, which, he said: 'destroys the greater number of its pupils altogether; it hinders and paralyses the greatest' (12.153). Part of his original attraction to the young artists who had banded together as the Pre-Raphaelite Brotherhood in 1848 was precisely because they too were in revolt against the teaching they received at the Academy. His reasoning was important, because it went beyond criticising the framing of a conventional neo-classical perception by studying from the antique. The teaching of art began with training the eye and the hand – but it had also to develop the mind. He said in evidence to the Royal Commission on the Royal Academy in 1863 that the influence of the teaching at the Academy was:

> Nearly nugatory: exceedingly painful in this respect, that the teaching of the Academy separates, as the whole idea of the country separates, the notion of art-education from other

education, and when you have made that one fundamental
mistake, all others follow. You teach a young man to manage
his chalk and his brush – not always that – but having done
that, you suppose you have made a painter of him; whereas to
educate a painter is the same thing as to educate a clergyman
or a physician – you must give him a liberal education pri-
marily, and that must be connected with the kind of learning
peculiarly fit for his profession. (14.479-80)

Logically, if for Ruskin the teaching of art is the teaching of
all things, the teaching of artists is the teaching of all things –
'a liberal education'. The extent to which Ruskin's art teaching
was in fact *not* aimed at the production of artists is insufficiently
appreciated. Just as sight preceded drawing, so the training he
proposed preceded the specialisms of fine art. He made this
abundantly clear at the London Working Men's College in the
1850s, and again at Oxford in the 1870s where he said that his
teaching at the Ruskin School of Drawing was 'a course of prac-
tice intended chiefly for students of literature' (20.120).

Ruskin's evidence to the Commission on the Royal Academy
is significant for a further reason. His choice of professions
comparable to that of the artist – clergymen and physicians – is
not arbitrary. Both have social responsibilities, indeed both are
healers, one of the body, the other of the soul, and it is clear that,
whether for practitioners or patrons, the liberal education he
proposed was a moral education. No art teaching, said Ruskin,
summarising his inaugural lecture as Slade Professor at Oxford
in 1870: 'could be of use to you, but would rather be harmful,
unless it was grafted on something deeper than all art' (20.74).

Sight was intended to lead to insight. In 1843, at the age of
24, in the first volume of *Modern Painters*, Ruskin laid down
the guiding principles by which he assessed the values of art.

Boldly, he set out to show that it was the artist's duty to paint the truth. Part of Ruskin's appeal today must be that in our contemporary state of queasy relativism, he had such a confident moral certainty about what the truth was. Truth in art, he said: 'signifies the faithful statement, either to the mind or the senses, of any fact of nature' (3.104). In these post-modern times, facts seem almost as unknowable as truth, but for Ruskin there was less difficulty. These 'facts of nature' could be discovered by diligent visual observation. Nonetheless he was not so naïve as to think that the truth these facts contained was achieved through a simple act of imitation:

> There is a moral as well as material truth, – a truth of impression as well as of form, – of thought as well as of matter; and the truth of impression and thought is a thousand times the more important of the two. (3.104)

He then went further:

> Truth may be stated by any signs or symbols which have a definite signification in the minds of those to whom they are addressed, although such signs be themselves no image nor likeness of anything. Whatever can excite in the mind the conception of certain facts, can give ideas of truth, though it be in no degree the imitation or resemblance of those facts. (3.104)

True sight leads to insight; true insight leads to revelation. This triadic structure corresponds to his theory of the imagination, which he also set out in that same first volume of *Modern Painters*: first, what he called the penetrative imagination saw clearly and deeply, then the associative imagination brought these perceptions towards unity, while the contemplative imagination meditated on and expressed the spiritual, symbolic truths

thus revealed. Mastery of this process, he believed, was what had made Turner the greatest of modern painters.

But these truths are still located in the 'facts of nature', and we will not get very far in understanding Ruskin's system of values if we do not appreciate the extent to which his cultural formation as a son of the Romantic Movement, and his religious training as an Evangelical Protestant led him to see Nature – that is, the entire external world – as the work of God. That is why he said: 'I would rather teach drawing that my pupils may learn to love Nature, than teach the looking at Nature that they may learn to draw' (15.13).

The earth and sky were not there simply for men's delight, nor to abuse and exploit as they thought fit, they were the material expressions of God's creative powers. They were real rocks and real clouds, to be observed with geological and meteorological accuracy, but they were also symbolic at the same time. And even when Ruskin abandoned the narrow paths of his early Evangelicalism, his faith in Nature as an expression of the values of the Creator remained. His horror at Darwin's nihilistic theories is the subject of Chapter XIV.

Faith in Nature is the root of his environmentalism, and there is no better demonstration of Ruskin's belief in the co-existence of the real and the symbolic than his lecture of 1884, 'The Storm-Cloud of the Nineteenth Century'. As a result of his observations of nature, especially of the sky at dawn and sunset, recorded in his diary, Ruskin claimed to detect a new atmospheric phenomenon: 'a plague-wind … panic-struck and feverish; and its sound is a hiss instead of a wail' (34.34). Ruskin was right, there was a new atmospheric phenomenon: industrial pollution, and meteorological records show the skies darkening over England. But for Ruskin it was something more:

Blanched Sun, – blighted grass, – blinded man. – If, in con-
clusion, you ask me for any conceivable cause of meaning of
these things – I can tell you none, according to your modern
beliefs; but I can tell you what meaning it would have borne
to the men of old time. Remember, for the last twenty years,
England, and all foreign nations, either tempting her, or fol-
lowing her, have blasphemed the name of God deliberately
and openly; and have done iniquity by proclamation, every
man doing as much injustice to his brother as it is in his
power to do. (34.40)

By 1884 Ruskin had long made the transition from writer
on art to critic of society, but it was his observation of the place
of man in Nature that brought that transition about – and
that transition had begun well before he formally declared his
position with the publication of his essays on political economy,
Unto This Last, in 1860.

It began when he literally saw through the gentlemanly
conventions of the picturesque. The word picturesque means,
in terms of the art theory that Ruskin had inherited, 'like a
picture', and it was precisely the extent to which he and his
generation had been taught to draw, not what he saw, but what
would look like a picture of what he saw, that at first limited
his vision. What attracted him to the Pre-Raphaelites was their
determination to reject the great tradition of painting that had
been handed down from the time of Raphael – hence their
deliberately provocative self-description as *Pre*-Raphaelites – in
order to achieve what was in fact an entirely modern vision,
going to Nature, in Ruskin's words, 'rejecting nothing, selecting
nothing, and scorning nothing' (3.629).

During the 1840s, as Ruskin began to see for himself, his
social as well as his critical conscience began to be troubled. The

decaying walls, the tumbledown hovels, the ragged clothes of beggars whose interesting textures made them standard subjects of the picturesque were more than mere intriguing challenges for the artist's eye and pencil – they were real signs of decay and distress. The success of Ruskin's father in the sherry trade meant he was comfortably off, but the evidence of his eyes made him uneasy. In 1845 he wrote to his father from Italy about the difficulties he was having as an artist – in this case with the art of poetry:

> I don't see how it is possible for a person who gets up at four, goes to bed at 10, eats ices when he is hot, beef when he is hungry, gets rid of all claims of charity by giving money which he hasn't earned – and those of compassion by treating all distress more as picturesque than as real – I don't see how it is at all possible for such a person to write good poetry. (1845L.142)

'More as picturesque than as real' is the key phrase, and it is what lies behind his evocation of man in nature in a Highland scene he describes in *Modern Painters*: 'At the turn of the brook I see a man fishing, with a boy and a dog – a picturesque and pretty group enough, certainly, if they had not been there all day starving' (7.269).

From man in nature it is a short step to man in society, and it was through art that Ruskin made that progression. In this case, it was through what Ruskin called the 'magnificently human art' (8.116) of architecture. As we saw in Chapter IV, Ruskin was initially drawn into the field of architectural criticism by his Protestantism, which led him to oppose the High Church tendencies of the Gothic Revival, but he found that he could not understand architecture without understanding the society that collectively produced it.

And as we saw in Chapter V, for Ruskin, the society that represented the extremes both of virtue and vice in architecture was that of Venice, but Venice seen through the contemporary lens of 19th century Britain. In Ruskin's eyes, England was as likely to succumb to the temptations of luxury and exploitation as Venice had done:

> We have much studied and much perfected, of late, the great civilised invention of the division of labour; only we give it a false name. It is not, truly speaking, the labour that is divided, but the men: – Divided into mere segments of men – broken into small fragments and crumbs of life; so that all the little piece of intelligence that is left in a man is not enough to make a pin, or a nail, but exhausts itself in making the point of a pin or the head of a nail. Now it is a good and desirable thing, truly, to make many pins in a day; but if we could only see with what crystal sand their points were polished, – sand of human soul, much to be magnified before it can be discerned for what it is – we should think there might be some loss in it also. (10.196)

It was not until 1860 that Ruskin completed his journey from art to social critic with the publication in essay-form of his attack on utilitarian economics in *Unto This Last*, discussed in my concluding chapter. It is one thing to see and record the condition of man in society, and another imaginatively to penetrate to the root causes of that condition. In Ruskin's case this was done in the most extraordinary way, through art, specifically, through æsthetics. In the final volume of *Modern Painters* he tackled a subject that he admitted he had previously neglected: the function of composition in painting.

In accordance with his Romantic and organic æsthetic,

formal composition was not a matter for rules, instead it was best defined as 'the help of everything in the picture by everything else' (7.205). This principle, which Ruskin promulgated as 'the Law of Help', is not as simple as it sounds. Everything that worked together in a picture, that made it cohere, gave it life. Take away the mutually coherent elements in a picture, or fill it with elements that clashed, and it became dead. Ruskin continues: 'Government and co-operation are in all things, and eternally the laws of life. Anarchy and competition, eternally, and in all things, the laws of death' (7.207).

Ruskin is discussing formal composition in painting, how the various visual elements in a picture work together, but, as will be further discussed in my concluding chapter, in order to convey this purely æsthetic principle, he chooses to use a political metaphor – the disharmony of Anarchy, the destructiveness of capitalist competition. When he came to write directly about political economy in *Unto This Last*, it was this same passage that seemed best to express what he was trying to say. In *Unto This Last* he writes that his principles of Political Economy 'were all summed in a single sentence in the last volume of *Modern Painters* – "Government and co-operation are in all things the Laws of Life; Anarchy and competition the Laws of Death"' (17.75). In what is in effect a visual rather than a verbal transition, the same metaphor is applied equally to painting and politics.

In her penetrating conclusion to *Ruskin and the Art of the Beholder* Elizabeth Helsinger demonstrates: 'Ruskin's commitment to the ideal of a composite art, a poetry using visual and verbal language together'.[3] This composite art, which sometimes combines verbal and visual allusions with actual illustrations, begins to emerge towards the end of *Modern Painters* volume five, just at the point where the Law of Help is promulgated.

This form of writing is not the powerful descriptive prose of earlier volumes of *Modern Painters*, where Ruskin's acute visual perception is translated into verbal equivalents of paintings and landscape. Helsinger defines it as 'emblematic ... sometime working as the literary complement to pictures, at other times embodying in itself the interplay of visual and verbal form'.[4] This poetic prose becomes a landscape where verbal and visual emblems carry the argument. It is the third stage in the imaginative process, where having seen keenly, the mind brings these perceptions towards a unity that can be expressed in symbolic – or, if you prefer, emblematic form.

There are difficulties in Ruskin's visual form of ratiocination, though learning to read it and see what it means is richly rewarding. It is, for instance, a language that is not, at least at first sight, appropriate to the technical intricacies of economic theory. Ruskin was unrepentant. He once boasted that he had never read a work of economics, except Adam Smith, though, as we shall see in Chapter XVII, that is not strictly true. But Ruskin was not interested in engaging the economists in their own language. What he was trying to do was confront them with the evidence of their own eyes – that the gathering storm-cloud of the 19th century was destroying the environment and causing deprivation and suffering for millions of men and women. It was a struggle between Life, representing human virtue and potential, and Death, representing human folly and greed. Life and Death, which when his writings are closely examined turn out to be the core concepts in all his arguments, have their visual counterparts in Light and Darkness, two of the ruling images in his work.[5]

By the time Ruskin gave his inaugural lecture as Oxford's first Slade Professor of Fine Art in February 1870 – and therefore took on the formal mantle of a teacher of art, the synthesis

between the values of art and the values of society was complete. Visual observation had led to social observation; and, as he had begun to argue in *The Stones of Venice*, it was not possible to have good art without a good society. As he declared in the peroration to his inaugural lecture:

> This is what I have chiefly to say to you. The art of any country *is the exponent of its social and political virtues*. I will show you that it is so in some detail, in … my subsequent course of lectures; meantime accept this as one of the things, and the most important of all things, I can positively declare to you. The art, or general productive and formative energy, of any country, is an exact exponent of its ethical life. You can have noble art only from noble persons, associated under laws fitted to their time and circumstances. And the best skill that any teacher of art could spend here in your help would not end in enabling you even so much as rightly to draw the water-lilies of the Cherwell (and though it did, the work when done would not be worth the lilies themselves) unless both he and you were seeking, as I trust we shall together seek, in the laws which regulate the finest industries, the clue to the laws which regulate *all* industries, and in better obedience to which we shall actually have henceforward to live: not merely in compliance with our own sense of what is right, but under the weight of quite literal necessity. (20.39-40)

These were the principles that underlie the essential coherence between what Ruskin taught in his drawing classes in the school he proceeded to found, what he taught in his lectures as Slade Professor, and what he wrote in *Fors Clavigera* as a means of reaching beyond Oxford, and which became the means of launching the Guild of St George.

And so, in true Ruskinian manner, our journey comes full circle, to Ruskin as a teacher of all things – but all those things framed by the visual dimension of art. In April 1877, the month after he published the issue of *Fors Clavigera* in which he made that apparently casual, but profoundly significant remark, Ruskin published the first part of what he sometimes referred to as the fourth volume of *The Stones of Venice, St Mark's Rest.* He introduced it with these words:

> Great nations write their autobiographies in three manuscripts; – the book of their deeds, the book of their words, and the book of their art. None of these books can be understood unless we read the two others; but of the three, the only quite trustworthy one is the last. (24.203)

As Ruskin also said:

> The greatest thing a human soul ever does in this world is to *see* something, and tell what it *saw* in a plain way. Hundreds of people can talk for one who can think, but thousands can think for one who can see. To see clearly is poetry, prophecy, and religion, – all in one. (5.333)

Ruskin began his life as a poet. He ended it as a prophet. Nature was fundamental to his religion, for it showed him the splendour of Creation, and bore visual witness to the miseries that 19th century economic individualism generated in its lust for wealth. Art, as a response to nature, was the expression of Life. So when Ruskin said that the 'teaching of art is, as I understand it, the teaching of all things', it is possible to see what he meant.

Based on a lecture given for the Ruskin School of Drawing and Fine Art, 2001

CHAPTER X

STRAIGHT LINES OR CURVED?
RUSKIN AND HENRY COLE

ↂ

Ruskin's objections to the system of art teaching imposed by the government's Department of Science and Practical Art – the so-called South Kensington system – have featured in the previous two chapters. But these objections were more than technical or æsthetic, they were at the heart of Ruskin's criticism of utilitarian thinking, both economic and social. The South Kensington system was largely the creation of one man, Henry Cole. Like Ruskin, Cole earned the right to be described as a Great Victorian, but his and Ruskin's attitudes and ambitions were so diametrically opposed as to represent the longitude and latitude of Victorian cultural values.

Cole was a generation older than Ruskin, born in 1807, dying in 1882. This age difference is somewhat balanced, however, by Ruskin's withdrawal into silence after 1889, and the fact that both came into prominence in the early 1840s, a time of social and economic distress when industrialization and the expansion of British cities raised important issues of morality and æsthetics for architecture and design. Their intertwined legacies expose issues that emerged in the developing conditions of industrial production in the 19th century.

Both were larger-than-life personalities, figures who not only shaped their own age, but who left an intellectual and institutional legacy as reformers. Ruskin – 'the Professor' – became

Opposite: Fig. 27: Leslie Ward ('Spy'), Caricature of Henry Cole, Vanity Fair, *1871*

a Victorian sage who dedicated himself first to the reform of the Victorian visual economy, and then to the reform of the nation's moral and political economy as a whole. Cole – 'King Cole' – was a man of administrative action, whose achievements not only include London's early cultural quarter 'Albertopolis', where he built the Victoria and Albert Museum and the Royal Albert Hall of the Arts and Sciences, but also the institution of the Public Record Office, the establishment of the Penny Post, reform of patent law, fixing the standard railway gauge – and founding the National Training School for Cookery.

Both had an interest in that great, now much neglected Victorian legacy, drains – Ruskin with his schemes to dam the waters of the Alps, Cole with his unhappy involvement with Scott's Sewage Company, of which he became Managing Director on his retirement in 1873 from the South Kensington Museum, renamed the Victoria & Albert Museum in 1899. Both wrote for children: Ruskin's *The King of the Golden River* remains in print to this day; Cole published a series of picture books under the genial *nom-de-plume* of Felix Summerly.

As reformers, both had to be communicators. In the 1850s Ruskin discovered his power as an enthralling lecturer, and the force of his personality energized his arguments. The much-expanded medium of the press played an important part in their efforts to influence people. Like Cole, Ruskin was an inveterate writer to the newspapers, though unlike Cole, he was not in the habit of answering his own letters under other, assumed, names. Cole, thanks to his family lodging in the house of the novelist and man of letters Thomas Love Peacock, had early experience as a theatre, music and art critic, and was in the habit of launching newspapers and journals to promote his ideas. Ruskin published his first articles on architecture as an

undergraduate. In 1871 he launched his own public newsletter, *Fors Clavigera*.

Cole fully understood, much better than Ruskin, the art of public relations. He describes in his uncompleted memoirs, *Fifty Years of Public Work*, how: 'the proprietors in the London and North Western Railway engaged my services to create a public opinion to support Uniformity of Gauge as best for national interests'.[1] It was Cole who ensured that the Press should have free tickets to the Great Exhibition.

Both men, as forceful characters, could be hated. Cole's daughter describes him as 'acting more or less as a despot with plenary powers on various occasions' over the dispositions of Albertopolis.[2] During his campaign to promote the building of the Royal Albert Hall in the 1860s, the Prime Minister Lord Derby described Cole as 'the most generally unpopular man I know'.[3] *The Birmingham Town Crier* satirised his sewage schemes:

> Sir Henry Cole was a funny old soul
> A funny old soul was he:
> His hat and his locks
> His collar and stocks
> Proclaimed him a rarity.[4]

Ruskin's views on art, as well as his views on political economy, could make him unpopular too. In 1856 *Punch* published the following 'Poem by a Perfectly Furious Academician'

> I takes and paints
> Hears no complaints
> And sells before I'm dry;
> Till savage Ruskin
> Sticks his tusks in
> Then nobody will buy. (14.xxvii)

Both were, in the best sense, amateur artists, though Ruskin was undoubtedly the greater of the two. Cole had drawing lessons from David Cox – an artist collected by Ruskin's father – and attended lectures at the Royal Academy, though he found Turner's lectures on perspective 'almost perfection in mumbling and unintelligibility'.[5] Ruskin – for whom, as we have seen, Turner was hero and friend – was taught by the best drawing masters of his day. This personal experience of art helps to explain their belief in art as a vehicle for reform, though their opinions on what kind of art that should be diverged. Arguably, Cole was the father of today's Creative Industries: he boastfully records in his memoirs: 'I believe I originated, in 1845, the term "Art Manufactures", meaning Fine Art, or beauty applied to mechanical production'.[6] This was something Ruskin was instinctively against, and would have regarded as an oxymoron.

In both cases, whatever the difference of definition, they believed in the redemptive possibilities offered by access to good art and architecture for members of the working class. They concurred that the fundamental means of understanding and appreciating art was through the practice of drawing. Both established drawing schools: Ruskin his School of Drawing at Oxford in the 1870s, Cole the national system of art education formulated in the 1850s, of which the national training school was to become the Royal College of Art. And both believed in the concomitant value of museums as teaching institutions and places of moral recreation. While the Victoria and Albert Museum has its origins in Cole's decision to form a Museum of Ornamental Art following the Great Exhibition, Ruskin's modest Museum of the Guild of St George, now re-housed in the Millennium Galleries in Sheffield, was just a fragment of a grand design.

An important social factor that these young men had in

common was that they were both, in class terms, *bourgeois*. Cole was the son of a Dragoon officer wounded in a street riot in Dublin who as a result of his injuries was forced to become a recruiting officer, and later a coal merchant. Ruskin was altogether wealthier, but his origins were also modest. Cole was poor, but gained a scholarship to Christ's Hospital in London where he learned a good enough writing hand to secure, in 1823, the position of a copyist in the Record Commission, the start of his civil service career.

As members of the rising middle classes, the key moment for both of them was the passage of the Reform Act of 1832, which did away with a decayed and corrupt system of Parliamentary representation. This was the symbolic moment of the entry into power and at least partial enfranchisement of a new class with new attitudes, and new tastes. It is here that the differences appear.

As the older man, Cole was the one who experienced most directly the political ferment and agitation that preceded the passage of the Reform Bill. Cole was closely connected to the promoters of the Bill, the so-called Philosophic Radicals grouped around James Mill, and his son John Stuart Mill. Cole was introduced to Mill by his landlord Thomas Love Peacock, who like Mill and his father was an official at East India House. They first met on 7th November 1826, not long after Mill's nervous breakdown as a result of the rigorous education imposed on him by his father.

Thus Cole joined Mill's circle at the beginning of the second stage of the Utilitarian project, when Mill's liberalism began to influence the management of government. Although Jeremy Bentham's principles for administrative reform are mentioned almost immediately in Cole's memoirs,[7] Cole was not oppressively

Benthamite. He did read the French theorist of industrialism, Henri de Saint-Simon, an influence on Mill, but an entry in his diary for 7th January 1831 casts an interesting light on his views: 'In the evening reading a review of Tennyson's poems in the W. R. [The *Westminster Review,* organ of utilitarianism]. The reviewer is a utilitarian and like the rest of that species knows little of poetical criticism or poetry itself'. The source of this opinion must have been Mill, who had cured his depression by reading Wordsworth, and offended his stricter friends by asserting the virtues of his poetry in their debating society. Cole likewise read Wordsworth and Coleridge, and joined Mill on his 1831 walking tour in the Lake District, when Mill met and dined with Wordsworth. Cole, however, being too young, or too undistinguished, had to stay behind at their lodgings.

Cole's, then, was what Raymond Williams has called 'the humanized Utilitarianism' of John Stuart Mill.[8] After that first meeting in 1826 he saw Mill frequently until some years after the passage of the Reform Act. He joined Mill's debating society, and attended the early morning political discussion group led by the historian George Grote. Through Mill he met the future administrative reformers and radical MPs of the post-1832 era. The group became Cole's informal university as he was caught up in the fervour of the Reform Bill years. He joined the pro-Reform Act National Political Union on its formation in November 1831, and it was in 1832 that he began his own campaign for a reform of the public records, administered by the Record Commission. His diary for 7th June 1832 reads: 'The King's assent was given to the Reform Bill which shortens his or his successors' notice to quit by some years'. These apparently republican sentiments did not, however, prevent Cole from later hitching his star to the Royal Consort, Prince Albert.

Ruskin was only thirteen in 1832, but as we saw in Chapter IV, his political formation, with its Scottish Tory background, was quite different to Cole's. The Ruskins were closely connected to a group of Ultra-Tory Evangelicals who rejected the Reform Act and much of his romantic anti-capitalism stems from these Ultra-Tory roots. There was an early, though indirect, brush with Cole on this score. One of the parliamentary leaders of the Ultra-Tories was the Evangelical Member for Oxford University, Sir Robert Inglis, who was friendly with the Ruskins. Inglis was also a member of the Record Commission, and gave Cole the most trouble when Cole, sacked from the Commission for his criticisms of its jobbery and corruption, was pushing for reform through a Parliamentary Select Committee.

Religion is another difference between the Romantic and the Utilitarian: faith – and the difficulties of sustaining it – was absolutely central to Ruskin's ideology, while Cole was a conventional churchgoer. According to his biographer Elizabeth Bonython: 'He always said ... he had become an agnostic, while a very young man, under the influence of Thomas Love Peacock.'[9] Cole's agnosticism, however, did not prevent him putting some of his spare energies into instituting weekday musical church services at Holy Trinity, Brompton, next door to the South Kensington Museum, for the particular benefit of the working classes.

Even before the building of Paxton's Crystal Palace, home of Cole's masterwork, the Great Exhibition of 1851, Cole had triumphed over political reaction, and with the aid of Mill and his radical contacts in the House of Commons, had helped to secure the establishment of the Public Record Office as an exemplary government institution. He had also straightened out the matter of a standard railway gauge and contributed to the

creation of the Penny Post. As a reformer, he had found his true vocation: the reform of design. And since design had to be done by somebody, it was necessary to reform public art education. This was entirely consistent with the utilitarian worldview. The economic rationale was that the country needed good design, while art education had to be wrested from the *ancien regime* of the Royal Academy and its schools. Cole told a Select Committee in 1849: 'I think to act upon the principle of "every one to his own taste", could be as mischievous as "every one to his own morals".'[10]

Much more than an administrator, Cole had become a cultural entrepreneur. In 1846 he joined the moribund Society for the encouragement of Arts, Manufactures and Commerce, and helped to revive it with a series of exhibitions of – as he had christened them – 'art manufactures'. He also went into business with Felix Summerly's Art Manufactures. His prize-winning design for a tea service helped to seal an alliance between Cole and the President of the Society of Arts, who just happened to be Queen Victoria's husband, Prince Albert. Together, they brought the Great Exhibition – what the architectural historian Jules Lubbock has called 'the transformation of Smith's *The Wealth of Nations* into a tableau' – into being.[11] With his typical administrative precision, Cole noted that during the course of the Exhibition in Hyde Park the public had consumed 1,800,000 buns. If only Cole had been placed in charge of the Millennium Dome in 2000.

Ruskin was sceptical, rather than outright hostile, towards what he described as 'a greenhouse larger than any greenhouse built before' (12.456). He was in the middle of writing *The Stones of Venice*, and he began the second volume on the very day the Great Exhibition opened. Effie went to the opening on her own.

Apart from some passing comments, Ruskin remained silent on the Great Exhibition until 1854, by which time the building had been re-erected at Sydenham – possibly uncomfortably close to Ruskin's home on Denmark Hill. He was actually in Switzerland when reports of the move inspired him to publish a pamphlet, *The Opening of the Crystal Palace, considered in some of its relations to the prospects of art.*

Typically, this is not really about the Crystal Palace at all, but he comments on the direction in which Cole's great achievement appeared to be leading: 'It is impossible, I repeat, to estimate the influence of such an institution on the minds of the working-classes', he writes (12.418):

> Let it not be thought that I would depreciate (were it possible to depreciate) the mechanical ingenuity which has been displayed in the erection of the Crystal Palace, or that I underrate the effect which its vastness may continue to produce on the popular imagination. But the mechanical ingenuity which has been displayed is *not* the essence of either painting or architecture, and largeness of dimension does not necessarily involve nobleness of design. (12.419)

In Ruskin's terms, this was building, not architecture, since it lacked expression. (He did, however, as we will see in Chapter XIV, countenance the use of iron in the construction of that truly Ruskinian Gothic building, the Oxford Museum, where the wrought-iron capitals express his organic æsthetic.)

What concerned Ruskin was that the Crystal Palace's modernity might cause people to neglect the past. He remarks that Turner had died in 1851, and that his great legacy, giving his works to the nation, was still stuck in a law dispute in Chancery because of the objections of Turner's relatives. Ruskin then

makes an explicit reference to Venice as he had seen it in 1851: 'When all that glittering [Crystal Palace] roof was built, in order to exhibit the paltry arts of our fashionable luxury – the carved bedsteads of Vienna, and glued toys of Switzerland, and gay jewellery of France – that very year, I say, the greatest pictures of the Venetian masters were rotting at Venice in the rain, for want of roof to cover them, with holes made by cannon shot through their canvas' (12.420-1). He is referring to the Austrian bombardment following the Venetian uprising in 1848, which dropped cannon balls through the roof of the Scuola di San Rocco, home to Tintoretto's great cycle of masterpieces. This lack of concern for the past extended to the contemporary vogue for restoration, and Ruskin concludes with an eloquent protest against the restorations then taking place, and calls for the formation of a society that would preserve buildings for public good rather than private pleasure – a call heeded by William Morris in 1877.

The contrast between the Crystal Palace and the Ducal Palace is legitimate, for they represent two different kinds of society. For Cole it was indeed an instrumental society, a society for getting on, even if the workingman and the shilling ticket holder were included in the scheme. Ruskin's was a conservative image, of an organic society of rights and duties. Cole's Crystal Palace represented an industrial meritocracy that looked forward to modernity; Ruskin's Ducal Palace a closed oligarchy that looked back to an imagined medieval past.

꙳ ꙳ ꙳

So, a utilitarian view on the one hand, an ultra-Tory one on the other. Yet when it came to what both men saw as essential to the

well-being of their societies, that is to say, creativity, from the moment Ruskin published the central chapter of *The Stones of Venice*, 'On the Nature of Gothic' in 1853, it was Ruskin who had the more radical position. This can be demonstrated by a brief account of Cole and Ruskin's direct dealings with each other.

On 19th December 1849 Ruskin wrote a somewhat cool letter to Cole, thanking him for sending a review of *The Seven Lamps of Architecture*, which had appeared in Cole's latest propaganda vehicle, *The Journal of Design and Manufactures*, in October (36.105). The review is anonymous, but Ruskin's letter implies that Cole had written it, as seems very likely. It shows that at this stage the two men were not so far apart. It approves of Ruskin's dislike of 'shams' and advocacy of truth in the use of materials:

> But with very sincere admiration for portions of this work, and for its excellent spirit generally, we think Mr Ruskin is often led to take narrow and half views, especially of many existing and inevitable circumstances which influence art at the present time. He seems to us to have altogether a very lopsided view of railways and railway architecture, and not to have any consistent theory of mechanical repetition as applied to art.[12]

The review concludes: '[Ruskin's] work is a most useful one, but to understand what shape his eloquent doctrines *practically* take see his illustrations – dreamy blotches – and his fantastic book cover'.[13] This is very much the Crystal Palace view of the world to which Ruskin became more and more opposed. His 1854 pamphlet, *The Opening of the Crystal Palace*, might even be a reply.

In 1856 it was Ruskin's turn to go on the offensive against Cole. Following the success of the Great Exhibition, Cole had

been placed in charge of the Government's Department of Science and Practical Art, with the remit to reform the national schools of design originally established in 1836. Initially located in Marlborough House, it was there that Cole opened his first museum, the Museum of Ornamental Art, based on exhibits purchased from the Great Exhibition. Richard Redgrave, RA, became superintendent of the Schools of Design.

On occasion, Ruskin would attend the meetings of the Society of Arts, which Cole continued to use as a platform for his projects. On 12th March 1856 Ruskin went to hear a paper by the headmaster of the Birmingham School of Art, George Wallis. Wallis had in passing deprecated the continuing preference among ladies for floral carpets, instead of the very best geometric designs available. Ruskin rose to chide Wallis for his 'ungallant attack upon the ladies' (16.427).

What might be called 'the case of the figure in the carpet' goes to the heart of different principles of design, in which Ruskin and Cole appear on different sides. Originally, Cole, like his colleague Richard Redgrave, who as his Art Superintendent put into practice South Kensington's principles, began as a naturalist, limiting his Benthamite design rules to ensuring that the decorative features derived from natural imagery did not interfere with the practical purposes of the object – as in his Summerly tea service. But Cole and Redgrave's experience at the Great Exhibition changed all that, and they switched sides, to promote a non-naturalist æsthetic that had its roots in the abstractions of classicism.

As someone steeped in natural theology, which treated nature as God's design, Ruskin was by contrast a naturalist. His argument for the virtues of Gothic architecture was that the style had flourished as compensation for the loss of association

with nature when men clustered in towns. Gothic ornament was rooted in nature, though that did not exclude a degree of abstraction. In *The Stones of Venice* he published a plate, 'Abstract Lines', to show that the most beautiful lines were already present in nature, from the curve of a glacier to the edge of a leaf. The classical sources of Cole's conventionalism were the heathen forms that had corrupted the Renaissance and enslaved the artisan.

In spite of this skirmish, Ruskin and Cole appeared to be friendly. Cole's diary records an 'At Home' at Lord Ashburton's on 10th May 1856: 'Ruskin said he thought we were "Popes" of doctrine at the Department and glad to hear we were beginning with Elementary Drawing.' Ruskin had reason to be polite, for he and Cole must have seen a good deal of each other at this time. By one of those accidents of fate, when the Turner bequest was released from its legal entanglements in Chancery, the National Gallery exhibited a selection of pictures at Marl-borough House – and Ruskin supplied the catalogue notes. Ralph Wornum, future Keeper of the National Gallery and alleged burner with Ruskin of Turner's erotic drawings, had originally been employed by Cole. On 10th February 1857 Cole's diary records a day at the office: 'Ruskin came and examined all the drawings carefully. Would be glad to assist, especially in promoting Natural History'. In letters to two different cor-respondents at this time Ruskin describes 'the Marlborough House people' as 'fraternizing' with him.[14] In July 1858 he went as far as telling his father that he hoped: 'to get my system taught at Marlborough House' (16.xxix).

But that was not to be. By 'my system' Ruskin meant the freer, nature-based approach he used at his own drawing classes at the London Working Men's College. There he saw the work of

students who had attended classes at Cole's Schools of Design, and on 13th January 1858 he took the battle to the enemy with a lecture in the newly opened, but still provisionally housed, museum at South Kensington. The occasion was the opening of the Architectural Museum, a separate institution that Ruskin had sponsored since its creation in 1850, and to whose collection of architectural casts, some of them donated by Ruskin, Cole was giving temporary house-room.

Ruskin's lecture 'On The Deteriorative Power of Conventional Art over Nations' turned on the distinction between naturalistic and conventionalising, abstract design, and was particularly critical of Indian design, which had been a revelation to Cole at the Great Exhibition, many examples of which he had acquired for his museum. Cole was present, and noted Ruskin's theme in his diary, and that it was a 'Full meeting'. But he clearly did not like what he heard. According to *The Times*, that year's annual report of the Department of Science and Practical Art stated that: 'in allowing certain persons, including Mr Ruskin, the author, to give illustrative lectures, the department is not responsible for their opinions'.[15]

There was another cause of friction between Ruskin and Cole. When the Marlborough House collections moved to South Kensington, the Turner watercolours that Ruskin had taken such pains to conserve and catalogue went too, and were hung in galleries illuminated by gas. On 29th April Cole noted in his diary: 'To private view of Royal Academy. A high average of interesting pictures. Ruskin asked if we were "Baking" the pictures, and if Turner's drawings had become white'.

When Ruskin and Cole's Art Superintendant, Richard Redgrave, shared a platform at the inauguration of the Cambridge School of Art on 29th October 1858, fraternization was over. By

this time Cole and Redgrave had turned the teaching of design into a magnificently self-perpetuating, self-financing system that reached from the National School at South Kensington through branch schools in every manufacturing town, right down to classes in elementary schools. The system trained up students who graduated as art teachers who could then go back and teach more students. Considerable income was drawn from the fees paid by middle-class students. At Cambridge, Redgrave announced:

> Under the old, exclusive system [that is to say, one exclusively devoted to artisans, and excluding classes for children or fee paying young ladies and gentlemen] nineteen schools were established, and about three thousand artisans availed themselves thereof; the cost to the state per man averaged three pounds two shillings and fourpence; in some cases – at Leeds for instance – the cost was seven pounds. Under the new system, up to 1856, the number of Art Schools amounted to sixty, and there were forty-two thousand, four hundred and twenty-six scholars, the average cost per head being only thirteen shillings, one penny three-farthings.[16]

For those concerned with university teaching today, these calculations have a strangely contemporary ring.

In a memoir, Redgrave writes that while the actual teaching system was his creation: 'Cole's clever invention of rules, his administrative abilities, his self-assertion have been wonderful co-agents; as without his firmness of purpose I should never have succeeded in carrying the system through'.[17] Redgrave and Cole believed that it was as important to be able to draw as to read and write. Ruskin believed that too, but in order to manage their vast system, it was necessary to impose a uniformity on

the teaching that must have crushed nearly all tendrils of individual creativity, which for Ruskin was the moral purpose of the exercise.

The National Course for Instruction was a rigid twenty-two stage series of exercises that led from the elementary school class up to South Kensington. The vast majority of students would be involved in laboriously copying from two-dimensional reproductions, using examples of decoration printed and distributed by the Department. An examination had to be passed before going on to the next stage, and most pupils were on stages one to ten, with up to half at stage two. The Primary Course omitted all drawing from life, landscape or natural objects. It was a rigorous training for the hand and eye, but death to the imagination.

During the 1860s, as Cole's system spread its tentacles across the land, Ruskin turned his attention from the visual economy to the political economy that sustained it. His lectures on art, such as the two entitled, *The Political Economy of Art*, given during the Manchester Art Treasures Exhibition of 1857, signalled the change of direction that led to the publication of his articles *Unto This Last* in 1860. Here Cole's friend John Stuart Mill was the emblematic target of Ruskin's attacks on *laissez-faire* economics and the exclusion of the moral calculus from notions of value. What mattered to Ruskin was value in use, not value in exchange, a principle that can be translated into a view of architecture and design.

Ruskin's economic views were largely ridiculed and rejected at the time of their first publication. But in 1869 he at last was given what he regarded as an official platform from which to promulgate his ideas, when he was elected as the first Slade Professor of Fine Art at Oxford. At his inaugural lecture in 1870 he

announced that he intended to *teach* art, as well as talk about it – and from this came Ruskin's answer to Cole, the Ruskin School of Drawing.

From this also came many of Ruskin's woes. The reason was that a branch school of the government system, the Oxford School of Science and Art, was already established in the University Galleries, where he intended to teach, and it was backed by the very same university politicians who had secured his own election. The school taught artisans – mainly boys and apprentices – as well as Ladies, Governesses, and Gentlemen. The Art Master, Alexander MacDonald, was a product of the South Kensington system. In 1871 Ruskin announced in *Fors Clavigera*: 'After carefully considering the operation of the Kensington system of Art-teaching throughout the country, and watching for two years its effects on various classes of students at Oxford, I became finally convinced that it fell short of its objects in more than one vital particular' (27.159), and he went on to explain that he had obtained permission to start his own school on his own lines.

Unfortunately, as is the way with universities, Ruskin's idea was fatally compromised by institutional politics. His backers insisted that the first Ruskin Drawing Master, funded out of Ruskin's own money, should be none other than Alexander Mac-Donald. Secondly, while the teaching of undergraduates in 'The Professor's Class' and of the middle classes in the 'Town Class' were reformed on Ruskinian lines, with the study of nature and the enjoyment of art as its primary motives, Ruskin was forced to allow the continuation of the government's 'artisans' class, taught on the South Kensington system, in the basement, by gaslight.

There are many reasons for the failure of Ruskin to achieve

his ambitions with his Drawing School – though the School thrives to this day. He had over-expended his energies in his attempts to reform Victorian society, such as the Guild of St George. At least some of his failure can be accounted for by the power of the national institution he had set himself up against. In July 1877 Ruskin told his readers in *Fors Clavigera*: 'The Professorship of Sir Henry Cole at Kensington has corrupted the system of art-teaching all over England into a state of abortion and falsehood from which it will take twenty years to recover' (29.154). Earlier that year he had had his first complete mental breakdown, and in 1878 resigned his Professorship, although he was to return from 1883 to 1885.

Cole had retired from South Kensington in 1873, – by which time the South Kensington empire had expanded to 120 schools – but that clearly had not assuaged Ruskin's animosity. Cole made no reply at the time – possibly because he was not a subscriber to *Fors Clavigera*. But the following year, on 28th November 1878, Cole travelled to Portsmouth for the prize-giving at the government School of Art. He wrote in his diary: 'Ruskin's abuse of me made a good text. Speech much applauded, and the Committee well pleased. Ruskin's attack on me was a source of fun'. We would not know which of Ruskin's attacks this was, had not Cole helpfully glued into his diary an extract from a court report from the previous day's *Times*.

The case in question was one of the great trials of the Victorian period, one that marks a cultural watershed, when Victorian moral authority is challenged, and defeated, by a new, amoral æstheticism. It is *Whistler versus Ruskin*, which had opened on 25th November 1878. Ruskin had written in *Fors Clavigera* that for Whistler to charge 200 guineas for paintings such as *The Falling Rocket* was like 'flinging a pot of paint in the public's face'

(29.160). In order to prove the 'personal and malicious' tone of *Fors*, Whistler's counsel, Sergeant Barry, cited other passages:

> In the same publication he twice described Professor Gordon Smith as a 'goose' – (Laughter in court) – and spoke of the Presidency of Sir Henry Cole at Kensington as having 'corrupted the system of art-teaching all over England into a state of abortion and falsehood from which it will take twenty years to recover'. (Laughter). That was pleasant for Sir Henry Cole. (Laughter).[18]

It may have been, as Cole remarked in his diary, 'a source of fun', but for Ruskin it was not. He had been unable to attend the trial because of his breakdown, and the verdict against him was another cause for resignation from Oxford. Ruskin's personal star began to wane from this point.

<center>⚜ ⚜ ⚜</center>

In the short run, it would appear that Cole had the greater success in his lifetime, and has left the larger legacy, notably the Albert Hall, which Cole had constructed, not in the Ruskinian Byzantine-Gothic proposed by Gilbert Scott, but the Renaissance style that Ruskin abhorred. Cole knew how to get things done, while Ruskin's dealing with institutions, even the ones he created himself, ended in failure.

And yet.

The National Course of Instruction was abandoned in the 1890s. In 1896 the National Art Training School changed its name to the Royal College of Art, and in the words of Christopher Frayling's history of the College 'The Art Workers' Guild Takes Over'[19] – notably with the appointment of the Ruskin

and Morris-influenced William Lethaby as the College's first Professor of Design in 1901. Ruskin's 'twenty years to recover' had come to pass, and it was Ruskin's 'arts and crafts' rather than Cole's 'art-manufactures' that became the æsthetic legacy that shaped the early 20th century.

So too – and paradoxically – with politics. When in the 1880s and 1890s the newly-enfranchised and better-educated artisan class broke their traditional concordat with the Liberal Party and sought their own voice, the language they found was Ruskin's. *Unto This Last*, which had sold fewer than a thousand copies in the 1860s, sold in hundreds of thousands, and became a shaping text for the founders of the Labour Party. Ruskin's Tory anti-capitalism ultimately inspired a democratic socialism that sought to soften the harshness of industrial exploitation and provide every citizen with the cultural and educational resources that would overcome the alienation of modern life.

Cole once said: 'Straight lines are a national want'.[20] Ruskin sought national revival through the curving, organic forms of the Gothic. These two traditions, the utilitarian and the romantic anti-capitalist, the rationalist and the imaginative, are as present in the 21st century as they were in the 19th.

In death, there is one final link between Ruskin and Cole. In April 1882, Henry Cole, then aged seventy-three, was as busy as ever, but he had over-exerted himself. In spite of feeling unwell, he insisted on turning up for a sitting for his portrait. After the sitting he had a seizure, and died the following day. The artist working on this unfinished portrait was James McNeil Whistler. Thus Whistler, victor over Ruskin in the law courts, harbinger of 20th century modernism, can be said to have been the nemesis of not one, but two, truly Great Victorians.

Revised from 'Straight lines or curved? The Victorian Values of John Ruskin and Henry Cole' in Architecture and Capitalism, *ed. Peggy Deamer, Routledge, 2014.*

CHAPTER XI

'COMMUNISM AND ART': RUSKIN, SHEFFIELD AND THE GUILD OF ST GEORGE

⌘

On Friday, 28th April 1876, the following report appeared on page three of the *Sheffield Daily Telegraph*:

> MR RUSKIN IN SHEFFIELD
>
> COMMUNISM AND ART
>
> Last evening, about twenty persons assembled at the New Museum established by Mr Ruskin, at Walkley, for the purpose of hearing Mr Ruskin's opinions on various subjects, and of giving their own. Amongst those present were six ladies. The proceedings were chiefly of a conversational nature, and no set speech on any one of the several subjects dealt with was given. Primarily, the subject of Communism came up, and its most extreme principles were freely and enthusiastically advocated by one or two of those present.[1]

This newspaper account is among the earliest public recognitions of Ruskin's association with Sheffield. The event reported was one of the first manifestations of his practical work for the society that he was in the process of forming, the Guild of St George, and it records the beginnings of an important and on-going connection between the Guild and Sheffield.

As seen though the eyes of what we assume was a local reporter who knew how to insert a touch of irony into his

Opposite: Fig. 28: Anon., The Museum of the Guild of St George, c. 1885. The original cottage has been extended to the rear to accommodate a growing collection

writing, Ruskin does not come off very well. Sent up to the hill-top suburb of Walkley to cover an obscure meeting in an obscure cottage with no more commitment than if he had been sent to cover a bankruptcy hearing, a meeting of the Sheffield School Board, or of shareholders in the Kelham Rolling Mills Company Ltd – all of which appear on the same page as his account of Walkley – the reporter must have been bemused to observe this encounter between one of the leading public intellectuals of the day, and a group of enthusiastic 'communists' – and six ladies.[2]

The social and æsthetic message that Ruskin had been preaching since the publication of *The Stones of Venice* in 1851-53, most explicitly in *Unto This Last* (1860), tended to be greeted with suspicion. When his decision to found a museum intended to enlighten the lives of working-class people in Sheffield was announced in 1875, the *Sheffield Portrait Gallery: a journal of literature, criticism and satire* published this snobbish comment from 'Barnaby Braggs', in his column, 'Jottings on my Thumbnail':

> Mr Ruskin is bent upon improving the people of Sheffield, by a museum which he is to fit up to his own liking. The greatest curiosity he could exhibit would be – himself.[3]

The period 1875-6 was very important in the history of the Guild of St George, and for Ruskin's proposals for social reform generally. It was the moment when a theoretical discussion of his ideas began to give way to their application in reality. What the anonymous report for the *Sheffield Daily Telegraph* gives us is a real Ruskin, in a real room. And a cramped and small one it turned out to be (Fig. 29).

<p align="center">⚜ ⚜ ⚜</p>

Fig. 29: Anon., The Museum of the Guild of St George, c. 1876. The earliest known photograph of the upper room of the cottage at Walkley

Ruskin's sought to promote his ideas on reform in art and society in two ways: the first was the publication *Fors Clavigera*, launched in January 1871. It was published and distributed by his assistant, George Allen, a former joiner whom, as we saw in Chapter VIII, Ruskin had recruited from his drawing classes for the London Working Men's College in the 1860s. Running in parallel with *Fors Clavigera* were Ruskin's lectures as the first Slade Professor of Fine Art at Oxford.

Although there is plenty of art matter in *Fors Clavigera*, and plenty of social criticism in the Oxford lectures, the appeal to the public in *Fors Clavigera* was chiefly of a social nature. *Fors Clavigera* was the vehicle through which he promoted the practical application of his ideas: first in the form of the St George's Fund, which was intended to buy up waste land and make it fruitful – a fund which he established with the gift of £7,000, one tenth of his shrinking personal fortune. This developed into the St George's Company, a group of people who would assist this social and environmental project in various ways, with

money or voluntary work. When legal difficulties prevented the use of the word 'Company' – the Board of Trade would not register a company that did not intend to make a profit – this became the Guild of St George, with a legal constitution appointing trustees, Ruskin as 'Master', a membership and a formal function. One of its responsibilities, when the Guild finally acquired a proper legal identity in 1878, was to own and administer the Museum at Walkley that had been brought into existence early in 1876.

While *Fors Clavigera* enabled Ruskin to promote his practical scheme for art and social reform, it is important to understand what these monthly letters really were. As Ruskin himself wrote:

> *Fors is a letter*, and written as a letter should be written, frankly, and as the mood, or topic, chances; so far as I finish and retouch it, which of late I have done more and more, it ceases to be what it should be, and becomes a serious treatise, which I never meant to undertake. (29.197)

The letters are a way of talking to people, or better, of arguing with them. As he said in one of the earliest numbers: 'I neither wish to please, nor displease you; but to provoke you to think' (27.99). As the popularity – or notoriety – of *Fors Clavigera* grew, people began to write to Ruskin, agreeing with him, or answering back, and hence a sort of correspondence column started to appear at the end of each monthly number, rather as comments appear at the bottom of a 21st century blog. It is from these correspondents, including the few who actually sent money to the St George's Fund, that the membership of the Guild of St George grew.

Personal discussions and arguments take a rather different shape from the formalised statements of public debate, and even

in debate the demands of rhetoric or the heat of the moment can lead to statements that would look absurd if printed in the chill print of a book – or a newspaper report. *Fors Clavigera* is the voice of Ruskin in conversation, and it has all the tones that we would expect to hear in a discursive dialogue: reminiscences, anecdote, bits out of the newspaper, humour, delight, teasing, satire, discussion, argument, anger, and, at the top of the scale, fierce polemic. We hear about Ruskin's schemes for the Guild of St George in these tones of voice, but rarely in the single authoritative voice of command. As Ruskin says: '*Fors Clavigera* contains not a plan or scheme, but a principle and tendency' (28.227).

Fors had been running for five years when Ruskin came to Walkley in 1876, and in spite of the jibes of the newspapers, who always found it good for a joke, *Fors* was building up a following. On 20th February 1876 George Allen wrote to another of Ruskin's occasional assistants, also recruited from the Working Men's College, the painter John Bunney:

> *Fors* is getting popular and we shall issue the full thousand per month of the current number, besides the back ones – you would be surprised at the number of bound sets we sell now – bound volumes'.[4]

The 'principle and tendency' of *Fors* was towards practical work, and by the beginning of 1876 the St George's scheme had received fifty-four subscriptions to the Fund, and twenty of the donors had been accepted into what would become the Guild as Companions. It had also acquired responsibility for seven acres of woodland in Bewdley, Worcestershire, (later growing to twenty) given by the Birmingham industrialist and local politician George Baker, and a small group of cottages at Barmouth in Wales, given by Ruskin's friend Mrs Fanny Talbot. It also

owned the cottage and property at Bellhagg Road, Walkley, Sheffield, which held the nucleus of the Museum of the Guild of St George.

Agriculture and museums may seem an odd combination of responsibilities for a single organisation, but the land and the museum collection are the polarities of Ruskin's unified scheme. In between – at least in theory – lay an elaborate social organisation, a society that would present a radical alternative to the structure of the contemporary world. The basis of this society was agriculture, for according to Ruskin's economic principles, as laid down in *Unto This Last*, labour was the only source of value. Only manual labour had dignity, which meant that steam engines and sewing machines were banned from Guild land. Members of the Guild were organised in a strict hierarchy, with a Master elected by an aristocracy of members. The Master was to have absolute authority over the Guild's affairs, although he could be deposed by a majority of the Companions. He was to be assisted by Marshals; below them came landlords, land agents, tenantry, tradesmen, and hired labourers; while outside the Guild there would be an 'irregular cavalry' of friends (28.424). In contrast to the Bishops of the Church of England there would be an Episcopal system by which Bishops of the Guild really oversaw and were responsible for the moral and physical welfare of every member – and acted as a kind of police force in financial matters.

Not all members of the Guild would work full-time on the Guild's schemes, for it was not intended as a retreat from the world, but rather, members would be 'a band of delivering knights' (28.538). Ruskin had wanted to call it a Company because that was the name given to the companies of mercenaries that had fought in Italy in the sixteenth century, but as we

have seen, that was not acceptable to the Board of Trade (28.628-9). There were to be three classes of members of the Guild: 'Companions Servant', who worked mainly for the Guild, with some private interests; 'Companions Militant' who worked full-time, such as agricultural workers; and 'Companions Consular' who gave one tenth of their income to the Guild, but carried on their normal occupations while following St George's principles (28.529). Ruskin later dropped the requirement that Companions should give one tenth of their income.

Because the capitalist system had created nothing but a National Debt, the Guild's purpose was to create a 'National Store':

> The possession of such a store by the nation would signify, that there were no taxes to pay; that everybody had clothes enough, and some stuff laid by for next year; that everybody had food enough, and plenty of salted pork, pickled walnuts, potted shrimps, or other conserves, in the cupboard; that everybody had jewels enough, and some of the biggest laid by, in treasuries and museums; and, of persons caring for such things, that everybody had as many books and pictures as they could read or look at; with quantities of the highest quality besides, in easily accessible public libraries and galleries. (28.641)

☙ ☙ ☙

The museum, then, was a manifestation of this delightful, generous conception of a National Store. But it also had an educational purpose, for land and farms meant people, and so a comprehensive system of education was necessary. The children of the Guild's labourers, Companions Militant, would be taught in:

Agricultural schools inland, and naval schools by the sea, the indispensable first condition of such education being that the boys learn either to ride or to sail; the girls to spin, weave, and sew, and at a proper age to cook all ordinary food exquisitely; the youth of both sexes to be disciplined daily in the strictest practice of vocal music; and for morality, to be taught gentleness to all brute creatures, – finished courtesy to each other, – to speak truth with rigid care, and to obey orders with the precision of slaves. (27.143)

The children would be taught with the aid of teaching examples, such as those he had provided for the School of Drawing that he had recently founded at Oxford. The teaching system extended into the Companions' homes, for each was to have a *Bibliotheca Pastorum*, a cottage library of standard volumes edited and published by the Guild (28.20). There would also be a standard collection of works of art available for each house.

This educational scheme, like the elaborate constitution for the Guild, was never put into practice, nor even fully worked out. For instance, at one stage he proposes that the boys and girls of the Guild should be taught Latin, elsewhere he says that they should not be taught to read or write at all. The Guild was a Ruskinian projection of how things might be. With fewer than a hundred participants, reality fell far short of his utopia; but one fragment of the scheme, an educational museum, did come into existence, at Walkley.

Why Walkley; and why Sheffield? There is what might be called an official, and an unofficial, reason for this. The official reason was given by Ruskin in his 'General Statement explaining the Nature and Purposes of St George's Guild', issued in 1882:

I am now frequently asked why I chose Sheffield for it – rather

than any other town. The answer is a simple one – that I acknowledge Ironwork as an art always necessary and useful to man, and English work in iron as masterful of its kind. ... Not for this reason only, however, but because Sheffield is in Yorkshire, and Yorkshire yet, in the main temper of its inhabitants, old English, and capable therefore of the ideas of Honesty and Piety by which Old England lived; finally, because Yorkshire is within easy reach of beautiful natural scenery, and of the best art of English hands, at Lincoln, York, Durham, Selby, Fountains, Bolton, and Furness. (30.51-52)

Complimentary as these reasons are, there was also a more direct reason for the choice of Sheffield as a location.

The timing of Ruskin's social appeal, and his attempt to put his ideas into practice, must be seen in the context of the 1870s, which saw the first stirrings of the reawakened radical movements of 1848, expressed in the formation of political groups, charitable settlements and utopian communities. Sheffield had a strong radical tradition, both in terms of religious dissent and of political memories that went back to the Chartists and the Sheffield Corresponding Society. It was a fruitful soil for those who wanted to cultivate social change, as the early socialist Edward Carpenter discovered when he moved to Sheffield in 1878. As Sheila Rowbotham has pointed out in her book on Carpenter: 'The communitarian tradition had never really died in the Sheffield area, perhaps because a structure of small workshop production and small holdings persisted'.[5]

It still required, however, someone to plant the particular seed of Ruskin's ideas in this well-prepared soil. That person was Henry Swan.

The links between Ruskin and Henry Swan go back to 1855, when Ruskin was teaching drawing at the London Working

Men's College, in its early days in Red Lion Square. Swan was one of his pupils, and like others he taught, became a cross between an assistant and a disciple. Born in Devizes in 1825, Swan was what can only be described as a 'character'. He served an apprenticeship to a copper-plate engraver; at the Working Men's College he took a particular interest in the illumination of manuscripts, being employed by Ruskin to copy manuscripts in the British Museum. He also at one time worked in London as a portrait photographer. In the 1850s he became a Quaker, and according to one of his obituarists this conversion was all the more remarkable for having been the result of his devotion to art and music, something treated with suspicion by some of the more serious-minded Friends.[6] Swan's interests were manifold, as this reminiscence records:

> He invented what was considered at the time an important improvement to photography. He was also the parent of a method of musical notation, and had perfected a system of phonetic spelling. He was also one of the first to introduce the now familiar bicycle into this country, and at another time made an attempt to popularise the throwing of the boomerang.[7]

Henry Swan was also a shorthand expert, a vegetarian, and, something that Ruskin's editors Cook and Wedderburn chose not mention, a Spiritualist.[8]

With no disrespect to Spiritualists, vegetarians and throwers of the boomerang, it appears that Swan was something of a crank, and 'crank' is precisely the word that George Allen used of him after his death.[9] But Ruskin put his trust in him, at least to begin with, and made him the first curator of the Guild Museum, on a salary of £40 a year. Writing to his solicitors,

Tarrant and Mackrell, and anxious to impress on them Swan's trustworthiness, Ruskin describes Swan as: 'an honest, though somewhat dreamy person ... [he is] very poor and has never asked me for money'.[10] Swan had settled in Sheffield in order to pursue his trade as an engraver – Ruskin says he was working 'on plated goods or silver', silver being a Sheffield speciality;[11] in August 1875 Ruskin gives his address as 33 Times Buildings, Bow Street, Sheffield.[12] By September 1875, however, it had become Bellhagg Road, Walkley.

Ruskin's immediate connections with Sheffield can be traced through the somewhat sketchy entries in his diary. The key time is the year preceding the visit of April 1876. On 26th January 1875 he passed through the Sheffield area on a posting tour, having made the somewhat eccentric decision to travel in the old fashioned way in a carriage driven by a postilion, changing horses along the way. He was again in Sheffield on 3rd July, although there is no indication that he stopped for long there. But Ruskin and Swan were already in correspondence about his plans for the Guild, and the vital entry in his diary is for 5th July: 'Pleasant letter from Sheffield to be answered' (D3.852). On 12th July he wrote to Swan:

> It is very wonderful to me the coming of your letters just
> at this time. The chief point in my own mind in mate-
> rial of education is getting a museum, however small, well
> explained and clearly and easily seen. Can you get with any
> Sheffield help, a room with good light, anywhere accessible to
> the men who would be likely to come to it? If so, I will send

you books and begin with minerals of considerable variety and interest, with short notes on each specimen, and others of less value, of the same kinds which the men may examine and handle at their ease.[13]

The idea of an educational museum as part of the work of St George was about to become a reality, for on 18th July he wrote again to Swan that he was prepared to negotiate for a site for the museum.

On 26th and 27th September 1875 Ruskin came to Sheffield, staying at the Royal Hotel, specifically to see Swan. The important phrase in the letter just quoted is 'the men'. It is evident that Swan was in touch with a group of Sheffield working men interested in social reform. On 26th September, the day of his arrival, Ruskin wrote to his cousin and companion Joan Severn:

> I've seen my Quaker friend and am going to lunch with him and have a talk with the men he wishes me to know of the Sheffield operatives but I shall not be back in time to tell you anything this evening.[14]

And he was not, so we do not know exactly what took place, apart from an entry in his diary for 27th September: 'I went up to Walkley and talked to workmen and returned, somewhat wearied, in gloomy wreck of watery sunset' (D3.863).

What we do know is that on the same day he wrote to his solicitors telling them to buy the cottage and land in Bellhagg Road, Walkley. The property was owned by the Rivelin View Society, one of the dozen building societies developing the Nether Hallam area, and the purchase, for £600, was completed on 10th November. On 3rd November Swan had been offered the post of curator. The location of the property was significant, high up above the dense pollution of industrial Sheffield, with,

in those days, a view of open countryside. As Mark Frost has commented: 'Ruskin's entry into Sheffield had all the symbolic power of St George meeting a smoke-breathing dragon'.[15]

We can thank the reporter of the *Sheffield Daily Telegraph* for his account of what happened when Ruskin next came to Sheffield, on 27th April 1876, to see what progress had been made. The 'new museum' the reporter describes was not as grand as the phrase suggests. It was in fact a small stone-built cottage, surrounded by a small orchard, in which Henry Swan, his wife, and his son Howard (and possibly another son, who later settled in Florida) were also living. This time Ruskin had brought Joan Severn and her husband, Arthur Severn, along for the trip, staying at the King's Head. They were making a holiday of it, on another positing tour, for which he had had a carriage especially built. (The carriage can be seen today at Ruskin's Lake District home, Brantwood, Coniston.) Arthur Severn wrote later that he remembered:

> The look of regret on the Professor's [Ruskin's] face when he saw how cramped the space was there for the things he had to show. However, with his usual kindness, he did not say much about it at the time, and he did not complain about the considerable amount of room it was necessary for the curator and his family to take up in that place.[16]

In view of the smallness of the room, the turnout of twenty persons (including those six ladies) seems impressive.

⚜ ⚜ ⚜

Having learnt why Ruskin chose Sheffield, the next question is why Sheffield – or the twenty persons who came to

Walkley – should chose to hear Ruskin. The answer lies in the headline to the *Telegraph* report: 'Communism and Art'. As the reporter writes, there were a number of people in the room who called themselves Communists. Whatever they understood by the word Communist – Frost says they were interested in 'communalism rather than Marxism'[17] – they were among the first of many to mistake the true direction in which Ruskin's politics lay.

The source of this misunderstanding is probably the seventh number of *Fors Clavigera*, for July 1871, where he does indeed describe himself as a Communist: 'of the old school – reddest also of the red' (27.116). But Ruskin's Communism was of a more domesticated kind. The three laws of Communism, he writes, are firstly: 'everybody must work in common, and do common or simple work for his dinner' (27.117). The second principle concerns property:

> It is that the public, or common, wealth shall be more and statelier in all its substance than private or singular wealth; that is to say (to come to my own special business for a moment) that there shall be only cheap and few pictures, if any, in the insides of houses, where nobody but the owner can see them; but costly pictures, and many, on the outsides of houses, where the people can see them. (27.120)

Finally, Ruskin says, it is an absolute law:

> That the fortunes of private persons should be small, and of little account in the State; but the common treasure of the whole nation should be of superb and precious things in redundant quantity, as pictures, statues, precious books, gold and silver vessels, preserved from ancient times; gold and silver bullion laid up for use, in case of any chance need

of buying anything suddenly from foreign nations; noble horses, cattle, and sheep, on the public lands; and vast spaces of land for culture, exercise and garden, round the cities, full of flowers, which, being everybody's property, nobody could gather; and of birds which, being everybody's property, nobody could shoot. (27.121)

These quotations abbreviate an argument of several pages, but it is plain that if this is Communism, it is of an unfamiliar and particularly æsthetic kind. As a statement of principles, it is at least more coherent than one made by a member of his audience at Walkley, who, the reporter noted: 'gave his idea of what a state a Communism ought to be. They should all live together in furnished apartments, and they should start at the outset by manufacturing boots' (30.307). To which Ruskin replied – why not hats?

The reason, in July 1871, that Ruskin should call himself a Communist 'of the old school' – and as Chapter IV showed, that phrase is significant – is that the whole number of *Fors* is set in the context of contemporary events in France. The word Communist had a certain resonance in view of the uprising known as the Commune from March to May in Paris that year. From the very first number of *Fors*, the Franco-Prussian war, the siege of Paris and the uprising by the *communards* that followed played an important part in his arguments, as facts in themselves, and as an example of the follies of the industrial age. He also gave charitable help by joining the committee of the Paris Relief Fund. For the government and the people of Paris to follow on the defeat by falling on one another – and setting fire to the Louvre in the process – was an extension of the tragedy. Ruskin responds to these events by presenting himself as an 'old' Communist, and his principles of co-operation and common

wealth are set down in contrast to those in operation in Paris. It is Ruskin being polemical, adopting an extreme position in order to turn the argument inside out. He is also teasing – were it not for his underlying seriousness.

During his visit to Sheffield in 1876 Ruskin reaffirmed: 'as to "Communism", that he believed in it in its broad principles, and had so far advocated it. The word Communism was susceptible of many meanings' (30.307). In Ruskin's case that was certainly true, for immediately after the 'communist' number of *Fors* appeared, Ruskin wrote to one of the Trustees of St George's Fund, the senior civil servant William Cowper-Temple: 'It is *not* to be *Communism*: quite the contrary. The old Feudal system applied to do good instead of evil – to save life, instead of destroy. That is the whole – in fewest words'.[18] This version of the purpose of the Guild gives a clue to the real source of Ruskin's vision.

Because of Ruskin's contradictory statements – all part of his polemical technique – Ruskin's politics have seemed ambiguous, even when he has made the most overt declarations of his beliefs. In the first number of *Fors* Ruskin had made his independence from party politics clear:

> As you would find it thus impossible to class me justly in either party, so you would find it impossible to class any person whatever, who had clear and developed political opinions, and who could define them accurately. Men only associate in parties by sacrificing their opinions, or by having none worth sacrificing; and the effect of party government is always to develop hostilities and hypocrisies, and to extinguish ideas. (27.15)

Nonetheless, recalling Chapter IV, there is one statement that can be taken at face value: 'I am, and my father was before me,

a violent Tory of the old school' (35.13). The Guild of St George can be seen as a practical expression of that other 'One of the Old School', David Robinson. It is remarkable, in the context of the Guild of St George, that Robinson should have commented in his articles for *Blackwood's Magazine*: 'To the plan for establishing the poor on waste land by means of societies, I am a warm friend'.[19]

A A A

In typical Ruskinian fashion, we have moved from museums to agriculture, but in true Ruskinian manner, they are intimately connected, for one of the results of the 1876 visit to Sheffield was an agricultural scheme. The bringing into cultivation of land, specifically waste land, was one of the declared principles of the Guild of St George. (Drainage, in particular, was almost an obsession of Ruskin's.) In his earliest sketch of the Guild scheme, in the fifth number of *Fors*, for May 1871, Ruskin says: 'I do not care with how many, or how few, this thing is begun, nor on what inconsiderable scale, – if it be but in two or three poor men's gardens. So much, at least, I can buy, myself, and give them' (27.95-6). And, lest there should be any doubt as to his authoritarianism, while he proposes to: 'take some small piece of English ground, beautiful, peaceful, and fruitful' (27.96), he also outlines the political system that will prevail there:

> We will have no liberty upon it; but constant obedience to known law, and appointed persons: no equality upon it; but recognition of every betterness that we can find, and reprobation of every worseness. (27.96)

There would be no liberty, no equality, and no fraternity

either. He wrote in 1879 to Swan's wife Emily: 'the vital power of St George's Guild is not sentiment – fraternity or any other principle of *personal* feeling'. Ruskin's residual Evangelical belief in the need for personal salvation appears to have made him rely on: 'the quantity of absolution in our own hearts, to do what we perceive to be plainly right'.[20]

Shortly after his visit to Sheffield in 1876, Ruskin found himself doing precisely what he had proposed, buying some land for poor men to cultivate. This was the thirteen-acre farm just across the county border with Derbyshire, in Totley. At first, Ruskin preferred to use the prettier name of Abbeydale. Since the Guild did not yet have a legal identity, he was obliged to buy the farm in his own name, and the tenants were not members of the Guild. They were in fact some of the working men gathered around Henry Swan. A single sheet of paper in the Guild's archives, unfortunately undated, lists the names and addresses of sixty 'working men', together with some fifty names and addresses of professional people under the heading 'List for communications (not working)'. Besides these lists, which would be of great interest to a local historian, there is a third, headed 'Candidates for Abbeydale', and giving a dozen names and addresses, some of them drawn from the list of working men. Henry Swan's skill in shorthand came in useful – for it is almost certainly his list. There are comments in shorthand on the families and characters of the 'candidates'; no fewer than four are noted as bootmakers, and it is apparent that the earnest Communist who wished to reach that ideal state by living in furnished apartments, had hopes that Totley would be a step towards that goal (Fig. 29).

The Totley scheme matches the proposals of David Robinson in that the idea was that the land should be used as allotments,

Fig. 30: Anon., St George's Farm, *probably in post-communist days*

and, if not exactly waste, it was certainly poor land, so poor that the two trustees of the St George's Fund eventually resigned in protest at the £2,287 purchase. The scheme was not a success. The reasons for the failure of the Totley commune are explained in detail in Mark Frost's excellent *The Lost Companions and John Ruskin's Guild of St George: A Revisionary History*, which has been already cited. Frost has had the advantage of access to the unpublished correspondence between Ruskin and Henry and Emily Swan held at the Rosenbach Museum and Library, Philadelphia.

There were misunderstandings from the beginning. While the men and women who struck an agreement with Ruskin believed that they would eventually own the property, Ruskin thought he was renting it to them. The group did not live at the farm, or work the land themselves, hiring a manager. They attracted many visitors and sold the farm's produce, but gradually fell out with each other. Ruskin commented in *Fors* for November 1877:

The root of all mischief is of course that the Master is out of the way, and the men, in his absence, tried at first to get on by vote of the majority; – it is at any rate to be counted as no small success that they have entirely convinced themselves of the impossibility of getting on in that popular manner. (29.273)

Ruskin may have derived some satisfaction from this failure of democracy, but had not helped matters by introducing a would-be disciple of his own, William Harrison Riley, into the commune. Riley, a republican, had been trying to interest Ruskin in co-operative ventures for some time; as a propagandist he edited a number of political journals, including the *Sheffield Socialist* which ran from June to December 1877. Having briefly shared the land with Riley, in 1878 the original communards were told to leave, and Riley and his family moved into the farm. Riley knew Edward Carpenter, and it was during the difficulties over the Totley farm that Ruskin and Carpenter corresponded.

It is Frost's judgement that Ruskin had been generous to the original Sheffielders and that the collapse of their scheme was largely their own fault, but: 'the failure of its more promising second phase under Riley must be almost entirely attributed to Ruskin.'[21] In August 1878 Ruskin sent his gardener David Downs – often used to supervise Ruskin's projects – to live at Totley, and he and Riley did not get on. Riley claimed that Downs had no respect for the principles of the Guild, or for Ruskin. In October 1879 Ruskin visited Totley, and shortly afterwards it was Riley's turn to be told to go. Ruskin later said: 'of all the blackguards I ever came into collision with in my long life [Riley] was out and out the worst'.[22] One of Riley's faults was that he was a smoker, which Ruskin abhorred. In 1880 Riley emigrated to America. Downs ran Totley successfully as a

farm and market garden, and died there in 1888. On the recommendation of Edward Carpenter the management passed to a former miner and quarry worker, George Pearson, who bought the house and land from the Guild in 1929.

During Totley's early troubled years two other Companions Militant who Frost regards as victims of Ruskin's authoritarianism and mismanagement, William Graham and James Burdon, were briefly employed at Totley. Both were sincere working-class disciples of Ruskin, townsmen who sought a purer agricultural life – and found out what hard work it was. After a time spent on the Isle of Man where another Ruskin disciple, Egbert Rydings, was setting up a linen mill on Ruskinian principles, Graham was sent to work at Totley in November 1878 and stayed till the following May, when he was directed to work on the land given to the Guild by the industrialist George Baker in the Wyre Forest at Bewdley. Frost describes a grim life of toil there, under Baker's unsympathetic direction, where for a time Graham was joined by another Companion Militant, John Guy, following Guy's abandonment after five years of a Guild property at Cloughton Moor, near Scarborough. In spite of being rebuffed by Ruskin when he visited Brantwood in 1881, and not being allowed to work properly with John Guy, Graham remained at Bewdley until 1886, when the failure of his appeals to Ruskin caused him to leave in bitterness.

James Burdon, who gave up mechanical engineering for agriculture, passed through Totley in 1877 before Graham. Like Graham, Ruskin's promises of financial support were irregularly met, and in November 1878, back in London, he successfully forged a Ruskin cheque. But he was caught when he did it again, and in March 1879 was sentenced to a year's hard labour. The troubles and scandals of Riley, Graham and Guy rumbled on

into the 1890s, by which time Ruskin had lost all control of his affairs. Frost argues that Ruskin's authoritarianism prevented any real engagement with the needs of actual working-men, while the way these committed people and their families were erased from the history of the Guild amounted – as we shall see with Oscar Wilde in the next chapter – to 'an old fashioned establishment cover up'.[23] Ruskin does not come out of Frost's account at all well.

∆ ∆ ∆

The narrative has taken us far ahead of the visit of 1876, and the reader may be feeling in the mood reported by the *Sheffield Telegraph*: 'A majority of those present had evidently begun to tire of so much time being consumed by the subject of Communism; and art matters were introduced' (30.307). On this occasion Ruskin did not have a great deal to say on art, although he made some critical remarks about Holman Hunt's painting *The Shadow of Death* (Pl. 19), which had been put on display in Sheffield at the Cutler's Hall that March, with considerable popular success. (The work portrays Jesus as a young carpenter in a pose that anticipates his crucifixion.) Ruskin criticised Hunt for spending so much time in Syria and losing touch with the old masters – 'it was a bad picture' (30.308). He would later praise Holman Hunt's *Triumph of the Innocents* (Pl. 16) however, as Chapter XV explores.

The real art matter was the museum itself. As with St George's Farm, the reality was less than the ideal. One problem was the sheer lack of space. As the collection grew, with the acquisitions tracking Ruskin's shifting interests, notably his concern to record key elements of Venice, with plaster casts of sculpture

Fig. 31: Anon., The Interior of the 1884 Extension to Walkley, *with plaster casts from Venice in cases on the walls, Ruskin's study of Santa Maria della Spina, Pisa on an easel, and John Bunney's painting of St Mark's behind*

and commissioned copies of mosaics and other works, the need to expand became urgent. In 1881 a plan to enlarge the Museum was replaced by a scheme to build on a new site at Endcliffe Gardens. There was considerable support for this locally, and funds were raised, but Ruskin had suffered his first mental breakdown in 1878, and from then on his control of the Guild became intermittent, as attacks recurred. In 1884 a wooden extension was built on the back of the Walkley cottage, partly in order to house the large painting of the West Front of St Mark's (Pl. 20) that Ruskin had commissioned from John Bunney in 1877, and which he completed shortly before he died in 1882 (Fig. 31).

In 1885 Ruskin announced a totally new plan, to leave Walkley as it was, and build a museum on the land owned by the Guild at Bewdley, but this came to nothing, partly because of

lack of funds and partly due to Ruskin's failing mental health. Sheffield, evidently, was proud of the Ruskin connection however, and when in 1886 the Corporation acquired Meersbrook House and Park, to the south of the city centre, they suggested the Museum could move there. Ruskin was reluctant because of the question of who would own the collection and how it would be displayed, but by 1889 Ruskin had lost command of his affairs, and it was agreed that the Guild would lend the Corporation the collection, and the Corporation would house and display it in the Georgian house, adapted into a conventional picture gallery, with domestic accommodation for the curator.

Our last sight of the Walkley cottage – whose front façade survives as part of a much enlarged building, which at one time served as a refuge for 'fallen women' – comes once more from *The Sheffield Daily Telegraph*, this time on the occasion of the grand opening of Meersbrook Park. It is unlikely that it was the same reporter, but the writer seems to be anxious to promote the Corporation's civic generosity through this unflattering description of the old location:

> From the very first the Walkley site found little favour with the people … set amid squalid surroundings, and free from the slightest architectural adornment, the outer aspect of the building was forbidding – tolerable in summer, but bleak and cheerless in the months of winter. The truth must be told that the people for whom Ruskin had done so much refused to climb the painful slopes, flanked by unsightly blocks of bricks and mortar, to reach the little temple of art, and so gradually, but surely, came to be regarded as utterly inaccessible. Nor was that all. Within its humble walls the costly treasures were cribbed, cabined and confined, and either piled in neglected nooks or thrust into positions which

robbed them of their beauty. And in addition to this the place was beset with restrictions of a most irritating nature.[24]

⚛ ⚛ ⚛

Fortunately for Henry Swan, he had died before this was published, and indeed Swan's death in 1889 may have made the move to Meersbrook Park and larger premises possible. Although Ruskin never broke with Swan, his curator had a habit of exasperating him. When it looked in 1881 as though the Corporation of Sheffield was going to build him a new museum, Ruskin wrote to Joan Severn: 'The old place [Walkley] will not be sold, but become a centre of Quaker St Georgeism – which has its qualities – of a sort – The Swans will stay there – the curators of the new museum must be of another sort'.[25]

There is, however, a warmer reminiscence of Walkley by the Reverend T. W. Holmes, describing a visit by Ruskin (its date is uncertain but relates to the move to Meersbrook Park):

> I see the room just now as I saw it then. No common carrier or big furniture van can move to Meersbrook or elsewhere the ideal museum that exists in the study of my imagination. There they hang – the picture of the 'Storm at Sea' [*by William Small*] over the fireplace; Mr Ruskin's own drawing of the mountains, against the wall opposite the window; the delicately lovely water-colour of Coblentz, by the fireplace, the glorious opals, sapphires, emeralds, amethysts and agates, in the glass cases; the boxes near the door holding etchings by Dürer and other great masters; the piles of books in the corner of splendid paintings of insects, shells, fishes and birds; the magnificently bound books; the rare specimens of cloisonné enamelled vases. (30.309)

The most distinguished visitor to the museum in Swan's time was Prince Leopold, the youngest son of Queen of Victoria, who had become a friend of Ruskin's in the 1870s when an undergraduate at Oxford, and a Royal patron of the Ruskin School of Drawing. The half-hour visit in October 1879, with Ruskin in attendance, was described at length in the *Sheffield and Rotherham Independent* (30.311-4), and we get a charming picture of Ruskin opening drawers and displaying specimens to the Prince. The reporter noted: "'I want", said [*Ruskin*], "to get everything beautiful"' (30.312).

And that, indeed, was one of the ruling motives behind the treasure trove that gradually accumulated: drawings, prints, photographs, coins, minerals and precious stones, a dozen illuminated manuscripts, printed books and collections of ornithological and botanical plates, furniture and Ruskin-designed display cases. When Ruskin was active the Guild acquisitions formed part of a bigger collection that circulated between his home at Brantwood, his rooms as Slade Professor at Corpus Christi College in Oxford, and the Drawing School, Whitelands teacher training college in Chelsea, Cheltenham Ladies College, Lady Margaret Hall and Somerville, fledging women's colleges at Oxford that he supported. When he lost control, some items ended up in the 'wrong' place, although to Ruskin it was all one. The core of the twenty or so artists in the collection came from the group of minor English and Italian painters that Ruskin and had employed – and often instructed by letter – to record works of art, flowers, landscape and buildings in France, Italy and Switzerland: John Bunney, W. Hackstoun, Charles Fairfax Murray, T. M. Rooke, Frank Randal, H. R. Newman, H. Stacy Marks, Angelo Allessandri and Raffaelle Carloforti.[26]

Turner was represented by prints, and facsimiles by William

Ward. Undoubtedly the most important work in the collection was *The Madonna adoring the Infant Christ* by the 15th century master Andrea del Verocchio, in whose studio Leonardo da Vinci had worked. Ruskin acquired the tempera painting for £100 from the Manfrini collection in Venice in 1877, transferring it from its original wood panel to canvas and having it restored. Ruskin told Prince Leopold that the painting was the answer to the question he was often asked: 'What do you want to teach us about art?' (30.311-2).

Although not intended to encourage a specific skill, as in the case of the collection he assembled for his School of Drawing in Oxford, the Museum did have a broad educational purpose: 'it will have nothing in it but what deserves respect in Art, or admiration in Nature' (30.1). The substantial number of photographs, engravings, facsimiles, reproductions, chromolithographs and casts in the collection show that he saw it as a popular, working and teaching museum, where the exhibits could be handled, and the 'authenticity' of the object was less important than what it taught. At least two local artists were inspired by visits to the collection at Walkley: Benjamin Creswick, a Sheffield grinder who became a sculptor and taught at Birmingham School of Art,[27] and the cabinet maker Frank Saltfleet, who rose to become President of the Sheffield Society of Artists. Ruskin never supplied his own complete catalogue, but the rich variety of materials, from art and nature, created a kind of self-portrait in this repository of his interests. An underlying theme was the museum as a form of conservation against the ravages of restoration. The 'memorial studies' (24.412) that he commissioned of St Mark's in Venice carry the melancholy suggestion that too much had already been lost.

From the descriptions that have been given of Walkley, it

is evident that the collection was, to say the least, informally displayed, but that is unlikely to have worried Ruskin a great deal, who believed in the oneness of things. A preliminary catalogue was drawn up by Henry Swan's son Howard in 1888. Swan's successor, William White, was indeed 'of another sort', a professionally trained curator who had plenty of space to lay out the museum by subject matter. In 1890 White published *A Descriptive Catalogue of the Library and Print Room of the Ruskin Museum*, and *The Principles of Art as illustrated by Examples in the Ruskin Museum at Sheffield; with passages, by permission, from the writings of John Ruskin*, which provided a different kind of order by linking the works in the collection to quotations from Ruskin's voluminous writings on art. At Meersbrook the collection proved popular. 61,000 visitors were recorded in 1891-2, and averaged 45,000 a year before the First Wold War. White, and his successor in 1899, Gill Parker, ran an educational programme, with school visits, and there was also a Ruskin Club that met at the museum.

<center>⚜ ⚜ ⚜</center>

It is clear, however, that the Museum of the Guild of St George was only a sketch, a gesture towards the National Store of wealth – of cultural capital – that Ruskin described when outlining his own principles of Communism. If we look at his third principle again, where in the same sentence he speaks of: 'superb and precious things in redundant quantity, as pictures, statues, precious books ... and vast spaces of land for culture, exercise, and garden, round the cities' (27.121), we can see that the museum at Walkley and the farm at Totley were essentially indivisible in his mind, as were art and society.

Ruskin had enunciated the principle of the indivisibility of art and society long before he came to Sheffield, and when he described the principles upon which the Guild was to be founded his true source of ideas was not Communism as understood by the working men of Sheffield, but society as organised by the citizens of a very different city – Venice. When he talks of having only cheap, and few, pictures on the insides of houses where nobody but the owner can see them, but: 'costly pictures, and many, on the outsides of houses, where the people can see them' (27.120), he is plainly referring to Venice, where in the days of Titian, Giorgione and Veronese the walls of the palaces on the Grand Canal glowed with frescoes, frescoes of which but faded stains remained in Ruskin's time.

The Guild of St George, as an *idea*, has more parallels with the *Scuole* of Venice than the English medieval trade guilds. The *Scuola* was a confraternity that was open to several ranks of citizens, and existed to perform both religious and charitable functions, while their chapels and meeting halls gave work to the great painters of Italy. Venice, though run by a closed oligarchy, was a republic, and it was the tradition that the great families devoted their wealth, not to the embellishment of private apartments, but to the city as a whole. It is not surprising then, to find in *Fors Clavigera* for January 1877 Ruskin addressing the men who planned to take on Totley in these terms: 'Elect a doge, if, for the present, to act only as purveyor-general: honest doge, he must be, with an active and kind duchess' (29.21). In the following month he holds out the idea that they may build themselves their own Ducal Palace, in Sheffield, one day.

It may be that it was the failure to elect a Doge, with dogal authority, that led to the squabbles at Totley. On the other hand, Mark Frost has shown that Ruskin, elected with absolute

authority by the Companions, to be Doge of the Guild of St George, did not act with perfect justice when challenged by his Companions Militant, nor did he show over-concern for their welfare. Absolute obedience came first, as he had warned in *Fors Clavigera* (27.96). In mitigation, it must be born in mind that after his first total breakdown in 1878, Ruskin was gradually losing control of everything, especially his mind.

The link between Venice and Sheffield was made sadly real when Ruskin chose the museum as the repository for the casts, photographs, and studies of Venetian art and architecture that he acquired in an effort to preserve at least a record of the culture of a society threatened with destruction by the capitalist energies so profitably at work in Sheffield.

It is a long way from the Ducal Palace and the Venetian lagoon to thirteen acres of poor land at Totley and Walkley's single room. Yet we must come back to the twenty persons who came to hear Ruskin speak there. We must look on Ruskin's projects for the Guild of St George in a special way. Just as the vehicle for his ideas, *Fors Clavigera*, represented a distinctive way of arguing, so the practical (and impractical) schemes of the Guild were an extension of that argument. They were gestures, challenges, ways of getting people to act and think for themselves. Repeatedly, Ruskin states that his own duties lie elsewhere than in man-management, that he wants others to take the responsibility. The Guild's task was educational in the widest sense, of leading people towards a fuller recognition of themselves and their potential. It did not exist to make that realisation for them. It was to Ruskin's everlasting regret that while people were prepared to follow, few were ready to find their own way. In gently sardonic tones Ruskin wrote in *Fors Clavigera*: 'it would be a poor design indeed, for the bettering

of the world, which any man could see either quite round the outside, or quite into the inside of' (28.235).

Ruskin's challenges did get responses, and his views on art and society, on the nature of work, on the need for education, and the damage done to the environment are just as challenging in the 21st century as they were in the 19th. In the closing sentences of the anonymous *Sheffield Daily Telegraph* report Ruskin makes it clear that he is challenging us to respond to his ideas, – that it is up to us now, just as much as it was up to his audience then:

> The subject of the Museum was then discursively alluded to, Mr Ruskin stating that it is at present merely the nucleus of what he will make it if he finds that it is properly appreciated. In that event he would have works of the very best class, whether engravings, metal works, and other art objects. The discussion then closed, having lasted about three hours. (30.309)

Based on the 1979 Guild of St George Lecture Art and Society: Ruskin in Sheffield 1876 *and reprinted by the Guild in revised form in 2011.*

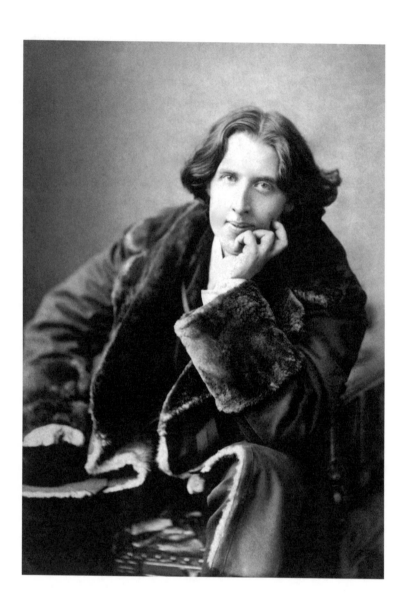

'FROM YOU I LEARNED NOTHING BUT WHAT WAS GOOD': RUSKIN AND OSCAR WILDE

છ્ર

Throughout these essays there has been regular reference to the Library Edition of Ruskin's complete works, the heroic editorial labour of E. T. Cook and Alexander Wedderburn, published between 1903 and 1912.[1] It runs to thirty-nine volumes, big fat books with handsome gold lettering on the spine. Side by side, they take up nearly two-and-a-half metres of shelf space. In addition to the texts of all Ruskin's published writings there are two volumes of letters, extracts from diaries and unpublished manuscripts, and a catalogue of his drawings. Every volume has a scholarly introduction, with full bibliographic details of the individual works it contains.

It is an astonishing editorial achievement, and serious study of Ruskin is almost impossible without it. But it is also true that in spite of all their invaluable work, Ruskin's editors, under the watchful eye of Ruskin's heir, Joan Severn, do not give a complete picture of Ruskin. Their liberal leanings tend to obscure Ruskin's Toryism, and though they do not conceal his passion for Rose La Touche, or the Rose-substitutes that followed her, they do not dwell on his emotional difficulties. It would have been surprising, in Edwardian England, if they did. But there is another revealing omission. The thirty-ninth volume, the index, contains more than 150,000 references; but out of the

Opposite: Fig. 32: Napoleon Sarony, Oscar Wilde in New York, 1882

hundreds of names in the Library Edition, there is no mention of Oscar Wilde.

This tells us two things: firstly, the extent to which, in the years immediately following his disgrace and imprisonment in 1895 and his death in 1900, Oscar Wilde was regarded as an un-person in British society. Secondly, it shows the extent to which even a publication as authoritative as the Library Edition can be distorted by the desire to protect someone's reputation. Yet Ruskin and Wilde knew each other, and liked each other. Oscar and Constance Wilde felt sufficiently close to Ruskin that they asked him to be a godfather to their younger son Vyvyan (although Ruskin declined, on the grounds that he was too broken by events).[2] Their relationship does not merit exclusion from the index to Ruskin's complete works.

<p style="text-align:center">⚛ ⚛ ⚛</p>

Ruskin was already famous when Wilde was born in 1854; he was part of the cultural landscape in which Wilde grew up. He was by no means the only figure in that landscape, but he was undoubtedly a formative influence, as Wilde's unacknowledged liftings from Ruskin in the reputation-making lectures that he gave in America and Canada in 1882 demonstrate. But in addition to the intellectual connection, there was also a personal one that was just as important.

In the autumn of 1874, after two years and two terms at Trinity College, Dublin, Wilde won a scholarship to Magdalen College, Oxford. Ruskin was a prominent public figure, in Wilde's own words, he was 'something of prophet, of priest, and of poet'.[3] From 1870 he had occupied what was in effect a personal pulpit at Oxford as the University's first Slade Professor of Fine

Fig. 33: J. Nash, Amateur Navvies at Oxford – Undergraduates Making a Road as
Suggested by Mr Ruskin, The Graphic, *27 June 1874*

Art. His lectures, which combined art history, natural history
and geology with the cultural and economic criticism that had
become increasingly important to him since the publication
of the economic essays, *Unto This Last*, in 1860, were popular
with undergraduates, but not necessarily with the university
authorities, who became increasingly worried by the criticisms
he made of the university itself.

Ruskin believed in doing, as well as talking. He used his
own money to endow the University with the Ruskin School
of Drawing. The University was duly grateful, even though, as
we saw in Chapter X, Ruskin's teaching methods presented a
challenge to the official, government sponsored art teaching of
the day. In the spring of 1874 he embarked on an experiment
that really upset the authorities. Ruskin strongly objected to
the undergraduates' passion for sport. He called Oxford: 'a
mere cockney watering place for learning to row'.[4] He therefore

decided that *his* pupils should have an opportunity to, as he put it, 'feel the pleasures of *useful* muscular work' (20.xli). Concerned as ever with the natural world, he would show them what a country road should look like, by leading them out to the nearby village of Ferry Hincksey, and getting them to build one (Fig. 33).

Ruskin's Oxford road building project has usually been treated as a bit of a joke. It was much satirised at the time, and the actual road and drainage scheme that Ruskin and his undergraduate 'diggers' created did not last long. But from the cadre of undergraduates, chiefly from Balliol College, who attended Ruskin's diggers' breakfasts and laboured on the project in the summer and winter of 1874 and the spring of 1875, there emerged a generation of leaders who would convert Ruskin's message about the dignity of labour and the horrors of industrialism into social policy and action. The best known of them is Arnold Toynbee, whose followers at Toynbee Hall had such an influence on the creation of the Welfare State, but there was also one of the future editors of the Library Edition, Alexander Wedderburn. And there was also – Oscar Wilde.

There has been some question as to whether Oscar actually worked on Ruskin's road. He was always something of a fabulist, and in his description of the project in his American lectures he talks about it as though he had been among the first undergraduates that Ruskin had persuaded to exchange rowing for road building in the summer of 1874 (Wilde was briefly an oarsman). That is impossible, because he didn't go up to Oxford until the autumn of that year. But Ruskin himself did not work on the road until the autumn of 1874 either, having spent the summer in Italy, and Wilde's description of the work involved has the ring of truth about it:

[We] learned how to lay levels, and dig, and break stones,
and to wheel barrows along a plank – a very difficult thing
to do. And Ruskin worked with us in the mist and mud of
an Oxford winter and our friends and our enemies came out
and mocked us from the banks, but we did not mind them
much, and we did not mind it since at all, but worked away
for two months at our road; I felt that if there was enough
spirit amongst the young men to go out to such work as
road making for the sake of a noble ideal of life, I can from
them create an artistic movement that might change, as it
has changed the face of England.[5]

This movement, Wilde had explained earlier, was: 'a move-
ment to show the rich what beautiful things they might enjoy,
and the poor what beautiful things they might create'.[6]

Apart from publishing a book of poems and a few articles,
and getting himself talked about as the model for Bunthorne in
Gilbert and Sullivan's comic opera, *Patience*, Wilde was better
known for being famous than for anything else when he arrived
in America in January 1882. He does not name the movement of
which he suggests himself as leader, but clearly it is the Æsthetic
Movement. In Oxford, and then London, Wilde, with his pas-
sion for blue and white china, his posturing with sunflowers
and lilies, and the peculiar costume he designed for himself
in which to give his American lectures, certainly created our
abiding image of an Æsthete (Fig. 32). But the image of Oscar
Wilde wheeling a wheelbarrow – even if only on a few occasions
as a student jest – might alter our understanding of what Wilde
thought the Æsthetic Movement was supposed to be. And again,
Ruskin may help us in changing the picture.

☙ ☙ ☙

"O. W."

"O, I feel just as happy as a bright Sunflower!'
Lays of Christy Minstrelsy.

Æsthete of Æsthetes!
What's in a name?
The poet is WILDE,
But his poetry's tame.

Fig. 34: Edward Linley Sambourne, Oscar Wilde as a Sunflower, Punch, *1881*

Wilde had a nice joke in his American lectures about the Æsthetic Movement: 'if you ask nine-tenths of the British public what is the meaning of the word "æsthetics" they will tell you it is the French for affectation or the German for a dado'.[7] Whether you treat the Æsthetic Movement as a coherent ideology or, as portrayed by Du Maurier in his cartoons for *Punch*, as a life-style

choice for the upper-middle classes, Wilde may have epitomised the movement, but he did not invent it. It has its origins in the writings of Théophile Gautier and Charles Baudelaire, in the poetry of Swinburne, and the criticism of Walter Pater and Arthur Symonds, while its visual language derives from the Pre-Raphaelites, especially the second generation Pre-Raphaelites William Morris and Edward Burne-Jones, to which was added the taste for *japonaiserie* and the stylish line of James McNeil Whistler.

Ruskin had an ambivalent relationship with the movement. He himself had sought to alert the puritanical British public to the significance of Beauty, both in art and nature, but his justification was that Beauty was God-given. The æsthetes seemed to have in mind something more material, sensual and sinister. Nonetheless, the term 'Æsthetic' was still sufficiently acceptable to Ruskin for him to use it in the title of a set of lectures at Oxford, *The Æsthetic and Mathematic Schools of Art in Florence*, where in passing he described himself as 'belonging wholly to the Æsthetic school' (23.225). These were given in November and December 1874, the months when he was also actively leading his road-building project – and Wilde was at those lectures.

In practice, æstheticism was an evolving term, but one of its turning points was the opening of the Grosvenor Gallery in London in April 1877. This was deliberately set up to promote the new art and the new artists that were being discriminated against or excluded by the Royal Academy. The stars of the first exhibition were Burne-Jones, Holman Hunt, G. F. Watts, Albert Moore, Alma-Tadema, and Whistler. The show became the subject of Wilde's very first published article, a review in the *Dublin University Magazine*. It is interesting to note that Wilde praised the works of Holman Hunt, Burne-Jones and Watts, all

artists of whom Ruskin also approved. Wilde called them 'the three golden keys to the gate of the House Beautiful' – by which he meant the æsthetically decorated Grosvenor Gallery.[8] But he was far less certain in his opinion of Whistler, and retreated into facetious humour:

> Numbers 8 and 9 are life-size portraits of two young ladies, evidently caught in a black London fog; they look like sisters but are not related probably, as one is a 'Harmony in Amber and Black', the other only an 'Arrangement in Brown'.[9]

What is really significant about the review is Wilde's conclusion, which describes the Grosvenor Gallery as an element in:

> That revival of culture and love of beauty which in great part owes its birth to Mr Ruskin, and which Mr Swinburne, and Mr Pater, and Mr Morris, and many others, are fostering and keeping alive, each in his own peculiar fashion.[10]

This revival of culture became the theme of Wilde's opening lecture on his American tour, 'The English Renascence'.

Wilde's comment treats Ruskin as the father of this renaissance, but acknowledges that others have contributed, notably another prominent Oxford figure, Walter Pater, fellow of Brasenose College, whose collection of essays, with the possibly suggestive title, *Studies in the History of The Renaissance*, had been published in 1873. A key text, the book was notorious for its conclusion, which urged his readers 'to burn always with this hard, gemlike flame'.[11] Wilde, who read the book as soon as he arrived in Oxford, and was said to know this passage off by heart, later told the poet W. B. Yeats that he never travelled without it, and that it was 'the very flower of decadence'.[12] Wilde would certainly have been aware of the book's homoerotic

subtext, for in 1876 Pater got into trouble for writing affectionate letters to another of Ruskin's Oxford diggers, William Hardinge – known to other diggers as 'the Balliol bugger' – who was sent down for writing homosexual poetry and bringing his college into disrepute.[13]

In 1877 Pater withdrew his controversial 'Conclusion' from the second edition of *The Renaissance*. His æstheticism was undoubtedly an influence on Wilde, notably on his prose style, but they did not actually meet until October 1877, by which time Wilde had sent Pater a copy of his Grosvenor Gallery review. At this point, Ruskin was the dominant figure. Wilde told the editor of the *Dublin University Magazine*: 'I always say clearly what I know to be true, such as that the revival of culture is due to Mr Ruskin'.[14]

The irony is that Ruskin appeared to deplore this particular 'revival', and what caused him most publicly to break with it was the very same exhibition at the Grosvenor Gallery. Ruskin also published his views on the exhibition, and although he praised Burne-Jones, he insulted the owner of Grosvenor Gallery, and attacked Whistler, accusing him of 'Cockney impudence' for 'flinging a pot of paint in the public's face' by asking 200 guineas for his work (29.160). Whistler successfully sued Ruskin for libel. It is tempting to think that Whistler's celebrated display of wit in the witness box may have influenced Wilde's decision in 1895 to launch a libel case against the father of his lover Bosie, the belligerent Marquis of Queensbury, with all the disastrous consequences that followed.

Whistler's legal defeat of Ruskin in 1878 was a blow to Ruskin's authority. He had been unable to attend the trial because of his first mental breakdown, and he resigned his Professorship at Oxford shortly afterwards. By 1881 Ruskin was associating

æstheticism with 'pig's-wash' (25.122), and in 1883 added a foot-note to a new edition of *Modern Painters* volume two denounc-ing the Æsthetic Movement: 'which in recent days has made art at once the corruption, and the jest, of the vulgar world' (4.35n). But that does not mean that his connection with Wilde was broken.

⚶ ⚶ ⚶

In January 1882 Wilde launched himself on America, at the start of an almost year-long lecture tour that would confirm his celebrity. He had continued to meet Ruskin in Oxford after the road-building project ended, until Ruskin's departure for his winter in Venice in 1876-7. After his Oxford career ended in triumph in 1878 with a double first and winning the Newdigate Prize for poetry (which Ruskin had won in 1839), but not the academic fellowship he had been hoping for, Wilde moved to London to lead the literary life. He went to the theatre with Ruskin, and is said to have introduced him to the future actress Lillie Langtry. He also befriended Ellen Terry who had been married to Ruskin's friend G. F. Watts. In 1881 he published his *Poems*, but the aborted London production of his first play, *Vera*, confirmed the rightness of his decision to accept Richard D'Oyly Carte's financially rewarding invitation to make a lec-ture tour of America, a subtle way of promoting the American production of Gilbert and Sullivan's caricature of the Æsthetic Movement, *Patience*.

Wilde's lectures, which gradually altered as the tour pro-gressed, drew heavily on Ruskin's ideas, so heavily that there are several passages that are copied straight out of Ruskin's own books, without acknowledgment. He does at least name

Ruskin, referring for instance to Ruskin's 'faultless and fervent eloquence' in support of the Pre-Raphaelites.[15] Walter Pater is also borrowed from, though to a lesser degree, and his name is not mentioned. But although Wilde was still using Ruskin's ideas – not to say words – he seems to have felt the need to assert his own leadership of the Æsthetic Movement – that 'movement to show the rich what beautiful things they might enjoy, and the poor what beautiful things they might create'[16] – which Ruskin's Oxford road-building project had inspired him to attempt to lead.

He did so in what admittedly seems a fairly obscure way, by arranging the publication in Philadelphia of the poems of a young English æsthetic friend of his at Oxford, Rennell Rodd. The volume, titled *Rose Leaf and Apple Leaf* is æsthetic in title, contents and as a decorative object in its own right, but what is significant is the introduction that Wilde added to Rodd's manuscript. The volume, Wilde says, is all part of his campaign to 'continue and perfect the English Renaissance'[17] – meaning that revival of culture that he had described in his review of the Grosvenor Gallery. But his ideas have moved on. The Pre-Raphaelites are politely pushed aside, and it is now Albert Moore and Whistler who have 'raised design and colour to the ideal level of poetry and music'.[18] He goes on:

> Now, this increased sense of the absolutely satisfying value of beautiful workmanship, this recognition of the primary importance of the sensuous element in art, this love of art for art's sake, is the point in which we of the younger school have made a departure from the teaching of Mr Ruskin, – a departure definite and definitive and decisive.[19]

This is an example of what psychologists like to call the

need to kill the father. Wilde goes on to pay fulsome tribute to Ruskin's teaching at Oxford and to the inspiration he has been to young men like himself. But:

> In his art criticism, his estimate of the joyous element of art, his whole method of approaching art, we are no longer with him; for the keystone to his æsthetic system is ethical always. He would judge of a picture by the number of moral ideas it expresses; but to us the channels by which all noble work in painting can touch, and does touch, the soul are not those truths of life or metaphysical truths. ... to us the rule of art is not the rule of morals. In an ethical system, indeed, of any gentle mercy good intentions will, one is fain to fancy, have their recognition; but of those that would enter the serene House of Beauty the question that we ask is not what they have ever meant to do, but what they have done. Their pathetic intentions [*by 'pathetic' Wilde means emotional*] are of no value to us, but their realized creations only.[20]

Wilde goes on to make the Paterian, and also thoroughly modernist, argument that in its 'primary aspect' a painting has no more 'spiritual message or meaning for us than a blue tile from the wall of Damascus, or a Hitzen vase. It is a beautifully coloured surface, nothing more'.[21]

And so, Oscar Wilde has stepped out from under the shadow of John Ruskin. But has he? For what is the purpose of the Beauty that this almost abstract conception of art conveys? Painting may have broken free of literature, but what Wilde calls its 'incommunicable artistic essence' still has its effects, enough, indeed, to: 'stir the most remote and divine of the chords which make music in our soul, and colour, indeed, is of itself a mystical presence on things, and tone a kind of sentiment'.[22]

In spite of this declared break with Ruskin, Wilde's æsthetics are still dependent on Ruskin's, or at the very least, they share a common source.

ᛘ ᛘ ᛘ

Although their years as undergraduates were decades apart, both Ruskin and Wilde had been formed by the traditions of classical scholarship. In Wilde's case the process began at his school in Enniskillen, Portora Royal School, where he won prizes for Greek. It continued at Trinity Dublin, where he won more prizes and met the scholar J. P. Mahaffy, with whom he was actually to travel to Greece in 1877. His training ended at Oxford, with his double first in *Literæ Humaniores*. Throughout his life Wilde was a Hellenist: the secret of Hellenism, he said, lay in accustoming the mind:

> To demand from art all that art can do in rearranging the facts of common life for us, whether it be by giving the most spiritual interpretation of one's own moments of highest passion or the most sensuous expression of those thoughts that are the farthest removed from sense, in accustoming it to love the things of the imagination for their own sake, and to desire beauty and grace in all things.[23]

Though Ruskin was also classically trained, we are accustomed to think of him as a Romantic Medievalist, and as someone tightly bound by the narrow morality of his Evangelical upbringing. This was true of him as a young man, but by the 1860s, though deploring its homoerotic aspects, Ruskin had become his own kind of Hellenist. He had lost his Evangelical faith in 1858, and discovered in the Greek myths a spirituality

that transcended narrow dogma. In his book *The Queen of the Air*, published in 1869, the goddess Athena becomes a kind of moral life force. (Wilde's Oxford notebooks show that he read *The Queen of the Air*.[24]) In the 1870s Ruskin was not simply rejecting æstheticism, but trying to rethink it, as the changes he made to a new edition of *Modern Painters* in 1883 indicate.

So what *did* Ruskin mean by 'æsthetic'? The answer lies in the Greek philosopher that both Ruskin and Wilde had studied as undergraduates: Aristotle.

When Ruskin first set out his critical principles in the second volume of *Modern Painters* in 1846 he borrowed a key term from Aristotle, *theoria*, meaning 'contemplation'. Contemplation is a higher form of perception than the mere reception of bodily sensation. As Ruskin put it, using the Greek term *æsthesis*:

> 'Æsthesis' properly signifies mere sensual perception of the outward qualities and necessary effects of bodies; in which sense only, if we could arrive at any accurate conclusions on this difficult subject, it should always be used. But I wholly deny that the impressions of beauty are in any way sensual: they are neither sensual nor intellectual, but moral: and for the faculty receiving them, whose difference from mere perception I shall immediately endeavour to explain, no term can be more accurate or convenient than that employed by the Greeks, 'Theoretic'. (4.42)

The purpose of what he called the theoretic faculty was to understand the moral nature of Beauty, that is to say, what he called 'the full comprehension and contemplation of the Beautiful as a Gift of God' (4.47).

Wilde, the lover of Beauty, may have rejected the ethical implications of Ruskin's emphasis on Beauty as a gift from

God, but he understood the perception of Beauty in the same way. In his dialogue of 1891, 'The Critic as Artist' he writes that there is in us:

> A beauty-sense, separate from the other senses and above them, separate from the reason and of nobler import, separate from the soul and of equal value – a sense that leads some to create, and the others, the finer spirits, as I think, to contemplate merely.[25]

That very word, 'contemplate', takes us back to Aristotle's *theoria*, and to a Wildeian version of Ruskin's theoretic faculty. As he writes earlier in the dialogue: 'to us, at any rate, the *bios theoreticus* [*the life of contemplation*] is the true ideal'.[26]

These ideas are to be found in Wilde's Oxford notebooks, where he makes the same distinction as Ruskin makes between æsthetic and theoretic perception. In their commentary on these notebooks Wilde's editors explain that while Walter Pater believed that Aristotle's term for heightened consciousness, *energeia* – what might be called burning with 'a hard gem-like flame' – was the highest good, Wilde believed that Aristotle's *theoria*: 'yielded wisdom, the true basis for the good and spiritual life'.[27] Pater offered no more than 'a utilitarian argument for æsthetic hedonism based on individual contemplation and enjoyment of sensual experience'.[28]

Wilde applied Ruskin's theoretic faculty in a Hellenist rather than Christian manner, but Wilde's belief that the contemplation of beauty gave access to a higher level of experience than mere sensual pleasure helps to explain the apparent paradox that the deeply moral Ruskin should have had such an influence on the – as so many people, including Ruskin's editors, saw him – deeply immoral Wilde. But it also helps to explain the even greater

Wildeian paradox: that there was no such thing as a moral or immoral book, only one that was badly written, and that art, as he wrote in 1888: 'never expresses anything but itself'.[29]

It is the very notion that art is distinct from life that makes art important to life. The Beautiful, which for both Wilde and Ruskin was also the Good, set the standards by which life could be criticised, and through which a better life could be aspired to. That is what Wilde meant when he said that 'one's real life is often the life that one does not lead'.[30] This better, realer life would be achieved by Wilde's distinctive version of Socialism:

> Socialism, Communism, or whatever one choses to call it, by converting private property into public wealth, and substituting co-operation for competition, will restore society to its proper condition of a thoroughly healthy organism, and ensure the material well being of each member of the community. It will, in fact, give Life its proper basis and its proper environment.[31]

We are back with Oscar Wilde and his wheelbarrow, and who is standing beside him but John Ruskin, who wrote in *Unto This Last*: 'Government and co-operation are in all things the Laws of Life; Anarchy and competition the Laws of Death' (17.75), adding later: 'there is no wealth but life' (17.105).

Again, this is an apparent paradox: we know that Ruskin was not a socialist, but rather, as he said himself, 'a violent Tory of the old school' (35.13). But then Wilde was not really a socialist either. He explicitly rejects socialism as we have come to understand it. What he termed 'authoritarian' socialism, armed with both political and economic power, leads to an industrial tyranny, so that 'the last state of man will be worse than the first'.[32] Instead, Wilde's socialism is really anarchist,

for *'the form of government that is most suitable to the artist is no government'* (Wilde's italics).[33] This is true not just for the artist, but for everyone else, because in place of authoritarianism Wilde advocates individualism. Individualism will be achieved through self-realization, and self-realization will be achieved through art.

Which returns us to Ruskin and the dignity of labour, for as Ruskin had been arguing ever since *The Stones of Venice*, everyone has the capacity for creativity and self-expression, if only society was organised towards that end. Here is how Wilde closes his dialogue, 'The Soul of Man under Socialism':

> The new Individualism, for whose service Socialism, whether it wills it or not, is working, will be perfect harmony. It will be what the Greeks sought for, but could not, except in Thought, realise completely, because they had slaves, and fed them; it will be what the Renaissance sought for, but could not realise completely, except in Art, because they had slaves, and starved them. It will be complete, and through it each man will attain to his perfection. The new Individualism is the new Hellenism.[34]

<center>⚘ ⚘ ⚘</center>

You would be forgiven for thinking that this chapter spends more time putting Ruskin's ideas back into Oscar Wilde, than Wilde's name into the index to Ruskin's *Works*. As we have seen, Ruskin and Wilde's connection continued after Oxford, although their careers took very different paths. Wilde's celebrity grew, and from 1886 onwards his homosexuality became more and more overt. Æstheticism was morphing into Decadence. At the same time, Ruskin's increasingly severe bouts of mental

illness meant that by 1890 he had virtually fallen silent, living in seclusion at Brantwood. It seems unlikely that he would have known much about the sudden collapse of Wilde's career in 1895, or said anything much about it.

The last time that they appear to have met is on 28th April, 1888. In 1881 the Reverend F. J. Faunthorpe, Principal of Whitelands College, a ladies' teacher-training college in Chelsea, launched an annual May Queen Festival. The Festival, which continues to be observed, though it is now open to all genders, was an invention of Ruskin's, whereby the students choose from amongst their number a 'Queen' who would be robed in a special costume – in 1888 it was designed by Kate Greenaway – and given a special cross, while Ruskin's books would be distributed. When Ruskin heard that the proposed prize-giver for 1888 had declined, he suggested that Constance Wilde might do the honours: 'Oscar has always been a most true friend to me, and <u>she</u> more than I know'.[35] (Constance also attended the ceremony in 1890 and 1892.)

Ruskin was not there in 1888; the previous year he had fallen out with Joan Severn, and from January to May was living in Sandgate on the south coast (whence he had written to Constance declining to be a godparent in January). He made occasional visits to London, and a note from Constance to Faunthorpe shows that she, Wilde and Ruskin had met at the Grosvenor Gallery on 28th April. In May Wilde published *The Happy Prince and Other Tales* and he sent Ruskin a copy. The volume is now in the Houghton Library, Harvard University, and is inscribed 'John Ruskin, in all love and loyalty, from Oscar Wilde, June '88'.[36]

The inscription suggests an approximate date for the following letter:

Dear Mr Ruskin

I send you my little book, *The Happy Prince and Other Tales*, and need hardly say how gratified I will be if you find in it any charm or beauty.

It was a great pleasure to me to meet you again: the dearest memories of my Oxford days are my walks and talks with you, and from you I learned nothing but was good. How else could it be? There is in you something of prophet, of priest, and of poet, and to you the gods gave eloquence such as they have given to none other, so your message might come to us with the fire of passion, and the marvel of music, making the deaf to hear, and the blind to see. I wish I had something better to give you, but, such as it is, take it with my love. Oscar Wilde.[37]

Wilde could write a good letter, and he knew how to flatter, but his tribute to John Ruskin is something that the editors of *The Works of John Ruskin* should not have ignored.

First given at a 'Wilde Weekend', Enniskillen in 2015, and adapted from The Wildean, *no. 49, July 2016.*

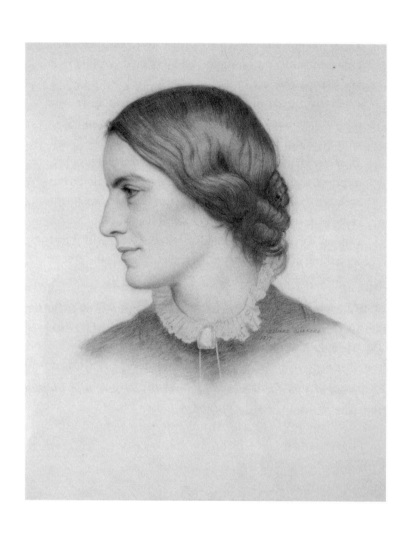

CHAPTER XIII

'YOU ARE DOING SOME OF THE WORK THAT I OUGHT TO DO': RUSKIN AND OCTAVIA HILL

❧

In 1896 the National Trust bought its very first building, the 14th century Clergy House at Alfriston in Sussex. The price was £10. It was cheap because it needed £320-worth of repairs, which was more than the Trust's annual income at the time. Octavia Hill, who was collaborating with the Society for the Protection of Ancient Buildings over the purchase, wrote: 'We should very naturally be asked to "restore" it, in so far as that odious word means preservation from decay'.[1] She was recalling the words of her friend and patron, John Ruskin, in *The Seven Lamps of Architecture*:

> Do not let us talk then of restoration. The thing is a Lie from beginning to end. You may make a model of a building as you may of a corpse, and your model may have the shell of the old walls within it, as your cast might have the skeleton, but with what advantage I neither see nor care: but the old building is destroyed, and that more totally and mercilessly than if it had sunk into a heap of dust, or melted into a mass of clay. (8.244)

The repairs to Alfriston, involving considerable structural intervention, nonetheless went ahead.

There is a heritage of objects, and a heritage of ideas, and in

Opposite: Fig. 35: Edward Clifford, Octavia Hill, Aged 39, *1877*

neither case is it possible to accept Ruskin's absolutist resistance to change: objects decay, their context alters, their meaning shifts. The same happens with institutions. In the 1930s, when the National Trust decided that it would acquire country houses, it moved a long way from Octavia Hill's principles. She wanted to preserve land, in order to give the poor access to it, not to preserve the properties of the privileged. But her values remain central to the Trust, and they are Ruskinian in origin.

<p style="text-align:center">⚜ ⚜ ⚜</p>

Although Octavia Hill was not entirely excluded from Ruskin's *Works*, in the manner of Oscar Wilde, she does not feature significantly in Cook and Wedderburn's Library Edition. It is true that they give due acknowledgement to the importance of Ruskin and Hill's joint enterprise. They write: 'probably none of his experiments will have had so permanent and so fruitful an influence towards the solution of modern problems as the demonstration which he enabled Miss Octavia Hill to give in model landlordism' (17.cx-cxi). It is also true that everything Ruskin wrote about her publically can be found in the Library Edition, but their relationship had begun in 1853 when Octavia was fifteen, and for ten years after 1855 he made her an allowance, before providing her with the first properties that were to be the basis of her experiments in 'model landlordism'.

The Library Edition publishes no correspondence between them, apart from the painful exchange of letters that Ruskin himself chose to publish in 1877, at the moment of the breakdown in their friendship. Yet a substantial and illuminating correspondence existed. It may be that Cook and Wedderburn did not wish to draw attention to Ruskin's cruel behaviour.

Equally, after the rupture, Octavia Hill emphasised the need for silence, and the fact that she did not die until 1912 would almost certainly have ensured that her discretion was respected. But subsequently two books have appeared that cast an illuminating light on Octavia Hill and Ruskin's relationship. Both pass over the actual breakdown of the friendship in silence, but nonetheless paint an affecting picture of the relationship between these two extraordinary people.

The first, published in 1913, is *The Life of Octavia Hill as told in her letters*, edited by the son of F. D. Maurice (founder of the Working Men's College), Charles Edmund Maurice, who had married Octavia's sister Emily.[2] The second appeared in 1928, this time edited by Emily Maurice, and titled *Octavia Hill: Early Ideals*.[3] Like her husband's, this is a biography constructed out of correspondence, and came about because the letters between Octavia and her co-worker Mary Harris had become available. But there is a third person in the narrative, Ruskin, with some forty letters and extracts of letters by him to Hill. Again, the circumstance of the rupture of 1877 are glossed over – the last letter from Ruskin is in 1875 – but Octavia's letters to Mary Harris allow her to express her feelings a little more directly, and although Hill's biographer Gillian Darley argues that she was not one of Ruskin's 'innumerable adolescent "pets"',[4] it is clear that she became more than just a little bit in love with him.

△ △ △

Octavia Hill was born in 1838. She came from a radical, dissenting background; her grandfather, mother and father were all campaigners, driven by a sense of social and religious mission, and the Hill family paid the price for its reforming views in the

shape of extreme poverty during her youth, the consequence of her father's financial and mental breakdowns. Her grandfather, Southwood Smith, was a leading sanitary, housing and labour reformer who helped Dickens with research into conditions in the mines. In 1852 Octavia and her sisters moved from what was then bucolic Finchley and Highgate to Russell Place, Holborn, where her mother had been given work as the manager of a newly founded co-operative crafts workshop for women and girls, the Ladies Guild. Octavia was put in charge of the toymakers, young girls from a ragged school, and immediately her powers of organisation and leadership became apparent. One of the backers of the venture was the Christian Socialist, Edward Vansittart Neale, who lost his fortune supporting the cooperative movements of the time. By 1855 Octavia was part of the Christian Socialist circle. She had met F. D. Maurice, whom she called a prophet, and Ruskin, whom she called a poet. When she met Ruskin at around the time of her fifteenth birthday in December 1853, it appears to have been Maurice who made the introduction by taking him to see the work of The Ladies Guild. She wrote after their meeting:

> If you had seen the kind, gentle way in which he spoke, the interest he showed, the noble way in which he treated every subject, the pretty way in which he gave the order, and lastly, if you had seen him as he said on going away, his eyes full of tears, 'I wish you all success with all my heart', you would have said with me that it was utterly wonderful to think that that was the man who was accused of being mad, presumptuous, conceited and prejudiced.[5]

The 'order' referred to was for a number of items produced by the Ladies Guild, including a painting on glass for a table

top of a hawthorn spray, and a text from the Psalms, painted by Octavia herself.

Octavia had already absorbed everything Ruskin had written since the publication of the first volume of *Modern Painters* a decade before. Ruskin was evidently impressed by her and the promise she showed as an artist, and offered to lend her pictures to copy. It may have been the imminent demise of the Ladies Guild that caused Ruskin to invite her to Denmark Hill in March 1855, and offer to train her as a copyist, starting with illuminated lettering. Octavia wrote a vivid description of the visit, which ends with a flutter of hope that Ruskin's interest in her might be more than philanthropic: 'this might be the opening to a more glorious path; and that I would give years, if I could bring to Ruskin "the peace that passeth all understanding".'[6]

For the next ten and a half years Ruskin was both her employer, paying her a pound a week for her art work, and her teacher. By making copies of old masters for Ruskin, she received a rigorous training of the hand and eye that qualified her in turn to teach others. Ruskin acknowledges her help in preparing illustrations for the fifth volume of *Modern Painters*. Her work is unsigned, but from the evidence of their correspondence it is fairly certain that she did the line drawings for the woodcuts based on

Fig. 36: Octavia Hill, Woodcuts Based on Etchings by Salvator Rosa, 1860, Figures 57 and 58 in Modern Painters, *volume five*

etchings by Salvator Rosa, figures, 41, 57, 58, 62 and 99, and almost certainly more (Fig. 35).

'He taught me a great deal in a few words', Octavia writes of a lesson in 1856.[7] Their shared æsthetic rested on a romantic and religious faith, informed by the natural theology that interpreted nature as symbolic of God's creation: 'I think to arrange beautiful colour, to show what I believe God's works are the symbols of', she told Ruskin.[8] God's work was to be found in the countryside, not in man-made towns, but Octavia was already also engaged with her true vocation: 'Colour and form (certainly in landscape) are so delicious to me that I should be quite happy to spend my working life in copying, though I believe I should always require some social work'.[9] In 1856 Octavia became secretary to the women's classes at the London Working Men's College.

Octavia, who had a punishing schedule of copying, teaching and administration, deeply admired both the Principal, F. D. Maurice, and Ruskin. In October 1858 she went to Cambridge to hear Ruskin give his inaugural address at the Cambridge School of Art. Her description is both a remarkable first-hand account of its reception, and reveals her emotional attachment to the speaker.

> I had felt painfully how Ruskin knew he had little sympathy from his audience, but that when he came to one part, the whole body of people listened in awe. I only knew it by the applause that burst and rolled out. He had carried the whole audience with him, and they felt that there was someone present greater than themselves. I heard the applause with triumph, but I heard it far off, and I only saw the single, slight, noble figure standing there in the light. I knew that there was more heart-value in the gradual, continual, silent

sympathy of those who had worked near him, and traced his power in his slighter sentences, his glory in his quiet spirit-work than in all that deafening roar.[10]

After attending Ruskin's lecture on 'Work' at the Camberwell Working Men's Institute in January 1865 she wrote: 'afterwards I had such a pressure of the hand from him, such consciousness of entire sympathy did it express'.[11]

But if Octavia did have hopes of Ruskin, sympathy did not grow into anything more. She continued to make copies for him, and performed useful tasks, such as keeping his mother company and trying to head off his persistent would-be pupil Anna Blunden,[12] but he could be critical of her copies, and as one reads her letters it becomes apparent that the way she describes his responses to her work is a barometer of her hopes and feelings for him. In October 1859 she realises: 'I believe what made me wretched was the sudden vivid thought of how very little pleasure I could ever give Ruskin, even by the most conscientious work'.[13] In spite of 'affection for and gratitude to Ruskin, and an ever deepening admiration for him' she seems to be realising that what she hoped for was not to be.[14] The letter ends: 'Sometimes Mama seems to think Ruskin capricious; and I am certain he is not. Well it is all over now'.[15]

Nonetheless she continued working for Ruskin, even when in 1862 Octavia, her mother and her sisters had opened their own school. Ruskin however recognised that Octavia's: 'infinite sympathy and power of teaching and helping people' was greater than her artistic talent.[16] In January 1863 she wrote: 'Ruskin's heart is with social things; and I was earnestly charged to leave any drawing, if I saw what of help I could give anywhere, believing (which is not difficult) that in doing *any* good, I was fulfilling Ruskin's wish and will as much as in drawing'.[17] The solution

emerged in 1864 when Ruskin's father died, and he found himself with a considerable inheritance. Octavia came to him with a socially useful way to invest some of it. She wrote to a friend:

> I have long been wanting to gather near us my friends among the poor, in some house arranged for their health and convenience, in fact a small private model lodging-house, where I may know everyone, and do something towards making their lives healthier and happier, and to my immense joy Ruskin has promised to help me work the plan.[18]

This project became a reality in 1865 and 1866 when he put up the money to buy the leases of slum housing in Paradise Place and Freshwater Place in Marylebone, telling her: 'you are doing some of the work that I ought to do'– which suggests that she influenced him, as well as he her.[19] His total investment was £3,500, and although this might seem at first the opposite of philanthropic on the part of the author of *Unto This Last*, he wanted a return of five per cent on the property. But as he explained: 'I furnished you with the means in order to prove and practise one of the first principles of my political economy: that proper use of money would give proper interest, and that no one could otherwise than *criminally* take more'.[20] This was not usury or exploitation, but a necessary economic discipline, and any surplus above five per cent was at Octavia's disposal to help the tenants. Octavia's career as a social worker had begun.

It must be understood that both Ruskin and Hill's political economy was profoundly conservative. As we saw in Chapter IV, it was not the aggressive individualism associated with market-driven modern conservatism, but harked back to the romantic anti-capitalism of the Ultra-Tories of the 1830s, where power and privilege were balanced by responsibilities. The word

'feudal' has been applied to both Ruskin and Hill. Both were members of the Charity Organization Society, formed in 1869 in an attempt to co-ordinate the efforts of competing charities, and which believed in what would now be called 'tough love', aimed at 'raising the poor without gifts'.[21] This made a firm distinction between the deserving and the undeserving poor, and tried to provide work, rather than income support through alms-giving. Octavia Hill's system depended on the close relationship between her tenants and the middle-class female rent collectors on the properties they managed. These were expected to monitor their tenants' welfare, find them work, and encourage suitable forms of recreation; it was care, but it was also control.

In spite of Hill's success and pervasive influence, this labour-intensive social work, seeking to reform each individual, rather than to change the social and economic structures that determined the way they lived, could only have a limited impact on the enormous housing problems that the industrialisation of Britain had generated. She was hostile to the municipal authorities that began to tackle the problem, and, like Ruskin, did not believe in state intervention. Her faith in charitable organisations, and distrust of locally elected authorities, chimes with the rhetoric of the former Conservative Prime Minister David Cameron's attempts to promote 'The Big Society', a form of localism that appeared to disempower democratically elected institutions in favour of individuals, special interest organisations and market forces.

⚜ ⚜ ⚜

After cleaning, ventilation and refurbishment, Paradise Place (which is now renamed Garbutt Place) and Freshwater Place

(now demolished) proved a success. A playground was created, and a Maypole celebration instituted, as Ruskin had done at Winnington School, a precursor to the May Queen Festival at Whitelands College. Octavia's example and influence began to spread, as other benefactors bought slum properties and handed them over to Octavia Hill's management, or managed them according to her principles. This called for more rent collectors – Octavia called them 'visitors' – creating more opportunities for middle-class women who wanted to lead useful lives, but for whom most channels were blocked. By the 1890s these were receiving formal training. In the 1870s she began to work in the even worse conditions of the East End. Ruskin continued to approve of her efforts, and it may have been as a favour to him that in 1876 she took over the management of Ruskin's unsuccessful tea shop in Paddington, after one of the Tovey sisters, former Ruskin servants employed to run the shop which had opened in 1874, died.[22]

By this time, however, Ruskin had embarked on his own programme of social reform, and it appears that his and Octavia's ideas began to differ. In July 1875 he wrote to her:

> My work is now, and must be, totally in another kind; not as you put it, that I want perfection, while you are content with the immediate possible – but that while your work is only mitigating of mortal pain, mine is radically curative. – London is as utterly doomed as Gomorrah, that is no reason why *you* should not open a window, or bring a field to give a moment longer breath to her plague-stricken children, but I have to labour wholly to fence round fresh fields beyond the smoke of her torment.[23]

Both where and how reform should be conducted is the

difference between them, and Ruskin appears to think Octavia's practical results merely palliative. In *Fors Clavigera* for April 1877 Ruskin announced his intention to hand over the leases and freeholds of the Marylebone properties to the Guild, though: 'under Miss Hill's superintendence always. I have already had the value of it back in interest, and have no business now to keep it any more' (29.102).

Unfortunately, this change of ownership appears to have alarmed Octavia, and, possibly with Ruskin's tea-shop in mind, she let pass a remark to a third party that criticised Ruskin's organisational skills: 'Do not look to Mr Ruskin for definite direction about practical things: he is not the best judge of them' (29.357). In the gossipy world of London charities this got back to Ruskin, who announced in the notes to *Fors* for January 1878 that there had been a hitch in the handover of the Marylebone properties (29.326). The following month he launched a full-blown attack on Hill.

Complaining that none of her friends had ever supported the Guild of St George, he proceeded to publish, with his own acid and angrily-footnoted commentary, the letters he and Octavia had exchanged once her criticisms of him had reached his ears. Not surprisingly, Octavia had taken umbrage, which Ruskin in turn found irritating, but he pressed on, until Octavia conceded 'I have spoken to you, I think, and certainly to others, of what appears to me an incapacity in you for management of great practical work', and she went on to admit the remark quoted earlier. He was a great teacher, but not a practical guide (29.356).

The dispute was deeply damaging to both sides. Ruskin did himself no service by publishing the private correspondence, and the anger and cruelty of some his remarks may foreshadow the mania to which he succumbed for the first time later in

1878. As we saw in Chapter XI, Ruskin could treat people who worked for him badly. Octavia, suffering from stress, overwork and the aftermath of a failed engagement, also broke down, and had to go abroad for more than a year to recover. In 1881 the Marylebone properties were sold to Octavia, and Ruskin gave away the money. In 1888 young Sydney Cockerell, whose father was a friend of Octavia's, and who himself worked as secretary to the Working Men's Club at her most elaborate project, the Red Cross Cottages and Hall in Southwark, attempted a reconciliation while on a visit to Brantwood. Ruskin was reluctant at first, but was at last persuaded to ask forgiveness in a letter to Cockerell's sister Olive, who was Octavia's god-daughter. He asked it:

> Nor for that error merely but for total wrongness in all one's thought – in all one's angers – in all one's pride. And while I see the disease now clearly, I am not yet the least convinced that my thoughts of city and country work were wrong.'[24]

As result, he did not cancel the offending pages in *Fors Clavigera*.

Cockerell sent Octavia Ruskin's letter, and her response is deeply moving:

> I think he is right about the forgiveness; and I think it *is* hard that any of you should expect a man, who had the place in the world that he had when he knew me as a girl of not fifteen years, should ask forgiveness. Not for a moment do I myself wish it, unless in any way it took away from him the sadness of the memory of what he did. I tell you, most distinctly, I do not think there is very much in the whole affair; that is, when the imperfections of earth and speech are taken away, I do not think there is very much to clear up between Mr Ruskin and me. Till that time, touched as I am by your

chivalrous kindness about it, I do seriously assure you I think a merciful silence is at once the best and the most dignified course, for him and for me. What has the world to do with it if we both feel silence all that is needed? There are things that nothing will ever put right in this world; and yet they don't really touch what is right for all worlds.

I say this for your sake, that you may feel at peace about it all; else nothing would make me say anything. Be at peace about it. I am. I hope Mr Ruskin is. He may be. The thing is past, let us bury it; that which the earth will not cover, which is not of it, lives in the Eternal Kingdom; and in the thought of it earthly imperfection or mistakes seem very small things.[25]

∆ ∆ ∆

Although the Guild of St George lives on as part of Ruskin's legacy, Hill was quite right about Ruskin's administrative inadequacies, but she was also right about his influence as a teacher. Incapacitated, and living at Brantwood, Ruskin was off the scene by 1895 when the National Trust came into being, but his influence on its founders was strong. His belief in the value of 'fresh fields beyond the smoke' was shared by Octavia, who from the beginning of her work with the child toymakers of Holborn had taken every opportunity to try to get slum dwellers access to the countryside, and create green spaces in towns. Nature, as we know, constituted the essential source of both æsthetic and moral value for Ruskin, and an æsthetic impulse combined with a moral imperative lay behind the Hill sisters' formation of the Kyrle Society in 1875, a 'Society for the Diffusion of Beauty', where beauty would ameliorate the lives of the poor.

Its four branches: Decorative, promoting what might now be called public art; Music, in the shape of choirs and concerts; Literature, to provide sound reading matter; and Open Spaces, seeking to turn London burial grounds into public gardens, all signalled a holistic attempt to improve the quality of the public realm, as well as anticipating the values of the National Trust.

The Open Spaces sub-committee was an extension of the Commons Preservation Society, founded in 1865, whose solicitor Robert Hunter also chaired the Kyrle Society sub-committee, and who went on with Octavia Hill to found the National Trust. The other key figure was Canon Hardwicke Rawnsley. The Ruskinian connection was direct, for Rawnsley had been one of Ruskin's Hincksey diggers at Oxford, before going to work as a curate in Soho, where at Ruskin's suggestion he contacted Octavia Hill, and became a rent-collector for Octavia's co-worker Emma Cons in Drury Lane. When he broke down as a result of overwork Octavia arranged for him to convalesce in the Lake District. Later, in 1877, he was given a parish near Windermere, just as the battle to stop Thirlmere being made into a reservoir for Manchester was getting under way.

That battle was lost, but in the succeeding years Rawnsley, Hunter and Octavia Hill collaborated in seeking ways to permanently protect threatened countryside. When it finally came into being in January 1895, the difference between the National Trust and the Commons Preservation Society, and the Open Spaces committee of the Kyrle Society that had preceded it, was that the Trust was not merely seeking to create public gardens from disused burial grounds, or protect existing common land and rights of way: the Trust was ready to take private land into public ownership.

Here, Octavia Hill would be firmly on the opposite side of

the fence to modern Conservatism. Writing in 1877, long before
the Trust came into being, she pointed out that one quarter of
the land in England was owned by only 710 individuals: 'The
more that fields and woods are closed, the more does every
atom of Common land, everywhere, all over England, become
of importance to the people of every class, except that which
owns its own parks and woods'.[26]

Ruskin had put the point about private land ownership
equally succinctly in *Fors Clavigera* in 1871:

> While Miss Hill, with intense effort and noble power, has
> partially moralized a couple of acres in Marylebone, at least
> fifty square miles of lovely country have been Demoralized
> outside London, by the increasing itch of the upper classes
> to live where they can get some gossip in their idleness, and
> show each other their dresses. (27.176)

Everything Ruskin had said about the need to establish a
right relationship between man and nature stood behind the
values of the Trust. It was entirely appropriate that the Trust's
first acquisition was land at Barmouth given by Ruskin's close
friend Fanny Talbot. Later, the Trust appealed for funds to
erect the memorial to Ruskin at Friar's Crag, on land they later
acquired at Derwentwater.

Octavia Hill, like Ruskin, wanted access to nature above all
for those trapped by poverty in towns, and expressed a belief in
collectivism that would be anathema to neo-liberals:

> In our common-land we are meant to learn an even deeper
> lesson: – something of the value of those possessions in which
> each of a large community has a distinct share, yet which
> each enjoys only by virtue of the share the many have in it;
> in which separate right is subordinated to the good of all;

each tiny bit of which would have no value if the surface were divided amongst the hundreds that use it, yet which when owned together and stretching away into loveliest space of heather or forest becomes the common possession of the neighbourhood, or even the County and Nation. It will give a sense of common possession to succeeding generations.[27]

A A A

The National Trust has achieved just that, and now it has a fight on its hands to protect both town and country from neo-liberal changes to planning law promoting 'sustainable development', which, in the words of Fiona Reynolds, the Trust's Director at the time these changes were proposed were: 'so clearly driven by economic concerns rather than sustainability'.[28] As Octavia Hill observed in *Our Common Land*: 'we are all so accustomed to treat money value as if it were the only true value!'.[29] This surely is an echo of *Unto This Last*.

The Trust has changed beyond recognition since the days of its founders: it has itself become the largest non-government land owner in the country, it manages a portfolio of historic houses that would have been unimaginable when Alfriston was acquired in 1896, and its membership of over five million is larger than that of all the political parties combined. But when it argues that the built and natural environment represents a higher common good that should be protected from market forces, it demonstrates that its values remain those of Octavia Hill and her mentor, John Ruskin. As she declared in 1889: 'New circumstances require various efforts, and it is the spirit, not the dead form that should be perpetuated'.[30]

Octavia Hill remained faithful to Ruskinian values. When

she was asked to contribute to a memorial to Ruskin to be erected in Westminster Abbey, she declined: 'Ruskin needs no memorial. His influence is deeply impressed on thousands; his memorial consists in his books, his life, his works.' She went on to make this Ruskinian point: 'The erection in the Abbey appears to me to be at least a questionable good. It is one which he himself might have felt as jarring with the surroundings. He cared so much for untouched buildings handed down to us. I could not join in a scheme for touching them'.[31]

An extended version of a contribution to a collection of essays celebrating the centenary of Octavia Hill's death: 'To the utmost of her power...': The Enduring Relevance of Octavia Hill, *(ed.) Samuel Jones, Demos, 2012.*

MAN·IS·BVT·A·WORM

CHAPTER XIV

'THE MIND REVOLTS': RUSKIN AND DARWIN

❧

It is one of the great ironies of Ruskin's life that, in 1860, a session of the annual conference of the British Association for the Advancement of Science should have been held in the as yet unfurnished library of The Oxford University Museum of Natural History. On Saturday 7th July some 700 people, dons, clergymen and men of science (some were all three), undergraduates, and townspeople, crammed into the empty Hope Library. Many were drawn by the prospect of hearing the great orator Samuel Wilberforce, Bishop of Oxford, denounce the theory of evolution, as propounded by Charles Darwin's recent publication, *On The Origin of Species*. Wilberforce, a Vice-President of the Association, and a supporter of the Oxford Museum, was expected to repeat the defence of scientific and theological orthodoxy made in a sermon before an earlier Oxford meeting of the Association in 1847, an attack on Robert Chambers' anonymous *Vestiges of the Natural History of Creation* (1844), which had started to undermine the principles of natural theology that Darwin's 1859 publication was to overthrow. The Bishop had already exposed some of the flaws in Darwin's case for the process of natural selection – Darwin did not use the term 'evolution' at this time – in the *Quarterly Review*.

The fact that there are no precise records of what was said has added to the mythical status of the meeting. Ruskin was

Opposite: Fig. 37: Linley Sambourne, Caricature of Charles Darwin, 'Man Is but a Worm', Punch Almanack for 1882

not there, he was in Switzerland; nor was Darwin, as often, he felt too ill to attend. But Darwin had a champion in the biologist and comparative anatomist Thomas Henry Huxley, coiner of the term Darwinism, who liked to describe himself as 'Darwin's bulldog'.[1] The clash occurred in the discussion following a paper by an American chemist on the evolution of civilisations, and picked up on an earlier spat between Huxley and the anti-Darwinian naturalist Richard Owen, the future founder of London's Natural History Museum. Wilberforce reportedly asked Huxley, in a flippant aside, whether the monkeys – from whom evolutionists were popularly supposed to believe men were descended – were on his grandfather's or his grandmother's side. Huxley later said he replied that he would rather have a miserable ape for a grandfather than a man who exploited his influence to bar the way to scientific truth. Some reports claimed he had said that, for a grandfather, he would rather have an ape than a bishop, which though untrue, was succinct, and captures the spirit of the cartoonists who found a thousand ways of linking Darwin with monkeys' tails.[2]

The irony for Ruskin was that the Oxford Museum had been intended to celebrate the unity of science and faith. Far from resisting the advance of science, Ruskin had backed his close friend, the dynamic Oxford politician Henry Acland, MD, in his campaign to establish a School of Natural Sciences at the University in 1847, which the new building was intended to house. He was not responsible for the choice of the museum's architects, but their winning Gothic design was clearly influenced by *The Stones of Venice*. Once Benjamin Woodward arrived in Oxford in 1854, Ruskin became closely involved in seeing the project through. He offered his own designs for carvings on the façade, lectured to the artisans, and donated at

Fig. 38: Anon., The Oxford Museum of Natural History

least £300 towards the embellishment of the building (Fig. 38).[3]

Ruskin's ideas were not simply decorative. The whole building, where the shafts of the columns were an inventory of British rocks, and the capitals were freely carved in stone from plants brought from Oxford's Botanical Gardens, was intended, like St Mark's, to be read like a book. This extended to the cast and wrought-iron columns of the interior court, which managed to be radically modern in construction, yet still suggest a forest of trees. It was an enactment of the Nature of Gothic. But no sooner was this paradise of natural theology completed in 1861 – or rather, left off, since Woodward died of tuberculosis that year, and the decorations were unfinished – than the serpent of a new science began to undermine the unity of faith in God and admiration for his creation on which the building had been built.

It was not like that in Ruskin's youth. As his father proudly declared: 'From boyhood my son has been an artist, but he has been a geologist from infancy'.[4] For Ruskin, there was no difference between the two callings, since both practiced the science of observation. At the age of eleven, following a tour with his parents to the Lake District, he produced 2,500 lines of doggerel, celebrating his active participation in the joy in nature:

> Now surveying a streamlet, now mineralizing, –
> Now admiring the mountains, and now botanizing, – [5]

Among the earliest surviving drawings by Ruskin are a series of maps made when he was eight; there can be no more literal way of expressing the features of the earth. His collection of minerals at Brantwood was to grow to more than 3,000 specimens, besides presentations to other institutions, including the British Museum. His first published prose, when he was fifteen, was an article in *The Magazine of Natural History* in 1834: 'Enquiries on the Cause of the Colour of the Water of the Rhone' (1.191-2), a painterly as well as scientific project.

In his youth, the harmony between science and art was easier to sustain because scientific methodology was closer to that of painters and poets. The early nineteenth-century scientist observed the phenomena of the natural world like a painter, and like a poet named and classified them. The leading scientific disciplines were observational: astronomy, geology, mineralogy, botany. Science was concerned with gaining empirical knowledge of the natural world and the scientist was a 'natural philosopher'. The artist and the scientist shared a moral commitment to accurately recording the truth of their perceptions.

Thus science could have a disciplinary effect on art, demanding truth to nature:

A long-experienced eye can, at a glance from the summit
of a mountain, point out with considerable certainty the
different formations of which a country is composed. Land-
scape-painters, by confounding together all these differences,
or by combining them irregularly, fail not only in accuracy,
but in giving their work that appearance, which shows, at
first glance, that it is not only a copy of nature, but a copy
by one who has formed a distinct conception of the general
and particular features of the inequalities observable on the
surface of the earth.[6]

This is not Ruskin, though it sounds like him. It is Robert
Jameson's *Manual of Mineralogy*, which he owned as a boy.
He was to make this argument for accurate observation one of
the foundation stones of his defence of Turner. It was Turner's
superior powers of observation that led him to say that Turner:
'is as much of a geologist as he is of a painter' (3.429).

Ruskin's scientific training continued in parallel with his
artistic development. In 1837 he joined the London Geological
Society, becoming a Fellow in 1840. At his first meeting he
heard a paper by Darwin, lately returned from the expedition
to South America and the Galapagos Islands which supplied the
evidence for the theory that two decades later was to prove so
devastating to Ruskin's worldview. When he went up to Oxford
later that year, he immediately began to attend the lectures of
the University's first Professor of Geology, the Reverend William
Buckland, a fellow of his college, Christ Church. The eccentric
Buckland took Ruskin up, and used his skills as a draughtsman
to prepare illustrations for his lectures. In April 1837 he dined
with Buckland; Darwin was another guest, and they had a
long talk. In retrospect, Darwin did not share Ruskin's enthu-
siasm for Buckland who: 'though very good-humoured and

good-natured, seemed to me a vulgar and almost coarse man'.[7]

Vulgar and eccentric or not, Buckland had persuaded the University to create his chair in geology by reconciling science and theology. In 1836 he had published *Geology and Mineralogy Considered with Reference to Natural Theology*, one of the so-called Bridgewater treatises sponsored by the eighth Earl of Bridgewater in order to demonstrate the goodness of God in the fields of astronomy, physics, geology and animal, vegetable and human physiology:

> No reasonable man can doubt that all the phenomena of the natural world derive their origin from God; and no one who believes the Bible to be the word of God, has cause to fear any discrepancy between this, his word, and the results of any discoveries respecting the nature of his works.[8]

Such discoveries were, however, stretching to breaking point the links between the evidence offered by the observable world and the Mosaic account of the creation of the earth in six days. In 1802 the Reverend William Paley's *Natural Theology or Evidences of the Existence and Attributes of the Deity*, made the case for God as a master architect and craftsman, who had designed the earth with its beauties and resources for the benefit of man. But as the century progressed the enquiries of natural scientists and biblical scholars began to bring into doubt not only the authority of the Biblical text, but also of the supposed author of that text. As Ruskin wrote to his friend Henry Acland in 1851: 'If only the Geologists would let me alone, I could do very well, but those dreadful Hammers! I hear the clink of them at the end of every cadence of the Bible verses' (36.115).

Ruskin's crisis of faith came in 1858, before the publication of *On The Origin of Species* in 1859. Yet although an 'un-converted

man' as far as Evangelicalism was concerned, he held on to the belief that the natural world gave access to the divine. As he wrote in 1869 to his friend Charles Eliot Norton, who had re-introduced Ruskin and Darwin in the previous year:

> That a power shaped both the heath bell and me – of which I know and can know nothing – but of which every day I am the passive instrument, and, in a permitted measure also the Wilful Helper or Resister – this – as distinctly – all nature teaches me – and it is in my present notions of things, a vital truth. (LN.178)

The abandonment of a strictly Evangelical view of the world as a work in God's handwriting did not weaken his faith in there being a creator, in fact, it strengthened it, for otherwise the world would have no meaning at all. His case for the existence of what he called a theoretic – that is to say, contemplative – faculty was that beauty was not a mere source of æsthetic pleasure, but a source of moral good – hence the need to convey the beauties of the natural world as accurately as possible. But accuracy was not enough, there had to be an emotional, indeed spiritual, understanding. In the third volume of *Modern Painters*, published in 1856, he concluded a chapter, aptly titled 'The Moral of Landscape' by making this point:

> We cannot fathom the mystery of a single flower, nor is it intended that we should; but that the pursuit of science should constantly be stayed by the love of beauty, and accuracy of knowledge by tenderness of emotion.
>
> Nor is it even just to speak of the love of beauty as in all respects unscientific; for there is a science of the aspects of things, as of their nature; and it is as much a fact to be noted in their constitution, that they produce such and such

an effect upon the eye or heart (as, for instance, that minor scales of sound cause melancholy), as that they are made up of certain atoms or vibrations of matter. (5.387)

Increasingly, however, this 'science of aspects' would come into conflict with the hard science of the evolutionists.

⨳ ⨳ ⨳

While the publication of *On The Origin of Species* marked a watershed for evolutionary theory, as did the publication of *Essays and Reviews* in 1860 for biblical criticism, and both did lasting damage to Natural Theology,[9] Ruskin, possibly because his mind had turned to political economy, was slow to respond publicly to the challenge of Darwinism. Evolution was in the air, and he could not have been unaware of the controversy launched in 1859, or of Darwin's argument, but although 'Darwinism' becomes a regular generic reference, he never cites *On The Origin Of Species* directly, which suggests he may not have read it, whereas, as we shall see, he specifically names and quotes other works.

It is possible that it took time for the full implications of Darwin's theory to sink in. Darwin had himself been brought up in the tradition of Natural Theology, and later admitted: 'I was not able to annul the influence of my former belief, then widely prevalent, that each species had been purposely created'.[10] Yet although he claimed: 'I see no good reason why the views given in this volume should shock the religious feelings of anyone',[11] and, by excluding the subject of man was able to avoid discussing man's relation to apes, there was plenty to undermine the idea of a world created in six days, or, if one no longer accepted

the time-frame of Genesis, by providential design. The full title, *On the Origin of Species by Means of Natural Selection, or the preservation of favoured races in the struggle for life*, sets out the argument: natural selection occurs when accidental variations within species produce advantages that allow them to supplant others in the Malthusian struggle for resources. Sexual selection, which becomes the dominant theme in his later study, *The Descent of Man*: 'depends, not on a struggle for existence, but on a struggle between males for possession of the females'.[12]

While the cautious Darwin was prepared to concede that the 'laws' of natural and sexual selection might be evidence of design by a 'Creator', his closing sentences impose an optimistic conclusion on an argument that fundamentally destroys the idea of a fixed, providential and benign world made for the benefit of man:

> Thus from the war of nature, from famine and death, the most exalted object of which we are capable of conceiving, namely, the production of the higher animals, directly follows. There is grandeur in this view of life, with its several powers, having been originally breathed by the Creator into a few forms or into one; and that whilst this planet has gone cycling on according to the fixed law of gravity, from so simple a beginning endless forms most beautiful and most wonderful have been, and are being evolved.[13]

⚛ ⚛ ⚛

Ruskin's first, and ambivalent, response to Darwin did not appear in print until 1869, in a strange book, *The Queen of the Air: being a study of the Greek Myths of Cloud and Storm*. This is a compilation from half a dozen sources, mainly lectures and

articles written between 1867 and 1869. Ruskin's comments on Darwin have to be understood in the context of a social encounter engineered in October 1868 by Ruskin's American friend, Charles Eliot Norton. Norton was staying in England near Darwin's home at Downe, in Kent. First, Ruskin went to Downe, and later Darwin made a reciprocal visit to Denmark Hill. It was during this visit that Ruskin discovered a blind-spot in Darwin: that he could not draw (which Darwin freely admitted), and that he lacked all æsthetic appreciation of Ruskin's Turners.

The cordiality of their exchanges (Darwin also visited Ruskin at Brantwood in 1879) may have inhibited Ruskin when he came to address the origins of life in terms of Athena – queen of the air – as a mythical expression of the spirit that infuses both plants and animals. Ruskin politely writes at the beginning of a footnote: 'The facts on which I am about to dwell are in no wise antagonistic to the theories which Mr Darwin's unwearied and unerring investigations are every day rendering more probable' (19.358n). But his argument in the main text sets out his objection to Darwinism, as he was coming to understand it. Without using the term – though referring a little coyly to 'the joy of love in human creatures' and 'the continuance of the human race', Ruskin attempts to turn Darwin's theory of sexual selection on its head.

Noting that what he calls 'the Spirit in the plant' is most evident when it flowers, he writes:

> Where this Life is in it at its full power, its form becomes
> invested with aspects that are chiefly delightful to our own
> human passions; namely, first, with the loveliest outlines of
> shape: and, secondly, with the most brilliant phases of the
> primary colours, blue, yellow, and red or white, the unison

of all; and to make it all more strange, this time of peculiar and perfect glory is associated with the relations of plants or blossoms to each other, correspondent to the joy of love in human creatures, and having the same object in the continuance of the race. (19.357)

Thus far, Ruskin allows that flowering is part of the process of sexual reproduction, but then goes on:

Only with respect to plants, as animals, we are wrong in speaking as if the object of this strong life were only the bequeathing of itself. The flower is the end or proper object of the seed, not the seed of the flower. The reason for seeds is that flowers may be; not the reason of flowers that seeds may be. The flower itself is the creature which the spirit makes; only, in connection with its perfectness, is placed the giving birth to its successor. (19.357-8)

The interest of this passage, which leads into a more general discussion of 'the distinctions of species' (19.358) with its pendant Darwinian disclaimer, quoted earlier, is that it is a direct contradiction, not of *On The Origin Of Species*, but something that Darwin wrote in 1862 in a follow-up publication: *On the various contrivances by which British and Foreign Orchids are fertilised by insects*. In the introduction, Darwin explains that the book is a case study showing how the general theory of natural selection outlined in *On The Origin* works in scientific detail. In its closing pages, he writes: 'The final end of the whole flower, with all its parts, is the production of seed'.[14]

In one of the books that came out of this dispute with Darwin, *Proserpina*, the book on orchids is cited twice (25.224, 546), so there no doubt that Ruskin read it. His argument with Darwin, and his attempt to offer a different, mythopoeic vision

of nature, exists in embryonic form in *The Queen of the Air*. It is possible that had he continued with his botanical studies in 1869, as he intended – the first chapter of *Proserpina* was drafted in November 1868 –, his answer to Darwin would have appeared sooner, but election as the first Slade Professor of Art at Oxford distracted him into preparing his inaugural *Lectures on Art*. By the time he returned to the subject, Darwin had published an even greater provocation.

There is, however, a possible explanation for Ruskin's respectful footnote in *The Queen of the Air*, so unlike his later sarcasms. The book was an untidy compilation, all the more so because in April 1869 Ruskin decided to go abroad, and handed the work of seeing it through the press to the man who had recently re-introduced him to Darwin, Charles Eliot Norton. Norton was clearly irked when, having given him the editorial job, Ruskin then refused to accept any of the changes that he suggested, so that, in Norton's words: 'the volume finally appeared without any proper revision'.[15] But Norton may have effected one change. While the text was still in preparation Ruskin wrote a letter to Norton on 12th April 1869: 'I've sent you three uncorrected sheets about species – so please look at them & tell me what the scientific people will say' (LN.130). We do not know how Norton replied, but as a friend and admirer of Darwin's – Ruskin complained in 1877 about Norton's 'foolishness' over Darwin (D3.394) – it is possible that the precautionary footnote was suggested by Norton.

☙ ☙ ☙

Ruskin's hostility to Darwin grew. He made sneering references to him in an Oxford lecture in March 1870 (20.101) and again

in November (20.267-8), but the event that really provoked him was the publication, on 24th February 1871, of Darwin's *The Descent of Man*, with its explicit subtitle: *and selection in relation to sex*. While man does not feature in *The Origin of Species*, here Darwin does not hold back from his argument that: 'it appears to me, in the plainest manner, that man is descended from some lower form'.[16] For good measure: 'There is no evidence that man was aboriginally endowed with the ennobling belief in the existence of an Omnipotent God'.[17] Darwin admits the existence of a moral sense in man, and the positive social instincts that man shares with animals such as ants, but these are merely utilitarian motives that sustain the preservation of the species: 'the greatest-happiness principle indirectly serves as a safe standard of right and wrong',[18] a Benthamite principle that was anathema to Ruskin.

According to Darwin, sexual selection, in man and animals, occurs when mating takes place between males and females that produce the most effective offspring. Males demonstrate their strength by fighting with their rivals: 'the season of love is that of battle',[19] but females are susceptible to a sense of beauty: 'This sense has been declared to be peculiar to man. But when we behold male birds elaborately displaying their plumes and splendid colours before the females, whilst other birds not thus decorated make no such display, it is impossible to doubt that the females admire the beauty of their male partners'.[20] The effect of this argument is to reduce the æsthetic sense to a mere motive for sex. Not only that, the æsthetic sense is not, as Ruskin's concept of the theoretic faculty would have it, a means to the discovery of divine truth, but mere sensation, and a relativistic one at that:

No doubt the perceptive powers of man and the lower animals are so constituted that brilliant colours and certain forms, as well as harmonious and rhythmical sounds, give pleasure and are called beautiful; but why this should be so, we know no more than why certain bodily sensations are agreeable and others disagreeable. It is certainly not true that there is in the mind of man any universal standard of beauty with respect to the human body.[21]

In *Modern Painters* volume two Ruskin had divided God-given beauty into two categories. Typical Beauty was to be found in abstract elements of light, colour and form that expressed the divine attributes of God; Vital Beauty consisted in: 'the appearance of felicitous fulfilment of function in living things, more especially of the joyful and right exertion of perfect life in man' (4.64). In *The Descent of Man* the felicitous fulfilment of function in living things is reduced to the sexual act – an experience unknown to Ruskin.

᠕ ᠕ ᠕

In his fascinating study, *Charles Darwin and Victorian Visual Culture* – its focus on Ruskin is such that it could have been called *Ruskin and Darwin* – Jonathan Smith rightly argues that Darwin's theories were: 'a direct and fundamental challenge to Ruskinian æsthetics'.[22] But this was much more than a question of æsthetics. The reduction of beauty to a reproductive stimulus completely undermines Ruskin's worldview, where beauty has a more than æsthetic purpose. The function of beauty is ideological: to forge a purposeful link between man and the higher intentions of the creator. As Smith shows, Darwin reduces the

mystery of life and its arts to mere utilitarian calculation and mechanical materialism:

> By locating the human æsthetic sense in the physical sen-
> sation of animals, he provides a naturalistic basis for the
> æsthetics of both bourgeois materialism and Art for Art's
> Sake. If beauty is ultimately about utility rather than truth,
> then art becomes just another Victorian commodity, pro-
> duced and consumed, trafficked in and hoarded. If it is
> ultimately about physical sensation and sexual reproduction
> rather than morality and character, then it becomes just
> another form of Victorian escapism, a retreat from commod-
> ity culture rather than a confrontation with it. For Ruskin,
> the stakes could not have been higher.[23]

The stakes for Ruskin *were* even higher. By knocking away the final props of the argument for Natural Theology – that no matter how long it had taken to create the world and its occu-pants, it and its resources were evidence of an intentional grand design – Darwin rendered existence purposeless. Without some long-term goal, a *telos*, life was merely an unending struggle for survival, and so, ultimately, meaningless. In the memoir he wrote for his family, Darwin declares: 'There seems to be no more design in the variability of organic beings and in the action of natural selection, than in the course which the wind blows'. He goes on to say: 'Everything in nature is the result of fixed laws'.[24] But these laws are not those of divine justice, but blind, physical forces: gravity, not divinity. He writes in *On The Origin*: 'It is difficult to avoid personifying the word Nature; but I mean by Nature, only the aggregate action and product of many natural laws, and by laws the sequence of events as ascertained by us'.[25] As the historian of science John Hedley Brooke writes:

'Darwin had abandoned traditional conceptions of teleology and transformed the history of life into one of the interplay of unconscious forces, independent of a directing will.'[26]

Darwin understood the difficulties this presented: 'The birth both of the species and of the individual are equally parts of that grand sequence of events, which our minds refuse to accept as the result of blind chance. The mind revolts at such a conclusion'.[27] As did Ruskin's.

⚛ ⚛ ⚛

Ruskin's first response to *The Descent of Man* came just two months after its publication on 24th February 1871. On 25th April he gave a short paper to the recently formed Metaphysical Society, and had it privately printed. 'The Range of Intellectual Conception Proportioned to the Rank in Animated Life' is a heavily ironical text in which, describing himself as a 'painter', he ranks himself lower than a metaphysician, but higher than a cuttlefish. (Darwin had written that cuttlefish have 'considerable mental powers').[28] Essentially, he mocks the Darwinian theory of the continuous development of species, which would lead cuttlefish to achieve, like metaphysicians, higher levels of thought. The humour is entertaining, but as his jibes against Darwin multiply in the following years, like a nervous tic, they seem more and more to be devices to avoid taking Darwin on directly. He calls an attack on Huxley in 1880: 'a piece of badinage' (26.343), but it is much more than that. There is anger and anxiety in a passage such as this, from an Oxford lecture on 'The Robin' in March 1873:

I have no doubt the Darwinian theory on the subject is that

the feathers of birds once stuck up all erect, like the bristles of a brush, and have only been blown flat by continually flying.

Nay, we might even sufficiently represent the general manner of conclusion in the Darwinian system by the statement that if you fasten a hair-brush to a mill-wheel, with the handle forward, so as to develop itself into a neck by moving always in the same direction, and within continual hearing of a steam-whistle, after a certain number of revolutions the hair-brush will fall in love with the whistle; they will marry, lay an egg, and the produce will be a nightingale.[29] (25.36)

Ruskin's choice of subject for his Oxford lectures in February and March 1872, the relationship of science and art in the context of the humanities, shows his desire to engage with Darwin, but the series, published as *The Eagle's Nest*, betrays an inability to focus on one theme or subject. This is an asset in the discursive pages of *Fors Clavigera*, launched in in 1871, but not here, entertaining as the lectures must have been when delivered in person. *The Descent of Man* (without the sub-title) is cited directly following Ruskin's assertion: 'very positively I can say to you that I have never heard yet one logical argument in its [*Darwinism's*] favour, and I have heard, and read, many that were beneath contempt' (22.247). The lectures also reveal a new anxiety, mixed with prudery:

The study of anatomy generally, whether of plants, animals, or man, is an impediment to graphic art …. especially in the treatment and conception of the human form the habit of contemplating its anatomical structure is not only a hindrance, but a degradation; and farther yet, that even the study of the external form of the human body, more exposed than it may be healthily and decently in daily life, has been

essentially destructive to every school of art in which it has
been practised. (22.222)

As the 1870s progressed, Ruskin began to over-stretch him-
self. In addition to writing his lectures for Oxford, where he was
also occupied with creating the teaching collections intended for
his Drawing School, *Fors Clavigera* was appearing monthly, and
he was encouraging the formation of the Guild of St George.
He had also bought Brantwood, and he continued to make
long continental tours, leading to the publication of *Mornings
in Florence* (1875-7) and later Venetian writings. *Fors Clavigera*
had established the pattern of part-publication, organised by
George Allen, which meant that material on different subjects
could be set up in type, and assembled as required – *The Queen
of the Air* is an early example – but not necessarily to good effect.
As Ruskin wrote to Allen in September 1877: 'I am perfectly
overwhelmed under the quantity of things which must be kept
in my mind, now, going like a juggler's balls in the air' (25.xxii).
As early as 1872 there are indications that Ruskin's mind
was under severe strain – for good reason. Extraordinarily, on
4th November 1872 he chose to publish a letter to *The Pall Mall
Gazette*, stimulated by the report of a case where a murderer had
got off on the grounds of insanity: 'I assure you sir, insanity is
a tender point with me. One of my best friends has just gone
mad; and all the rest say I am mad myself' (28.220). The 'best
friend' was Rose La Touche, and their vexed relationship was
spiralling towards tragedy. Ruskin subsequently reprinted his
letter in the 'Notes and Correspondence' section of *Fors Clav-
igera* in December 1874, in the context of a rhetorical question
in the main text: 'Does it never occur to me ... that I may be
mad myself?' (28.206). His answer was that work was the only
cure for his loneliness and frustration with the way the world

was going. But that loneliness only increased in 1875, when Rose died on the 25th May.

The date is deliberately cited in a passage on hawthorn blossoms in his botanical study *Proserpina*. As Dinah Birch has demonstrated, there is an intimate association between Rose and the goddess, who, condemned to six months of the year in Hades, returns with the flowers in the spring.[30] Her very name enfolds Rose's in her own. Ruskin had been studying the hawthorn when he heard the news of Rose's death, and he strays into an attack on Darwin's theory of the mutability of species: 'Undeveloped, thinks Mr Darwin, the poor shortcoming, ill blanched thorn blossom – going to be a Rose, some day soon; and, what next? – who knows? – perhaps a Peony!' (25.301). As we have seen, Ruskin's mind almost gave way at Christmas 1876. The increasingly intermittent publications of the following years have to be plotted against the complete breakdowns of February to May 1878, February to May 1880, March 1881, July 1885, and July 1886 – which brought his publishing virtually to an end – and then the final breakdown of August 1889. Ruskin publicly acknowledged his 'illnesses' in his texts. Revealingly, in November 1878, after the first breakdown had led to his resignation as Slade Professor, he wrote to his sponsor, Dean Liddell, thanking him for looking at some pages of *Proserpina*:

I felt as if they might seem to you only a form of continuous fantasy remaining from my illness; nor do I myself look for the slightest effect upon the scientific world while I live; but if I do live a few years more the collation of what I have systematised for the first time in Art Education with what I have learned of natural science in pure love of it, and not in ambition of discovery, *will* form a code of school teaching entirely separate from the technical formalities of each

several branch of science as now pursued, and which I believe
many parents and children will thank me for. (25.xli)

It was his hope that the knowledge that he had gained 'in
pure love' would transcend the narrow technicalities of formal
science.

⚜ ⚜ ⚜

Ruskin's scientific writings are gathered under three titles, *Love's
Meinie*, *Proserpina* and *Deucalion*. But it would be a mistake to
think of these as books in the ordinary sense, even if they were
eventually assembled between hard covers. None was completed.
Love's Meinie was a loose bundle of lectures on ornithology –
delivered and undelivered – published between 1873 and 1881.
Proserpina, on botany, and *Deucalion*, on geology and miner-
alogy, were in simultaneous production in parts between 1875
and 1883 for *Deucalion*, and to 1886 for *Proserpina*. Because
Ruskin did not bother to fit his chapters to the page-length
limit of the 'signature' of paper that folded to form the pages
of a single part, the original parts sometimes broke off in mid-
chapter, and then resumed, which must have added to the
reader's confusion. Part one of *Deucalion* appeared in volume
form in 1882, as did a similar version of *Proserpina*. The print-run
for the parts from which the bound copies were later assembled
was a thousand.

Ruskin's great biographer, Tim Hilton, has pointed out that
as far as *Proserpina* – considered Ruskin's most concerted chal-
lenge to conventional science – was concerned: 'there is simply
no record that anyone at all had any public reaction to his
botanical book'.[31] Yet, as with Ruskin's economics, his argu-
ments are worth considering, if only because his re-naming

and re-ordering of birds, stones and flowers are an attempt to re-assert the moral meaning of a world that Darwin was in the process of making meaningless.

In his placatory footnote on Darwin in *The Queen of the Air* Ruskin had asserted: 'The æsthetic relations of species are independent of their origin' (19.358n), a comment that appears to separate Ruskinian æsthetics from Darwinian science entirely. But Ruskin was trying to find an answer to Darwin, though on his own terms. As Frederick Kirchhoff has commented: 'Ruskin's science becomes a kind of natural mythology'.[32] From *The Queen of the Air* onwards, Ruskin's distinctive, partly philological, approach to mythology as a symbolic order gradually replaces his former use of typology. He had no difficulty in combining botany with mythology, because he brought the same way of seeing the world to both. It was a unified conception, where all meanings related to the one underlying message – that the world *had* meaning, and had purpose.

Darwin challenged that view, and Ruskin was determined to resist him:

> I think it well that the young student should first learn the myths of the betrayal and redemption, as the Spirit which moved on the face of the wide first waters, taught them to the heathen world. And because, in this power, Proserpine and Deucalion are at least as true as Eve or Noah; and all four together incomparably truer than the Darwinian Theory. And in general, the reader may take it for a first principle, both in science and literature, that the feeblest myth is better than the strongest theory: the one recording a natural impression on the imaginations of great men, and of unpretending multitudes; the other, an unnatural exertion of the wits of little men, and half-wits of impertinent multitudes. (26.98-9)

Ruskin is arguing that whereas Darwin's science addressed only narrow questions of the physical intercourse of men and animals, driven by the blinds laws of physical science, life, as lived through the experience of love, art and a sense of the divine, carried so much more meaning. Speculation about the origin of animals was idle: 'while you remain in nearly total ignorance of what they are' (25,57) – that is to say not only their physical quiddity, but their moral significance. One of the purposes of his Drawing School was to instil the skills necessary to practice the science of aspects. He wished to promote an approach to knowledge – what he called 'sophia', or wisdom – that took a distinctive view of the appropriate subjects for both artistic and scientific investigation: 'it is not the arrangement of new systems, nor the discovery of new facts, which constitutes a man of science; but the submission to an eternal system, and the proper grasp of facts already known' (22.150).

Ruskin values science only if it contributes to a higher form of knowledge. As Francis O'Gorman has commented: 'Ruskin uses science to teach not only reverence but respect, not only affection but obedience, offering a politically and socially committed pedagogy'.[33] He was prepared to accept that his students might abandon faith in God the Father and God the Son, but not the Holy Ghost:

> All Nature, with one voice – with one glory, – is set to teach you reverence for the life communicated to you from the Father of Spirits. The song of birds, and their plumage; the scent of flowers, their colour, their very existence, are in direct connection with the mystery of that communicated life: and all the strength, and all the arts of men, are measured by, and founded upon, their reverence for the passion, and their guardianship of the purity, of Love. (22.237)

Ruskin's reverence, however, was not extended to Darwin or his associates. The geologist John Tyndall is attacked throughout *Deucalion* for his disagreement with the late James Forbes, whom Ruskin had met, over glacier theory. His lecture on snakes, 'Living Waves' given in 1880 and printed, incongruously, in *Deucalion*, is a direct riposte to Huxley on the same subject. The Liberal politician and promoter of science and archæology, Sir John Lubbock, who had supported Huxley at the 1860 British Association debate, was attacked for recommending Darwin's books to the Working Men's College (34.584). *Deucalion* and *Proserpina* reveal the wide range of Ruskin's scientific reading, but his favourite sources are from an earlier generation: Linnæus, de Saussure, Humboldt, betraying a nostalgia for: 'the majestic science of those days', as opposed to: 'the wild theories, or foul curiosities of our own' (26.339).

Though enriched by passages of poetic prose, of description and memory, Ruskin's scientific writings, with their drift between mythology and philology over an undercurrent of biblical reference and literary criticism, with sudden bursts of sermonizing, are not easy to follow, partly because of the method of their composition and publication, and partly because of the changes of tone produced by the shifting audiences he tried to address. Sometimes it is the scientific community at large, sometimes it is his students at Oxford, sometimes it is the readers in the projected schools of the Guild of St George, sometimes it appears to be children. As his 'illnesses' recur, the discursive language of *Fors Clavigera* hinders the sense.

Ruskin recognised this. In May 1883, in the last part of *Deucalion* to be issued before it was abandoned, he begins with a chapter titled 'Revision'. In it he announces his intention to bring a new clarity to the meaning of the words he has used in

his 'unfinished books', *Deucalion, Proserpina, Love's Meinie* and *Fors Clavigera*. He fails to do so. Earlier in the chapter he had made one more attempt to justify his project, in the characteristic terms of an argument of the eye:

> I have never given myself out for a philosopher; nor spoken of teaching attempted in connection with any subject of inquiry, as other than that of a village showman's 'look – and you shall see.' But, during the last twenty years, so many baseless semblances of philosophy have announced themselves; and the laws of decent thought and rational question have been so far transgressed (even in our universities, where the moral philosophy they once taught is only remembered as an obscure tradition, and the natural science in which they are proud, presented as an impious conjecture), that it is forced upon me, as the only means of making what I have said on these subjects permanently useful, to put into clear terms the natural philosophy and natural theology to which my books refer, as accepted by the intellectual leaders of all past time. (26.333-4)

In support of this project, Ruskin told his readers that, in spite of his previous reluctance to reprint the text, he had decided to publish a rearranged, two-volume, version of the second volume of *Modern Painters* (1846). (These new volumes had appeared the previous month, in April 1883.)

His motives were twofold: firstly, he wanted to emphasise the difference between the 'pigs' flavouring of pigs'-wash' (25.122) that he now associated with the fashionable Æsthetic Movement, as we saw in Chapter XII, and his conception of the theoretic faculty that gave a deeper understanding of beauty than mere æsthetic sensation. Secondly, he wished to re-iterate:

The first and foundational law respecting human contemplation of the natural phenomena under whose influence we exist, – that they can only be seen with their properly belonging joy, and interpreted up to the measure of proper human intelligence, when they are accepted as the work, and the gift, of a Living Spirit greater than our own. (26.334)

The 'revision' made no significant alterations to the actual text, Ruskin contenting himself with a sardonic commentary on the excessive piety of his youth in added footnotes. But re-arranged section-headings tried to clarify the building blocks of his æsthetics, with 'Ideas of Beauty' occupying the first volume, in three sections: The Theoretic Faculty, Typical Beauty and Vital Beauty. His theory of the Imagination occupied the second. There were new introductions to each volume, and an autobiographical epilogue that anticipates the tone of *Præterita*.

This release of a reframed but fundamentally unaltered volume of *Modern Painters* as a stand-alone publication shows Ruskin returning to the foundations of his thought: 'the natural philosophy [*science*] and natural theology [*faith*]' of his youth, restored to their pre-Darwinian innocence and purity. Myth was a higher form of knowledge than 'the Darwinian Theory' because Darwin's science was limited to the observation of the laws of the physical world, and excluded precisely those moral and spiritual questions that art, literature and the humanities in general addressed. Ruskin's science of aspects makes the world meaningful in a way that the blind laws of Darwin's science do not.

A A A

At the beginning of that same year, 1883, Ruskin returned to

Oxford for a second term as Slade Professor. Both he, and the University, had changed. His first period of office had been embittered by his disputes with the University over arrangements for the Drawing School. These continued in his second, but there was a fiercer struggle over a building of even greater symbolic significance: The Oxford Museum.[34]

This time Ruskin found himself on the opposite side to his closest ally, Henry Acland. Acland, for whom the promotion of science at Oxford had always been more important than supporting Ruskin, had secured the election of Sir John Bourden-Sanderson as first Waynflete Professor of Physiology. The Professor had a post, but no means for his demonstrations, and accordingly the University was asked to vote money to equip a laboratory. It was well known that he held a licence under the 1876 Cruelty to Animals Act to conduct experiments in vivisection, and the proposed laboratory was immediately associated with such experiments. Ruskin, who had long railed against anatomy, and expressly forbade its study in his Drawing School, was horrified, and joined in a growing anti-vivisection campaign.

His passion – and probably renewed signs of mental strain – showed in his lectures in October and December 1884. He wrote to a friend: 'The scientists slink out of my way now, as if I was a mad dog' (33.liv). His last two lectures of the year had been advertised as 'The Pleasures of Sense (Science)' and 'The Pleasures of Nonsense (Atheism)', and it was known that he was planning to use them to attack the vivisectionists. He was dissuaded by Acland and the Vice-Chancellor, Benjamin Jowett, and substituted two lectures delivered extempore. The last lecture, on 6th December, was reported by Ruskin's future editor and biographer, E. T. Cook in *The Pall Mall Gazette*:

[*Ruskin*] began with an expression of the 'disappointment and surprise which, on reviewing the results of my lecturing and working here for upwards of twelve years, I feel in being forced to the sorrowful confession that not a single pupil has learned the things I primarily endeavoured to teach'. (33.532)

It was a bitter ending, made all the more so in March 1885, when Ruskin joined the anti-vivisectionists in making a last attempt to stop the laboratory going ahead by preventing money being voted for its heating and lighting. Acland defeated them, and on 22nd March Ruskin formally resigned as Slade Professor. He told his cousin, Joan Severn: 'I cannot lecture in the next room to a shrieking cat – nor address myself to the men who have been – there's no words for it'.[35]

The scientists had won.

Substantially rewritten from 'Paradise Lost: Ruskin and Science' in Time and Tide: Ruskin and Science, *(ed.) Michael Wheeler, Pilkington Press, 1996.*

CHAPTER XV

THE TRIUMPH OF THE INNOCENTS: RUSKIN, HOLMAN HUNT AND SPIRITUALISM

❧

On 9th March 1883 Ruskin gave his opening lecture at the start of his second period as Slade Professor of Fine Art at Oxford. His first appointment had lasted from 1869 to 1878, but partly because of his frustration with the University authorities over the Drawing School, partly because of the humiliation of the outcome of *Whistler versus Ruskin*, and partly because of his mental breakdown in February 1878, he resigned his chair at the end of that year. By 1882, however, he had recovered his mental health and his spirits, and he prompted his Oxford friends to secure his re-election in January 1883. The following report appeared in *Truth* for 15th March 1883:

> There was a scene of great enthusiasm when Mr Ruskin appeared to deliver his first lecture on his re-election. Although there was a fair sprinkling of ladies, young and old, the majority of the audience was made up of undergraduates; and as they had begun to assemble an hour and half beforehand, some of the principal persons in the University were unable to obtain admission. The Vice-Chancellor, who attended with the proctors, rose at the end of the lecture to say a few words of welcome, and his graceful remarks were received with a storm of applause. (33.259)

The lecture was such a success that he had to repeat it the following day.

Opposite: Fig. 39: Frederick Hollyer, John Ruskin and Holman Hunt, *September 1894*

The topic of Ruskin's lectures had been announced as 'Recent English Art' – the working title for the series that was published the following year as *The Art of England*. 21st century readers have the advantage of being able to see: 'the picture of which I came today chiefly to speak' (33.277), but which on that day Ruskin's hearers could only imagine. In any case, in 1881 the picture was not yet finished (Pl. 16).

Hunt's *The Triumph of the Innocents* does not appeal to 21st century taste. Religious art is not popular in Britain; nor is much religion. The tonality of the painting, the handling of the figures, the peculiar bubbles, the ludicrous floating cherubs and the sweetness that lies like glue over the whole picture make this an image just about as far removed from contemporary appetites as it is possible to be. Even Ruskin had some reservations: in a later lecture he admitted that 'the souls of the Innocents are a little too chubby, and one or two of them, I should say, just a dimple too fat' (33.291). The picture sums up just about everything that is disliked about Victorian religious sentiment. When I proposed showing this picture at the climax to the Ruskin centenary exhibition at Tate Britain in 2000, *Ruskin, Turner and the Pre-Raphaelites*,[1] the authorities at Tate took some convincing. Yet Ruskin declared: 'it will, both in reality and in esteem, be the greatest religious painting of our time' (33.277).

This is a strong statement, and it seems even more astonishing when it is understood that it was made before the painting was finished. It was not until March 1885 that the picture went on show at the Fine Art Society in Bond Street. But there are reasons why Ruskin should hold this opinion, and why this painting deserves to be celebrated as the last Pre-Raphaelite masterpiece.

We must begin by recovering Holman Hunt's own conception

of the picture. At the Fine Art Society, where it was shown in a theatrical setting, surrounded by dark drapes and brightly lit, with benches in front for an audience that had paid to see this 'sensation picture', Hunt supplied a fifteen-page pamphlet in which he laid out the whole programme and the circumstances of the work. Deploying his Biblical scholarship, he explained:

> The Flight into Egypt I have assumed to have occurred about sixteen months after the birth of Jesus. Guided by Christian tradition, and holding the birth of our Lord to have taken place in December, it follows that the period which I have assigned to the Flight into Egypt is the second April in His life.[2]

Having given information on the climate and agriculture of the location, which is the Philistine plain, thirty miles from Bethlehem on the road to Gaza, and indicating the time as very early morning, Hunt moves on to the less realistic aspects of his canvas. As he explains, the Holy Family are fleeing the massacre of first-born children ordered by Herod:

> Conscious of the divine mercy, the heart of Mary rejoicing over her rescued son, feels compassion for the murdered Innocents, and for the childless mothers less happy and less honoured than herself. It is at this moment, when the Virgin has been replacing the garments in which the infant has been hurriedly wrapped at the time of escape from Bethlehem, that Jesus recognises the spirits of the slain Innocents, his little neighbours of Bethlehem, children like Himself. They reveal the signs of their martyrdom. Garlanded for the sacrifice, bearing branches and blossoms of trees, they progressively mark their understanding of the glory of their service. An infant spirit isolated in wonder, finds no mark of

harm where the sword wounded him, permitted to appear on his glorified body. Behind in the air are the babes as yet hardly awakened to the new life.[3]

With Ruskin's permission, Hunt also reprinted some of Ruskin's commentary from his 1883 lecture in the pamphlet. For Ruskin, *The Triumph of the Innocents* was a symbol of the Resurrection. He told his Oxford audience:

> For all human loss and pain, there is no comfort, no interpretation worth a thought, except only the doctrine of the Resurrection; of which doctrine, remember, it is an immutable historical fact that all the beautiful work, and all the happy existence of mankind, hitherto, has depended on, or consisted in, the hope of it. (33.276-7)

This reference to Resurrection frames his introduction and paragraph-long description of the painting (which, recall, his audience could not see), concluding: 'To how many bereaved households may not this happy vision of conquered death bring, in the future, days of peace!' (33.278). The phrase: 'vision of conquered death' is an important clue to the painting's significance.

By 1883, Ruskin and Holman Hunt had known each other for more than thirty years, but their relationship had been a far from easy one, in spite of the support that Ruskin had given to Hunt and his Pre-Raphaelite brothers in his influential letters to *The Times*. The complications of the Ruskin/Hunt relationship over the next thirty years can be seen by contrasting Ruskin's response to just two of Hunt's pictures, *The Light of the World* (Pl. 14), first exhibited in 1854, and *The Scapegoat* (Pl. 18) exhibited in 1856.

As discussed in Chapter VI, *The Light of the World* was shown at the Royal Academy in the same year as *The Awakening Conscience*, to which it was intended as an accompanying

piece. Hunt's text, arguing that our consciences need to be awakened by the light of the world, was: 'Behold, I stand at the door, and knock; if any man hear my voice, and open the door, I will come in to him, and will sup with him, and he with me' (Revelations 3:20).

The painting was begun in 1851, and in accordance with Pre-Raphaelite principles, it was begun outdoors, and painted at night, by candlelight, with Hunt sheltered by a small hut. Work continued on and off in the studio until 1853, with both Christina Rossetti and Elizabeth Siddal helping by modelling the figure. As we know from Chapter VI, it and its companion were not well received, notably by Ruskin's old enemy *The Athenæum*. Once more Ruskin took up his pen to write to *The Times*, and once more he wrote two letters, the first addressing *The Light of the World*. He was already familiar with the picture, for he had seen it in Hunt's studio, and had even suggested a title, 'The Watchman', but in his letter to *The Times* he claimed Hunt had never explained its programme to him. Ruskin proceeded to offer his own interpretation:

> On the left-hand side of the picture is seen this door of the human soul. It is fast barred: its bars and nails are rusty; it is knitted and bound to its stanchions by creeping tendrils of ivy, showing that it has never been opened. A bat hovers about it; its threshold is overgrown with brambles, nettles, and fruitless corn, – the wild grass 'whereof the mower filleth not his hand, nor he that bindeth the sheaves his bosom.' Christ approaches it in the night-time, – Christ, in his everlasting offices of prophet, priest and king. He wears the white robe, representing the power of the Spirit upon him; the jewelled robe and breastplate, representing the sacerdotal investiture; the rayed crown of gold, interwoven

with the crown of thorns; not dead thorns, but now bearing
soft leaves, for the healing of the nations. (12.329)

Ruskin's analysis continues for three paragraphs, focussing
on that distinctly Ruskinian symbolic value, Light, before he
declares: 'I think it one of the very noblest works of sacred art
ever produced in this or any other age' (12.330).

The reason for this claim, which placed a young contempo-
rary artist at the same level as Angelico, Tintoretto or Leonardo
da Vinci, can be found in Hunt's adherence to the principles
Ruskin had enunciated in the first volume of *Modern Painters*,
in his brief chapter on 'Ideas of Truth':

> Truth may be stated by any signs or symbols which have a
> definite signification in the minds of those to whom they are
> addressed, although such signs be themselves no image nor
> likeness of anything. Whatever can excite in the mind the
> conception of certain facts, can give ideas of truth, though
> it be in no degree the imitation or resemblance of those
> facts. (3.104)

Hunt does not present the figure of Christ as a 'fact'. The
figure and conception is plainly imaginary. But, as with *The
Awakening Conscience*, the authority of the image comes from
Hunt's use of natural fact, closely observed, with which to
construct its symbolic meaning. Hunt is not using traditional
iconography, but constructing a natural iconography of his own,
using 'signs or symbols which have a definite signification in
the minds of those to whom they are addressed'. It is not nec-
essary to be a sophisticated connoisseur of art to appreciate this
image, – which explains why foxed and dusty reproductions of it
are still to be found in the chilly corridors of country vicarages,
and in the dank cupboards of abandoned board schools.

Ruskin's demonstration of Hunt's symbolic realism, however, does not end with this *éxplication de texte*, which is very similar to Hunt's own. He concludes with some interesting comments on the difference between Pre-Raphaelite realism and its imitators:

> The true work represents all objects exactly as they would appear in nature in the position and at the distances which the arrangement of the picture supposes. The false work represents them with all their details, as if seen through a microscope. Examine closely the ivy on the door in Mr Hunt's picture, and there will be not be found in it a single clear outline. All is the most exquisite mystery of colour; becoming reality at its due distance. In like manner examine the small gems on the robe of the figure. Not one will be made out in form, and yet there is not one of all those minute points of green colour, but it has two or three distinctly varied shades of green in it, giving it mysterious value and lustre. (12.331)

False works contain 'none of the infinity of nature' (12.332). In the second volume of *Modern Painters* he had described infinity as 'the type of divine incomprehensibility' (4.76), a mystery such as the 'exquisite mystery of colour' in Hunt's painting. As we shall see, Ruskin later described *The Light of the World* as a 'mystic' work.

⚜ ⚜ ⚜

Hunt was obviously grateful for, and gratified by, Ruskin's support in 1854, especially as he himself was in the Holy Land, from which he did not return until 1856. There he had undergone much danger and hardship in order to achieve the image

of the sacrificial scapegoat, dying for the sins of man in the salt marshes of the Dead Sea.

When *The Scapegoat* was exhibited at the Royal Academy that year, accompanied by appropriate citations from Leviticus and Isaiah, it was honoured by being hung on the line, and excited a great deal of comment. Here is the *Athenæum* again: 'We shudder ... in anticipation of the dreamy fantasies and the deep allegories which will be deduced from this figure of a goat in difficulties'.[4] But in spite of this provocation, Ruskin's response was unexpected. This time he had no need to write to *The Times*, for in 1855 he had begun to publish his opinions, under his own name, in his *Notes on Some of the Principal Pictures exhibited in the Rooms of the Royal Academy, and the Society of Painters in Water-Colours*, the controversial pamphlets, sold at the Academy door, and generally known as *Academy Notes*.

Ruskin gave *The Scapegoat* his longest review, several pages as opposed to the paragraph he afforded to W. F. Witherington's *The Glen, Chudliegh, Devon* or to *The Prosperous Days of Job* by W. T. C. Dobson. But one can imagine Hunt's heart sinking, and gorge rising, when he read the opening comment: 'This singular picture, though in many respects faultful, and in some wholly a failure, is yet the one of all in the gallery which should furnish us most with food for thought' (14.61). Ruskin does not doubt Hunt's sincerity or seriousness – though patriotism causes him to question how Hunt could have peaceably pitched his tent beside the Dead Sea when 'the hills of the Crimea were white with tents of war' (14.62).[5] He does not dismiss the subject matter, nor the usefulness of being reminded of the allegorical significance of the scapegoat. He even seems to suggest the composition parodies 'the "Cattle pieces" or "Lake scenes"' (14.64) of the domestic picturesque – but:

This picture indicates a danger to our students of a kind
hitherto unknown in any school – the danger of a too great
intensity of feeling, making them forget the requirements
of painting as an *art*. This picture regarded merely as a
landscape, or as a composition, is a total failure. The mind
of the painter has been so excited by the circumstances of
the scene, that, like a youth expressing his earnest feeling
by feeble verse (which seems to him good, because he *means*
so much by it), Mr Hunt has been blinded by his intense sen-
timent to the real weakness of the pictorial expression; and
in his earnest desire to paint the Scapegoat, has forgotten
to ask himself first, whether he could paint a goat at all.
(14.64-5)

It would be going too far to suggest that in a passage like
this Ruskin could be aligned with Roger Fry or even Clement
Greenberg, but Ruskin's emphasis on the painterliness of paint-
ing, and on the formal qualities of art is striking. Would even
Whistler have disagreed with Ruskin's statement: 'a painter's
business is first to *paint*' (14.65)?

Holman Hunt, however, seemed bent upon another path, by
his own lights a new one in religious art. Although it was not
completed until 1860, he had begun work at the same time as *The
Scapegoat* on a piece of almost ethnographic realism, *The Finding
of the Saviour in the Temple*. In 1873 he showed another work,
The Shadow of Death (Pl. 19), a carpenter's shop that has the
same attention to detail as the *Finding of the Saviour*. Linking
it to *The Finding of the Saviour*, Hunt explained: 'my picture is
strictly – as the Temple picture was – *historic* with not a single
fact in it of a supernatural nature, and in this I contend it is
different for (*sic*) all previous work in religious art'.[6]

As with *The Scapegoat*, Ruskin responded negatively. Having

abandoned his *Academy Notes* in 1859, his only direct comment on *The Finding of the Saviour* is in the fifth volume of *Modern Painters*, published in 1860: 'neither that picture, great as it is, nor any other of Hunt's, are the best he could have done. They are the least he could have done' (7.451). His comment was made in the context of Ruskin's anger at the state of contemporary political economy which made life so hard for artists like Hunt, but Ruskin's relative silence on a picture that, if only in commercial terms, represented the triumph of the Pre-Raphaelite vision launched a decade before, is more eloquent than this somewhat obscure comment in *Modern Painters*. This is Ruskin's only direct reference, but there is also a revealing comment in a lecture of 1878, 'The Three Colours of Pre-Raphaelitism':

> Hunt, not knowing the necessity of masters any more than the rest of our painters, and attaching too great importance to the externals of the life of Christ, separated himself for long years from all discipline by the recognised laws of his art; and fell into errors which woefully shortened his hand and discredited his cause – into which again I hold it no part of my duty to enter. (34.168)

Although Ruskin shies away from pursuing the thought, it shows that Ruskin, as with *The Scapegoat*, reacted against the archæological realism of the work. This may seem surprising. In a letter to the historian J. A. Froude in 1874 that, without naming it, almost certainly refers to *The Shadow of Death* (shown the year before), Ruskin describes himself as 'the Exponent of the Reaction for Veracity in Art', and goes on to discuss Hunt's work in terms of his commitment to realism as opposed to idealism. He makes three points about Hunt's method. Firstly:

> He has never for an instant faltered in his conviction that

a picture should be as like reality as possible, down to its minutest detail. This is Dante's conviction. It was Apelles'. It was Titian's. Believe me, *It is right.*

(II) It is quite true that the greatest painters have been careless of antiquarianism. But the result has been that the knowledge and imagination of the spectators have been confused. Hunt is perfectly right in *daring* to be *Learned*. (27.83)

These comments suggest a complete sympathy with Hunt's verisimilitude, but his third point shows that he was looking for something more:

And lastly, distinguish always strictly between mystic pictures and realist.

Mystic pictures (Madonna del San Sisto [*by Raphael*], and the gilded throne ones of Angelico, etc.) are very beautiful and desirable. But it is not Hunt's business to paint them. It is Perugino's. I wish we had a Perugino also, but don't wish we had him instead of Hunt. (The Light of the World *was* mystic, however.)

Realistic pictures – Rubens, etc. – have been, to utter loathsomeness of horror – of the Crucifixion of Christ, and His fleshly agony. Never yet of His quiet early life – of His real human trials – of His nobleness as a Man, the Example of Men before He is their Saviour – (I speak as a Christian mind – from Hunt's point of thought).

And I only mourn the shortness of that human life – in this true loving disciple, that he who alone is able to give some of this better truth, should be able only to give it us by labour of the twelfth part of a life on one picture. (27.83-4)

Though Ruskin adds that this labour is 'well spent', his convoluted argument leads to the conclusion that a too laborious,

antiquarian (that is to say, historically accurate) realism leaves no mystery in the painting.

The contrast between Ruskin's praise for *The Light of the World* and his objections to *The Scapegoat* and its successors in Hunt's self-described 'historic' mode is significant when it comes to considering *The Triumph of the Innocents*. While *The Light of the World* deploys realism at the service of symbolism, the hard won realism of *The Scapegoat* not only militates against the higher significance intended by the scene, but overwhelms the picture as a picture. Just as Ruskin was disappointed by the verisimilitude of John Brett's *Val d'Aosta*, a landscape that he had in effect commissioned – 'it seems to me wholly emotionless' (14.236) –, Hunt's reconstructive historicism was not enough.

The answer to the question why Ruskin liked *The Triumph of the Innocents* then appears to be simple. Hunt had abandoned those principles of historic realism that he had applied in earlier works depicting the life of Jesus, and had introduced imaginary elements – indeed supernatural elements – that respected Ruskin's emphasis on the imperatives of the imagination. But that is not the whole answer – for we still have to ask why Hunt decided to add the supernatural elements to his otherwise scrupulously factually-constructed composition.

☙ ☙ ☙

Hunt had made a second visit to Palestine from 1869 to 1872. He had tried to get there in 1866, shortly after his marriage to Fanny Waugh, but had been forced by quarantine regulations to break his journey in Florence, where in October 1866 Fanny bore him a son, but then died of fever in December. He returned to England. At last back in Jerusalem in 1869, while working

on *The Shadow of Death* he conceived the picture that was to prove a trial even greater than any of those he had experienced before. In February 1870 he made an expedition to Gaza where he sketched by moonlight the waterwheel and the trees that, like the orchard in *The Light of the World*, create a real, but because of the moonlight, mysteriously luminous background to his subject. He also made an oil sketch, left in Jerusalem when he returned to England in 1872. In 1875 he was back in Jerusalem for a third visit, having flown in the face of convention and the English law by marrying his dead wife's sister, Edith.

Unfortunately, his painting materials and the very large canvas, one-and-a-half by two-and-a-half metres, that he had ordered so as to be able to paint the full picture he had conceived, were delayed in transit. Anxious to get on, Hunt made the fatal mistake of buying local linen in the bazaar and stretching it himself. As Hunt started to stretch the linen, it began to tear, so he could not apply full tension. As a result, the surface began to wrinkle and sag. When his painting materials did arrive from England in March 1876 Hunt foolishly pressed on: he had begun by painting the figures of the children towards the edge of the support, but as he worked on the Holy Family in the centre of picture the surface became almost impossible to paint on. It was now late 1877, and political disturbances had made him take his wife and new baby daughter to safety in Jaffa, though the journey added the view of distant mountains, the stream and the village under the pine trees. Hunt tried moving his figures to other parts of the canvas, but the same defect appeared, and so after 'twenty attempts'[7] he gave up, returning to England with the unfinished canvas in April 1878, where the painting was further damaged by customs inspectors opening its crate.

Hunt did not settle on somewhere to live in London until March 1879, and, having had the canvas relined, he carried on, but to no avail. A second expert, recommended by Millais, did further remedial work, but by the end of 1879 Hunt was ill and at his wit's end. He began to believe that supernatural powers were conspiring to prevent him finishing the work. His friend, the artist and writer William Bell Scott, was surprised to be invited by Hunt to his studio on 31st December 1879, where he saw the picture for the first time. He found Hunt in an agitated state, and Scott records that he 'startled and grieved' him 'by relating a preternatural incident, or something like one, that had happened to him a few days past, on Christmas Day'.[8] In a strange echo of Ruskin's 'Christmas Story' of 1876, told in Chapter V, Hunt believed he had had an encounter with the Devil.

Scott, however, was not Hunt's only visitor at this moment of crisis. Some time before 22nd February 1880, Ruskin also saw the unfinished picture. He was so enthusiastic that Hunt finally decided that there was nothing for it, but to start again on a new canvas altogether – the canvas that is now in the Tate. We know the new canvas was begun before 22nd February 1880 because of a letter from Ruskin to Hunt of that date, in which he writes: 'I am partly grieved but much more glad, that you began this new picture – I was so afraid of the other's sinking away *after* you had done it. I hope the Adversity may be looked on as really Diabolic and finally conquerable utterly'.[9] Evidently, Hunt had told Ruskin of his struggles with the Devil over Christmas.

Thus Ruskin was an ardent admirer of the work, three years before his first public comment in his Oxford lecture. His opinion was only confirmed when in July 1882 he made another visit to Hunt's studio to see how the new canvas had progressed. On this occasion he wrote to his cousin Joan Severn that Hunt's

painting was 'out and out the grandest picture he has ever done, which will restore him at once, when it is seen, to his former sacred throne' (37.404). The implication is that Ruskin recognised in it the 'mystic' quality he found in *The Light of the World*, and missing from subsequent works. But by this time Ruskin and Hunt had a further, deeper, and more personal level of engagement: spiritualism.

<p align="center">▵ ▵ ▵</p>

During the 1860s the practice of spiritualism and the use of mediums began to be taken seriously, by a number of serious people. With conventional religion giving way in the face of Biblical scholarship and Darwinian science, it offered some hope of there being an after-life to people who, like Ruskin, had lost their formal faith but not their spiritual need. Ruskin attended his first séance in February 1864, at the invitation of his close friends Lord and Lady Mount-Temple, who became leading figures in the spiritualist movement. They were also Ruskin's confidantes in his troubled relationship with Rose La Touche. Ruskin attended several séances with the American medium Daniel Dunglass Home, who impressed him, and he maintained an interest in spiritualist manifestations of the after-life until March 1868, when some of the charlatanism associated with the movement caused him to become disillusioned.

But in 1868 Rose La Touche was still alive. Her death in 1875 gave Ruskin an entirely new motive for believing what spiritualists told him. Just before Christmas in 1875 Ruskin went to stay with the Mount-Temples at their grand house, Broadlands, and – though Ruskin heard and saw nothing – a famous medium told him just what he wanted to hear: Rose

La Touche was beside him, and seeking to communicate with him. This did not happen within a formal séance, but it was enough for Ruskin to write in his diary that he had had: 'the most overwhelming evidence of the other state of the world that has ever come to me' (D3.876). As we saw in Chapter V, the following year in Venice Ruskin became convinced that Rose was trying to get in touch with him through Carpaccio's *The Dream of St Ursula*, and came close to mental breakdown. In February 1878, still seeking a sign from Rose, he broke down completely for the first time: 'I went crazy about St Ursula and the other saints, – chiefly young lady saints' (LN.412).

Holman Hunt had also lost a loved one, his first wife Fanny Waugh, and early in 1867 he too sought the help of mediums. His friend William Bell Scott was sceptical about spiritualism, which may account for Hunt's guarded discussions of the subject in his letters to Scott. But Hunt certainly was interested. He wrote to Scott in February 1871:

> You say true, that I have had no experience whatever of (professional) spiritualism of a kind to justify me in believing in any celestial guidance of the affairs of the world, and that I have no arguments to offer in proof of the possibility of facts such as those recorded in the Testament. But in my own experience I have had occasional presentiments and other psychological consciousnesses, of a nature that forbid me the conclusion that we are mere burning bonfires, to cease with the consumption of the fuel. These experiences, of course, would only serve to my own conviction, and so they need not be cited; from the conclusions they suggest to me, however, it is an easy translation to the best religious revelation I can find.[10]

One such 'presentiment' would have been the diabolic encounter at Christmas 1879 to which Scott and Ruskin were indirect witnesses. Scott plays down the event, while nonetheless making some significant connections: 'The incident in Hunt's studio was somewhat similar to asserted phenomena among spiritualists, but it was totally different, inasmuch as my dear friend Hunt is a sincerely orthodox believer, whereas the so-called spiritualists have neither faith nor philosophy worth enquiring about'.[11]

It is apparent that by early 1880, when the visit by Ruskin gave Hunt the courage to start again on a fresh canvas, neither man was an attender of séances or a frequenter of mediums, but their experience of spiritualism undoubtedly framed their discussions of the picture. This is confirmed by a passage in Hunt's memoirs that can only refer to *The Triumph of the Innocents*. In 1869, while Hunt was on his way to Palestine for the second time, he and Ruskin met, it seems by chance, in Venice. Together they visited the Scuola di San Rocco, and Ruskin read the passage from *Modern Painters* on Tintoretto's *Annunciation* that had so inspired the young Holman Hunt in 1848, as we saw in Chapter VI (Pl. 15). Afterwards they went to dinner at the Hotel Danieli and had a long heart to heart, during which Ruskin confessed his loss of orthodox faith. Hunt's account then continues:

> Ten years later [*which would make it 1879 or 1880*] I met him in London. We had been dwelling upon a picture for which he expressed great enthusiasm. As we were driving together, he said, 'One reason I so much value the picture we have seen is that it carries emphatic teaching of the immortality of the soul'. 'What,' I exclaimed, 'I was supposing that you were

approving of it for its artistic qualities of design, colour, and handling; for you must remember that when we last met you declared you had given up all belief in immortality.'

'I remember well,' Ruskin replied; 'what has mainly caused the change in my views is the unanswerable evidence of spiritualism. I know there is much vulgar fraud and stupidity connected with it, but underneath there is, I am sure, enough to convince us that there is personal life independent of the body; but with this once proved I have no further interest in spiritualism'.[12]

This helps to explain why *The Triumph of the Innocents* is such a strange picture, and why it needs to be seen in a new light. There are, in fact, two lights in the painting: the moonlight that falls on the Pre-Raphaelite landscape background, and the supernatural lustre that informs the spirits of the murdered innocents who are joining the Holy Family. As Hunt explained in his pamphlet accompanying its exhibition at the Fine Art Society in 1885, while the stream they cross reflects the night sky:

> The flood upon which the spiritual children advance forms a contrast to this, by being in motion. The living fountains of water – the streams of eternal life – furnish this, mystically portrayed as ever rolling onward. Instead of being dissipated in natural vapour, the play of its wavelets takes the form of airy globes, which image the Jewish belief in the Millennium that is to follow the advent of the Messiah.[13]

These 'airy globes' are the strange bubbles referred to at the start of this chapter (Pl. 17). The largest contains images of the union of Heaven and Earth by way of the Tree of Life, and of Jacob's ladder, up and down which the servants of God are climbing. In a second, smaller globe, in front of Joseph, we

find the Sinner yearning for the Salvation that is promised by Christ's crushing of a serpent with his heel. Even more important, Holman Hunt's 'too chubby' innocents are not cherubs or baroque *putti*, but spiritualist manifestations. That the children are not to be read as angels is confirmed by a letter Hunt wrote to William Bell Scott in January 1880. Hunt was drawing on: 'my experience of the embodiment of ideal personages. These develop in solidity and brightness by degrees, and I imagine the Virgin to have seen these children at first, scarcely discerning that they were not natural figures under the natural light'.[14] Even the sceptical Scott seems to have accepted the reality of Hunt's vision, commenting: 'The treatment of the halo as an inborn phosphoric light shining outwards, which mesmerists have affirmed to be sometimes visible in real life, is here introduced with great effect'.[15]

⚶ ⚶ ⚶

Looking at the picture with fresh eyes, it is possible to see why Ruskin in his lecture on 9th March 1883 should have placed such emphasis on the picture as an image of the Resurrection. When he said that this image of conquered death would give comfort in so many bereaved homes, he meant precisely that, for the whole basis of spiritualism was – indeed is – the promise that, to quote Holman Hunt, we are not 'mere burning bonfires, to cease with the consumption of the fuel'. Even though his encounters with mediums undoubtedly contributed to his mental breakdown, Ruskin could draw comfort from the thought that one day he would again see Rose La Touche.

These personal considerations aside, this strange picture is a synthesis of Holman Hunt's Pre-Raphaelite love of fact with his

use of typology and other forms of symbolism, and something that comes close to combining Ruskin's emphasis on the necessity for visual truth with his insistence that noble pictures must be works of the imagination. The synthesis of visual fact with moral truth was intended to achieve the spiritual transcendence that is precisely the programme of the picture. If we take Holman Hunt's hint that he had indeed had 'experience of the embodiment of ideal personages', then the picture may be more factual than we might at first suppose.[16]

The existence of the picture, both in the version Hunt completed in 1885, and the version now in the Walker Art Gallery in Liverpool which he completed in 1887, once he had at last had his original defective canvas repaired, is at least in part a tribute to Ruskin's encouragement to an artist he had also been honest enough to criticise. It shows that great critics are positive critics. In January 1885 Hunt wrote to Ruskin to tell him the picture was at last finished:

> I think I should have confessed myself beaten, and given up the subject in despair had not your encouragement made me put aside my superstition, and trust that God did not intend that I should lose all the labour which had made you admire so much the idea of the design, and thus I determined to set to work on it again.[17]

In spite of their estrangement in the middle years of their friendship, Ruskin had once more proved an inspiration, as he had in *Modern Painters*. Hunt told Ruskin in 1880 that reading the book had put him on the path of religious faith: 'It was the voice of God'.[18]

Good critics also learn, and as the eminent Ruskinian George Landow has argued, Ruskin's engagement with Hunt's elaborate

iconography in *The Light of the World* and *The Awakening Conscience*: 'stimulated him to develop those theories of symbolism which figure so importantly in the last three volumes of *Modern Painters*'.[19] Ruskin, however, should have the last word: 'It is a strange habit of wise humanity to speak in enigmas only, so that the highest truths and usefullest laws must be hunted through whole picture galleries of dreams which to the vulgar seem dreams only' (17.208). Such is *The Triumph of the Innocents*.

Revised from an unpublished Slade Lecture given at Oxford in 2000.

CHAPTER XVI

OF RUSKIN'S GARDENS:
RUSKIN AND THE PARADISE MYTH

☙

*For what can we conceive of that first Eden which we might
not yet win back, if we chose?* (7.13)

Like those anecdotal hill farmers who bought Ruskin's religious
tract *Notes on the Construction of Sheepfolds* in the mistaken
belief that they would learn something about agriculture, there
may be readers of this chapter who expect to learn something
about horticulture. Gardens do come into it, for just as Ruskin's
sheepfolds were a useful metaphor for his pastoral message,
there is emblematic significance in the actual gardens of South
London and Ruskin's Lake District home, Brantwood, that were
so important in his life.

It is helpful to be able to introduce the words agriculture and
horticulture, for as Raymond Williams' immensely useful book
Keywords reminds us, the idea of 'culture' is literally rooted in
these words.[1] From agriculture we get the idea of cultivation –
first of the soil, and then of the soul. Culture, in that later more
elevated sense, only acquired this meaning in Ruskin's lifetime.
The index of the Library Edition has an entry for 'civilisation',
but not for 'culture'. When he does use the word, as in the phrase
'moral culture' (17.147) it still carries overtones of the word's root
meaning. Even Matthew Arnold's essays *Culture and Anarchy*,

Opposite: Fig. 40: Angelo Alessandri, after Jacopo Tintoretto, Study of the Paradise in
the Hall of the Great Council, Ducal Palace, *detail, 1886-1905*

first published in 1869, which helped to bring the word into more general discourse, uses culture as a synonym for 'civilisation', as opposed to the barbarism of anarchy. Arnold's emphasis was on *self*-cultivation. It was our duty to get to know 'the best which has been thought and said' – for the alternative was anarchy.[2] Ruskin did not disagree about anarchy, but he had a less selfish view of his own development, and took a more generous view of his fellow men. He set up the Guild of St George with the intention that everyone, not just the self-cultivated, should have a garden.

The garden, however, is not just a place for digging and delving. It is also the place where man, who emerges from nature, begins to shape nature to his own ends, both nutritional and æsthetic. It is a created space, defined by limits, by man-made barriers, be they hedges or walls. To build a wall, Ruskin reminds us, is the beginning of architecture. To make a garden beautiful, begins the transition from craft to art. Thus, while the garden retains an essential connection with nature, by controlling nature, it becomes part of culture, in the sense that we have come to understand that word. Ruskin was a committed gardener.[3]

Western culture, in particular, has been shaped by the idea of a garden. A garden created for man, lost by man, but also potentially restored to man, as a jewelled city on a hill. The garden of Paradise is not only one of the most important world myths, but also the shaping myth of Ruskin's life.

⚛ ⚛ ⚛

Although its roots are ancient, geographically located in what is now the tragic scrapheap of Iraq, for Ruskin the main literary

source of the myth was his Bible, famously read through in childhood 'from Genesis to the Apocalypse, about once a year' (35.14), with the fifth and sixth books of Revelation among the passages learned by heart (35.42). The shaping narrative of expulsion from an organic idyll, of descent into travail, of a journey through sin, punishment, sacrifice and redemption, ending in judgment and the revelation of an eternal city on a hill, was reinforced by Sunday reading of John Bunyan's *Pilgrim's Progress* (1678), and John Milton's *Paradise Lost* (1667) and *Paradise Regained* (1671).

In his youth, Ruskin preferred Bunyan's allegory of the journey of the Christian soul to Milton's accounts of the fall of man and the war in heaven. He found Milton 'too rhetorical' (35.610), but during his time in Venice in 1851-52 he tried to read him 'all through', and both works inform *The Stones of Venice*.[4] As he gradually moved away from Evangelicalism, Dante became his guiding spirit, even before the painful parallels between Dante's love for Beatrice and Ruskin's love for Rose La Touche became apparent.

An intense absorption in the Christian myth of apocalyptic redemption was reinforced by the traditional Romance literature that ran in parallel to it, supplying the motifs of quest, trial and benign female presences (and their demonic opposites) that shape much of Ruskin's later writing, in particular the significantly titled 13th century *Romaunt of the Rose*. Chaucer, whose translation of the *Roman* he regularly cites, fed his imagination, but the most important text for him was Edmund Spenser's *The Færie Queene* (1590, 1596). He read Spenser while researching the second volume of *Modern Painters*, and found him indispensable to his developing theory of the imagination. Ruskin also much enjoyed William Morris's *The Earthly Paradise* (1868-70),

a retelling of Greek and Norse myths that he recommended in his own study of mythology, *The Queen of the Air* (19.309).

As Dante superseded Milton, so Greek mythology became as important an imaginative world as that of Christian myth. The ecumenical fusion of these traditions is summed up in Ruskin's announced intention in 1876 to produce a group of 'standard theological writings' as the foundation for the projected library of the Guild of St George, the *Bibliotheca Pastorum*. His seven chosen authors were 'Moses, David, Hesiod, Virgil, Dante, Chaucer, and, for seventh, summing the whole with vision of judgment, St John the Divine' – the author of the book of Revelation (28.500). Ruskin's reading of 'the moral significance of the image, which is in all the great myths eternally and beneficently true' (19.300) combined Biblical and classical mythology, and was similarly applied to the natural world, to medieval sculpture and great artists such as Turner and Carpaccio. To use the critic Northrop Frye's phrase, the synthesis of Christian and classical myth in his reading of Turner's *The Goddess of Discord Choosing the Apple of Contention in the Garden of the Hesperides* (Pl. 12) constitutes Ruskin's 'mythological universe'.[5]

<p style="text-align:center">△ △ △</p>

From an early age, Ruskin understood the Paradise myth in terms of 'an Eastern allegory' (1.485). In his anthology, *The Literary Criticism of John Ruskin*, Harold Bloom argues that the Paradise myth constitutes the buried foundation of all Ruskin's thought:

> Because of his intimate knowledge of Biblical and Classical iconology, and of Dante, Spenser, and Milton as the heirs

of such iconology, Ruskin arrived at a comprehensive theory of literature, which he never made fully explicit but which is evident throughout his criticism. One major assumption of this theory is that all great poetry whatsoever is allegorical; and that what it allegorizes is a fundamental myth of universal man, his fall from Paradise and his quest for a revelation that would restore him to Paradise. This myth is clearest in the Ruskin of the 1860s. ... Though it is an obsession in the later Ruskin, a consciousness of this myth was always present in his criticism, since he relied from the start on a Wordsworthian experience of paradisal intimations within a wholly natural context.[6]

Ruskin's 'comprehensive theory' applied to more than literature; it took in the visual arts, architecture and, in the case of Venice, cultural history. The roots of Ruskin's allegorical approach lie in the discipline of typological reading instilled as a child, reinforced by Bunyan, Milton, Herbert, Wordsworth and Carlyle, though by the time the tradition has reached Carlyle it has lost most of its explicitly Christian meaning. Dante represents the epitome of the penetrative imagination of *Modern Painters* volume two, where the approach acquires a psychological inflection. There is 'in every word set down by the imaginative mind an awful under-current of meaning, and evidence and shadow upon it of the deep places out of which it has come' (4.252). Dante is also the exemplar when Ruskin's theory of the imagination matures into fully-fledged symbolism in the 'noble grotesque' of volume three of *The Stones of Venice*.

Ruskin's encounter with Rose La Touche in 1858 meant that another layer of tragic meaning would be added to the *Divine Comedy*. Dante was a cult figure for the Pre-Raphaelites, and especially – unsurprisingly – for Dante Gabriel Rossetti. The

interest of Rossetti's approach is his emphasis on the reality of Beatrice as a historical character, pointing out that in the *Vita Nuova* she is not an allegorical figure. Rossetti stressed: 'what I believe to lie at the heart of all true Dantesque commentary; that is, the existence always of the actual events even when the allegorical superstructure has been raised by Dante himself'.[7]

This is entirely consonant with Ruskin's understanding, based as it was on the typological theory that the events in the Bible are both historically true, and symbolic pre-figurations of later events, and the natural theology that saw the natural world as both real and symbolic of God's creation. In *Modern Painters* volume three he argues that in the *Divine Comedy* Beatrice and her associate Matilda each have 'a spiritual and symbolic character in their glorified state, yet retaining their definite personality' (5.277). This is relevant to his mythologizing of Rose La Touche; Dante and Beatrice do not consummate their relationship in the *Divine Comedy*. As Ruskin wrote in his lecture 'Of Queens' Gardens': 'stooping only to pity, never to love, she yet saves him from destruction – saves him from hell' (18.116). The pity of this passage is that it appears in *Sesame and Lilies*, the book written: 'to please one girl', Rose La Touche (18.47).

<p style="text-align:center">𝕬　𝕬　𝕬</p>

The Bible story, from Genesis to Revelation, supplied the frame for Ruskin's critical theory; it was also the source of his imagery. Eden has a geography and a topography, the archetypal fecund, harmonious enclosure with flowing water, flowers, fruit, and trees, one the Tree of Life, the other the fatal Tree of Knowledge. It is conceived as occupying a space below the firmament but above the ordinary world, which in turn stands above the

underworld of Hell, thus associating it with mountains and high places. The Fall, which enacts this spatial metaphor, occurs because of the persuasiveness of the Serpent, archetype of Satan, evil, and sexual desire. It is a kind of deformation that leads to the expulsion from the garden, and the beginning of the long quest of Adam, Eve and their descendents for redemption and return. The Flood is both destruction and a cleansing. Yet the Fall also contains a promise of redemption, which is worked out through the life, death and resurrection of Christ. Ruskin declared in 1883:

> For all human loss and pain, there is no comfort, no inter-
> pretation worth a thought, except only in the doctrine of
> the Resurrection; of which doctrine, remember, it is an
> immutable historical fact that all beautiful work, and all the
> happy existence of mankind, hitherto has depended on, or
> consisted in, the hope of it. (33.276-7)

Hence Ruskin's profound appreciation of Holman Hunt's *The Triumph of the Innocents* (Pl. 16).

Redemption is manifested in the last book of the New Testament, Revelation, carefully crafted to draw the themes and the symbols of both Testaments into an apocalyptic vision. The Fall is repeated, in terms of the fall of Babylon, which (like Venice): 'made all nations drink of the wine of the wrath of her fornication' (Revelation 14:8). But the Tree of Life reappears, this time within the enclosure of a jewelled city: 'the city was pure gold, like unto clear glass' (Revelation 21:18). There is a 'new heaven and new earth' (Revelation 21:1) and the city is the New Jerusalem seen by St John the Divine 'coming down from God out of heaven, prepared as a bride adorned for her husband' (Revelation 21:2), and set on 'a great and high mountain' (Revelation 21:10).

Between the lost Eden and the New Jerusalem runs the archetype of the journey of life. This is the earthly world of the Romance, which as Northrop Frye stresses, is not the same as the Christian myth, but which shares many elements of the same founding symbolism, for instance, in its spatial aspects. The heroes and villains of Romance, Frye writes,

> exist primarily to symbolise a contrast between two worlds, one above the level of ordinary experience, the other below it. There is, first, a world associated with happiness, security and peace; the emphasis is often thrown on childhood or on an 'innocent' or pre-genital period of youth, and the images are those of spring and summer, flowers and sunshine. I shall call this world the idyllic world. The other is a world of exciting adventures, but adventures which involve separation, loneliness, humiliation, pain, and the threat of more pain. I shall call this world the demonic or night world.[8]

These worlds can be read back as Paradise and Hell, or Ruskin's opposition of Light and Dark, or the structure of his unfinished autobiography *Præterita*, where he made a deliberate attempt to exclude separation, loneliness, humiliation, pain and the demonic world of his accelerating periods first of depression, and then madness.

Significantly, the Romance plot is circular. It begins with a descent – a Fall – and the quest is in search of a return to the original idyllic world. Frye writes:

> More frequently, the quest romance takes on a spiral form, an open circle where the end is the beginning transformed and renewed by the heroic quest. Dante's *Inferno* is a descending spiral, taking us into narrowing and unchangeable closed circles; the *Purgatorio* spiral gives us the opposite creative

Fig. 41: John Ruskin, Study of a Paper Nautilus Shell, *10 February 1867*

movement. When Dante reaches the presence of God at the end of the *Paradiso*, the universe turns inside out, becoming God-centered instead of earth-centered, an end that reverses the beginning of all things.[9]

Writing to his mother from Venice in 1869, Ruskin combines the spiral form with the antithetical doubling of Romance in a striking image of the history of Venice:

> It is the history of all men, not 'in a nutshell', but in a nautilus shell – my white nautilus that I painted so carefully is a lovely type of Venice. (19.liv) (Fig. 41)

If time and history are circular, then they can be redeemed, and Paradise regained. When Ruskin closed the series of *Fors Clavigera* at Christmas 1884 with Letter 96: '(Terminal) Rosy Vale' (29.517), he ended with an echo of the Book of Revelation, an evocation of the coming Judgment as a form of blessing, and the waters as a redemption:

> Surely the time is come when all these faithful armies should lift up the standard of their Lord, – not by might, nor by power, but by His spirit, bringing forth judgment unto victory. That they should no more be hidden, nor overcome of evil, but overcome evil with good. If the enemy cometh in like a flood, how much more may the rivers of Paradise? Are there not fountains of the great deep that open to bless, not destroy? (29.528)

The rivers of Paradise may yet flow back to the waters of Herne Hill.

The prolonged practice of allegorical reading leads to the practice of allegorical writing: *The Stones of Venice* is shaped by the allegory of rise and fall. Paul Sawyer sees *Fors Clavigera* as 'built around a central allegory of the spiritual condition of Europe in the nineteenth century' plotted as a journey through Hell towards Paradise.[10] The work that lends itself most strongly to a reading in terms of Romance is his last, *Præterita*. As Bruce Redford argues, the text has:

> A larger mythic plot, which moves in circular fashion from Fall through Exile to Redemption/Return. All three elements of the romance triad – the beauty that was, the loss that is, and the return that may be – are simultaneously present in five of the book's paradises: Herne Hill, Abbeville, Geneva, St Martin and the final vision of Denmark Hill-Siena.

It is, Redford writes, 'the Edenic motif which not only organises but structures the work as a whole'.[11]

As Ruskin wrote in *Modern Painters* volume five: 'Paradise was full of pleasant shades and fruitful avenues' (7.13), and so was the garden of his childhood evoked in Chapter II of *Præterita*. Set on a hill, it is a small, enclosed space, ordered, feminised and fruitful with trees, flowers and water. The cycle of the seasons embeds the circularity of time and, in Ruskin's thinking, allows a place in Eden for a benign form of Death. He told his friend Edward Clayton: 'if there were trees in the Garden of Eden, there was death … the very meaning of the word flower is – something to supply *death*' (1.476), a remark that anticipates the organic argument of *The Stones of Venice* (but which, as we saw in Chapter XIV, he later revises in his dealings with Darwin). With characteristic wit, in *Præterita* Ruskin is careful to make a distinction between his idyll and the original:

> The differences of primal importance which I observed between the nature of this garden, and that of Eden, as I had imagined it, were, that, in this one, *all* the fruit was forbidden; and there were no companionable beasts: in other respects the little domain answered every purpose of Paradise to me. (35.36)

There is, however, no Eve in his Eden, which instead is ruled by his mother.

Here, there was 'nothing to love' (35.44), not even his parents. As we saw in Chapter II:

> My parents were – in a sort – visible powers of nature to me, no more loved than the sun and the moon: only I should have been annoyed and puzzled if either of them had gone out. (35.44)

This helps to explain his blighted emotional development, but there is also an element of the Paradise myth here. The sun and moon were regarded as part of God's original creation, the upper firmament that survived the obliteration of the earthly paradise, and so, in this sense, father and mother remain as part of Heaven.

Through time and change the Paradise of Herne Hill is lost, when he is, as he puts it: 'cast out at last into the world' (35.46), but as Redford has pointed out, it is only the first of a series of paradisal locations found and lost. The banks of the Tay (35.69) and the water-surrounded city of Abbeville (35.156) are only a foretaste of what the chapter summary describes as: 'First sight of the Alps: the author's entrance into life' (35.7). This is one of the many epiphanies in the text: 'Infinitely beyond all that we had thought or dreamed, – the seen walls of lost Eden could not have been more beautiful to us; not more awful, round heaven,

the walls of sacred Death' (35.115). In the chapter 'The Col De La Faucille' the crossing of the Alps is presented as a kind of pilgrim's progress, rewarded with a sight that, he stresses, he was permitted to see clearly for only once in his life, in 1835, when he was able to see the whole chain of the Alps, free of clouds, and the Lake of Geneva below: 'That day of 1835 opened to me in distinct vision the Holy Land of my future work and true home in this world' (35.167).

Several commentators have explored the Edenic allegory of *Præterita*, but there is a yet larger pattern to be discovered. The Alps, where Ruskin always sought refreshment both before and after his visits to Venice, were not a metaphorical, but an actual lost Eden, polluted in his lifetime by modernity and tourism, as visitors to modern Chamonix will know. In the first two volumes of *Modern Painters* mountains are the ultimate expression of undefiled, God-created nature, before the man-made substitute of architecture interrupts the progression of that text with the *Seven Lamps of Architecture* and the fallen city of *The Stones of Venice*. The post-Venice vision of nature in *Modern Painters* volumes three and four is darker, leading to Turner's polluted 'paradise of smoke' in *Modern Painters* volume five (7.408).

In *Præterita*, the vision of the 'Holy Land' is followed by a descent onto the plain, and the most elaborated of his descriptions of the walled cities that he has already named as 'centres of my life's thought: Rouen, Geneva, and Pisa' (35.156). As Pierre Fontaney has demonstrated, the description of Geneva and the Rhone follows the archetypal patterns that will be becoming familiar. Geneva is the centre of the world, a small, enclosed space within a paradisal countryside that in Fontaney's words is 'the embodiment of Ruskin's deep-set pastoral dream of happiness and social justice'.[12] Walled cities also present obstacles to

entrance; by way of trial, they become an object of quest – in this case the purchase of a jewel – requiring purification.

The Geneva passage in *Præterita* was not the first such metaphorical quest. The pivotal description of St Mark's in *The Stones of Venice* is an even more elaborated journey towards a jewel. The Protestant beholder threads his way through a labyrinth of streets towards St Mark's: 'a treasure-heap, it seems, partly of gold and partly of opal and mother-of-pearl' (10.82). But this first discovery, surrounded as the church is by fallen beings, lounging in its shade, is followed by a plunge into darkness, and a second journey through the Catholic space of the interior before reaching a climax that is both ecstatic and ironic, for the value of the jewel is invisible to modernity.

The description of St Mark's helps to establish Venice as, in John Rosenberg's phrase: 'a Gothic Eden'.[13] Richard Stein comments of the St Mark's passage: 'we are meant to feel that with him we have glimpsed heaven on earth. We are also meant to refer this perception back to the original Edenic fact of Venetian civilization, of which the splendour of St Mark's is a first instance'.[14] Venice – in a private diary in 1841 and repeated in *Præterita*, is Ruskin's 'Paradise of cities' (35.296) – a jewelled city, walled by water, where even today the snows of the Alps can sometimes be seen. It also has its counter-image as labyrinth and Babylon. At the heart of its seat of government, the Ducal Palace, is Tintoretto's image of Paradise, the largest canvas and also 'the thoughtfullest as well as mightiest picture' in the world (22.105). In order to ensure its preservation and draw attention to its significance, Ruskin commissioned a series of studies by his Venetian Angelo Alessandri, now in the collection of the Guild of St George (Fig. 41). The whole of Ruskin's ideas on the Renaissance are encapsulated by his lecture on 'The Relation between Michael Angelo and

Fig. 42: Angelo Alessandri, after Jacopo Tintoretto, Study of the Paradise in the Hall of
the Great Council, Ducal Palace, *1886-1905*

Tintoret' (1872), which opposes Michael Angelo's *Last Judgment*
to Tintoretto's *Paradise.* For Ruskin, these works presented man
with the choice between God's curse, and his blessing (21.108).

The Stones of Venice are a study of the Fall, passed over in
Præterita in order, among other reasons, to avoid humiliation
and pain. But Ruskin could not evade the knowledge of the
fallen state of his hero, Turner, which had been confirmed to
him when sorting Turner's drawings in the basement of the
National Gallery in 1858. The meditation on Turner's Paradise
in *Modern Painters* volume five is a national expulsion from the
Eden of pre-industrial England. In *Præterita*, 1858 is the year
when Ruskin enters into knowledge, at the climax of a chapter
reviewing the development of his religious life that ends in his
un-conversion in Turin. It is also the year he meets Rose La
Touche, and a new quest begins.

The Turin chapter of *Præterita* was issued early in 1888. What
turned out to be the final chapter, written in May and June
1889, somehow achieves a concluding return. His childhood

home, Herne Hill, may have had, as he wrote in 1874, its gate 'closed now on me for evermore' (28.79), but he is able to return in memory to the garden that he had constructed at the family's second home at Denmark Hill, with its flowers, walks and ordered waters:

> I draw back to my own home, twenty years ago, permitted to thank Heaven once more for the peace, and hope, and loveliness of it, and the Elysian walks with Joanie, and Paradisiacal with Rosie, under the peach-blossom branches by the little glittering stream which I had paved with crystal for them. (35.560)

Paradise is gained, and lost, and gained as Ruskin's tenses change from past to present: 'I have been sorrowful enough for myself, since ever I lost sight of that peach-blossom avenue. "Eden-land" Rosie sometimes calls it in her letters' (35.561). His closing word associations, the last he ever published, are of purifying water and fountains, leading to memories of the Fonte Branda in Siena that bring Dante briefly to the surface. Sparkling water changes into fireflies: 'the fireflies everywhere in sky and cloud rising and falling, mixed with the lightning, and more intense than the stars' (35.562). Like Dante and Virgil before him, Ruskin has come through Hell and is on his way to Paradise. The closing line of the *Inferno* is:

> Thence issuing we again beheld the stars.[15]

Before Ruskin could see the stars, however, he had to pass through the vale of tears. After recovering Venice as a Gothic

Eden in the early 1850s, he began more and more to cast himself as a wandering expellee: 'I stand – so far as I can discern – alone in conviction, in hope, and in resolution, in the wilderness of this modern world' (28.425). He had abandoned the security of his original Evangelical faith, and entered the world of desire. The interpretative method shifts from typology to archetypology; the ruling myth, while still fundamentally Biblical, changes mode to Romance, whose central form, according to Frye: 'is dialectical: everything is focussed on a conflict between the hero and his enemy'.[16] Ruskin is his own hero, for whom the dialectic becomes the emblematic struggle between the Christian values of Light and Life, and the Satanic values of Darkness and Death, represented by industrialism and utilitarianism. The treasure at the end of his quest is not gold, but nature: 'There is no wealth but life' (17.105). The quest begins with a descent, as he falls into depression in the early 1860s. In one sense, there must be a Fall: Christ descended into Hell, and Ruskin descended into and returned from madness more than once. But though beginning with a descent, an archetypal quest will have an upward movement, an ascent – as in key passages of the Old and New Testament, in Dante, Spenser and Bunyan.

In circular time, Paradise can be regained. *Modern Painters* volume five begins with a meditation on Paradise that asks if mankind is willing to restore the earth that it has ravaged, and to face the flaming sword that bars the gates of Eden: 'For what can we conceive of that first Eden which we might not yet win back, if we chose?' (7.13). The choice exists, and even dead Venice might rise again. Hence the particular significance Ruskin attached to the word Restoration, with its echoes of the restoration of the Temple at Jerusalem.[17] The redemption myth gives a whole new meaning to the Gothic Revival, for: 'the

goodly building is then most glorious when it is sculptured into the likeness of the leaves of Paradise' (10.239). Thanks in part to Ruskin's efforts, the jewel of St Mark's was not reconstructed by architectural vandals, but restored by a more sensitive approach.

Ruskin's reading of the sculptures of the Ducal Palace in *The Stones of Venice* turns into a lengthy discussion of the iconology of the Bible and Plato, Dante and Spenser, and extends, in an appendix to volume three, to a three-page summary of book one of *The Færie Queene* (11.251-4). The sub-textual reason is that the account of the Redcrosse Knight's adventures is an allegory of the defeat of Catholicism by the Protestant Church, but this most Biblical of Romances offers up all the imagery that Ruskin would need in the quest to restore the Earthly Paradise after the Fall of the city of *The Stones of Venice*. Drawing on the work of Frye, Jeffrey Spear discovers the Romance form at the heart of Ruskin's social criticism. His social programmes were an attempt to change England, even if he could not find a spiritual Eden.[18] For Ruskin, the perfect vehicle for this transformation was the Guild of the red-cross knight St George, whose entire iconography, with its associations of restoring a waste land, could meet the needs of his public and private self. As Paul Sawyer writes:

> On the one hand, the letters [*Fors Clavigera*] are a series of public sermons in which the St George legend allegorises the spiritual rebirth of the English nation. On the other, they are a series of confessions in which Ruskin records a private quest for a lost Eden, a 'Paradise within', creating a myth out of his own actions and desires.[19]

The public Ruskin sought to kill the dragon Mammon and restore the waste land of British society. His Carlylean insistence on the virtues of manual labour (the curse of Adam) became

a founding principle of the Guild of St George. He sought to redeem his Oxford undergraduates from idleness by setting them to dig drains and build roads – and some of his volunteers were indeed inspired to try to rebuild English society. His schemes to channel the waters of the Alps were intended to restore an Italian paradise. His Lake District home, Brantwood, facing a high mountain, with its gardens and managed streams, was another attempt to construct an Earthly Eden.

ᗩ ᗩ ᗩ

At the same time, the private Ruskin had a real as well as symbolic quest: his love for Rose La Touche. It is symbolically enacted by Ruskin's obsessive study of the fresco of the marriage of St Francis with the rose-garlanded figure of Poverty in the lower church at Assisi in 1874 (Pl. 7) and consummated – or at least reconciled – through Ruskin's Christmas communion with St Ursula in Venice in 1876 (Pl. 8). Even Death was no obstacle, for guided by St Ursula, as the Redcrosse Knight is guided by Una, he was able to recover Rose from beyond the grave.

Northrop Frye associates the hero's ascent in Romance with 'the great Eros theme in which a lover is driven by his love to ascend to a higher world', the example being Dante's climb towards Beatrice, during which he recovers his original, pure self.[20] One form of quest preserves virginity, but there is also the parallel sexual quest, ending in marriage. According to Frye: 'The traditional symbolic basis of the sexual quest, which goes back to the Song of Songs in the Bible, is the identification of the mistress's body with the paradisal garden. The great medieval quest of sexual union, paralleling the sublimated quest of the *Purgatorio*, is *The Romaunt of the Rose*'.[21] Ruskin cited Solomon

the law-giver, but Solomon was also by tradition the author of the Song of Songs.

While it is possible to dismiss a psychosexual reading of *The Stones of Venice*, it is impossible to ignore the sexual nature of Ruskin's quest for Rose. His falling in love with her meant that he sought to ascend to a higher plane of existence. That Rose died is a tragedy in the world of actuality, but Ruskin was drawn up, uncontaminated by consummation, into the world of spiritualism, where Rose merges with Proserpina, St Ursula and all the other lady saints.

In Romance, virginity helps to preserve the idyllic world. Ruskin's demonic descents into madness are an ironic doubling of the ecstasy of communication with Rose. Like Dante, Ruskin must pass through Hell and Purgatory before ascending the mountain that leads to the Garden of Eden. Such was the identification between Rose and Beatrice that in *Præterita* Ruskin mistakes Rose's age, making her 'nine years old, on 3rd January, 1858' (35.525), the same age as Beatrice when Dante first met her, whereas she was in fact ten. Beatrice, like Rose, died in her twenties. Ruskin was hoping for a mystic marriage, such as St Francis's with Poverty, but while Dante recovers his prelapsarian state in unconsummated union with Beatrice, in spite of his rejection of the sexual implications of Darwinism, Ruskin appears to have longed for a physical consummation.

ᛉ ᛉ ᛉ

In reality, however, Rose died, and Venice, 'the Paradise of Cities' was dying. Ruskin's fate was not tragic, but worse, ironic. The world of modernity was the negative of everything that the idyll of the Guild of St George represented. But it was the world

that *Fors Clavigera* had to address, so that, as Jeffrey Spear has pointed out: '*Fors* evolved in two incompatible modes: romance and irony'.[22]

Yet that incompatibility is precisely the ironic form: the idyllic and the real world each assert the reverse of the other. Venice was very much living, bringing the changes that made Ruskin think of the city as dead. Ruskin, – and this is certainly ironic – contributed to the life in death of Venice. He hated the mass tourism that developed from the 1850s, yet he was also partly responsible for it. Having contributed to Murray's *Handbooks for Travellers*, his own guidebook, *St Mark's Rest* is caustically 'written for the help of the few travellers who still care for her monuments' (24.193). Having declared the death of Venetian architecture and the absolute impossibility of restoring a building without destroying it, it was he who helped to save the west front of St Mark's for posterity – and the crowds to come.

ᐱ　ᐱ　ᐱ

In modernity, a simple return to the idyll was no longer possible, while on the plane of reality Venice could not recover her former state as Gothic garden. As early as 1852 he imagined a time when the circle of history had returned St Mark's Place to:

> A green field, and the front of the Ducal Palace and the marble shafts of St Mark's will be rooted in wild violets and wreathed with vines. She will be beautiful again then, and I could almost wish that the time might come quickly, were it not that so many beautiful pictures must be destroyed first. (11.xxvii-iii)

After Ruskin, death in Venice becomes a recurrent late 19th

century trope. The difference between Ruskin and decadents such as Maurice Barrès, who in *La Mort de Venise* (1903) finds the decay of Venice both diseased and erotic, is that he wanted Venice to live, by recreating it through Romance.[23] This was an act of the imagination, defined by Ruskin as 'the highest faculty of man – mental creation' (27.346n). Even Death could be contained in Ruskin's Paradise, for it was enfolded in the flower that contained the future. According to Northrop Frye, at the end of the Romance quest there is a return to the original idyll, but it is not the original; it is a recreation. Such was Ruskin's paradise of cities:

> A city of marble, did I say? nay, rather a golden city, paved with emerald. For truly, every pinnacle and turret glanced or glowed, overlaid with gold, or bossed with jasper. Beneath, the unsullied sea drew in deep breathing, to and fro, its eddies of green wave. Deep-hearted, majestic, terrible as the sea, – the men of Venice moved in sway of power and war; pure as her pillars of alabaster, stood her mothers and maidens; from foot to brow, all noble, walked her knights; the low bronzed gleaming of sea-rusted armour shot angrily under their blood-red mantle-folds. Fearless, faithful, patient, impenetrable, implacable, – every word a fate – sate her senate. In hope and honour, lulled by flowing of wave around their isles of sacred sand, each with his name written and the cross graved at his side, lay her dead. A wonderful piece of world. Rather, itself a world. (7.374)

A world, yes, but a world of the imagination. In truth, Venice, like Paradise, cannot be recovered, yet in Ruskin it is constantly resurrected, and this is the power of art. Art not only delights, it instructs; it reveals the horrors of the world, but also

offers the possibility of redemption. Whatever the coarse and crowded reality of contemporary Venice, or the ski-slopes of the Alps, art has the power to show us a better world, or at least the possibility that such a world may yet exist. This imagined world should be the destination of our quest. Art alone cannot save us, but through art, there is still the possibility that we can save ourselves.

Based on a lecture given to The Guild of St George, 2009 and adapted from Ruskin on Venice: 'The Paradise of Cities', Yale University Press, 2010.

CHAPTER XVII

RELEVANT TO THE 21ST CENTURY:
RUSKIN AND CULTURAL VALUE

❧

We know what things cost but have
no idea what they are worth.
Tony Judt, *Ill Fares the Land* (2010)[1]

Anniversaries are arbitrary affairs – even when celebrating as significant a moment as the two hundredth anniversary of the birth of John Ruskin on 8th February 1819. But the anniversarial device so beloved of television producers stuck for a programme idea does have its uses. It brings the past into the present; by making us revisit, and rethink, familiar material. On occasion, it can bring the present into the past.

It becomes vividly significant, for instance, that in 1860, the year that Ruskin set out directly to challenge the ruling economic assumptions and cultural values of his day with his essays in *The Cornhill* magazine, later published as *Unto This Last*, both Britain and America had recently experienced a severe financial crisis. In 1857, a run on, and subsequent failure, of a number of banks in the north of England (shades of the run on Northern Rock in 2007), caused an economic emergency that led to the suspension of the Bank Act of 1844. As a result, the Bank of England was allowed to exceed the legal limits on the amount of paper money in circulation (16.137n). This procedure was

Opposite: Fig. 43: Hubert von Herkomer, John Ruskin, *1880*

the Victorian equivalent of a term with which we have become familiar since the financial crisis of 2008: quantitative easing.

The 1857 suspension occurred just as Ruskin was preparing to publish the lectures that he had delivered in July, on the occasion of the Manchester 'Art Treasures' exhibition. He called them: *The Political Economy of Art*. The choice of the home of economic liberalism, Manchester, as the site for a celebration of cultural wealth equivalent to the industrial wealth of the Great Exhibition, justified Ruskin's conjunction of 'economy' and 'art'. He explicitly refers to the banking crisis in his *addenda* to the printed version of the lectures, issued in December of that year.

In this conclusion, I want to bring the present into the past in such a way as to illuminate both Ruskin's thinking, and some of our present discontents. I want to test Ruskin's more than academic relevance to the 21st century. This turns on the most important cultural question we face today: what do we mean by 'value'?

The idea that 'culture' – the symbolic organisation of social meaning – has a distinct value is an ancient one, but the theory of Cultural Value, as an aspect of what it is wholly accurate to call the political economy of the arts, is a development of the 21st century. Cultural Value, and the related concept, Public Value, has been taken up by think tanks, by politicians, by the BBC, and by academics. In 2015 the University of Warwick published the results of one of its investigative 'Commissions': *Enriching Britain: culture, creativity and growth: The 2015 report by the Warwick Commission on the future of cultural value*.[2] This was followed in 2016 by publication of the results of an even larger enquiry, funded by the Arts and Humanities Research Council to the tune of half a million pounds: *Understanding the value of arts & culture: The AHRC Cultural Value Project*.[3]

The spontaneous emergence of the debate about Cultural Value and the variety of contributors to the discussion – including the semi-official role played by the AHRC – suggests that we are witnessing a paradigm shift that will change the debate about culture itself. There is an anxiety in the air, and, like the bank crisis of 1857 and Ruskin's political economy of art, there is more than a coincidental link between the crisis of values in the political economy, and the debate about value in the cultural sector.

♈ ♈ ♈

Ruskin had a theory of Cultural Value that is both implicit and explicit in his writings. In its modern context, Cultural Value is principally a concern of cultural economics, which is itself a very recent and junior subset of the science of political economy, founded in the 18th century. *The Journal of Cultural Economics* began publication only in 1973. Since then, because of the social and economic changes in developed countries that have obliged governments to recognise the importance of the political economy of the arts, cultural economics has proved to be a growth industry. The problem, however, – and here Ruskin would be the first to agree – is that for too long cultural economics has been left to the economists.

Cultural production and cultural consumption are indeed economic activities; they have effects that can be discussed in economic terms. But, as economists themselves acknowledge, such production and consumption also have effects that are less susceptible to economic measurement – that are, indeed, cultural. My case is that we do not have to reduce our understanding of cultural production exclusively *either* to the language of economic analysis, *or* to that of cultural theory. Instead, we

must try to re-establish some useful link between economists and those concerned with the symbolic, but meaningful, matter of culture. That link will depend on our understanding of a word that both sides have in common, but to which they attach different meanings. The issue at stake is what is meant by 'value'. Here, Ruskin definitely has something useful to tell us.

In their introduction to *Beyond Price: Value in Culture, Economics and the Arts*, the cultural economists Michael Hutter and David Throsby give a helpful account of how the distinction between economic value and cultural value came to be established. In the 18th century, philosophers of the Scottish Enlightenment, notably Francis Hutcheson, David Hume and Adam Smith:

> Saw a distinction between value arising from the disinterested experience of beauty, and value from objects that serve the self-love of individuals. The former was seen as clearly superior since it related to a contemplation of the Divine. Economic value, its complement, related to the pleasure from personal gratification. While morally inferior, the attainment of the greatest amount of utility became a legitimate and relevant goal of private consumption.[4]

In practice, this distinction became a deep divide. We can trace the opening of the fissure to Adam Smith's *An Enquiry into the Wealth of Nations*, first published in 1776, and a work we should pay some attention to, for as Ruskin roundly declared in 1857: 'I have never read any author on political economy, except Adam Smith, twenty years ago' (16.10). Readers of this book will immediately suspect that this is not quite accurate. Since he also makes a passing reference to Mill's *Principles of Political Economy* in his *addenda* to *The Political Economy of Art*

(16.131n), this statement is more rhetorical than truthful, and he had certainly taken steps to rectify this deficiency in his reading by 1860.

Because Ruskin acknowledges Adam Smith, it is worth seeing how Smith treated the concept of value:

> The word VALUE, it is to be observed, has two different meanings, and sometimes expresses the utility of some particular object, and sometimes the power of purchasing other goods which the possession of that object conveys. The one may be called 'value in use'; the other, 'value in exchange'. The things which have the greatest value in use have frequently little or no value in exchange; and on the contrary, those which have the greatest value in exchange have frequently little or no value in use. Nothing is more useful than water: but it will purchase scarce any thing; scarce any thing can be had in exchange for it. A diamond, on the contrary, has scarce any value in use; but a great quantity of other goods may frequently be had in exchange for it.[5]

However contemptuous Ruskin may have been of orthodox economists – in 1862 he told his Edinburgh friend, Dr John Brown: 'Political Economy *is* a Lie' (36.417, italics his) – Smith's distinction between value in use and value in exchange became a fundamental part of Ruskin's argument – which he then turned against the economists. His problem with Adam Smith was that, although he acknowledges the existence of 'value in use', *The Wealth of Nations* proceeds to concentrate on 'value in exchange'. In the hands of the classical economists who followed Smith, including Mill and David Ricardo, whom Ruskin also read, 'usefulness' and 'utility' become weasel words capable of indicating both practical and hedonic, or selfish, use.

When Mill published his *Principles of Political Economy* in 1848, he felt confident enough to say: 'Happily, there is nothing in the laws of Value which remains for the present or any future writer to clear up; the theory of the subject is complete'.[6] It is possible that this confidence – this arrogance – together with Mill's opening remark: 'Everyone has a notion, sufficiently correct for common purposes, of what is mean by wealth',[7] is the reason that Mill becomes the principal object of Ruskin's scorn.

Ruskin's reading of Mill's *Principles of Political Economy* can be followed very directly, because his own copy, complete with his characteristic markings, is preserved in the British Library. It is the second edition, published in the same year as the first, 1848, and although it is not known precisely when Ruskin read it for the first time, the correspondences between the quotations he makes from Mill in *Unto This Last* and the scorings in his copy make it almost certain that he read it between mentioning 'opening Mill's *Political Economy*' in 1857 (16.131n), and 1860.

Ruskin's decision to write *The Political Economy of Art* has rightly been taken as a harbinger of his direct engagement with social concerns in the 1860s, but in the 1857 lectures Ruskin's use of economic terms to frame his argument – 'The Discovery and Application of Art' is the title of Lecture I, and 'The Accumulation and Distribution of Art' is the title of Lecture II – is largely metaphorical, whereas in *Unto This Last* he attacks his adversaries on the ground of, and in the language of, economics, though it is enriched by Ruskin's characteristic Biblical and etymological allusions.

Ruskin is certainly adversarial towards Mill in *Unto This Last*, but his scribbled comments are more respectful, even if on page 33 we find the exclamation 'bosh'. Ruskin appears to have read the first of Mill's two volumes fairly closely. His

last marking is on page 549 of the second volume, where Mill comments on the rising intellectual – and therefore political – confidence of the working classes (something Ruskin's writings were to encourage). The key section for Ruskin is the chapter on Value, about which Mill felt so confident. Mill cites Adam Smith's foundational statement, quoted earlier, and then, in spite of having proposed that there was nothing more to be said about Value, points out that Smith, in his statement on: 'the obvious ambiguity of the word value' had, when saying that a diamond had no value in use, introduced an ambiguity of his own:

> This is employing the word use, not in the sense in which political economy is concerned with it, but in that other sense in which use is opposed to pleasure. Political economy has nothing to do with the comparative estimation of different uses in the judgment of a philosopher or of a moralist. The use of a thing, in political economy, means its capacity to satisfy a desire, or serve a purpose. Diamonds have this capacity in a high degree, and unless they had it, would not bear any price.[8]

Mill's phrase: 'to satisfy a desire, or serve a purpose' is an example of the ambiguity in economics between practical and hedonic – that is to say, personally pleasurable – utility. We may wish to satisfy desires that are æsthetic, or indeed spiritual, but such desires, which become purposes, do not necessarily translate into value in exchange – even if diamonds are a girl's best friend.

In the introduction to his *Principles*, Mill had stated: 'moral and psychological' causes were the legitimate object of: 'moral and social science, and … the object of Political Economy' – in his copy Ruskin underscores the phrase 'moral

and psychological'.[9] But in the later passage, quoted above, Mill appears to exclude: 'the judgment of a philosopher or of a moralist'. (A moralist would question the use to which something obtained in exchange – guns for blood diamonds, for instance – was put.) The word value, Mill goes on to say: 'when used without adjunct, always means, in political economy, value in exchange'.[10] Ruskin underscores 'value in exchange', makes three short pencil strokes in the margin, and writes: 'curious admission'.

This is the nub of the argument, around which we still jostle today: the difference between economic calculation and moral evaluation. Mill's last-quoted sentence, together with his exclusion of 'the judgement of a philosopher or a moralist' is the starting point for Ruskin's final, extended essay in *Unto This Last*, 'Ad Valorem'. It is extended because Ruskin's essays in *The Cornhill* had caused such controversy that the editor, George Smith, decided to cut the series short. But Smith was also Ruskin's publisher, and therefore gave Ruskin's final essay more space – possibly to placate a valuable author on his list.

The point of Ruskin's conclusion to a forcibly truncated argument is that the subject of the real, as opposed to 'bastard' (17.85) science of political economy is not value in exchange, but value in use. And value in use is a matter not of quantitative, but qualitative, judgment; of ethics, not economics. Not only must an object have some 'usefulness and agreeableness' (17.80) – Ruskin here links practical and hedonic utility – in order to acquire value in exchange; the use to which it is put once it has been acquired in exchange – for good or evil, creativity or destruction – will govern its value to the user. The definition of wealth therefore becomes: 'The possession of useful articles, *which we can use*' (17.87, italics his). Not only that, the use we

make of these articles will depend on our own capacity for good or evil, so that wealth becomes 'THE POSSESSION OF THE VALUABLE BY THE VALIANT' (17.88, capitals his), and much of what we call wealth, because of the way it is used, should rather be called, in Ruskin's striking coinage, 'illth' (17.89).

The 'one great fact' that Ruskin urgently wished to get across, knowing that his own publisher had insisted that these attacks on the 'bastard science' must be brought to a halt, was:

> THERE IS NO WEALTH BUT LIFE. Life, including all its powers of love, of joy, and of admiration. That country is the richest which nourishes the greatest number of noble and happy human beings; that man is richest who, having perfected the functions of his own life to the utmost, has also the widest helpful influence, both personal, and by means of his possessions over the lives of others. (17.105)

Ruskin's argument that – contrary to Mill – we do not have 'a notion, sufficiently correct for common purposes, of what is mean by wealth' is not original. As an undergraduate at Oxford he read in Aristotle's *Nicomachean Ethics*: 'wealth is clearly not the good we are seeking, since it is merely useful, for getting something else'.[11] His personal copy of the Greek text, also in the British Library, suggests that he had read this passage, although it is mainly interesting for the handful of tiny sketches of Gothic details in the margins.[12] For Aristotle, as for Ruskin, wealth, an expression of value in exchange, is subordinate to value in use.

Ruskin's move onto the economists' own ground, just as the principles of *laissez-faire* were entering their golden age, did not go down well. When his truncated essays appeared in 1862 in book form as *Unto This Last*, the edition sold fewer than nine

hundred copies in the following ten years. The same fate befell his next series of economic essays, for *Fraser's Magazine*, which were similarly cut short in 1863, and not republished until 1872, as *Munera Pulveris*. Ruskin presented these as the preface to an 'exhaustive treatise on Political Economy' (17.143), but he never wrote it. It was not until the changed economic circumstances of the 1880s that a new class of literate, largely self-educated, working men and a fresh generation of university-educated idealists – some of them former Hincksey diggers – began to use Ruskin's ideas to argue for a new social and economic settlement. His time would come, as these ideas informed the thinking of the founders of the Labour Party and the future architects of the Welfare State.

It is tempting to see the editorial foreclosure of *Unto This Last* as the symbolic parting of the ways between economics and culture. Hutter and Throsby write that by the mid-19th century æsthetics and economics were so far apart that exchange value, established by the interaction of supply and demand, had become the only form of economic value, while intrinsic value retreated to the autonomous sphere of æsthetics – that 'disinterested experience of beauty' that Immanuel Kant had elevated above ordinary existence because it gave access to 'the Divine'.

Except that the central question of what we mean by value – and specifically, Cultural Value – has never gone away. We may have lost touch with the Divine, and be unfamiliar with Kant's ideas on the transcendental nature of beauty, but the suspicion remains that there is something more to the experience of art than material self-indulgence, and that it means something more

than pounds, shillings and pence. It is the economists who have brought the question back. In 2001 David Throsby published his study *Economics and Culture*. Being an economist, he put the word economics first, but his underlying point was that however abstract an economic theory might appear to be, it is never, in the broadest sense, culture-free, because all human activity exists in a cultural context – what I have called the sphere of symbolic meaning. Value turns out to be a socially constructed phenomenon. It follows that the question of value should be the place to explore the possibility of re-connecting economic and cultural enquiry. Throsby – who also cites Adam Smith's foundational distinction between value in use and value in exchange – writes:

> In both of the fields of our concern, economics and culture, the notion of value can be seen, despite its differing origins, as an expression of worth, not just in a static or passive sense but also in a dynamic and active way as a negotiated or transactional phenomenon. It can therefore be suggested that value can be seen as a starting point in a process of linking the two fields together, that is as a foundation stone upon which a joint consideration of economics and culture can be built.[13]

Note the use of the word 'worth', a possible bridge between the alternative meanings of value. Throsby does jointly consider economics and culture, firstly by deploying the theory of contingent valuation as a means of establishing an eqivalent monetary value for cultural phenomena, such as landscape or publicly owned works of art.[14] Secondly, he identifies a series of cultural values that cannot be directly established by value in exchange, but which nonetheless contribute to an object or activity's worth. He suggested that Cultural Value can be disaggregated into:

Æsthetic value
Spiritual value
Social value
Historical value
Symbolic value
Authenticity value[15]

All of these are subjective and unstable categories, but they begin to develop a useful conceptual vocabulary. At the same time that Throsby was exploring this issue, environmentalists were similarly evolving a vocabulary for notions of environmental value that could not be established by value in exchange. The precautionary principle, that care must be taken not to foreclose future possibilities; the need for inter-generational equity to ensure future generations will have equal access to present natural resources, and the need for bio-diversity to ensure the continuation of life, have also contributed to the concept of Cultural Value.[16]

In spite of wishing to link cultural and economic value, however – and Throsby cites Ruskin's objections to the idea that something can be valued only in monetary terms – he insists on keeping cultural and economic value in separate boxes:

> We continue to maintain the necessity of regarding economic and cultural value as distinct entities when defined for any cultural commodity, each one telling us something different of importance to an understanding of the commodity's worth.[17]

Thus Throsby's concept of Cultural Value remains binary, resting on two, separate, foundation stones, however usefully he discusses the relationship between them. Nonetheless, some readers of Throsby, especially of his work on the cultural

economics of the natural and built heritage, have felt encouraged to take the theory of Cultural Value further.

The reason for this is that Throsby's work – as does the whole issue of Cultural Value – exists within an economic and cultural context. It is, as I have argued, socially constructed. The current context is the consequence of developments in contemporary capitalism, where there is much greater emphasis on the manufacture, exchange and consumption of what have become known as 'symbolic goods' – where the exchange value of an object or activity depends not so much on their value in use as on their secondary cultural associations with imagery and ideas. The notion that company or product brands have an exchange value is an important example, and clearly the power of brand imagery to associate a commodity with desirable ideas is a function that operates within the cultural sphere of æsthetics and the imagination. The production of symbolic goods is the defining function of what, since the 1990s, have been called the Cultural and Creative Industries – an expression that Ruskin would certainly have satirised, like Henry Cole's 'Art Manufactures' as oxymoronic.

$$\lambda \quad \lambda \quad \lambda$$

The increasing commodification of the cultural sphere, and the use of culture as an instrument of social and economic policy, have been key drivers of attempts to evolve a theory of Cultural Value. So have been the commodification and instrumentalization of the entire public realm, in accordance with that phenomenon of the 1980s, the New Public Management. Following the principles of neoliberal economic theory, this not only called for the transfer to private ownership of public assets

such as power utilities and transport, but also demanded that institutions responsible for functions within the public realm – health services, local authorities, universities, schools, broadcasting, national agencies, government departments and cultural institutions – should themselves behave as far as possible like private enterprises, and submit to the discipline of 'the market'. As the ideology of neoliberalism established its intellectual and cultural hegemony, the watchword became 'Value for Money'.[18]

The challenge for those operating in the public realm, however, was how to demonstrate value for money when the value of a public service – health, for instance – is difficult to measure in terms of value in exchange. The elements of social capital – trust, tolerance, social cohesion, secure collective identity, co-operation rather than competition, the sense of wellbeing – are difficult to reduce to a figure on a spread sheet, especially when the outcomes are so hard to measure. One solution was to posit that there was something called Public Value, a concept articulated in a study published in 1995 by Mark Moore, a Professor at the Kennedy School of Government, Harvard University: *Creating Public Value: Strategic Management in Government*.[19] This concept was taken up in Britain in a paper written in 2002 by the New Labour government's strategy unit, based in the Cabinet Office.[20] In 2004, in preparation for the renewal of its Royal Charter, and in defence of its funding by licence fee, the BBC argued that in addition to its economic contribution as a lead player in the Cultural and Creative industries, it generated Public Value as a source of untainted information, by its commitment to education and cultural enlargement, and its contribution to a sense of national identity.[21]

The need to demonstrate value for money was particularly pressing in the cultural sector, where the ideology of the New

Public Management imposed a strict regime of accountability on those in receipt of public funds, either directly, as in the case of national museums, or indirectly through arm's-length bodies such as Arts Council England. The comfortable consensus that the arts were 'a good thing' broke down. Now, the arts had to do good things, not in the Aristotelian sense, but in terms of measurable outcomes such as driving urban regeneration, encouraging social cohesion, and preventing crime.[22] Public subsidy, without which many arts organisations would not survive, became a contractual arrangement, with agreed targets and measurable deliverables – to use the un-enchanting language of the hour. The practical difficulty of convincingly demonstrating these outcomes is one of the reasons why cultural economics has become such an important discipline.

But at the beginning of the 21st century the cultural economists had not settled the theory of Cultural Value so as to combine value in use and value in exchange, and enable cultural organisations to demonstrate, not only that they gave value for money, but that they should be given money to generate values. Stimulated by her attendance at a conference in 2003 organised by the think tank Demos for the National Theatre and the National Gallery, under the title *Valuing Culture*, the then Secretary of State for Culture, Media and Sport, Tessa Jowell, published her thoughts on the matter: *Government and the Value of Culture*. She asked: 'How, in going beyond targets, can we best capture the value of culture?'.[23] Jowell contrasted the definitions of wealth given by Mill and Ruskin, and favoured Ruskin's.[24]

There have been a number of attempts to answer Tessa Jowell's question, including the theory of Cultural Value as it has been developed by my friend and colleague John Holden and myself in a series of pamphlets, books, reports and presentations

published since 2004.[25] Although the fundamental issue has not changed, the language has shifted. Whereas in Adam Smith – and Ruskin – the crucial distinction is between value in use and value in exchange, the 21st century has settled on the assumed opposition between the intrinsic and the instrumental value of cultural objects and activities. This can be sloganized as the difference between art as an autonomous practice with its own value system, and art at the service of social and economic outcomes: art for art's sake, versus art for the state's sake.

Like Throsby, the Hewison/Holden argument sees Cultural Value as: 'a negotiated or transactional phenomenon'.[26] By 'intrinsic' is understood those aspects of an object or activity that relate to it as it is experienced in and of itself. Æsthetic value is an obvious example, but Throsby's typology of non-monetizable values cited earlier can be included in this category.[27] Such values are principally engaged with at a personal level, but much cultural experience – for instance a rock concert – is collective. Such experiences are hard to measure, though æsthetic value finds its monetary equivalences in the salerooms of Sotheby's and Christie's, or the scalpers' resale price for tickets to the O2.

Instrumental value derives from what might be called the positive externalities associated with culture, that is to say the beneficial economic and social outcomes that have become the stated objectives of public subsidy. These are usually experienced collectively, and however questionable the methodologies used, can be translated into 'measurable' social and economic equivalents to value in exchange. But there is a third term, a third and distinct form of value that significantly alters the dynamic between intrinsic and instrumental value. This is Institutional Value. The introduction of the concept of Institutional Value triangulates the assumed binary opposition between the

Intrinsic and the Instrumental, and is intended to express the Public Value aspects of cultural activity. The way that cultural institutions treat their publics and, equally important, their own staff, is capable of both positive and negative outcomes, most obviously in terms of trust, and represents value in use rather than in exchange.

Cultural Value thus emerges, not as a single unit of account, but as an expression of the dynamic relationship between value in use and value in exchange. It does not exclude the social and economic benefits that flow from cultural activity, but rather, seeks to show that instrumental value is a consequence of intrinsic value, and that intrinsic value is capable of analysis and articulation in a far more sophisticated way than the simple assertion that art exists for art's sake. Above all, the theory of Cultural Value seeks to establish a language that provides a conceptual framework within which both senses of the word value – the numinous and the numismatic – can be rationally discussed.

ᛉ ᛉ ᛉ

So how far have we travelled since the publication of *Unto This Last*? Notwithstanding the introduction of the concept of Institutional Value, hardly any distance at all. Take, for instance, Ruskin's discussion of intrinsic value. He does not use the word in *Unto This Last*, but it is a key term in *Munera Pulveris*. In his preface, when he published this second set of aborted essays in 1872, he asserted, in characteristic style: '*the modern political economists have been, without exception, incapable of apprehending the nature of intrinsic value at all*' (17.135, italics his). That is because they exclude from their calculations the real meaning of value in use. Value, he writes: 'signifies the strength, or 'availing'

of anything towards the sustaining of life, and is always twofold; that is to say, primarily, INTRINSIC, and secondarily, EFFEC-TUAL' (17.153, capitals his). The intrinsic quality of an object, and he cites as examples land, buildings, books and works of art, is a power that is latent in the object, and does not depend on its actual use. But for intrinsic value to become effectual, it must be put to use. Not only must it be useful, but the user must know how to use it. Thus the intrinsic is only realisable through the instrumental – the moral outcome of the æsthetic engagement.

Ruskin's original justification for that engagement was that it was, as Throsby and Hutter have phrased it, 'related to a contemplation of the Divine'. But as the convictions of Evangelicalism and the consolations of Natural Theology waned he came to see that a theologically-driven approach to art and culture was insufficient in the face of the economic and social effects of capitalism, and the fragmentation of society caused by economic individualism. Inverting Adam Smith's claim that the wealth of nations depended on the division of labour, and using Smith's own example of pin-making, he wrote in *The Stones of Venice*:

> It is not, truly speaking, the labour that is divided; but the men: – Divided into mere segments of men – broken into small fragments and crumbs of life; so that all the little piece of intelligence that is left in a man is not enough to make a pin, or a nail, but exhausts itself in making the point of a pin or the head of a nail. (10.196)

In response to this fragmentation, the purpose of *Unto This Last* was to reorder the connection between the æsthetic and the economic and to establish a moral economy of the arts. The consequence for Ruskin was not just the transition from the religio-æsthetic concerns of *Modern Painters* to the social

concerns of *Unto This Last*, but a drive to make intrinsic value effectual. He hoped that the instrumental outcomes of the Guild of St George would transform society. The work of the Guild in the 21st century continues to offer a practical critique of the values of the contemporary world.

The purpose of the theory of Cultural Value is similarly to re-integrate the æsthetic and the economic, the intrinsic and the instrumental. The importance of culture lies not in its value in exchange, but its value in use. Value arises in utility – the practical and the hedonic –, and ends in it. Which brings us, finally, to our present discontents.

We have been permanently affected by the financial crisis of 2008. We have had more than ten years of 'austerity', but there is no end in sight to the pressure on public services, the squeeze on ordinary people's earnings, or the increase in public and private debt. Past and present collide, when we learn that the gap between the rich and the poor in Britain is as great as it was in the 1850s, and that on average the rich enjoy ten more years of life than the poor. Added to that, we are passing through a crisis of national identity created by our departure from the European Union, whose root cause is the exclusion of so many people from the economic, social and cultural benefits of post-industrial Britain.

 ⚜ ⚜ ⚜

What makes Ruskin relevant to the 21st century is that the arguments he used to attack the economic liberalism of the 19th century are equally valid against the economic neoliberalism of today. The past comes into the present. In *Unto This Last* Ruskin said that his principles of political economy: 'were all summed

up in a single sentence in the last volume of *Modern Painters* – "Government and co-operation are in all things the Laws of Life; Anarchy and competition the Laws of Death'" (17.75). That he should choose to quote himself from *Modern Painters* demonstrates the unity of his thought. In *Modern Painters*, where the line is: 'Government and co-operation are in all things and eternally the laws of life. Anarchy and competition, eternally and in all things the laws of death' (7.207), the context is æsthetic; in *Unto This Last* it is economic. The one, in the terms identified in this chapter, intrinsic; the other, instrumental. But both are asserting the essence of Ruskinian value.

Ruskin introduced this key argument in the brief chapter, already discussed in Chapter IX, 'The Law of Help', which opens Part VIII of *Modern Painters* volume five, and which begins his conclusion to the work. It was written in 1859-60, that is to say, after his un-conversion in Turin in 1858.[28] But it is still within a frame of belief, as he considers: 'the relations of art to God and man' (7.205). Pursuing the argument of the eye, these are shaped by what he had originally called 'composition' – the visual relationships between all parts of an image one to another – but which he prefers here to call 'invention', on the grounds that composition had become a formula that can be taught. In so far as it is a mechanical, rule-bound practice, it becomes false; but true invention, guided by the associative imagination, is inspired, and every work is unique. Still in visual mode, invention is governed by: 'the help of everything in the picture by everything else' (7.205). But as he approaches the promulgation of the Law of Help, quoted earlier, help becomes an expression of Ruskin's ruling value, Life. The absence of help becomes Death.

In 1856, in an exercise in mythopoeic geology that anticipates his anti-Darwinian science of aspects of the 1870s, Ruskin

describes the contents of a lump of mud, found: 'on a beaten footpath on a rainy day, near a large manufacturing town' (7.207) – the allusion to industrialism is apposite. It is a slimy mixture of clay, sand, soot and water. Under the conditions of help, these elements have the power to refine themselves into jewels: 'for the ounce of slime which we had by the political economy of competition, we have by the political economy of co-operation, a sapphire, an opal, and a diamond, set in a star of snow' (7.208).

The purpose of this fanciful metamorphosis is to show that the incommunicable power of invention in art, music, painting, poetry, operates in obedience to what, in his post-un-conversion language he calls 'the Ruling Spirit' (7.203). This is not a compelled obedience, but a voluntary submission to faith that allows man to put life into things to create harmony, and to convey: 'the passion or emotion of life' (7.215).

In the *Modern Painters* iteration of his argument the emphasis is on the positive properties of Life. In *Unto This Last* the emphasis is on Death. Ruskin's 'government and co-operation' are not socialist principles. His idea of government, as several chapters in this book have shown, was authoritarian, however much this idea suggests positive order and benign control and self-control. Ruskinian co-operation depends on mutual consent to the authority of a Platonic idea of government, whereas 'Anarchy and competition', are the destructive opposites. By implication, Ruskin anticipates the opposition between civilised order and social chaos in the title of Matthew Arnold's *Culture and Anarchy* (1869). In a commentary on the *Modern Painters* passage in his Socratic dialogues *The Ethics of the Dust*, based on his conversations with the girls of Winnington School, Ruskin speaks of the 'anarchy of the mass' (18.358) in which the elements

of his metaphorical slime are mingled, while remaining separate parts at war with each other. He means mass in a physical sense, but the phrase is suggestive both of the growing working class in the 19th century, and of the mass markets of the 20th. This slime is the 'freedom' of the market place, a chaotic, hostile environment where each element seeks to gain advantage over the other, with the ultimate aim of achieving, not choice on the part of the consumer, but monopoly.

This is death by competition. It is the Malthusian world of the fight for resources that gave Darwin the clue to *The Origin of Species* and shaped his view of Victorian England. Darwin's blind struggle for life is the equivalent of *laissez-faire's* invisible hand of the market. Darwinism and neoliberalism share an essentially utilitarian belief that the efficiency of the market will achieve the greatest good for the greatest number. For Darwin, as we saw in Chapter XIV: 'the greatest-happiness principle indirectly serves as a safe standard of right and wrong'.[29] Ruskin utterly rejected this Benthamite calculus. In *Unto This Last* he points out that the purpose of the market is not to produce justice, but advantage: for every plus there is a minus, and the minuses have: 'a tendency to retire into back streets, and other places of shade, – or even to get themselves wholly and finally out of sight in graves: which renders the algebra of this science peculiar, and difficultly legible' (17.91-2).

Yet, as the sociologist William Davies points out in *The Limits of Neoliberalism*, the spirit of competition that so horrified Ruskin has, in the 21st century, penetrated a great deal further than the market:

> The neoliberal state takes the principle of competition and the ethos of competitiveness (which historically have been found in and around markets), and seeks to reorganise

society around them. Quite how competition and competitiveness are defined and politically instituted is a matter of historical and theoretical speculation, which is partly what *The Limits of Neoliberalism* seeks to do. But at the bare minimum, organising social relations in terms of 'competition' means that individuals, organisations, cities and regions are to be tested in their capacity to out-do each other.[30]

As Ruskin's humble minuses demonstrated, the purpose of competition is to produce inequality. Inequality prevents co-operation, and can lead to anarchy. Yet, as Davies points out, for market competition to be accepted as legitimate, the results must somehow be accepted as fair. The paradox of neoliberalism is that the abstract freedom of the market relies on the extensive material intervention of the state, in the form of regulation and, however reluctantly, help to the minuses who might otherwise feel forced to disrupt the smooth operations of the market. Following the financial crisis of 2008, however, when banks and insurance companies were themselves threated with becoming minuses, there was no reluctance to accept the intervention of the state, in order to preserve the financial status quo.

The fact that, more than a decade on from the run on Northern Rock, so little has changed, helps to explain why the paradigm shift adumbrated by the debate about Cultural Value has not yet taken place. The non-commercial elements of cultural life cling to the notion of Public Value, but are subject to an instrumental regime of measurement and management in order to qualify for the 'investment' that was once public patronage. Art schools and universities now function as competing businesses whose 'customers' are loaded with astronomical levels of long-term debt, their futures predicated not on the quality of their education, but the quantity of money they may earn in

later life. Both teaching and research are reduced to metrics to encourage competition. The spurious technocratic instrumentalism represented by the imposition of the EBacc on state schools is closing off access to the very creativity and imagination on which the 'creative economy' depends. The environment is treated exclusively as an economic resource. All policy decisions that affect the public realm are subject to the cost/benefit calculations of the Treasury's *Green Book*.

In his conclusion, in spite of his exposure of the severe limitations and internal contradictions of neoliberalism, William Davies asks if it is possible to save neoliberalism from itself: 'This means radically reducing the scope of economics again, and rediscovering rival measures and theories of value. A liberal separation of powers needs to be mirrored in a liberal separation of valuation techniques and principles, possibly also of monies'.[31] He does not use the term Cultural Value, but his discussion of 'social valuation' suggests a parallel technique, with parallel problems:

> When intrinsic values are reduced to metrics of value, the danger of this type of commensuration with economics and prices is ever-present. But if values are not reduced to metrics of value then they forego certain rhetorical and performative opportunities, that a numbers-obsessed public sphere might otherwise offer. A statement such as 'art for art's sake' can be portrayed as elitist, while a legal normative commitment to human rights or juridical procedure can appear to be a special minority interest or lobby group that is 'out of touch' with public sentiment. Intrinsic valuation has lost publicly plausible metaphysical substrates, but extrinsic, utilitarian valuation is pure babble, unless it has some tacitly assumed connection to a reality which exceeds it.[32]

That reality is the intrinsic value that precedes the instrumental. If we are to re-empower 'rival measures and theories of value', and revive a metaphysics, as opposed to a physics, of value, then Cultural Value offers a way forward. At its simplest, as Oscar Wilde first put it, it is the difference between Price and Worth – Worth: 'not just in a static or passive sense but also in a dynamic and active way as a negotiated or transactional phenomenon'.[33]

Cultural Value cannot be reduced to a number: price. Thus it escapes the limits of neoliberalism. This may make it illegitimate in terms of neoliberal economics, but neoliberalism is illegitimate in terms of ethics. And, as Ruskin spent much of his life arguing, ethics trump economics.

Though the age of Cultural Value has not yet arrived, there is hope in the knowledge that Ruskin published *Unto This Last* just as *laissez-faire* economics were reaching their apogee. It would be twenty years before his arguments took root, and they did not blossom until another century, when his ideas influenced the founders of the Welfare State. The 21st century does not need to reproduce Ruskinianism – he famously said: '*no true* disciple of mine will ever be a "Ruskinian"!' (24.371) – but we can discover in his work those values that avail themselves to Life, including all its powers: 'of love, of joy, and of admiration'. His love of the beauty of the natural world, his own joy in conveying it in pictures and evoking it in words, and his admiration for the artists and writers of all ages who did the same, are the key. As Ruskin has taught us: 'All great art is praise' (15.351).

Based on the 2010 Mikimoto Memorial Lecture, Lancaster University.

NOTES

⁊ↄ

1: John Ruskin and the Argument of the Eye, pp. 1-17

1. W. Wordsworth, 'Lines Composed a Few Miles above Tintern Abbey ...', lines 96-7.

2. Ruskin's collection has been superbly catalogued and reproduced in Ken Jacobson & Jenny Jacobson's *Carrying Off the Palaces: John Ruskin's Lost Daguerreotypes*, Quaritch, 2015.

2: 'All My Eye and Betty Martin': Ruskin and His Father, pp. 19-41

1. Jeffrey Spear has a penetrating discussion of Ruskin's 'calamities' in his *Dreams of an English Eden: Ruskin and His Tradition in Social Criticism*, Columbia University Press, 1984, pp. 18-34.

2. Macleod, Dianne Sachko (1986) *Art and the Victorian Middle Class: Money and the Making of Cultural Identity*, Cambridge University Press.

3: 'I Think He Must Have Read My Book': Ruskin and Turner, pp. 43-67

1. Ruskin is so determined to emphasise the 'terminal' significance of *Téméraire* that in his unofficial catalogue of 1857 he ignores the chronological display of the paintings, and very deliberately writes about it last.

2. Alan Davis explores the importance of the *Liber Studiorum* in 'The "dark clue" and the Law of Help: Ruskin, Turner and the *Liber Studiorum*' in *Ruskin's Artists: Studies in the Victorian Visual Economy*, ed. R. Hewison, Ashgate, 2000, pp. 31-51.

3. Dinah Birch, *Ruskin's Myths*, Clarendon Press, 1988.

4. Ruskin was embarrassed when Thornbury published this advice in his muckraking biography.

5. Alan Davis, 'Inventing the Truth: Ruskin's Etched Illustrations after Turner in *Modern Painters V*', *Turner Society News*, no. 80, pp. 7-10. This 'improvement' is discussed further below.

6. A. J. Finberg, *The Life of J. M. W. Turner RA*, Clarendon Press, 1961, p. 419.

7. John Gage (ed.), *Collected correspondence of J. M. W. Turner: with an early diary and a memoir by George Jones*, Clarendon Press, 1980, p. 281.

8. Gage, *op. cit.*, p. 221.

9. Gage, *op. cit.*, p. 281.

10. See: Al Weil, 'Alexander J. Finberg – a Tribute', *Turner Society News* 19 (1980), p. 3.

11. The letter to Wornum of 3 May 1862 is quoted by Ian Warrell in *Turner's Secret Sketches*, Tate Publishing, 2012, p. 46. This a revised version of his article 'Exploring the "dark side": Ruskin and the problem of Turner's erotica', *The British Art Journal*, vol. IV, no. 1, 2003, pp. 5-45, which includes a checklist of all the erotic drawings now held at Tate Britain.

12. In Warrell, *op. cit.*, p. 22.

13. Ms notes on the Turner Bequest: A.B.42 P.B.

14. Warrell, *op. cit.*, p. 48

15. Warrell *op. cit.*, p. 11. See also James L. Spates, 'John Ruskin's Dark Star: New Lights on his Life based on the

unpublished Biographical materials and Research of Helen Gill Viljoen', *Bulletin of the John Rylands University Library of Manchester*, vol. 82, no. 1 (Spring 2000), pp. 135-91.

16. Alan Davis 'Misinterpreting Ruskin: New light on the 'dark clue' in the basement of the National Gallery, 1857-58', *Nineteenth-Century Prose*, (Fall 2011), p. 53.

17. Francis O'Gorman, Review of 'Nineteenth-Century Prose. Special Issue: John Ruskin', *Ruskin Review and Bulletin*, vol. 8, no. 1 (Spring 2012), p. 72.

18. Dinah Birch, 'Fathers and Sons: Ruskin, John James Ruskin, and Turner', *Nineteenth Century Contexts*, 1994, vol. 18, p. 157.

4: 'A Violent Tory of the Old School': Ruskin and Politics, pp. 69-89

Works Consulted:

P. D. Anthony, *John Ruskin's Labour: A study of Ruskin's social theory*, Cambridge University Press, 1983

Lawrence Goldman, 'Ruskin, Oxford, and the British Labour Movement 1880-1914' in *Ruskin and the Dawn of the Modern*, ed. Dinah Birch, Oxford University Press, 1999, pp. 57-86.

Lawrence Goldman, *From Art to Politics: John Ruskin and William Morris: The Kelmscott Lecture, 2000*, William Morris Society, 2005

Jose Harris, 'Ruskin and Social Reform', in *Ruskin and the Dawn of the Modern*, ed. Dinah Birch, Oxford University Press, 1999, pp. 7-33.

Willie Henderson, *John Ruskin's Political Economy*, 2000, Routledge Studies in the History of Economics 32

Jeffrey L. Spear, *Dreams of an English Eden: Ruskin and His Tradition in Social Criticism*, Columbia University Press, 1984

1. Francis O'Gorman (ed.) *The Cambridge Companion to John Ruskin*, Cambridge University Press, 2015, p. 2.

2. Nicholas Shrimpton, 'Politics and economics' in *The Cambridge Companion to John Ruskin, op. cit.*, p. 117.

3. Stuart Eagles, 'Political legacies', in *The Cambridge Companion to John Ruskin, op. cit.*, p. 255. For an extensive discussion of Ruskin's political and social influence, see Stuart Eagles, *After Ruskin: The Social and Political Legacies of a Victorian Prophet, 1870-1920*, Oxford University Press, 2011.

4. J. J. Ruskin to J. Ruskin, ALS 5-6 December 1851, Ruskin Library, Lancaster University.

5. Much of what follows is based on a doctoral thesis by Dr G. S. Simes, 'The Ultra-Tories in British Politics 1824-1834' D.Phil thesis for Oxford University, 1974.

6. Boyd Hilton, *The Age of Atonement: The Influence of Evangelicalism on Social and Economic Thought 1785-1865* (1998), Clarendon Press, 1991. p. 21. For more on Ruskin and Evangelicalism, see Michael Wheeler, *Ruskin's God*, Cambridge University Press, 1999, and Robert Brownell, *A Torch at Midnight: A study of Ruskin's The Seven Lamps of Architecture*, Old Mission Publishing, 2006, especially pp. 44-72. There is an excellent brief account of the sources of the Ruskin family's Evangelicalism in the introduction to Van Akin Burd's *The Winnington Letters: John Ruskin's Correspondence with Margaret Alexis Bell and the Children at Winnington Hall*, The Belknap Press of Harvard University Press, 1969, pp. 55-63.

7. James Grant, *The Metropolitan Pulpit: or Sketches of the Most Popular Preachers in London*, 2 vols., George Virtue, 1839, vol. 2, p. 20.

8. The articles followed the custom of being signed pseudonymously. 'Political

Economy', *Blackwood's Magazine* vol. 26, September 1829, pp. 510-23; October 1829, pp. 671-687; November 1829, pp. 789-808; vol. 27, January 1830, pp. 22-47.

9. Gill C. Cockram, *Ruskin and Social Reform: Ethics and Economics in the Victorian Age*, Tauris Academic Editions, 2007, p. 38.

10. There is not the space to discuss it here, but Ruskin's anti-Catholicism prevented his acknowledgment of the influence of the Catholic convert and Gothic Revival architect Augustus Welby Pugin. Both men saw Gothic architecture as a source of moral and spiritual, as well as architectural, revival, but Ruskin's Protestant prejudice would not allow him to give Pugin his due. Ruskin's relation to Pugin is discussed in Chapter VII.

11. San Pietro in Castello remained Venice's nominal cathedral until 1807, when St Mark's took over.

12. J. J. Ruskin to J. Ruskin, ALS 20 March 1852, Ruskin Library, Lancaster University. The reference to '*Libers*' is to Turner's *Liber Studiorum*. Furnivall and Kingsley were Christian Socialists, as discussed in Chapter VIII.

13. Nicholas Shrimpton, 'Rust and Dust', in *New Approaches to Ruskin: Thirteen Essays*, Routledge, 1981 (reprinted as a Routledge Revival, 2015), p. 52.

14. Adam Smith, *An Enquiry into the Nature and Causes of the Wealth of Nations* (1776), ed. Cannan, 6th edition, 2 vols Methuen, 1961, vol. 1, p. 8.

15. William Morris, *The Nature of Gothic A Chapter Of The Stones Of Venice By John Ruskin* (1892), facsimile edition, Pallas Athene Arts, 2011, p. i.

5: 'Paradise of Cities': Ruskin and Venice, pp. 91-121

1. Samuel Rogers, *Italy, a poem*, Cadell & Moxon, 2nd edition, 1830, p. 47.

2. Byron, *Childe Harold's Pilgrimage*, Canto IV, verse v xvii.

3. J. Ruskin, ALS to Willoughby Jones, 1835, Ruskin Library, Lancaster.

4. Mary Lutyens (ed.), *Effie in Venice* (1965), Pallas Editions, 1999, p. 129.

5. John James Ruskin, ALS, 11 February 1852, Ruskin Library, Lancaster University.

6. J. Ruskin, ALS to Joan Severn, 11 May 1869, Ruskin Library, Lancaster University.

7. J. Ruskin, ALS to Joan Severn, 19 September 1876, Ruskin Library, Lancaster University. The full story is told in Van Akin Burd, *Christmas Story: John Ruskin's Venetian Letters of 1876-1877*, Associated University Publishers, 1990.

8. Van Akin Burd, *Christmas Story, op. cit.*, p. 256.

9. Van Akin Burd, *Christmas Story, op. cit.*, pp. 274-5.

10. For a discussion of Daru and *la leggenda nera* see David Barns, 'Historicizing the Stones: Ruskin's *The Stones of Venice* and Italian Nationalism', *Comparative Literature*, vol. 62, no. 3 (2010), pp. 246-61.

11. J. B. Bullen, 'Ruskin and the tradition of Renaissance historiography', in *The Lamp of Memory: Ruskin, Tradition and Architecture*, ed. Michael Wheeler and Nigel Whiteley, Manchester University Press, 1992, p. 56.

6: *The Awakening Conscience*: Ruskin and Holman Hunt, pp. 123-135

1. Quoted in Judith Bronkhurst, *William Holman Hunt: A Catalogue Raisonné*, 2 vols, Yale University Press, 2006, vol 1, p. 165.

2. William Holman Hunt, *Pre-Raphaelitism and the Pre-Raphaelite Brotherhood*, 2 vols, Macmillan, 1905, vol 1, p. 347.

4. Quoted in Bronkhurst *op. cit.*, vol. 1, p. 165.

4. *Illustrated London News*, 13 May 1854, p. 438.

5. Bronkhurst, *op. cit.*, vol. 1, p. 163.

6. *Athenæum*, 6 May 1854, p. 561.

7. Hunt, *op. cit.*, vol 1, p. 90.

8. Richard Leppert, *Sound Judgment: Selected Essays*, Aldershot, Ashgate, 2007, p. 127.

9. William Holman Hunt, *An Apology for the Symbolism Introduced into the Picture called The Light of the World*, London, B. R. Rothschild, New Gallery, 1865.

10. Kate Flint, 'Reading *The Awakening Conscience* Rightly', in *Pre-Raphælites re-viewed*, ed. Marcia Pointon, Manchester University Press, 1989, pp. 45-65.

11. Judith Bronkhurst, catalogue entry (no. 58), *The Awakening Conscience* in *The Pre-Raphælites*, Tate Gallery exhibition, ed. Leslie Parris, London, Tate Gallery Publications, 1984, p. 121.

12. Hunt, *op. cit.*, vol 1, p. 150.

13. Caroline Arscott, 'Employer, husband, spectator: Thomas Fairbairn's commission of *The Awakening Conscience*', in *The Culture of Capital: art, power, and the nineteenth-century middle class*, ed. Janet Wolff & John Seed, Manchester University Press, 1988, p. 185.

14. Isaiah chapter 35:4, in Bishop Lowell's translation.

15. Carol Jacobi, *William Holman Hunt: Painter, Painting, Paint*, Manchester University Press, 2006, p. 131.

16. Letter of 10 June 1854, unpublished ALS, Pierpont Morgan Library, New York.

17. Letter of 5 June 1854, ALS, Pierpont Morgan Library, New York. Partly quoted in Mary Lutyens, *Millais and the Ruskins*, London, John Murray, 1967, p. 222.

7: 'The Most Disgusting Book Ever Written by Man': Ruskin and Victor Hugo, pp. 371-151

1. Harold Bloom, *The Anxiety of Influence:*

A Theory of Poetry, Oxford University Press, 1973.

2. William Hazlitt, the son of the art critic of the same name, used the title, *Notre-Dame: A Tale of the Ancient Regime* (Effingham Wilson, 1833).

3. Victor Hugo, *The Hunchback of Notre Dame ... with a sketch of the life and writings of the author*, translated by Frederic Shoberl, Richard Bentley, 1833.

4. Kenneth Hooker, *The Fortunes of Victor Hugo in England*, Columbia University Press, 1938, p. 91.

5. There are a number of unpublished letters from Ruskin to Furnivall of the period in the Ruskin Library, Lancaster, but these do not help. There is also a substantial unpublished Ruskin/Furnivall correspondence in the Huntington Library in California, but I have not been able to consult it, so what follows is speculation.

6. Victor Hugo, *Victor Hugo à Napoléon Bonaparte*, reprinted in V. Hugo, *Actes et Paroles* (1876), 2 vols, J. Hetzel, A. Quantin, 1883, vol 2, p. 197.

7. Victor Hugo, *op. cit.*, vol 2, p. 202.

8. Victor Hugo, *op. cit.*, vol 2, p. 208.

9. Victor Hugo, 'Sur Walter Scott: à propos de *Quentin Durward*', in *Oeuvres Complètes: Critiques*, ed. Jean Pierre Reynaud, Editions Robert Laffont, 1985, p. 149.

10. J. B. Bullen, 'The tradition of Renaissance historiography', in *The Lamp of Memory: Ruskin, tradition and architecture*, ed Michael Wheeler and Nigel Whiteley, Manchester University Press, 1992. Bullen subsequently developed his ideas in his full-length study, *The Myth of the Italian Renaissance in the Nineteenth Century*, 1994.

11. J. B. Bullen, 'The tradition of Renaissance historiography', *op. cit.*, p. 62.

12. Alexis F. Rio, *De la poésie chrétienne dans son principe, dans sa matière et dans*

ses formes, Debécourt, Hachette, 1836, p. 527.

13. A. F. Rio, *op. cit.*, p. 537.

14. 'This was the decadence we call the Renaissance', Victor Hugo, *Notre-Dame of Paris* (1831), transl. John Sturrock, Penguin Books, 1978, p. 197.

15. V. Hugo, *op. cit.*, p. 191.

16. V. Hugo, *op. cit.*, pp. 126-7.

17. J. B. Bullen, *op. cit.*, p. 63.

18. John Ruskin, *The Letters of John Ruskin to Frederick J. Furnivall, MA, Hon. Dr Phil. And other Correspondents*, ed. Thomas J. Wise, privately printed, 1897, p. 49.

19. This is a reference to the Oxford Society for the Preservation of Gothic Architecture, of which he became a founder member in 1839. The Cambridge Camden Society – later the High Church, Gothic-loving, Ecclesiological Society – was formed in the same year.

20. Charles Augustus Welby Pugin, *The True Principles of Pointed or Christian Architecture*, John Weale, 1841, p. 1.

21. V. Hugo, *Notre-Dame of Paris, op. cit.*, p. 304.

22. Graham Robb, *Victor Hugo* (1997), Picador, 1998 p. 259.

8: 'Only to See': Ruskin and the London Working Men's College, pp. 155-169

1. F. J. Furnivall, *Two Letters Concerning 'Notes on the Construction of Sheepfolds'. Addressed to the Rev. F. D. Maurice in 1851 by John Ruskin*, privately printed, 1890, p. 7.

2. Letter to Rawdown Brown, 9 May 1854, in Mary Lutyens (ed.), *Millais and the Ruskins*, John Murray, 1967, p. 207.

3. F. J. Furnivall, *op. cit.*, p. 8.

4. F. D. Maurice, *Learning and Working* (1855), Oxford University Press, 1968, pp. 4-5.

5. Frederick Harrison, *John Ruskin*, Macmillan, 1907, p. 86.

6. Ruskin to Ebenezer Cooke, 12 February 1875, ALS, London Working Men's College Archive.

7. J. Llewelyn Davies (ed.), *The History of the Working Men's College 1854 -1904*, Macmillan, 1904, p. 41.

8. J. Llewelyn Davies, *op. cit.*, p. 11.

9. Frederick Harrison, *op. cit.*, p. 97.

9: 'The Teaching of Art Is the Teaching of All Things': Ruskin, Sight and Insight, pp. 171-185

1. Semir Zeki, *Inner Vision: An Exploration of Art and the Brain*, Oxford University Press, 1999.

2. For an excellent overview of Ruskin's views on art education, including his influence in America, see Ray Haslam, '"According to the requirements of his scholars": Ruskin, drawing and education' in, *Ruskin's Artists: Studies in the Victorian Visual Economy*, (ed.) R. Hewison, Ashgate, 2000, pp. 147-165.

3. Elizabeth K. Helsinger, *Ruskin and the Art of the Beholder*, Harvard University Press, 1982, p. 298.

4. Helsinger, *op. cit.*, p. 289.

5. For a demonstration of the Law of Help and its relation to Ruskin's emblematic contrast between Life and Death, which draws on Helsinger's observations on the relationship between Ruskin's visual prose and use of illustration, see Alan Davis, '*Chateau de Blois* and the Law of Help', *Ruskin Review and Bulletin*, vol. 6, no. 1 (Spring 2010), pp. 43-48.

10: Straight Lines or Curved? Ruskin and Henry Cole, pp. 187-207

1. Henry Cole, *Fifty Years of Public Work of Sir Henry Cole, K. C. B. Accounted for in his deeds, speeches and writings*, 2 vols, George Bell, 1884, vol. 1, p. 82.

2. Henry Cole, *op. cit.*, vol. 1, p. 226.

3. Elizabeth Bonython. *King Cole: A picture portrait of Sir Henry Cole, KCB,*

1808-1882, Victoria & Albert Museum, (no date), p. 2.

4. R. Clark, *A History of the Royal Albert Hall*, Hamish Hamilton, 1958, p. 103.

5. The Diary of Henry Cole, 14 January 1828: the manuscript volumes, and a typescript, transcribed and indexed by Elizabeth Bonython, are in the National Art Library at the Victorian and Albert Museum. The dates of entries further cited are given in the text.

6. Henry Cole, *op. cit.*, vol. 1, p. 103n.

7. Henry Cole, *op. cit.*, vol. 1, p. 6.

8. Raymond Williams, *Culture & Society 1780-1950* (1958), Penguin Books, 1961, p. 83

9. Bonython, *op. cit.*, p. 61.

10. Henry Cole, *op. cit.*, vol. 1, p. 286.

11. Jules Lubbock, *The Tyranny of Taste: The Politics of Architecture and Design in Britain*, Yale University Press, 1995, p. 270.

12. Anon, 'The Seven Lamps of Architecture.' *The Journal of Design and Manufactures* vol. 2, no. 8 (October 1849), p. 72.

13. *Ibid.*

14. Virginia Surtees (ed), *Sublime and Instructive: Letters of John Ruskin to Louisa, Marchioness of Waterford, Anna Blunden and Ellen Heaton*, Michael Joseph, 1972, p. 211; Bradley, John and Iain Ousby (eds), *The Correspondence of John Ruskin and Charles Eliot Norton*, Cambridge University Press, 1987, p. 36.

15. *The Times*, 14 June 1858.

16. A. Burton, 'Redgrave as Art Educator, Museum Official and Design Theorist' in *Richard Redgrave 1804-1888*, (ed.) S. P. Casteras and R. Parkinson, Yale University Press, 1988, p. 48.

17. A. Burton, *op. cit.*, p. 56.

18. *The Times*, 27 November 1877.

19. Christopher Frayling, *The Royal College of Art: One Hundred and Fifty Years of Art and Design*, Barrie & Jenkins, 1987, p. 66.

20. Stuart MacDonald, *The History and*

Philosophy of Art Education, University of London Press, 1970, p. 228.

11: 'Communism and Art': Ruskin, Sheffield and the Guild of St George, pp. 209-239

1. The report is reprinted, with slight variations, at (30.306-9).

2. The 'ladies' were almost certainly wives of the communards, but the reporter felt it necessary to draw attention to their gender. One of them may have been Joan Severn.

3. *The Sheffield Portrait Gallery*, November, 1875. Some of the evident hostility may stem from the fact that Sheffield was about to open its own gallery, the Graves, at this time.

4. Letter of G. Allen to John Bunney, 20 February 1876, quoted by Dr C. Williams in her unpublished catalogue to the Museum of the Guild of St George.

5. S. Rowbotham (with Jeffrey Weeks), *Socialism and the New Life*, London, Pluto Press, 1977, p. 38.

6. T. Hancock, 'Henry Swan, The Quaker', *Pall Mall Gazette*, 3 April 1889.

7. W. Hargrave, 'The Faithful Steward of the Ruskin Museum', *Pall Mall Gazette*, 2 April 1889.

8. In search of Henry Swan I consulted *The Phonograph: A Shorthand Literary Magazine*, published from July 1879 to March 1881 by M. Hurst, 23 Church Street, Sheffield. Unfortunately I was none the wiser, as it was all in shorthand. Swan's name, however, does not appear in the printed list of contributors.

9. Letter of G. Allen to John Hobbs, 26 April 1890, Pierpont Morgan Library, New York.

10. Typed transcript made for Cook and Wedderburn of a letter from Ruskin to Tarrant and Mackrell, 27 September 1875. These transcripts are in the Bodleian Library, Oxford.

11. *Ibid.*

12. Typed transcript of a letter from Ruskin to G. Allen, 27 August 1875, Bodleian Library, Oxford.

13. The first two sentences of this quotation are taken from transcripts made by Helen Gill Viljoen from the correspondence between Ruskin and Swan held by the Rosenbach Foundation, Philadelphia. Viljoen continued the quotation in *The Brantwood Diary of John Ruskin*, ed. H. G. Viljoen, New Haven and London, Yale University Press, 1971, p. 42n.

14. ALS John Ruskin to Joan Severn, 26 September 1876, the Ruskin Library, Lancaster University.

15. Mark Frost, *The Lost Companions and John Ruskin's Guild of St George: A Revisionary History*, Anthem Press, 2014, p. 115.

16. *The Professor: Arthur Severn's Memoir of John Ruskin*, ed. J. S. Dearden, London, Allen & Unwin, 1967, p. 88.

17. Frost, *op. cit.*, p. 135. As far as is known, Ruskin knew nothing of Karl Marx, and Marx knew nothing of Ruskin.

18. *The Letters of John Ruskin to Lord and Lady Mount-Temple*, ed. J. L. Bradley, Ohio State University Press, p. 314. Letter of 4 August 1871.

19. [David Robinson], 'Political Economy', *Blackwood's Magazine*, Vol. 27 (January 1830), p. 36.

20. Quoted in Frost, *op. cit.*, p. 129.

21. Frost, *op. cit.*, p. 133.

22. Frost, *op. cit.*, p. 219.

23. *The Brantwood Diary of John Ruskin*, *op. cit.*, p. 603.

24. *The Sheffield Daily Telegraph*, 14 April 1890.

25. ALS John Ruskin to Joan Severn, 25 July [1881], the Ruskin Library, Lancaster University.

26. In 2002 the Guild acquired the Bunney family collection and archive, substantially increasing its holdings.

27. For Creswick, see Annie Dawson Creswick (with Paul Dawson), *Benjamin Creswick*, The Guild of St George Publications, 2015.

12: 'From You I Learned Nothing But What Was Good': Ruskin and Oscar Wilde, pp. 241-258

1. John Ruskin, *The Works of John Ruskin*, Library Edition (1903-12), ed. E. T. Cook and Alexander Wedderburn, 39 vols, George Allen, London and Longmans, New York. The entire text of the Library Edition is available online from the website of the Ruskin Library, Lancaster University, as a free download.

2. Ruskin's letter to Constance Wilde, dated Sandgate 25 January 1888, is reproduced in *Oscar Wilde in Context*, ed. Kerry Powell & Peter Raby, Cambridge University Press, 2013, pp. 128-9. Part of the transcription reads: You <u>may</u> trust, with your husband – with your children as they bloom round you – in what I <u>was</u> – but not in the wreck of it'.

3. Oscar Wilde, *The Letters of Oscar Wilde*, ed. Rupert Hart-Davis, London, 1962, p. 217.

4. Quoted in Robert Hewison, *Ruskin and Oxford*, Clarendon Press, 1996, p. 24.

5. Kevin O'Brien, *Oscar Wilde in Canada: An Apostle for the Arts*, expanded edition, Ontario, The Battered Silicone Dispatch Box, 2010, p. 203. In the view of Bernard Richards: 'Wilde did not participate very much in the project', and the account given in his American lectures is fanciful. But he was there. Bernard Richards, 'Oscar Wilde and Ruskin's Road', *The Wildean*, no. 40, (January 2012), p. 74.

6. K. O'Brien, *op. cit.*, p. 202.

7. K. O'Brien, *op. cit.*, p. 175.

8. Oscar Wilde, 'The Grosvenor Gallery', *Dublin University Magazine*, vol. 90, no. 535 (July 1877), p. 119.

9. Wilde, *op. cit.*, p. 124.

10. Wilde, *op. cit.*, p. 126.

11. Walter Pater, *The Renaissance: Studies in Art and Poetry* (Library Edition), Macmillan, 1910, p. 236.

12. Quoted in Richard Ellmann, *Oscar Wilde*, Hamish Hamilton, 1987, p. 284.

13. R. Ellmann, *op. cit.*, p. 58.

14. O. Wilde, *Letters, op. cit.*, p. 39. For a recent discussion of the comparative influences of Ruskin and Pater on Wilde, see John Paul Riquelme, 'Between two worlds and beyond them: John Ruskin and Walter Pater', in *Oscar Wilde in Context*, ed. Kerry Powell & Peter Raby, Cambridge University Press, 2013, pp. 125-36. 'Pater's influence during the last quarter of the 19th century was prodigious, but T. S. Eliot claimed that Ruskin was the most important writer. Wilde's reactions to them suggest that he drew a similar conclusion', Riquelme, p. 126.

15. K. O'Brien, *op. cit.*, p. 177.

16. K. O'Brien, *op. cit.*, p. 202.

17. Rennell Rodd, *Rose Leaf and Apple Leaf*, with an introduction by Oscar Wilde, Philadelphia, J. M. Stoddart, 1882, p. 11.

18. R. Rodd, *op. cit.*, p. 12.

19. R. Rodd, *op. cit.*, p. 13.

20. R. Rodd, *op. cit.*, p. 14.

21. R. Rodd, *op. cit.*, p. 15.

22. R. Rodd, *op. cit.*, p. 16.

23. K. O'Brien, *op. cit.*, p. 198.

24. Oscar Wilde, *Oscar Wilde's Oxford Notebooks: A Portrait of Mind in the Making*, ed. With a commentary, Philip E. Smith II & Michael S. Helford, Oxford University Press, 1989, p. 210, n. 44.

25. Oscar Wilde, *The Complete Works of Oscar Wilde*, ed. Robert Ross, Methuen, 1980, vol 8, p. 200.

26. O. Wilde, *Complete Works, op. cit.*, vol. 8, p. 182.

27. O. Wilde, *Notebooks, op. cit.*, p. ix.

28. O. Wilde, *Notebooks, op. cit.*, p. 14.

29. O. Wilde, *Complete Works, op. cit.*, vol. 8, p. 44.

30. R. Rodd, *op. cit.*, p. 24.

31. O. Wilde, *Complete Works, op. cit.*, vol. 8, p. 276.

32. O. Wilde, *Complete Works, op. cit.*, vol. 8, p. 276

33. O. Wilde, *Complete Works, op. cit.*, vol. 8, p. 322.

34. O. Wilde, *Complete Works, op. cit.*, vol. 8, p. 335.

35. John Unrau, 'Ruskin and the Wildes: The Whitelands Connection', *Notes and Queries*, vol. 29 (1982) p. 316. The meeting with Ruskin is mentioned in the same article.

36. I am very grateful to Dr Stuart Eagles for this information.

37. O. Wilde, *Letters, op. cit.*, pp. 217-8.

13: 'You Are Doing Some of the Work That I Ought to Do': Ruskin and Octavia Hill, pp. 261-275

1. Quoted in John Gaze, *Figures in a Landscape: A History of the National Trust*, Barrie & Jenkins, 1988, p. 36.

2. Charles E. Maurice, (ed.), *The Life of Octavia Hill as told in her letters*, Macmillan, 1913.

3. Emily S. Maurice, (ed.) *Octavia Hill: Early Ideals*, Allen & Unwin, 1928.

4. Gillian Darley, *Octavia Hill: Social reformer and founder of the National Trust*, Francis Boutle, 2010, p. 48

5. C. Maurice, *Life, op. cit.*, p. 30.

6. C. Maurice, *Life, op. cit.*, p. 39.

7. E. Maurice, *Ideals, op. cit.*, p. 121.

8. E. Maurice, *Ideals, op. cit.*, p. 127.

9. E. Maurice, *Ideals, op. cit.*, p. 128.

10. E. Maurice, *Ideals, op. cit.*, pp. 140-1.

11. E. Maurice, *Ideals, op. cit.*, p. 80.

12. For Ruskin and Anna Blunden, see Virginia Surtees (ed.), *Sublime and Instructive: Letters from John Ruskin to Louisa, Marchioness of Waterford, Anna Blunden and Ellen Heaton*, Michael Joseph, 1972.

13. C. Maurice, *Life*, *op. cit.*, p. 159.
14. C. Maurice, *Life*, *op. cit.*, p. 160.
15. *Ibid.*
16. E. Maurice, *Ideals*, *op. cit.*, p. 156.
17. C. Maurice, *Life*, *op. cit.*, p. 203.
18. C. Maurice, *Life*, *op. cit.*, p. 212.
19. E. Maurice, *Ideals*, *op. cit.*, p. 163.
20. *Ibid.*
21. E. Maurice, *Ideals*, *op. cit.*, p. 179.
22. Ruskin wanted to defeat the ordinary principles of shop-keeping by selling tea at the same price, regardless of the quantity bought. He probably also wanted to provide employment for the Tovey sisters. The experiment was not a success.
23. E. Maurice, *Ideals*, *op. cit.*, p. 187.
24. Quoted in Darley, *op. cit.*, p. 241.
25. C. Maurice, *Life*, *op. cit.*, pp. 499-500.
26. Octavia Hill, (1877), *Our Common Land (and other short essays)*, Macmillan, 1877, p. 7.
27. O. Hill, *op. cit.*, pp. 205-6.
28. Fiona Reynolds, 'The Government must stop the insults, and listen to our concerns', *The Telegraph*, 3 September 2011. Since stepping down as Director of the National Trust, Fiona Reynolds has published *The Fight For Beauty*, Oneworld, 2016, tracing the struggle of campaigners like herself to insist that the protection of natural beauty should be public policy.
29. O. Hill, *op. cit.*, p. 13)
30. Quoted in Darley, *op. cit.*, p. 322.
31. C. Maurice, *Life*, *op. cit.*, p. 543.

Thank you to Dr Melanie Hall for her comments on this chapter.

14: 'The Mind Revolts': Ruskin and Darwin, pp. 279-305

1. For an explanation of this term, see A. N. Wilson, *Charles Darwin: Victorian Mythmaker*, John Murray, 2017, p. 17.
2. For an account of the Wilberforce/ Huxley encounter, see J. Vernon Jensen, *Thomas Henry Huxley: communicating for science*, University of Delaware Press, 1988, and A. N. Wilson, *op. cit.*, pp. 258-74.
3. For a well-illustrated description of the project, see Trevor Garnham, *Oxford Museum: Deane and Woodward*, Phaidon, 1992.
4. E. T. Cook, *The Life of John Ruskin*, W. H. Allen, 1911, vol. 1, p. 32.
5. John Ruskin, *Iteriad; or, Three Weeks Among the Lakes*, (ed.) J. S. Dearden, Graham, 1969, lines 615-6, p. 113.
6. Robert Jameson, *Manual of Mineralogy*, Constable, 1821, pp. 363-4.
7. Charles Darwin, *Autobiographies*, (ed.) Michael Neve & Sharon Messenger, Penguin, 2002, p. 59.
8. William Buckland, *Geology and Mineralogy Considered with Reference to Natural Theology*, Pickering, 1836, vol. 1, p. 9.
9. *Essays and Reviews* was a collection of seven essays, six of them by Anglican clergymen, arguing for the application of historical and textual criticism to the Bible. The seventh was by a geologist, Charles Goodwin, demolishing the natural theologians and their attempt to reconcile their discoveries with Genesis: 'the interpretation proposed by Buckland to be given to the Mosaic description will not bear a moment's discussion'. C. Goodwin 'On the Mosaic Cosmogeny' reprinted in *Science and Religion in the Nineteenth Century*, (ed.) Tess Cosslett, Cambridge University Press, 1984, p. 128.
10. Charles Darwin, *The Descent of Man, and selection in relation to sex*, 2 vols, John Murray, 1871, vol. 1, p. 153.
11. Charles Darwin, *On the Origin of Species by Means of Natural Selection, or the preservation of favoured races in the struggle for life*, 3rd. edition, John Murray, 1861, p. 516.

12. Charles Darwin, *On The Origin of Species, op. cit.*, p. 92.

13. Charles Darwin, *On The Origin of Species, op. cit.*, p. 525

14. Charles Darwin, *On the various contrivances by which British and Foreign Orchids are fertilised by insects, and on the good effects of crossing*, John Murray, 1862, p. 343.

15. C. E. Norton, introduction to the 'Brantwood' edition of *The Queen of the Air*, New York, Charles Merrill, 1891, p. x.

16. Charles Darwin, *The Descent of Man, op. cit.*, vol. 1, p. 185.

17. Charles Darwin, *The Descent of Man, op. cit.*, vol. 1, p. 185.

18. Charles Darwin, *The Descent of Man, op. cit.*, vol. 2, p. 393.

19. Charles Darwin, *The Descent of Man, op. cit.*, vol. 2, p. 48.

20. Charles Darwin, *The Descent of Man, op. cit.*, vol. 1, p. 63.

21. Charles Darwin, *The Descent of Man, op. cit.*, vol. 2, p. 353.

22. Jonathan Smith, *Charles Darwin and Victorian Visual Culture*, Cambridge University Press, 2006, p. 2.

23. Jonathan Smith, *op. cit.*, p. 136.

24. Charles Darwin, *Autobiographies, op. cit.*, p. 50.

25. Charles Darwin, *On The Origin of Species, op. cit.*, p. 85.

26. John Hedley-Brooke, *Science and Religion: Some Historical Perspectives*, Cambridge University Press, p. 293.

27. Charles Darwin, *The Descent of Man, op. cit.*, vol. 2, p. 396.

28. Charles Darwin, *The Descent of Man, op. cit.*, vol. 1, p. 325.

29. Ruskin may be parodying a passage on the snipe in *The Descent of Man, op. cit.*, vol. 2, p. 64.

30. Dinah Birch, 'Ruskin and the Science of *Proserpina*', in *New Approaches to Ruskin*, (ed.) R. Hewison, Routledge, 1981, p. 145 *et seq.* See also Frederick Kirchhoff, 'A Science against Sciences: Ruskin's Floral Mythology', in U. C. Knoepflmacher & G. B. Tennyson, (eds), *Nature and the Victorian Imagination*, University of California Press, 1977, p. 255n, where Ruskin is himself likened to Proserpina.

31. Tim Hilton, *John Ruskin*, (vol. 1, 1985, vol. 2, 2000), combined paperback edition 2002, Yale University Press, p. 594.

32. Frederick Kirchhoff, 'A Science against Sciences', *op. cit.*, p. 255.

33. Francis O'Gorman, 'Ruskin's Science of the 1870s', in Dinah Birch, (ed.) *John Ruskin and the Dawn of the Modern*, Clarendon Press, 1999, p. 49.

34. For a fuller account of Ruskin's second Slade Professorship, try to get hold of my obscurest (and most expensive) publication, *The Ruskin Art Collection at Oxford: Catalogue of the Rudimentary Series*, (ed.) Robert Hewison, Lion and Unicorn Press, 1984, pp. 29-32.

35. Bodleian Library, MS Eng Lett c.47 folio 403 (Letter of 22nd March 1885).

15: *The Triumph of the Innocents*: Ruskin, Holman Hunt and Spiritualism, pp. 307-327

1. Robert Hewison, Ian Warrell & Stephen Wildman, *Ruskin, Turner and the Pre-Raphaelites*, Tate Publishing, 2000.

2. Quoted in Mary Bennett, *Artists of the Pre-Raphaelite Circle: The First Generation*, catalogue of Works in the Walker Art Gallery, Lady Lever Art Gallery and Sudley Art Gallery, Lund Humphries, 1988, p. 91

3. Quoted in Mary Bennett, *op. cit.*, pp. 91-2.

4. Quoted in Mary Bennett, *op. cit.*, p. 73).

5. The Crimean War with Russia ran from October 1853 to March 1856.

6. Quoted in Leslie Parris, *The Pre-Raphaelites*, Tate Publishing, 1984, p. 221.

7. William Holman Hunt, *Pre-Raphaelitism and the Pre-Raphaelite Brotherhood*, Macmillan, 2 vols., 1905, vol. 2. p. 330.

8. William Bell Scott, *Autobiographical Notes of the Life of William Bell Scott*, (ed.) W. Minto, James R. Osgood, 2 vols., 1892, vol. 2, p. 227.

9. George P. Landow, "'Your good influence on me": The Correspondence of John Ruskin and William Holman Hunt', *Bulletin of the John Rylands Library*, vol. 59, (Autumn 1976), pp. 95-126, (Spring 1977), pp. 367-96, p. 376.

10. William Bell Scott, *op. cit.*, vol. 2, p. 99.

11. William Bell Scott, *op. cit.*, vol. 2, p. 235.

12. William Holman Hunt, *op. cit.*, vol. 2, p. 271.

13. Quoted in Mary Bennett, *op. cit.*, p. 92.

14. William Bell Scott, *op. cit.*, vol. 2, p. 229.

15. William Bell Scott, *op. cit.*, vol. 2, p. 226.

16. My friend and colleague Alan Davis draws attention to this passage from *Modern Painters* volume four, where Ruskin insists on the importance and truth of the imagination: 'some people see only things that exist, and others see things that do not exist, or do not exist apparently. And if they really *see* these non-apparent things, they are quite right to draw them; the only harm is when people try to draw non-apparent things, who *don't* see them, but think they can calculate or compose into existence what is to them for evermore invisible. If some people really see angels where others see only empty space, let them paint the angels' (6.28). Hunt appears to have seen non-apparent things.

17. G. P. Landow, *op. cit.*, p. 388.

18. G. P. Landow, *op. cit.*, p. 377.

19. G. P. Landow, *op. cit.*, p. 104. For a discussion of Holman Hunt's development of a modern symbolism, which has informed both this chapter and Chapter VI, see George P. Landow, *William Holman Hunt and Typological Symbolism*, Yale, 1979.

16: Of Ruskin's Gardens: Ruskin and the Paradise Myth, pp. 329-351

1. Raymond Williams, *Keywords* (1976), Fontana, 1988, p. 87.

2. Matthew Arnold, (ed) J. Dover Wilson, *Culture and Anarchy* (1869), Cambridge University Press, 1961, p. 6.

3. David Ingram's *The Gardens at Brantwood: Evolution of John Ruskin's Lakeland paradise*, Pallas Athene and the Ruskin Foundation, 2014, is an invaluable exploration of and guide to Ruskin's horticulture.

4. Bradley, J. L. (ed.), *Ruskin's Letters from Venice, 1851-1852*, Yale University Press, 1955, p. 238.

5. Northrop Frye, (2006) *Anatomy of Criticism: Four Essays* (1957), (ed.) Robert D. Denham, *Collected Works of Northrop Frye*, vol. 22, University of Toronto Press, 2006, p. 60.

6. Harold Bloom, (ed.) (1965) *The Literary Criticism of John Ruskin*, New York, Doubleday, 1965, p. xxiv.

7. D. G. Rossetti, *Collected Poetry and Prose*, (ed.) Jerome McGann, Yale University Press, 2003, p. 288. Ruskin paid for the publication of Rossetti's *Early Italian Poets* in 1861.

8. Frye, *op. cit.*, p. 53.

9. Frye, *op. cit.*, p. 174.

10. Sawyer, Paul L. Sawyer, 'Ruskin and St George: The Dragon-killing myth in *Fors Clavigera*', *Victorian Studies*, vol. 23 (Autumn 1979), p. 6.

11. Bruce Redford, 'Ruskin Unparadized: Emblems of Eden in *Præterita*', *Studies in English Literature, 1500-1900*, 22 (1982), p. 676.

12. Pierre Fontaney, 'Ruskin and Paradise Regained', *Victorian Studies*, vol. 12 no. 3 (March 1969), pp. 348-9.

13. John D. Rosenberg, *The Darkening Glass: A Portrait of Ruskin's Genius*, Routledge, Kegan Paul, 1963, p. 47.

14. Richard L. Stein, *The Ritual of Interpretation: The Fine Arts as Literature in Ruskin, Rossetti, and Pater*, Harvard University Press, 1975, pp. 92-3.

15. Dante Alighieri, *The Vision or Hell, Purgatory and Paradise by Dante Alighieri*, translated by Henry Francis Cary, Henry Froude/Oxford University Press, 1910, p. 120.

16. Frye, *op. cit.*, p. 174.

17. Michael Wheeler makes this point in 'Ruskin among the ruins: tradition and the temple', in M. Wheeler and N. Whiteley (eds), *The lamp of memory: Ruskin, tradition and architecture*, Manchester University Press, 1992, pp. 77-97.

18. Jeffrey L. Spear (1984) *Dreams of an English Eden: Ruskin and His Tradition in Social Criticism*, Columbia University Press, 1984.

19. Sawyer, *op. cit.*, p. 7.

20. Northrop Frye, *The Secular Scripture: A Study of the Structure of Romance*, Harvard University Press, 1976, p. 151.

21. Frye 1976, *op. cit.*, p. 153.

22. Spear *op. cit.*, p. 188.

23. Maurice Barrès, *Amori et Dolori Sacrum: La Mort de Venise*, Felix Juven, 1903.

17: Relevant to the 21st Century: Ruskin and Cultural Value, pp. 353-377

1. Tony Judt, *Ill Fares The Land: a treatise on our present discontents*, Allen Lane, 2010, p. 1. I used this same quotation as the epigraph to *Cultural Capital: The Rise and Fall of Creative Britain*, Verso, 2014, p. 121. The repetition is not accidental.

2. Warwick Commission, *Enriching Britain: culture, creativity and growth. The 2015 report by the Warwick Commission on the future of cultural value*, University of Warwick, 2015.

3. Geoffrey Crossick and Patrycja Kaszynska, *Understanding the value of arts & culture: The AHRC Cultural Value Project*, Arts & Humanities Research Council, 2016. The project commissioned 70 different investigations into aspects of Cultural Value, the results are summarised in this report.

4. Michael Hutter & and David Throsby, (eds.), *Beyond Price: Value in Culture, Economics and the Arts*, Cambridge University Press, p. 2.

5. Adam Smith, *An Enquiry into the Nature and Causes of The Wealth of Nations* (1776), (ed.) Edwin Cannan, 4th edition, 2 vols., Methuen, vol. 1, p. 30.

6. J. S. Mill, *Principles of Political Economy* 2 vols., 2nd edition, London, Parker. (With marginal notes by Ruskin, British Library c.60.l.10), vol. 1, p. 515.

7. J. S. Mill, *op. cit.*, vol. 1, p. 2. This is quoted by Ruskin in the preface to *Unto This Last* when published in book form in 1862 (17.18), and again in the preface to the later essays gathered together as *Munera Pulveris* (17.131).

8. J. S. Mill, *op. cit.*, vol. 1, p. 515.

9. J. S. Mill, *op. cit.*, vol. 1, p. 25.

10. J. S. Mill, *op. cit.*, vol. 1, p. 516.

11. Aristotle, *Nicomachean Ethics*, translated and edited by Roger Crisp, Cambridge, Cambridge University Press, 2000, p. 7

12. Aristotle, *The Nicomachean Ethics of Aristotle, with English notes*, ed. John S. Brewer, Oxford, Henry Slatter, 1836. With marginal notes and drawings by Ruskin, British Library c.44.d.3. He has written on the flyleaf: 'Old schoolbook – woeful to see, thrown out, Brantwood, April 1880'.

13. David Throsby, *Economics and Culture*, Cambridge University Press, 2001, pp. 19-20.

14. Also known as 'Willingness to Pay', the theory of contingent valuation is that because the monetary value of public goods cannot be established through the

process of value in exchange, as can be with privately owned goods, people are asked what they would be willing to pay if the public good in question otherwise became unavailable.

15. D. Throsby, *op. cit.*, pp. 28-9.
16. See for instance John Holden, *Capturing Cultural Value*, Demos, 2004, pp. 37-9.
17. D. Throsby, *op. cit.*, p. 33.
18. Readers of my work will recognise that this was the mainspring of my study *Culture and Consensus: England , Art and Politics since 1940 (1995)*, revised edition, Routledge Revival, 2015.
19. Mark Moore, *Creating Public Value: Strategic Management in Government*, Harvard University Press, 1995.
20. Gavin Kelly, Geoff Mulgan, Stephen Muers, *Creating Public Value: an analytical framework for public service reform*, Cabinet Office paper, 2002
21. BBC, *Building Public Value: Renewing the BBC for a digital world*, BBC, 2004.
22. See for instance Policy Action Team 10, *Arts and Sport: a report to the Social Exclusion Unit*, Department for Culture. Media and Sport, 1999.
23. Tessa Jowell, *Government and the Value of Culture*, Department for Culture, Media and Sport, 2004, p. 18.
24. T. Jowell, *op. cit.*, p. 9.
25. John Holden, *Capturing Cultural Value*,

Demos, 2004; J. Holden, *Cultural Value and the Crisis of Legitimacy*, London, Demos 2006; R. Hewison, *Not a Side show: Leadership and Cultural Value*, London, Demos, 2006. R. Hewison & J. Holden, *Challenge and Change: HLF and Cultural Value*, Heritage Lottery Fund/Demos, 2004, R. Hewison & J. Holden, *The Cultural Leadership Handbook: How to run a creative organization*, Gower, 2011. Full disclosure, through Demos we arranged the conference *Valuing Culture*.

26. D. Throsby, *op. cit.*, p. 20.
27. We have sought to elaborate the typology in relation to the heritage in Robert Hewison & John Holden, *Challenge and Change: HLF and Cultural Value*, Heritage Lottery Fund/Demos, 2004, p. 42.
28. See Elizabeth Helsinger, *Ruskin and the Art of the Beholder*, Harvard University Press, 1982, p. 273.
29. Charles Darwin, *The Descent of Man*, 2 vols, John Murray, 1871, vol. 1, p. 63.
30. William Davies, *The Limits of Neoliberalism: Authority, Sovereignty and the Logic of Competition* (2015), revised edition, Sage, 2016, p. xvi.
31. William Davies, *op. cit.*, p. 196.
32. *Ibid.*
33. David Throsby, *Economics and Culture*, *op. cit.*, pp. 19-20.

LIST OF ILLUSTRATIONS

❧

Front cover/dustjacket Charles Fairfax Murray, *Portrait of John Ruskin*, 1875, © Tate 2018

Back cover/dustjacket John Ruskin, *Study of a Paper Nautilius Shell*, 10 February 1867, © Ashmolean Museum, University of Oxford, WA.RS.ED.196

Colour plates

Text figures

INDEX

✂

PALLAS ATHENE

The Nature of Gothic
John Ruskin

*designed, typeset and with a preface by William Morris
and essays by Robert Hewison, Tony Pinkney
and Robert Brownell*

One of the very few necessary and inevitable utterances of the century.
William Morris, in the Preface

The Nature of Gothic started life as a chapter in Ruskin's masterwork, *The Stones of Venice*. It marked his progression from art critic to social critic; in it he found the true seam of his thought, and it was quickly recognised for the revolutionary writing it was. As Morris himself put it, *The Nature of Gothic* 'pointed out a new road on which the world should travel'.

Forty years after he first read it, Morris chose Ruskin's text for one of the first books to be published at his Kelmscott Press. It is one of the most beautiful books ever published. In this first-ever facsimile edition of this rare book, the reader can fully appreciate the importance and legacy of Ruskin's words.

150pp ISBN 978 1 84368 101 4 £14.99

'A New and Noble School':
Ruskin and the Pre-Raphaelites

*edited by Stephen Wildman
and with an introduction by Robert Hewison*

The first compilation of all of Ruskin's published writings relating to the Pre-Raphaelites, beginning with the celebrated passage in the first volume of *Modern Painters* (1843) exhorting young artists to 'go to nature in all ... rejecting nothing, selecting nothing and scorning nothing'.

310pp ISBN 978 1 84368 0864 £19.99

PALLAS ATHENE

A John Ruskin Collection
James S. Dearden

Nobody has done more than James Dearden to encourage the revival
of interest in Ruskin over the past fifty years. His scholarship, his
bibliographical expertise, and his humane appreciation of Ruskin
are all evident in this latest collection.
Robert Hewison

This collection brings together a lifetime of articles on the lives of John Ruskin
and those around him, showcasing James Dearden's vast knowledge of Ruskin
and his exceptional capacity for recollection.

In each chapter, Dearden deftly illuminates his subject, moving between
everyday domestic routines and emotional, intellectual and artistic lives. In doing
so, he not only helps us to understand the lives of Ruskin and his family, friends
and servants, but also achieves an impressive evocation of nineteenth-century
life. Fascinating to Ruskinians and non-Ruskinians alike.

260pp ISBN 978 1 84368 152 6 £19.99

Rambling Reminiscences
A Ruskinian's Recollections
James S. Dearden

James Dearden has spent a lifetime working with the great legacy of John
Ruskin, from his schooldays under the leading Ruskin collector, John Howard
Whitehouse, to his recent, magisterial study, *The Library of John Ruskin*. All
Ruskinians will be fascinated to read the details of James's thoughts and often
trenchant reflections on this life well lived.

342pp ISBN 978 1 84368 105 2 £19.99

PALLAS ATHENE

The Worlds of John Ruskin
Kevin Jackson

Brilliantly introduces Ruskin to the general reader and offers
insights into his continuing relevance.
Heather Birchall in *Art Quarterly*

Jackson's pacy text is a masterly compression of an extraordinary life,
offering at every juncture some apt historical context ... Among the 165 full-
colour images are many outstanding and little-known masterpieces of the
kind that only Ruskin's keen eye could produce.
Stephen Wildman in *Art Newspaper*

A fine tribute, generously illustrated.
Sunday Telegraph

Second edition 160pp with 165 colour illustrations
ISBN 978 1 84368 148 9 £17.99

A Ruskin Alphabet
Kevin Jackson

A pocket-sized volume with comprehensive entries ranging from art to zoology,
the Middle Ages, pantomimes, Tolstoy and usury. As well as a wealth of infor-
mation, the book offers insight into the life of one of the nineteenth century's
most extraordinary men.

64pp ISBN 978 1 84368 098 7 £4.99

PALLAS ATHENE

Marriage of Inconvenience
Robert Brownell

One of the two or three most important books
about Ruskin of the last thirty years.
James Dearden, former Master of Guild of St George

Robert Brownell weighed in with an enjoyably obsessive re-examination of
the marriage of Effie and John Ruskin and the pubic hair question.
Observer Books of the Year

Ruskin's disastrous marriage to Effie Gray has distracted many readers from
the vital force of his thought and writings; lurid speculation and absurd urban
myths have made it a byword. But what really happened in the most scandalous
love triangle of the nineteenth century? Was it all about impotence and pubic
hair? Or was it about money, power and freedom? If so, whose? What possibilities
were there for these young people caught in a world racked by social, financial
and political turmoil? And why did a very private matter become public gossip –
entirely to the benefit of élites most threatened by Ruskin's teachings?

History books, novels, television series, operas and films have all followed
the standard line of a repressed and repressive Victorian man and his daringly
independent wife. It seems to offer an easy take on the Victorians and how we
have moved on. But the story isn't true. In *Marriage of Inconvenience* Robert
Brownell uses extensive documentary evidence – much of it never seen before,
and much of it hitherto suppressed – to reveal a story no less fascinating and
human, no less illuminating about the Victorians, and far more instructive about
our own times, than the myths that have grown up about the most notorious
marriage of the nineteenth century

580 pp with 32 pp of colour
Hardback ISBN 978 1 84368 076 5 £24.99
Paperback ISBN 978 1 84368 096 3 £17.99

PALLAS ATHENE

A Torch at Midnight
Robert Brownell

The popular myth of Ruskin as the archetypal Victorian patriarch has persistently clouded interpretation of his ideas, introducing spurious psycho-social motives based on a misunderstood scandal. The Ruskin that emerges from *A Torch at Midnight* is quite different: heretical in religion, radical in politics, subversive in economics and relentless in the pursuit of truth and meaning.

<div align="center">

500pp

Hardback ISBN 978 1 84368 142 7 £49.99
Paperback ISBN 978 1 84368 077 2 £19.99

</div>

The Reviews of John Ruskin's 'The Seven Lamps of Architecture'
compiled and with an introduction by Robert Brownell

These forty-five major English-language reviews, gathered for the first time into one volume by Robert Brownell, document the initial critical reaction to Ruskin's *The Seven Lamps of Architecture*. They give a fascinating insight into contemporary thought, not only with regard to architecture, but also to religion, politics and social issues. This collection of reviews is an essential research tool for anyone interested in Ruskin, architecture and Victorian society and culture.

<div align="center">

850pp

Hardback ISBN 978 1 84368 141 0 £49.99
Paperback ISBN 978 1 84368 079 6 £19.99

</div>

Published by
Pallas Athene (Publishers) Ltd,
Studio 11A, Archway Studios
25-27 Bickerton Road, London N19 5JT
For further information on our books please visit
www.pallasathene.co.uk

 pallasathenebooks PallasAtheneBooks

 Pallas_books issuu Pallasathene0

ISBN Paperback 978 1 84368 168 7
Hardback 978 1 84368 176 2

Printed in England